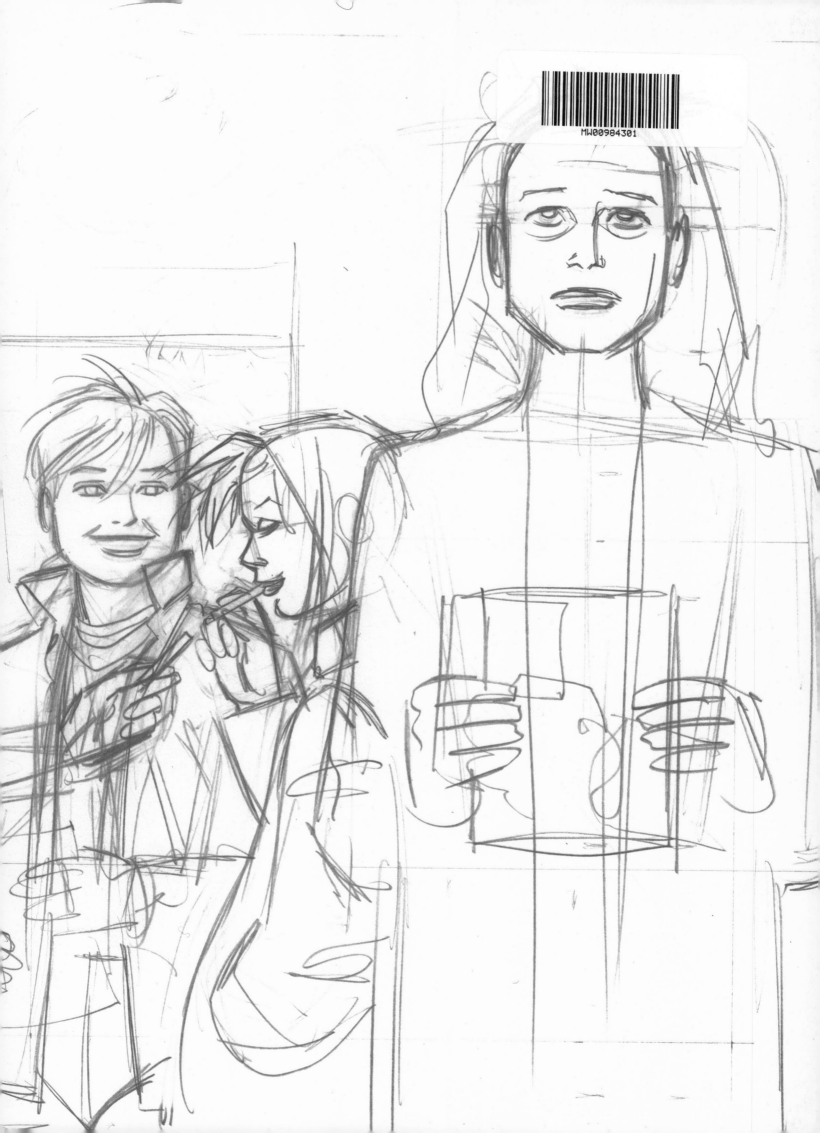

THE ART OF JAIME HERNANDEZ

The Art of Jaime Hernandez

THE SECRETS OF LIFE AND DEATH

TODD HIGNITE

ABRAMS COMICARTS

NEW YORK

DEDICATED TO
MRS. AURORA HERNANDEZ

contents

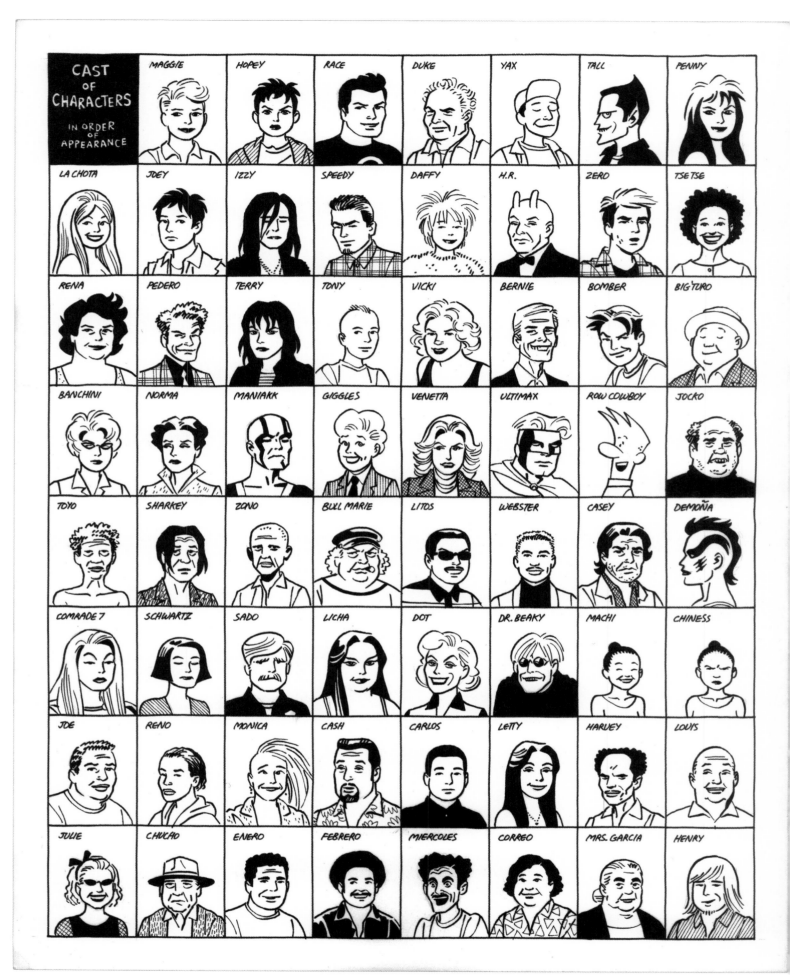

Original artwork for "Cast of Characters," *Maggie the Mechanic*, 2007.

Introduction

ALL I CAN SAY IS, it's a good thing I didn't discover *Love and Rockets* until I'd been drawing my own comics for a couple of years, or I'd still be a production assistant at the American Institute for Certified Public Accountants, and someone else would be writing this introduction.

Well . . . perhaps I exaggerate. I could just as easily have hung up my pen in despair in 1986, when I read Jaime Hernandez's work for the first time, as I could have in 1982 when we were both starting out. But I didn't. His comics clearly existed on such a lofty aesthetic plane that it didn't even occur to me to compare them to my own. This is not to say that Jaime's work didn't seep into my subconscious and influence me in ways I was completely unaware of. Indeed, as I was looking through my *Love and Rockets* collection to research this piece, I was taken aback by an alarming coincidence. My character Lois, a butch dyke with freckles and a blond crew cut, whom I introduced in 1987, looked strikingly like Jaime's Tom Tom, a freckled, boyish young punk who appears in *Love and Rockets* no. 17 from June 1986—the earliest issue that I own. Could I possibly have done something that brazen? Lifted a character wholesale? No one else would see the similarity—my drawing of Lois looks about as much like Tom Tom as early Garfield looks like late Krazy Kat. But whether it's an homage or outright plagiarism, my imitative effort is testimony to the seductive power of Jaime's numinous line.

I came somewhat late to the series due to my reluctance, in the eighties, to set foot inside a comic book store. Every now and then I would brave the collectibles and super heroes and pubescents to look for a copy of *Weirdo* or *American Splendor* on that tiny shelf in the back. But I didn't linger.

Then one day someone told me I had to see this new comic book with these two women in it who were lovers. "Yeah, right," I suppose I said, probably also rolling my eyes for good measure at the prospect of yet another male cartoonist's balloon-breasted masturbation fantasies—this one with a dash of girl-on-girl action thrown in for good measure.

But it felt incumbent on me as a lesbian cartoonist to check it out, so I stomped into DreamHaven Books in Minneapolis and bought *Love and Rockets* no. 17. I thenceforth proceeded to stomp back in at three- to four-month intervals to see whether the next issue was out, so I could continue my monitoring.

The Locas stories may have been, in part, a masturbation fantasy—the women are certainly beautiful, and drawn with an unmistakable sexual vitality. But that same vitality—voluptuous, palpable, acutely observed—infused everything in Jaime's stories, from the telephone poles, to the exhaled plumes of cigarette smoke, to the folds in a sleeve, to the precisely calibrated tension in the ropes of a wrestling ring. This drawn world had a pulse.

And so did these sexy women. Unlike 99.87 percent of the female characters in every other conceivable corner of the culture, from lowest-brow pulp to highest-brow art, Maggie and Hopey were subjects bursting with agency. And if their on-again, off-again sexual relationship was titillating, it was all the more so because of the rich, authentic delineation of their complicated personalities and their emotional rapport. Perhaps Jaime romanticized the tolerance the other characters have for Maggie and Hopey's bisexuality. And perhaps his men aren't drawn with the same lavish sensuality as his women (though I appreciate the egalitarian esprit of the occasional male frontal nudity).

But these are infinitesimal quibbles in the face of a vast contribution to the visual representation of women, not to mention the deconstruction of the male gaze. Clearly Jaime understands a thing or two about otherness, the way it excludes and dehumanizes, and he does something about it. Much as I love R. Crumb, there's a universe of difference between Devil Girl's steatopygic grandeur and Maggie's. Devil Girl remains opaque to us, but Maggie's radiant soul is imminent in her monumental and lovingly rendered thighs.

Rereading the early Locas stories, I find that although my recall of some of the plots is hazy, all of the drawings remain vividly incised in my memory. To be honest, I think I didn't so much read Jaime's stories as look at them, soaking up the nuanced tales told by those deceptively limpid lines. Thanks to Todd Hignite, it was interesting to learn in this book that as a child Jaime had a tendency to follow the pictures in comics and not the words, even after learning to read. Of course you can't dispense with Jaime's spot-on dialogue, but his visual storytelling remains remarkably intact without it.

Perhaps even more astonishing than Jaime's instinct for which details are narratively necessary is his unerring sense of which details to exclude. His pen picks out what is essential and elides what is not, leaving white spaces as intentional and vibrant as any inked lines in comics.

What remains is less a stylized world than a world distilled to its fantastic, magical, quotidian essence. A manifestly legible world replete with goofy cartoon conventions and empathic characterization rivaling Tolstoy. But most of all, a humane world where black and white, presence and absence, male and female, are balanced so exquisitely that we have no choice but to realize that the other, to paraphrase Pogo, is us.

ALISON BECHDEL
VERMONT
MAY 2008

ALISON BECHDEL is the bestselling, critically acclaimed author of the comic strip *Dykes to Watch Out For* and the graphic novel memoir *Fun Home*, a finalist for the National Book Critics Circle Award in 2006.

Li'l Maggie convention drawing, 2006.

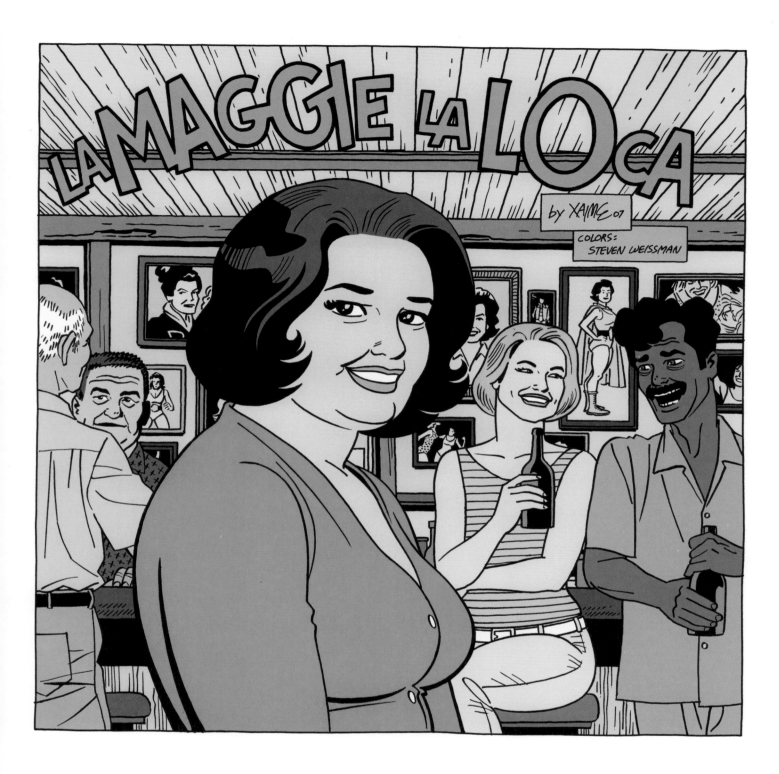

Preface

On April 23, 2006, the first installment of Jaime Hernandez's twenty-page comic "La Maggie La Loca" appeared in the *New York Times Magazine*, the second strip to be serialized in the venerable newspaper's newly launched "Funny Pages" section. While the publication served to introduce Hernandez to a significantly larger demographic, his real entrance in comics had been twenty-five years prior with the publication of *Love and Rockets*, a comic book featuring separate stories by "Los Bros. Hernandez": Jaime and Gilbert (along with occasional contributor Mario). Since the first issue, their comics have done nothing short of shatter parameters of realism and narrative invention in the medium, and Jaime Hernandez's poignantly humane stories have chronicled the lives of some of the most memorable and fully formed characters comics have ever seen. His captivating female

above and following pages
"La Maggie La Loca," 2006–07.
Originally serialized in the *New York Times Magazine* in 2006, this is Hernandez's expanded version, with new title page and three additional story pages; first collected in *Love and Rockets* no. 20 (Fantagraphics Books, 2007).

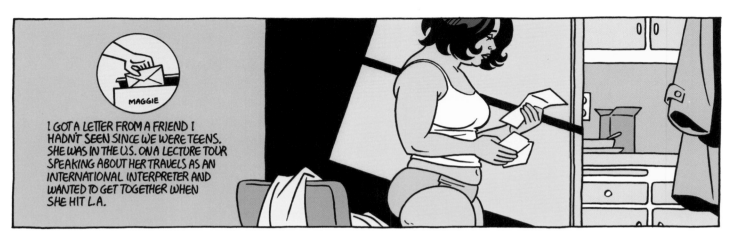

I GOT A LETTER FROM A FRIEND I HADN'T SEEN SINCE WE WERE TEENS. SHE WAS IN THE U.S. ON A LECTURE TOUR SPEAKING ABOUT HER TRAVELS AS AN INTERNATIONAL INTERPRETER AND WANTED TO GET TOGETHER WHEN SHE HIT L.A.

I WENT TO MEET HER AT THE LECTURE. I WAS REALLY STOKED TO SEE HOW GROWN-UP TSE TSE, I MEAN, PROFESSOR BAÑUELOS, HAD BECOME BUT ALSO A BIT INTIMIDATED, TO BE TRUTHFUL. WHEN I FIRST MET HER, SHE SPOKE FOUR LANGUAGES. NOW, 20 YEARS LATER, SHE WAS UP TO NINE.

AFTERWARD, WE HIT UP THE TOWN. I ASKED HER WHAT SHE WANTED TO SEE, MUSEUMS OR WHATEVER. SHE WANTED TO SEE THE BROWN DERBY. I HAD TO TELL HER THAT IT'S BEEN A MINI-MALL FOR DECADES. SHE SETTLED FOR JAY SILVERHEELS'S STAR ON THE WALK OF FAME.

WE WENT TO DINNER, WHERE SHE GRILLED ME ABOUT MY BORING LIFE. SHE SEEMED VERY INTERESTED IN THE FACT THAT I WAS THE MANAGER OF SOME SHODDY APARTMENTS. BUT THEN, TSE TSE WOULD BUILD ME UP IF I WERE A BLOCK OF CEMENT.

THEN WE GOT ON THE SUBJECT OF A MUTUAL FRIEND OF OURS WHO LIVES IN TSE TSE'S NECK OF THE WORLD, AND LITTLE DID I KNOW THAT THE NEXT FEW WEEKS OF MY LIFE WOULD TAKE QUITE AN INTERESTING TURN.

protagonists, led by Maggie (Margarita Luisa Chascarrillo) and Hopey (Esperanza Leticia Glass), are masterfully delineated with humor, candor, and breathtaking affection, and come to life within Southern California's Mexican-American culture and the punk milieu's heyday (and gradually fading aftermath). Such groundbreaking depiction of everyday, ethnically diverse lives, which Hernandez has continued to expand, deepen, and interweave in his stories, is his most impressive achievement, and the aspect of his work most often commented upon. However, it is not merely his subject matter, but rather how he treats the material, that is revolutionary. While there were superficial antecedents

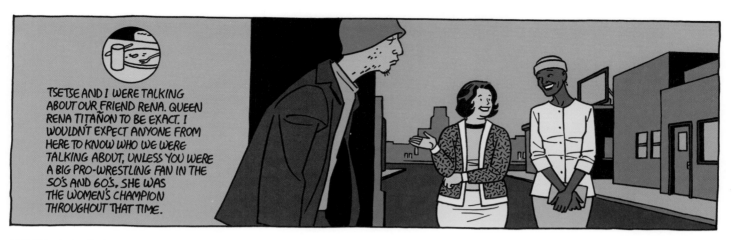

TSETSE AND I WERE TALKING ABOUT OUR FRIEND RENA. QUEEN RENA TITAÑON TO BE EXACT. I WOULDN'T EXPECT ANYONE FROM HERE TO KNOW WHO WE WERE TALKING ABOUT, UNLESS YOU WERE A BIG PRO-WRESTLING FAN IN THE 50's AND 60's. SHE WAS THE WOMEN'S CHAMPION THROUGHOUT THAT TIME.

BUT YOU ASK ANYBODY IN MOST LATIN COUNTRIES AND YOU INSULT THEIR INTELLIGENCE. YOU MAY AS WELL BE SPITTING ON THE POPE. SHE'S LIKE THIS LEGENDARY FIGURE. THIS MODERN-DAY SAINT AMONG SAINTS.

HER FANS RANGED FROM THE POWERFUL RICH TO THE POWERLESS POOR, AND RENA, COMING FROM THE LATTER, USED HER POPULARITY TO HELP HER PEOPLE. ONE THING LED TO ANOTHER, AND SHE BECAME A SYMBOL OF UPHEAVAL AND REVOLT IN LATIN AMERICA, AND ALL SHE HAD TO DO WAS WRESTLE.

NOW, DECADES LATER, SHE LIVES ON SOME REMOTE ISLAND, HIDDEN AWAY FROM HER COLORFUL PAST. JUST WHEN I THINK THAT MUST BE LIVING, TSE TSE TELLS ME THAT RENA WOULD LIKE ME TO COME VISIT HER FOR A COUPLE OF WEEKS. I TELL HER I CAN'T AFFORD IT, AND SHE TELLS ME RENA WILL PAY.

I TELL TSE TSE I'LL THINK ABOUT IT, BUT I REALLY DON'T. I JUST GO HOME, BACK TO MY SAFE BOREDOM. THAT NIGHT HOPEY SCOLDS ME FOR MISSING OUT ON AN OPPORTUNITY FOR A LITTLE ADVENTURE IN MY LIFE. I CALL HER A FREAK, BUT THE NEXT THING I KNOW IS I'M ON MY WAY TO THE AIRPORT.

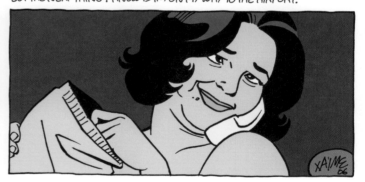

that formed the building blocks of the brothers' sensibilities, upon publication in 1981 there was literally no context for what *Love and Rockets* was to accomplish.

These days comics are seemingly everywhere in the American cultural consciousness, increasingly free from genre restrictions or commercially dictated editorial control, marked by unrivaled formal invention and conceptual sophistication. But when the Hernandez brothers released their first, self-published issue of *Love and Rockets*, the battle for independence was still being fought and the climate of the industry was quite different. Young cartoonists working during

SO HERE I WAS ON THIS PLANE HEADED TO VISIT RENA. THE FLIGHT WAS LONG, AND A MILLION HOURS LATER I HAD ARRIVED. OR I THOUGHT I HAD ARRIVED. RENA HAD THESE INCREDIBLY SECRET ROUNDABOUT INSTRUCTIONS ON HOW TO GET TO HER HOUSE.

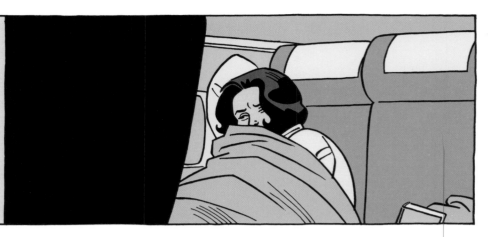

FIRST I HAD TO FIND THE CABBY WEARING A HAWAIIAN SHIRT. TWENTY CABBIES WERE WEARING HAWAIIAN SHIRTS, BUT ONLY ONE WAS WEARING AN L.A. DODGERS HAWAIIAN SHIRT. HE DROVE ME TO A SMALL CANTINA WAY AT THE EDGE OF TOWN, WHERE I STUFFED MY FACE.

NEXT I WAS TO TAKE A BUS TO THE MIDDLE OF NOWHERE. THE BUS RIDE WAS PEACEFUL, BUT ALL THIS SECRECY WAS MAKING ME NERVOUS. RENA MADE A LOT OF ENEMIES AS WELL AS ALLIES IN THOSE DAYS OF REVOLT AND UPHEAVAL — THE KIND OF ENEMIES WHO NEVER FORGET.

I DON'T THINK I COULD LIVE LIFE CONSTANTLY LOOKING OVER MY SHOULDER, BUT THEN I'M NOT RENA. AFTER THE BUS RIDE, ANOTHER CAR PICKED ME UP AND TOOK ME TO A BEACH, WHERE I TOOK A SMALL BOAT TO THE ISLAND.

TSE TSE MET ME ONSHORE. WHY WE COULDN'T FLY IN TOGETHER WAS NO DOUBT ANOTHER RENA TACTIC. BUT THIS TIME I REALLY FELT LIKE I HAD ARRIVED. THAT IS, UNTIL WE HAD TO WALK A MILLION MILES UP TO RENA'S HOUSE.

this time—Jaime Hernandez was twenty-one—were armed with an expansive history at their disposal, covering commercial genre comic books from their youth, newly reprinted historical comic strips, and the revolutionary, liberating, and taboo-decimating late sixties underground comix. But comics were still very much dominated by two companies—Marvel and DC—and a few acceptable (and predictable) genres—mainly super heroes and readily identifiable fantasy. Although both Gilbert and Jaime Hernandez were weaned on these classic mid-century comics, from the outset their stories were marked by an unmistakable personal interpretation of past

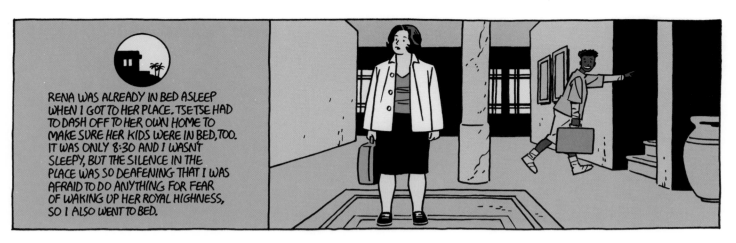

RENA WAS ALREADY IN BED ASLEEP WHEN I GOT TO HER PLACE. TSETSE HAD TO DASH OFF TO HER OWN HOME TO MAKE SURE HER KIDS WERE IN BED, TOO. IT WAS ONLY 8:30 AND I WASN'T SLEEPY, BUT THE SILENCE IN THE PLACE WAS SO DEAFENING THAT I WAS AFRAID TO DO ANYTHING FOR FEAR OF WAKING UP HER ROYAL HIGHNESS, SO I ALSO WENT TO BED.

THERE WAS A PORTRAIT OF RENA ABOVE MY BED. I HAD ALMOST FORGOTTEN WHAT AN AWESOME SIGHT SHE WAS BACK IN HER HEYDAY, EVEN UPSIDE DOWN.

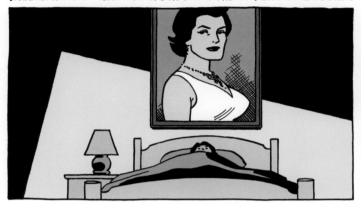

IT TOOK ME FOREVER TO GET TO SLEEP, BUT WHEN I DID, I WAS WOKEN UP BY A CREEPY FEELING THAT SOMEONE ELSE WAS IN THE ROOM. I DIDN'T DARE MOVE. THEN I REALIZED IT WAS RENA CHECKING IN ON ME. CRAZY, BUT I STILL DIDN'T MOVE. SHE SPENT THE NEXT HOUR PACING IN THE ROOM BEFORE RETURNING TO BED.

I WOKE UP IN THE MORNING TO THE SOUND OF AN ANT CRAWLING ON MY FLOOR. THE SUN WAS BRIGHT AND HOT, AND OUT IN THE BACK OF THE HOUSE, I COULD SEE RENA WRESTLING WITH A TREE STUMP SHE WAS TRYING TO UPROOT.

I SHOUTED TO HER NOT TO HURT HERSELF, AND SHE SHOUTED MY NAME AND QUICKLY CAME TO GREET ME. IT HAD BEEN ABOUT A DECADE SINCE I LAST SAW HER, BUT I HAD TO ADMIT, SHE SURE HAD AGED. IT COULD HAVE BEEN BECAUSE SHE HAD STOPPED DYEING HER HAIR. AND SHE IS 70-ISH, I GUESS.

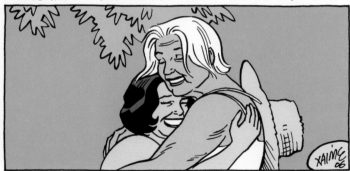

conventions—always within an idiosyncratic twist, and rooted in topical real-life human drama.

In 1982, shortly after the appearance of the Hernandez brothers' first self-published effort, publisher Fantagraphics expanded and rereleased *Love and Rockets*. The title is still being published, the ongoing story released in various formats that continue to redefine and push the boundaries of the medium. Looking back, the series represents a pivotal point in the burgeoning "alternative" comics movement, and many of the most prominent contemporary cartoonists began their careers following in the Hernandez brothers' wake. Published independently of

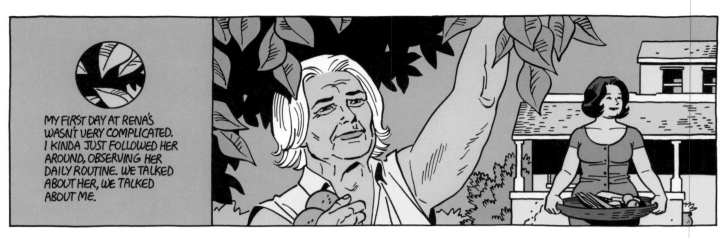

MY FIRST DAY AT RENA'S WASN'T VERY COMPLICATED. I KINDA JUST FOLLOWED HER AROUND, OBSERVING HER DAILY ROUTINE. WE TALKED ABOUT HER, WE TALKED ABOUT ME.

WOULDN'T YOU KNOW IT, RENA WAS ALL EXCITED THAT I WAS A STUPID OL' APARTMENT MANAGER. I SWORE TSE TSE WAS HIDING OUT SOMEWHERE, LAUGHING HER HEAD OFF, HAVING THE WHOLE THING VIDEOTAPED.

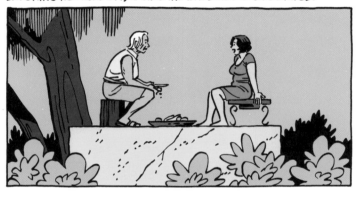

I HELPED RENA MAKE LUNCH. SHE SAID THE AVOCADOS WERE SENT ALL THE WAY FROM THE STATES. OF COURSE, THEY'D HAVE TO BE PICKED UP AND DELIVERED IN TOTAL SECRET FASHION. YOU'D THINK THEY'D HAVE ROTTED BY THEN.

I TRIED TO JOKE WITH RENA ABOUT HER CHECKING IN ON ME IN THE MIDDLE OF THE NIGHT, BUT SHE DIDN'T SEEM TO KNOW WHAT I WAS TALKING ABOUT. I QUICKLY DROPPED THE SUBJECT. WE SPENT THE REST OF THE DAY NAPPING.

SO THIS IS RENA'S LIFE. SHE SORTA JUST GETS UP IN THE MORNING AND THEN KINDA STAYS ALIVE, AND THEN IT'S TIME FOR BED. NOT MUCH DIFFERENT THAN THIS APARTMENT MANAGER'S LIFE, THAT'S FOR SURE.

the mainstream, these "alternatives" were distinctive in subject matter and narrative strategies, and have come to represent an important moment between the heyday of the undergrounds and the widespread critical and commercial attention that is being paid to graphic novels today. It would be difficult to overstate the importance of *Love and Rockets* in this trajectory.

While the work of Jaime Hernandez has continued to evolve over the last twenty-five years, his early comics sprang forth surprisingly loaded with the qualities that would become their hallmark. The major constant is his most enduring character, Maggie. It is her first-person

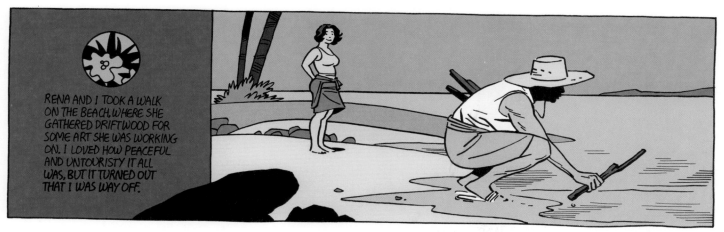

RENA AND I TOOK A WALK ON THE BEACH, WHERE SHE GATHERED DRIFTWOOD FOR SOME ART SHE WAS WORKING ON. I LOVED HOW PEACEFUL AND UNTOURISTY IT ALL WAS, BUT IT TURNED OUT THAT I WAS WAY OFF.

DOWN THE WAY, A PHOTOGRAPHER WAS SHOOTING A SWIMSUIT MODEL, IN SEARCH OF THE PERFECT BACKDROP. OBVIOUSLY MAINLANDERS. I THOUGHT THEY WERE BEING TOTALLY OBNOXIOUS. RENA APPEARED TO BE UNFAZED.

WHEN THEY ASKED HER IF SHE WOULD BE IN THEIR PHOTO, I THOUGHT FOR SURE SHE WOULD BREAK THEIR CAMERA. BUT SHE JUST IGNORED THEM, AND WE CONTINUED ON OUR WAY. THEN, TO MY SURPRISE, I FOUND THAT RENA AND I HAD COMPLETELY DIFFERENT PERSPECTIVES ON THE INCIDENT.

IT WAS CLEAR TO ME THAT THEY WANTED A SHOT OF A CRAGGY THIRD-WORLD ISLAND LOCAL AS CONTRAST FOR THE HIP BIG-CITY BIKINI GIRL. RENA WAS CERTAIN THAT THEY WERE JUST FANS IN SEARCH OF A CELEBRITY MEMENTO.

I STARTED TO PIECE IT TOGETHER, AND I FIGURED OUT THAT IN RENA'S WORLD, THAT PHOTOGRAPHER WAS MANY THINGS—A NUISANCE, A SPY, A FAN, AN ASSASSIN. IT ALL DEPENDED ON HER MOOD THAT DAY. REALIZING THAT SURE DIDN'T MAKE ME SLEEP BETTER THAT NIGHT.

voice that leads the story "La Maggie La Loca," as she travels to meet her old friend and hero, former wrestler, adventurer, and political/cultural icon Rena Titañon, who teamed with Maggie in Hernandez's first lengthy story, "Mechanics" (1982–83). The mythic Rena, who was last seen in shadowy exile, is a character emblematic of Hernandez's early comics. Rooted in traditional genres, these stories gradually gave way to slice-of-life tales about Maggie and her circle of friends in and around the fictional Huerta (specifically, the area of town called Hoppers), a city outside of Los Angeles modeled after Hernandez's home of Oxnard. In returning to characters and themes from the early days of *Love and*

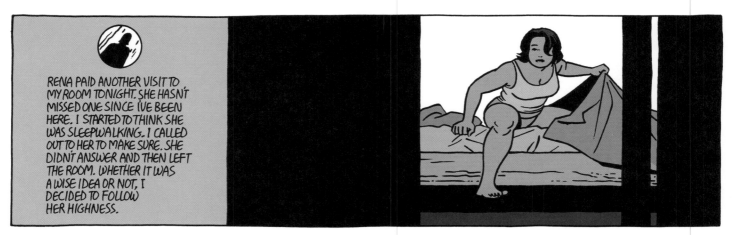

RENA PAID ANOTHER VISIT TO MY ROOM TONIGHT. SHE HASN'T MISSED ONE SINCE I'VE BEEN HERE. I STARTED TO THINK SHE WAS SLEEPWALKING. I CALLED OUT TO HER TO MAKE SURE. SHE DIDN'T ANSWER AND THEN LEFT THE ROOM. WHETHER IT WAS A WISE IDEA OR NOT, I DECIDED TO FOLLOW HER HIGHNESS.

IN THAT SUPER DARK HOUSE, I COULDN'T TELL WHERE SHE WENT, SO I FELT MY WAY UP TO HER ROOM. SHE WAS FAST ASLEEP IN HER BED, ALMOST LIKE SHE NEVER LEFT IT. HER LAYING THERE REMINDED ME HOW I'VE ALWAYS FELT THAT OLD PEOPLE LOOK DEAD WHEN THEY SLEEP, LORD STRIKE ME DOWN.

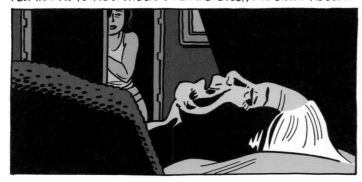

I CAME ACROSS SOME OF RENA'S OLD SCRAPBOOKS. ONE OF THEM WAS FULL OF OLD NEWSPAPER CLIPPINGS, MOSTLY EN ESPAÑOL. ANOTHER ONE CONTAINED GREETING CARDS SENT FROM FRIENDS AND ADMIRERS. IT WAS HARD TO MAKE OUT THE SIGNATURE, BUT ONE I BELIEVE CAME FROM CARY GRANT.

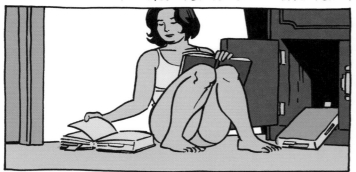

I COULDN'T GO BACK TO SLEEP, SO I WANDERED AROUND THE DARK HOUSE. I ACCIDENTLY KICKED OVER A PIECE OF RENA'S ART. I PUT IT BACK TOGETHER THE BEST I COULD. I HOPE SHE'S NOT TRYING TO SELL IT, BUT IF SHE IS AND ENDS UP GETTING MILLIONS FOR IT, MAN, DOES SHE OWE ME.

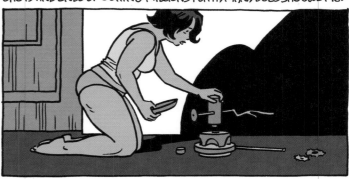

JUST THEN I HEARD RENA SHUFFLING ABOUT. AT FIRST I THOUGHT SHE WAS SLEEPWALKING AGAIN. THEN I REALIZED SHE WAS JUST GETTING UP FOR THE DAY, AND THE FIRST THING SHE DID WAS HEAD OUT TO GO WRESTLE WITH THAT STUMP. I INCONSPICUOUSLY WENT BACK TO BED FOR ANOTHER TEN HOURS.

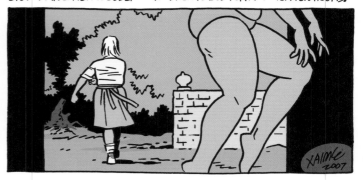

Rockets, "La Maggie La Loca" brings Hernandez full circle in many senses, providing a concise introduction to his freewheeling cast of characters, while demonstrating how his sophisticated approach to characterization and comic book storytelling has evolved throughout the years.

Told over the course of twenty weekly installments, the strip epitomizes all that is engaging about Hernandez's lengthy career: his inimitable ear for dialogue and eye for the telling detail; ethnic diversity (a marked contrast to the general landscape of comics); seamlessly shifting narrative perspectives and tenses; a dignified voice

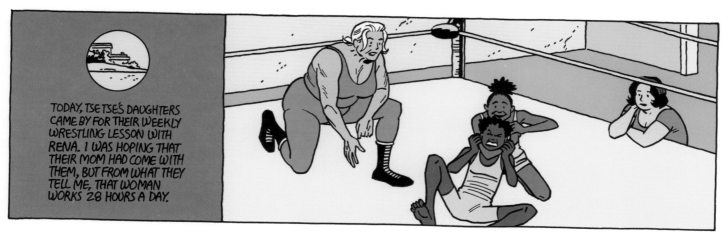

TODAY, TSE TSE'S DAUGHTERS CAME BY FOR THEIR WEEKLY WRESTLING LESSON WITH RENA. I WAS HOPING THAT THEIR MOM HAD COME WITH THEM, BUT FROM WHAT THEY TELL ME, THAT WOMAN WORKS 28 HOURS A DAY.

DURING THE LESSON, RENA STARTED TO TELL THE KIDS ABOUT HER ILLUSTRIOUS WRESTLING CAREER, THE ONE THAT I'VE ONLY HEARD ABOUT A MILLION TIMES, AND EVERY TIME I HEAR IT, IT GETS A NEW TWEAK. THIS TIME, SHE BEAT ALL FOUR TIGER SISTERS IN A HANDICAPPED MATCH, INSTEAD OF JUST TWO.

I HAD TO EXCUSE MYSELF AND WAS OUT THE DOOR PRETTY FAST. I BLAMED RENA'S RANTING, BUT THAT WASN'T ALL OF IT. I BELIEVE THAT I WAS SLOWLY STARTING TO BE DRIVEN MAD FROM ALL THE SOLITUDE. I HATED TO ADMIT IT, BUT I HAD BECOME BLIND STINKIN' BORED OUT OF MY BRAIN.

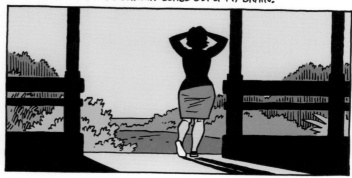

I CAME ACROSS DELFINO, THE BOY WHO BROUGHT ME OVER TO THE DAMN ISLAND IN THAT SMALL BOAT. HE WAS DELIVERING SOME HOUSEHOLD ITEMS FROM THE MAINLAND. I CORNERED HIM FOR SOME NEWS FROM THE OUTSIDE WORLD, AND WE ENDED UP HAVING A NICE CONVERSATION, TILL HE HAD TO LEAVE.

I WENT BACK INTO THE WRESTLING ROOM, AND RENA WAS STILL AT IT WITH HER TALL TALES. I MADE SOME KIND OF WISECRACK, AND SHE DRAGGED ME INTO THE RING AND TURNED ME INTO A PRETZEL. SHE DIDN'T TALK TO ME FOR THE REST OF THE DAY. MY ACHIN' BODY WAS FINE WITH THAT, THANK YOU.

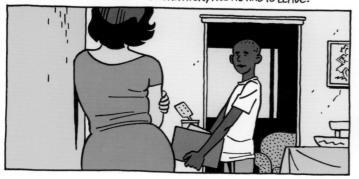

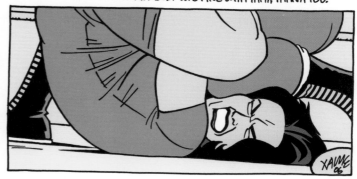

given to the marginalized or dismissed; seemingly slight pop culture references that provide the springboard for deep emotional experience; and characters who always resist easy definition and who constantly thwart stereotypes (comic and otherwise) based on gender, ethnicity, physical appearance, or lot in life.

The most immediately striking aspect of Hernandez's comics is the sheer exuberance of his snappy, spare inking. While evolving in range, his preternatural gift for subtlety within a mastery of traditional comic book techniques has been there from the beginning—not only the shorthand rendering and poignant details, but also pacing and narrative

TODAY WAS MORE ABOUT DOING NOTHING. RENA WAS GOING BACK AND FORTH BETWEEN HER ART AND THAT DAMN STUMP, SO I DECIDED TO HAVE SOME ALONE TIME DOWN ON THE BEACH. SADLY, THERE WERE NO ASSHOLE PHOTOGRAPHERS TO CAPTURE MY BEAUTY.

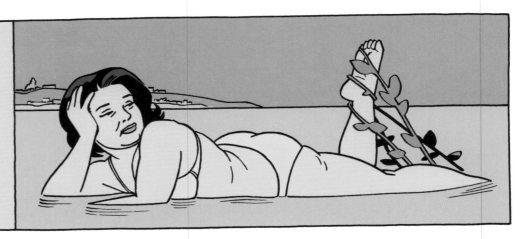

TRYING TO MAKE THE BEST OF IT, I TRIED TO FANTASIZE ABOUT A DESERT ISLAND ROMANCE BETWEEN ME AND SOME NAMELESS HUNK OF FLESH, BUT ALL I COULD PICTURE WAS GILLIGAN RIDING A BAMBOO BICYCLE INTO THE LAGOON. IN FAST MOTION, NO LESS. THAT LED ME TO THINK OF HOME.

I KNOW I WASN'T SUPPOSED TO, BUT AT LEAST NOT ALL OF IT WAS ABOUT TAKING CARE OF TENANTS. SOME OF IT HAD TO DO WITH THE POSSIBILITY OF ME BEING INVOLVED IN SOME BREWING RELATIONSHIP BACK HOME.

I JUST FORGOT TO REMIND MYSELF THAT THAT SHIT DOESN'T ACTUALIZE IF CERTAIN PARTIES INVOLVED (NAMELY ME) FAIL TO ADD INGREDIENTS TO THE BREW. THEN I DID REMIND MYSELF THAT VACATIONS LIKE THIS ARE DESIGNED TO WIPE AWAY ANY SUCH FOOLISH THOUGHTS THAT ARE DESIGNED TO CORRUPT.

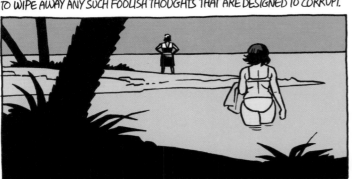

RENA AND I SPENT THE REST OF THE DAY WATCHING VIDEO TAPES OF HER OLD MATCHES, AND EVERY TIME SHE WAS CLOBBERED OR BODY SLAMMED ON SCREEN, THE PRESENT DAY RENA WOULD LET OUT A SLIGHT GRUNT.

devices—alongside all the old comic book tricks of the masters. More so than any contemporary cartoonist, Jaime's pen line is replete with an entire history, an adherence to "cartoony" drawing that provides an immediate, and sometimes confusing, first impression. The egalitarian accessibility of style enhances and directs the meaning of the content, but his sophisticated stories never attempt to be anything other than "comics," bearing witness to a faith in the rich history of the language that conveys an increasingly powerful emotional truth.

While showcasing Jaime's aesthetic sensibility, "La Maggie La Loca" also serves as an introduction to his most important contribution

THIS MORNING RENA AND I FOUND OURSELVES RUNNING THROUGH THE MARKETPLACE LIKE A COUPLE OF HEADLESS CHICKENS, ALL BECAUSE SHE INTERPRETED A FRIENDLY GREETING FROM A STRANGER AS AN ASSASSIN'S THREAT. THAT WAS THE LAST STRAW FOR ME.

I BASICALLY TOLD HER THAT SHE HAD GONE BEYOND PARANOID, AND SHE TOLD ME THAT I HAD NO ROOM TO TALK, LIVING IN MY SAFE LITTLE SISSY APARTMENT BACK HOME. WE GOT INTO A SUPER-BIG ARGUMENT AND DIDN'T TALK TO EACH OTHER THE REST OF THE WAY HOME.

I WAS GOING BATTY. I NEEDED SOMEONE SANE TO TALK TO, LIKE TSE TSE, BUT I DIDN'T EVEN KNOW WHERE THE HELL SHE LIVED, THANKS TO THE CRAZY WRESTLER LADY, NO DOUBT. I STARTED TO TAKE MY FRUSTRATIONS OUT ON A STICK AND THE GROUND, TILL I SAW MY GOOD BUDDY DELFINO.

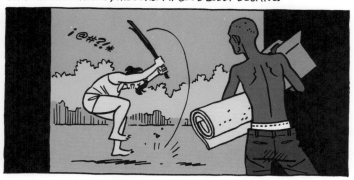

I ASKED HIM WHAT HE DID FOR KICKS. HE CONFESSED TO ME THAT AT NIGHT, AFTER HIS FOLKS GO TO SLEEP, HE AND A BUDDY LIKE TO SNEAK OFF IN HIS BOAT AND GO BARHOPPING ON THE MAINLAND. IN A FIT OF DESPERATION, I ALL BUT BEGGED HIM TO TAKE ME WITH THEM ON THEIR NEXT VOYAGE.

HE WAS RELUCTANT, FOR FEAR THAT RENA WOULD DISAPPROVE, BUT THAT MADE ME ALL THE MORE PERSISTENT. WE FINALLY MADE A PACT NOT TO RAT ON EACH OTHER, AND THE DATE WAS SET. I WAS TO MEET THEM ON THE BEACH AFTER THE CRAZY-WRESTLER-SLEEPWALKER LADY HAD FINISHED HER NIGHTLY ROUND.

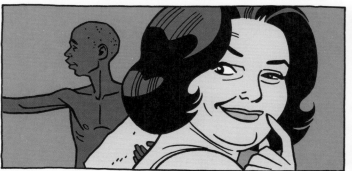
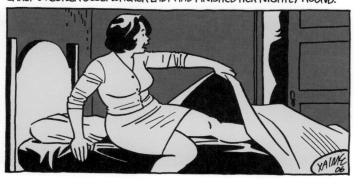

to the medium—literary characterization that surpasses anything previously accomplished in comics. Crucially, characters come alive through facial expressions and telling gestures as much as in dialogue; in the play between expertly crafted image and text, his is perfect cartooning, and the élan evident in his drawing is matched only by the spirit of his characters. The core of Jaime's art chronicles Maggie's wobbly acceptance of her place in the world—from teen mechanic, wrestling manager, peripatetic drifter, to now apartment manager in Los Angeles's San Fernando Valley. In agreeing to create this strip for the *Times*, the task of remaining true to the expansive world he created,

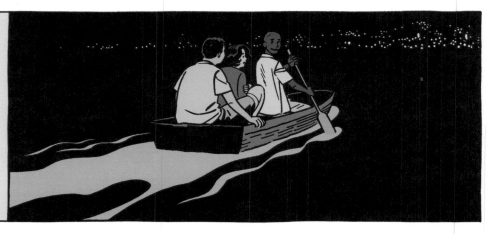

THE MAINLAND WASN'T TWO MILES FROM THE ISLAND, BUT THE BOAT RIDE WAS STILL KINDA SCARY IN THE BLACK NIGHT. DELFINO'S BUDDY TECHO SEEMED A LITTLE UNSURE OF HAVING THIS OLDER, DRESSED-UP CITY LADY ALONG ON THEIR SECRET ADVENTURE.

I TOLD THEM IT WAS FINE WITH ME IF THEY WENT OFF AND DID THEIR OWN THING, THAT I WOULD MEET THEM BACK AT THE BOAT AT AN AGREED TIME, BUT DELFINO HAD ANOTHER IDEA. HE WANTED ME TO MEET SOME FRIENDS OF HIS. TECHO AND I FOLLOWED HIM INTO ONE OF THE CANTINAS ONSHORE.

I WAS BLOWN AWAY WHEN I SAW WHO HIS FRIENDS WERE. THERE WAS THE CABBY WHO PICKED ME UP AT THE AIRPORT WHEN I FIRST ARRIVED, THE BUS DRIVER, EVEN THE FLIGHT ATTENDANT WHO SERVED ME ON THE PLANE RIDE OVER. IT DIDN'T TAKE LONG TO FIGURE OUT WHY DELFINO TOOK ME THERE.

EACH ONE OF THEM TOOK A TURN AND TOLD ME HOW RENA HAD HELPED THEM IN ONE WAY OR ANOTHER AND THAT THEY OWED HER THEIR VERY LIVES. THE CABBY EVEN STARTED TO CRY. TWO DRINKS LATER, AND I JOINED HIM. ONCE AGAIN, THE CRAZY WRESTLER LADY WAS MY DEAREST, MOST AWESOME FRIEND.

AS THE NIGHT RAGED ON, EVERYONE TOOK TURNS DANCING WITH ME, EVEN ATENAS, THE FLIGHT ATTENDANT. I WAS HAVING SUCH A BLAST, EVEN WITH THE GUILT OF HAVING CROSSED RENA INSIDE ME. I MEAN, SHE WOULDN'T DENY ME A SINGLE NIGHT OF INDULGENCE, WOULD SHE?

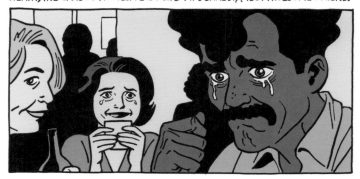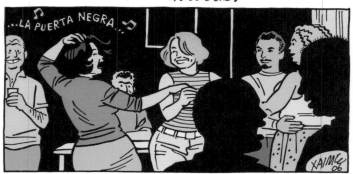

while also telling a story that simultaneously stood on its own for both a devout readership and an audience with little knowledge of the intricate histories and relationships accrued over the years, gave him pause.

Following Chris Ware, whose strip "Building Stories" (serialized in the magazine 2005–06) chronicled the physical and metaphysical lives of the residents of an apartment building over many years, Hernandez felt he didn't have to worry about overlap in structure, based on the two cartoonists' divergent approaches to narrative. But his course in determining the subject matter and framework for a self-contained comic was a juggling act: "One night I just had an image of someone on

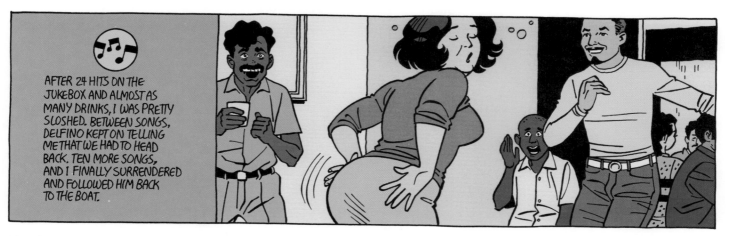

AFTER 24 HITS ON THE JUKEBOX AND ALMOST AS MANY DRINKS, I WAS PRETTY SLOSHED. BETWEEN SONGS, DELFINO KEPT ON TELLING ME THAT WE HAD TO HEAD BACK. TEN MORE SONGS, AND I FINALLY SURRENDERED AND FOLLOWED HIM BACK TO THE BOAT.

I ASKED DELFINO WHERE HIS BUDDY WAS, AND HE TOLD ME THAT TECHO WAS GONNA HANG OUT LONGER AND THAT HE WOULD FIND HIS OWN RIDE BACK. I SENSED THAT THERE WAS MORE TO IT, THAT THE FAT, DRUNK CITY LADY MIGHT HAVE SPOILED THEIR BUDDY TIME AND THAT THEY GOT IN A FIGHT OVER IT.

I ASKED DELFINO IF IT WAS TRUE, AND HE TOLD ME NOT TO WORRY ABOUT IT. WHEN WE GOT BACK TO THE ISLAND, I THANKED HIM FOR THE RIDE AND FOR SETTING ME UP TO MEET HIS FRIENDS SO THAT I COULD SEE HOW FOOLISH I HAD BEEN ACTING TOWARD RENA. HE SAID GOOD NIGHT, AND WE PARTED.

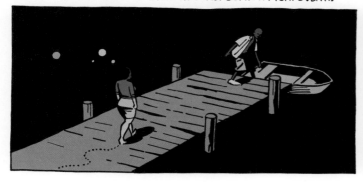

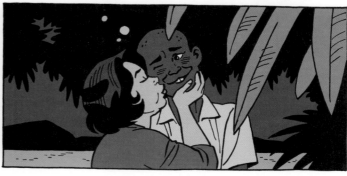

I STUMBLED MY WAY THROUGH THE WOODS BACK TO RENA'S HOUSE. I HAD AN EXTREME CASE OF THE GIGGLES, AND I COULDN'T GET A TIGRES DEL NORTE SONG OUT OF MY HEAD. I THOUGHT THAT IF I SANG IT AT THE TOP OF MY LUNGS, NO WILD ANIMALS WOULD WANT TO EAT ME.

I WASN'T TOO SURPRISED TO SEE RENA WAITING UP FOR ME WHEN I WALKED THROUGH THE DOOR, BUT DID SHE HAVE TO LOOK JUST LIKE MY MOM? I COULDN'T HELP LAUGHING, BECAUSE I KNEW WHAT WAS COMING NEXT, AND BY NOW IT WAS ALL SO DAMN RIDICULOUS.

the beach, picking up driftwood, then thought, 'I know, it'll be about Rena's life on her island.' But if I did that, I realized I'd have to tell her whole backstory, since I'd be dealing with readers who don't know that history. I started getting intimidated by that—my whole life has been spent getting intimidated by the fact that if I do something for someone else [a venue other than *Love and Rockets*], I have to worry about what the world thinks, and that never works for me. So at the last minute I just thought, 'Fuck it, I'm going to do what I do. I can't worry about what the world thinks.' Of course, that was still in the back of my mind!"

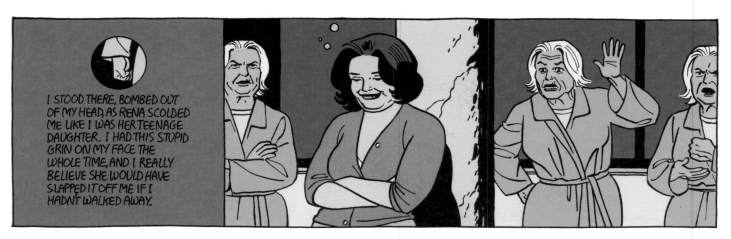

I STOOD THERE, BOMBED OUT OF MY HEAD, AS RENA SCOLDED ME LIKE I WAS HER TEENAGE DAUGHTER. I HAD THIS STUPID GRIN ON MY FACE THE WHOLE TIME, AND I REALLY BELIEVE SHE WOULD HAVE SLAPPED IT OFF ME IF I HADN'T WALKED AWAY.

I WAS FUMING. MY BORN-AGAIN LOVE AND RESPECT FOR RENA RETURNED TO CONTEMPT. INSTEAD OF GOING TO BED, I HEADED BACK TO THE BEACH. THIS WAS MY NIGHT, AND NOBODY WAS GONNA SPOIL IT FOR ME. I WAS GOING BACK TO THE MAINLAND IF I HAD TO ROW THE BOAT MYSELF.

SO THERE I WAS, CROSSING THAT BLACK WATER IN THE BLACK OF NIGHT, BLIND STINKIN' DRUNK AND STUPIDER THAN SIN. MIDDLE-AGED GOING ON ADOLESCENT, THAT WAS ME.

HOW I MADE IT TO THE MAINLAND ALL BY MYSELF WAS A TOTAL MIRACLE. BY THE TIME I REACHED THE SHORE, I DIDN'T FEEL ANGRY ANYMORE, JUST FOOLISH. EVEN THEN, I WASN'T READY TO BRAVE THE TRIP BACK ACROSS, SO I WANDERED ALONG THE BEACH, AT LEAST UNTIL I SOBERED UP A LITTLE.

I ENDED UP AT THE BAR THAT I WAS AT EARLIER WITH DELFINO AND HIS PALS. I THOUGHT THAT MAYBE ONE OF THEM COULD TAKE ME BACK TO THE ISLAND, BUT THEY WERE ALL GONE. ALL EXCEPT TECHO, DELFINO'S CRABBY BUDDY.

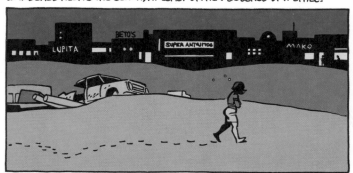

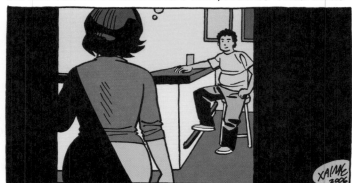

In order to get around having a significant chunk of the story take place in Rena's head, which Hernandez wanted to avoid, he framed it around a visit by Maggie, writing the exposition from her point of view. Maggie discovers the story chapter by chapter, an unfolding that reflects Jaime's method of composing installment by installment. "That's how I approach Maggie as a character—her brain goes along with mine, so we both discover things in the end." Once Jaime determined this path, as in all of his work, the history of traditional comics construction informed his process.

Since he was working outside of his comic book element, Hernandez

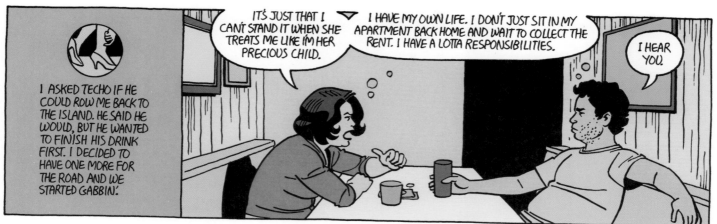

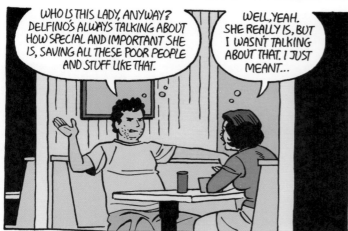

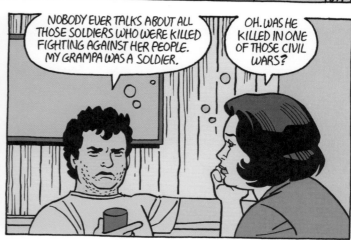

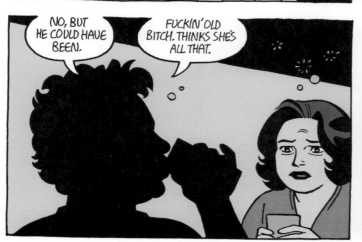

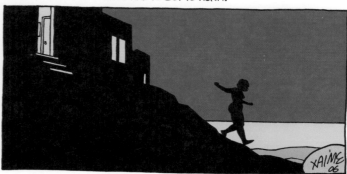

framed each weekly "episode" to end with a dramatic cliffhanger in reference to the style of classic Sunday adventure strips: "I purposely did the story in a straight, serialized adventure comic-strip mode because I knew every other cartoonist doing this was going to try and impress the *New York Times* readership. So I decided to go in the opposite direction and do a straight adventure strip with nothing highfalutin about it." This rejection of overt formal experimentation in favor of ingrained comic book pacing and "clarity" (which is actually quite complex to do in a manner as sophisticated as Hernandez has) is a cornerstone of his work. And the "adventure" of the strip harkens back to his earliest

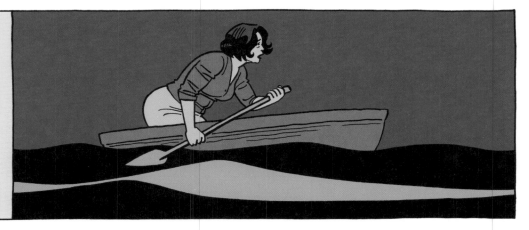

TECHO'S NEGATIVITY TOWARD RENA MADE ME SEE FOR THE FIRST TIME THAT SOMEONE COULD BE CRAZY ENOUGH TO WANT TO HURT HER, EVEN KILL HER. I JUST WANTED TO GET BACK TO HER, TO BE THERE FOR HER, TO PROTECT HER.

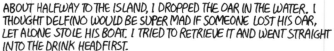

I GOT TIRED OF ROWING AND SAT FOR A WHILE. ALL OF A SUDDEN, I FELT REAL SMALL WITH THAT VAST OCEAN BELOW ME AND THAT ETERNAL SKY ABOVE ME. IT MADE ME REALIZE MY TEENY-TINY ROLE IN RENA'S LEGENDARY LIFE. I STARTED TO ROW AGAIN, BUT THIS TIME AT A MUCH HUMBLER PACE.

ABOUT HALFWAY TO THE ISLAND, I DROPPED THE OAR IN THE WATER. I THOUGHT DELFINO WOULD BE SUPER MAD IF SOMEONE LOST HIS OAR, LET ALONE STOLE HIS BOAT. I TRIED TO RETRIEVE IT AND WENT STRAIGHT INTO THE DRINK HEADFIRST.

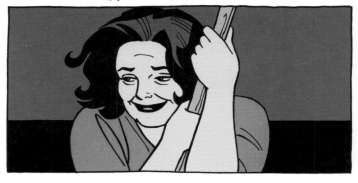

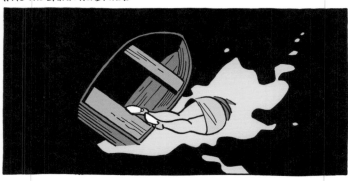

I TRIED TO REACH FOR THE BOAT, WHICH WASN'T MORE THAN A FOOT AWAY, BUT THE MORE I TRIED, THE MORE IT DRIFTED AWAY. PRETTY SOON IT WAS TOO FAR AWAY TO EVEN SEE. DELFINO, PLEASE DON'T BE MAD.

I COULDN'T BELIEVE WHAT WAS HAPPENING. I HAD ALWAYS IMAGINED THAT I WOULD END UP DYING IN A HOSPITAL BED OR A COFFEE SHOP CHOKING ON A TOFURKEY SANDWICH, NOT IN SOME FOREIGN BLACK WATERS IN THE BLACK NIGHT ALL BY MYSELF.

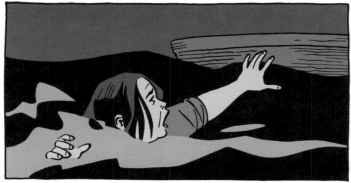

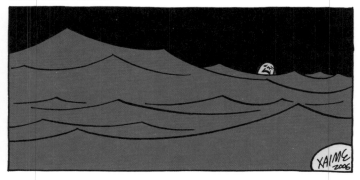

stories involving Maggie and Rena, demonstrating how his take on such conventions has evolved in "trying to find the balance between Maggie's science-fiction past—and what she did in that past—and her present real life." As Jaime mentions, the creation of the strip was in good part dictated by single images that appeared in his mind, and his process of nonlinear jumping from episode to episode, panel to panel, and connecting specific images that then lead the direction of the nascent story—and define character—provides a subtle key to his comics' resonance; specific, iconic panels lodge in the reader's mind, which wanders back and forth in the narrative long after the comic has been set aside.

TREADING WATER IN THE MIDDLE OF ALL THE BLACKNESS FELT LIKE THERE WAS NO LAND, NO BOTTOM, NO SKY. JUST BLACK, BLACK, BLACK, BLACK.

I WAS GETTING REAL TIRED, AND I STARTED TO PANIC. I TOOK A MOUTHFUL OF WATER AND WENT STRAIGHT UNDER. THAT'S WHEN I FELT SOMETHING BONK MY HEAD. I GRABBED ON TO FIND THAT IT WAS AN OAR. I THOUGHT IT WAS MY (DELFINO'S) OAR, TILL I FELT IT PULLING ME UP.

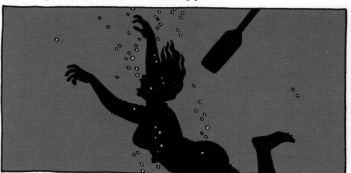

IT WAS TECHO IN ANOTHER SMALL BOAT. I MUST HAVE BEEN TOO HEAVY FOR HIM TO PULL ME IN, BECAUSE HE TOLD ME TO HOLD ON TO THE SIDE AS WE MADE OUR WAY TO THE SHORE. I WAS ONLY TOO HAPPY TO FOLLOW ORDERS.

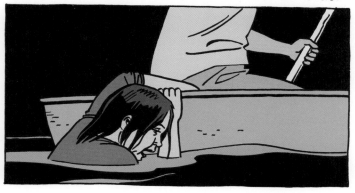

HE KEPT ASKING ME IF I WAS O.K., AND THEN HE TOLD ME THAT HE HAD BORROWED A BOAT TO GET HIMSELF HOME, AND THAT HE KNEW SOMETHING WAS FUNNY WHEN HE SAW DELFINO'S (MY) BOAT FLOATING ALONG BY ITSELF. I WAS JUST GRATEFUL THAT HE HAD FOUND ME IN ALL THAT DARKNESS.

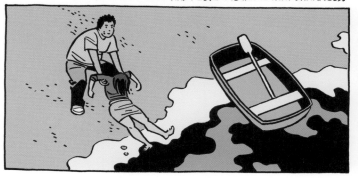

TECHO OFFERED TO HELP ME GET BACK TO RENA'S, BUT I WAS TOO BUSY CHECKING TO SEE IF I HAD LOST MY PASSPORT, WHICH I HAD PUT IN THE INNER POCKET OF MY SKIRT, IN CASE I NEEDED IT WHEN I VISITED THE MAINLAND. THAT'S WHEN THINGS GOT DOWNRIGHT SURREAL.

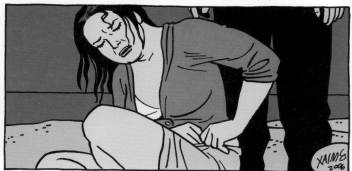

In the last few panels of the strip's final installment, Maggie mentions that her birthday took place during the events of the story, but she saved that for her "own book," pointing readers in the direction of *Love and Rockets'* resplendent, uninterrupted tapestry. Steadfastly uninterested in any cache associated with the newspaper, Hernandez originally turned down this project, anticipating unwanted editorial input and general hassle, which he doesn't have to contend with when doing his comic. Upon agreeing, he performed more self-editing than usual, and when "La Maggie La Loca" was later collected in comic book form (*Love and Rockets* vol. II, no. 20, 2007), Hernandez restored any

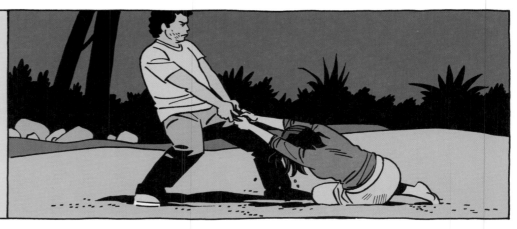

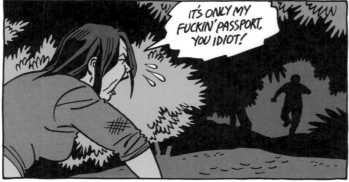
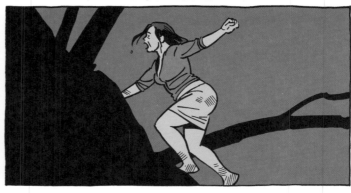
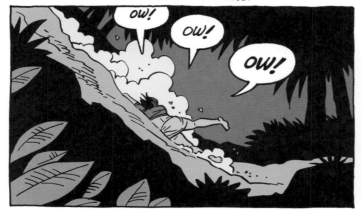
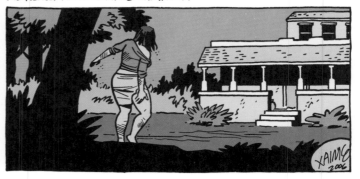

minor edits to Maggie's voice and added a title page (page 11) and three new pages interspersed throughout the strip (pages 18, 20, and 33) to flesh out her character. This expanded version is printed here and, in its simultaneous concision and open-ended resonance, serves as a perfect initiation into the world of Jaime Hernandez.

Incorporating interviews with the artist and reproductions of his artwork from all stages of the process, this book is intended to introduce and give voice to Hernandez's richly varied oeuvre. Reflecting the global nature of his characters and stories—and bearing witness to their success as both entertainment and art—Hernandez's comics have

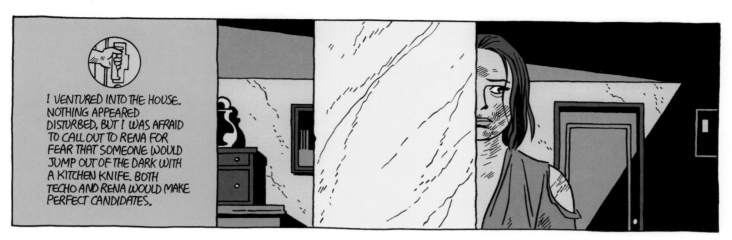

I VENTURED INTO THE HOUSE. NOTHING APPEARED DISTURBED, BUT I WAS AFRAID TO CALL OUT TO RENA FOR FEAR THAT SOMEONE WOULD JUMP OUT OF THE DARK WITH A KITCHEN KNIFE. BOTH TECHO AND RENA WOULD MAKE PERFECT CANDIDATES.

THE BOTTOM FLOOR WAS EMPTY. BEFORE I MADE MY WAY UPSTAIRS, I SAT MY SOGGY ASS DOWN TO REST FOR A MINUTE. I WAS OUT IN TWO SECONDS.

IT'S BEYOND ME HOW LONG I LAID THERE, BUT IT WAS LIGHT WHEN I WOKE UP. THINGS REMAINED QUIET. NOBODY HAD KILLED ME. NOBODY EVEN BOTHERED TO WAKE ME TO TELL ME TO CLEAN UP MY MOLDY, BATTERED BODY, SO I WENT AHEAD AND TOLD MYSELF.

I TOOK A BATH AND DRESSED MY WOUNDS. ANOTHER HOUR HAD PASSED, AND THERE WAS STILL NO SIGN OF LIFE. I STARTED TO FEEL LIKE I WAS BEING PUNISHED FOR MY IDIOTIC BEHAVIOR, AND I GOT ALL BLUBBERY.

I THOUGHT OF PACKING MY BAGS AND GOING HOME, BUT I HADN'T THE SLIGHTEST CLUE OF HOW TO GO ABOUT IT. I STEPPED OUTSIDE FOR SOME AIR, AND I SAW A GROUP OF MEN RUNNING BY. ONE OF THEM POINTED AT ME. I ALMOST RAN BACK INTO THE HOUSE, BUT I SAW THAT TSE TSE WAS WITH THEM.

been written about extensively since the early eighties from diverse points of view: Chicana and Japanese-American activists, academics of all stripes, queer theorists, feminists, documenters of punk and fringe subcultures, mainstream journalists, and the entire spectrum of comics critics and scholars have all found various entryways into his world. To give a sense of this range, what follows are selected highlights from a body of work that has altered the trajectory of the comics medium and expanded the popular and critical understanding of its possibilities.

TSE TSE RAN UP AND HUGGED ME LIKE I HAD JUST COME BACK FROM THE DEAD. IT FELT GOOD TO SEE A FRIENDLY FACE AND TO KNOW THAT SOMEONE CARED. BUT JUST WHEN I THOUGHT IT WAS ALL ABOUT ME ME ME...

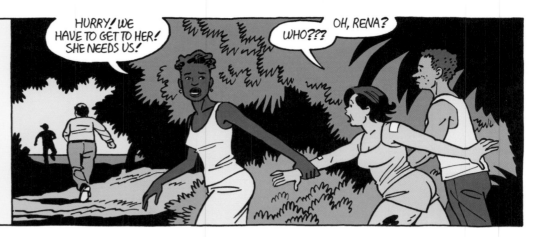

HURRY! WE HAVE TO GET TO HER! SHE NEEDS US!

WHO???

OH, RENA?

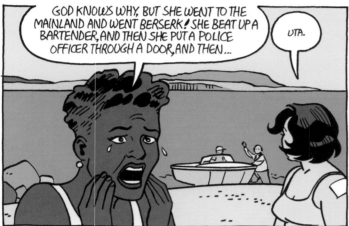

GOD KNOWS WHY, BUT SHE WENT TO THE MAINLAND AND WENT BERSERK! SHE BEAT UP A BARTENDER, AND THEN SHE PUT A POLICE OFFICER THROUGH A DOOR, AND THEN...

UTA.

RENA MUST HAVE GONE LOOKING FOR ME, BUT NOBODY SEEMED TO KNOW THAT. TSE TSE STOPPED FOR A MINUTE TO ASK ME ABOUT MY BANDAGES AND BRUISES, BUT I TOLD HER THAT I JUST FELL INTO A BUSH OUTSIDE RENA'S HOUSE. I FELT THAT IT MIGHT BE BETTER IF I KEPT MY ADVENTURE TO MYSELF.

I DIDN'T EVEN LET ON THAT CROSSING THAT STUPID WATER ONE MORE TIME WAS GIVING ME A STOMACHACHE. WE TOOK A CAB TO THE POLICE STATION, BUT THE STREET WAS BLOCKED WITH PEOPLE, SO WE HAD TO WALK THE REST OF THE WAY. IT SURE DIDN'T FEEL LIKE THERE WAS A STREET FAIR GOING ON.

IT WAS JUST AS I THOUGHT. ALL THOSE PEOPLE WERE THERE FOR RENA. WORD ABOUT HER RAMPAGE MUST HAVE SPREAD LIKE WILDFIRE, BECAUSE IT BECAME A REGULAR MEDIA CIRCUS. WHETHER SHE WANTED IT OR NOT, RENA WAS DEFINITELY BACK IN THE SPOTLIGHT.

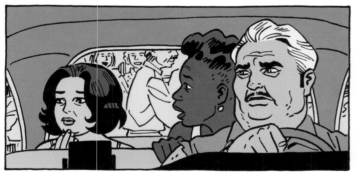

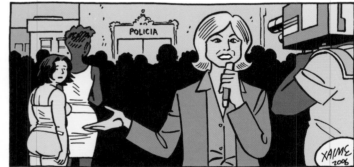

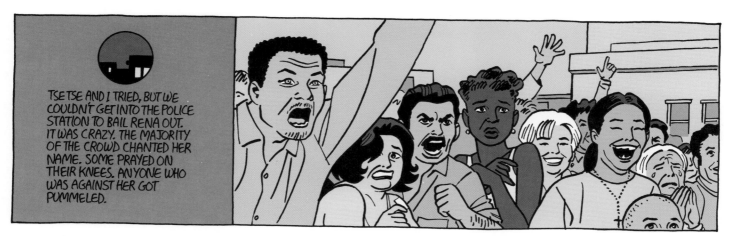

TSE TSE AND I TRIED, BUT WE COULDN'T GET INTO THE POLICE STATION TO BAIL RENA OUT. IT WAS CRAZY. THE MAJORITY OF THE CROWD CHANTED HER NAME. SOME PRAYED ON THEIR KNEES. ANYONE WHO WAS AGAINST HER GOT PUMMELED.

WE WEREN'T SURE IF WE SHOULD STAY AND WAIT FOR HER, BUT WE DID. TSE TSE APOLOGIZED FOR BEING ABSENT DURING MY VISIT AND LEAVING ME TO DEAL WITH THE CRAZY WRESTLER LADY MYSELF. THEN SHE ASKED ME HOW MY STAY HAS BEEN. I SMILED, SHE NODDED AND WE LEFT IT AT THAT.

WE STARTED TO TALK ABOUT HOW THE THREE OF US MET 20-SOME-ODD YEARS AGO. I WAS A YOUNG ASPIRING MECHANIC'S ASSISTANT WORKING IN A SOUTH AMERICAN JUNGLE. TSE TSE WAS A TRANSLATOR FOR THE NATIVES OF THE REGION. RENA WAS THERE BECAUSE SHE'S RENA.

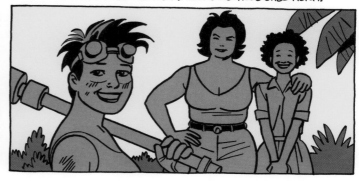

MOST OF IT IS A BLUR NOW, BUT I DO REMEMBER THAT IT WAS QUITE AN ADVENTURE. COME TO THINK OF IT, THE FEW TIMES I'VE EVER SPENT WITH RENA HAVE ALWAYS TURNED INTO SOME KIND OF CRAZY ADVENTURE, BUT NONE I HAVE EVER REGRETTED, I'M PLEASED AND SURPRISED TO SAY.

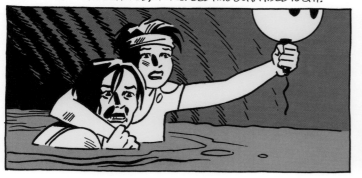

THEN THE CROWD FELL SILENT. I LOOKED UP TO SEE THAT SHE HAD COME OUT, LOOKING LIKE A QUEEN HOLDING COURT. SHE RAISED HER HAND TO WAVE, AND THE PLACE WENT BONKERS. I HAD TO ADMIT, THE OLD GIRL STILL HAD IT. LIKE IN THE PORTRAIT ABOVE MY BED, RENA WAS STILL AN AWESOME SIGHT.

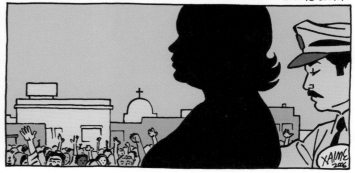

RENA WAS LET OUT OF JAIL ON HER OWN RECOGNIZANCE. WE GOT HER HOME AS FAST AS WE COULD. SHE APPEARED CALM BUT DIDN'T SAY A WORD. SHE WALKED INTO THE HOUSE AND WENT STRAIGHT TO BED. I DIDN'T CARE. AS LONG AS SHE WAS HOME AND SAFE.

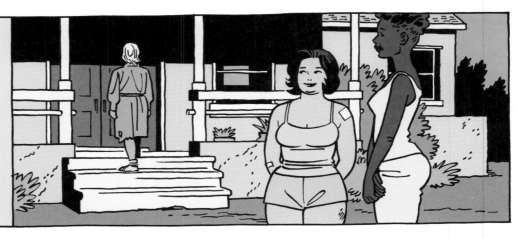

A FEW MINUTES LATER, DELFINO WALKED UP. MY HEART JUMPED BECAUSE SEEING HIM REMINDED ME THAT I LOST HIS BOAT IN THAT STUPID OCEAN. IT JUMPED A SECOND TIME WHEN HE HANDED ME MY SOGGY PASSPORT. HE SAID THAT HE FOUND IT IN THE JUNGLE NOT FAR FROM THE BEACH.

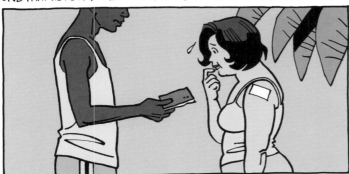

I WAS THE CLOSEST TO KNOWING ANYTHING OF HIS WHEREABOUTS, AND I KNEW ZILCH, SO I KEPT MY MOUTH SHUT. I DECIDED TO KEEP THE ENTIRE TECHO-PASSPORT-BLACK OCEAN THING TO MYSELF. IN A WAY, TECHO WAS CLAMMING UP, TOO. HELL, I WOULD IF I WERE THE WORLD'S WORST ROBBER.

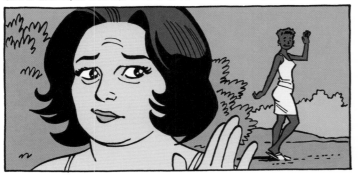

HE ALSO SAID THAT HIS BOAT WAS FOUND WASHED UP ON THE OTHER SIDE OF THE ISLAND. BEFORE I COULD CONFESS, HE ACCUSED HIS BUDDY TECHO OF STEALING IT AND SAID THAT HE WOULD CLOBBER HIM—THAT IS, IF HE COULD FIND HIM. IT TURNED OUT THAT TECHO HAD PRETTY MUCH DISAPPEARED.

BUT WHAT WAS RENA'S TAKE ON ALL THIS? WAS I IN FOR THE SPANKING OF MY LIFE? IF SHE FOUND OUT ABOUT TECHO, WOULD HE GET IT WORSE? I WAS SORT OF HOPING NOT. AFTER ALL, THE BOY DID SAVE MY LIFE. NO, I BELIEVE THE ANSWER CAME AFTER I PUT MYSELF TO BED THAT NIGHT.

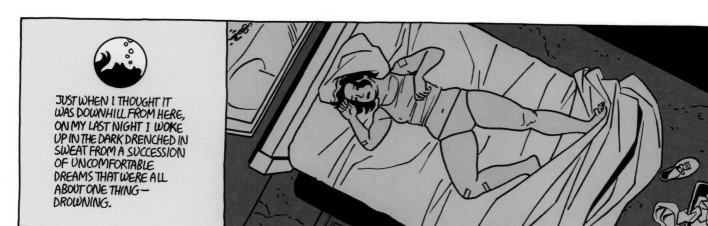

JUST WHEN I THOUGHT IT WAS DOWNHILL FROM HERE, ON MY LAST NIGHT I WOKE UP IN THE DARK DRENCHED IN SWEAT FROM A SUCCESSION OF UNCOMFORTABLE DREAMS THAT WERE ALL ABOUT ONE THING— DROWNING.

I WAS AFRAID IF I WENT BACK TO SLEEP, THE DREAMS WOULD CONTINUE, SO I TRIED TO CONCENTRATE ON MY DESERT ISLAND ROMANCE FANTASY AND IT ACTUALLY STARTED TO WORK. THE WEIRD THING WAS, MY PARTNER HAD NO FACE. MAYBE THAT WAS BECAUSE I WAS AFRAID TO OPEN MY EYES.

I WAS GETTING ALL HOT AND BOTHERED, THEN MY FANTASY SLIPPED INTO A DREAM. WE ROCKED AND ROLLED ON THE SAND AND PREDICTABLY ENDED UP IN THE WATER AND STARTED TO DROWN. AT LEAST I WAS ABLE TO WAKE UP. MY PARTNER WASN'T SO LUCKY. OH WELL, I WAS GOING HOME IN THE MORNING.

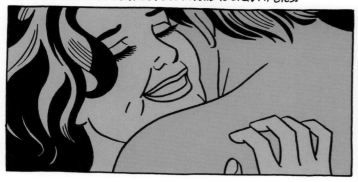

I ROLLED OUT OF BED TO A FAMILIAR SIGHT OF RENA STANDING ON HER PORCH FACING THE DREADED STUMP THAT STUBBORNLY SAT UNMOVED. BUT THIS TIME SHE SEEMED CONCERNED ABOUT SOMETHING ELSE ALTOGETHER.

AT HER FEET LAY FLOWERS AND GIFTS LEFT OVERNIGHT BY WHAT SEEMED TO BE FANS AND ADMIRERS. SHE GRUMBLED SOMETHING UNDER HER BREATH ABOUT TRESPASSING BUT I COULD TELL SHE WAS REALLY PRETTY STOKED.

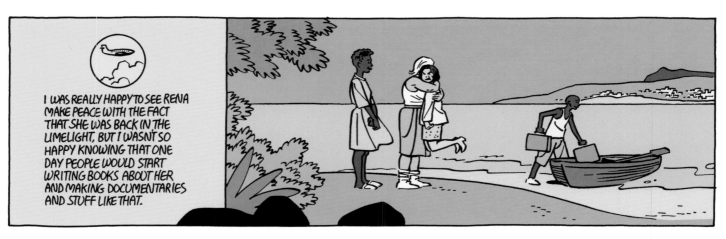

I WAS REALLY HAPPY TO SEE RENA MAKE PEACE WITH THE FACT THAT SHE WAS BACK IN THE LIMELIGHT, BUT I WASN'T SO HAPPY KNOWING THAT ONE DAY PEOPLE WOULD START WRITING BOOKS ABOUT HER AND MAKING DOCUMENTARIES AND STUFF LIKE THAT.

HISTORY IS OFTEN WRITTEN AFTER THE SUBJECT IS DEAD AND GONE AND BY COMPLETE STRANGERS, SO HOW ARE THEY GONNA WRITE ABOUT RENA AND ME? ABOUT MY LOVE AND ADMIRATION FOR HER? THEY'RE NOT GONNA WRITE ABOUT OUR BITTER FIGHTS AN' SHIT. THEN AGAIN, WHY SHOULD THEY?

COMPARED WITH EVERYTHING SHE HAS ACCOMPLISHED IN HER AMAZING LIFE, THAT'S JUST A TEENY-TINY FACT FLOATING SOMEWHERE OUT IN THAT BLACK OCEAN. I GUESS IT WOULD HAVE TO BELONG IN MY OWN BOOK, HUH? "COLLECTING THE RENT — SECRETS OF THE APARTMENT MANAGER."

I TURNED 40 ON THE DAY OF THE BIG TECHO ADVENTURE. I THINK IT WAS OBVIOUS WHY I DIDN'T TELL ANYONE. I SIMPLY DID NOT WANT TO BE SEEN AS THE FAT, OLD CITY LADY, EVEN THOUGH THAT IS EXACTLY WHAT I WAS SEEN AS. PETTY AND VAIN AS IT SEEMS, THAT WAS MY BIRTHDAY WISH.

NOW, WITH ALL THAT SAID AND DONE, I'M GLAD I NEVER TOLD ANYONE, BECAUSE I FEEL THAT THAT WAS MY VERY OWN SPECIAL NIGHT. ONE THAT SOMEDAY WILL BE TOLD ABOUT IN MY OWN BOOK. THE END.

...LA PUERTA NEGRA... ♫

JAIME 2006

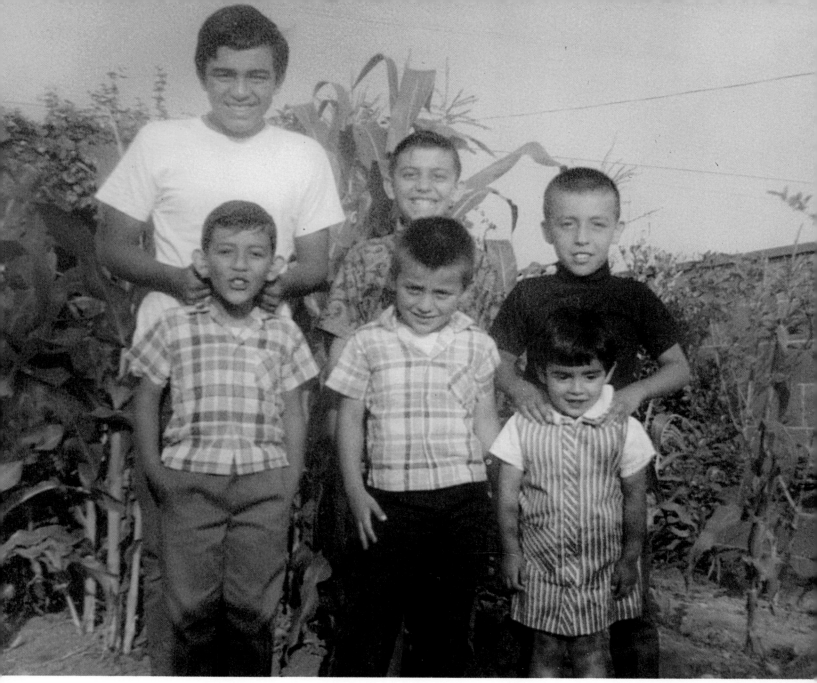

Love (Family) and Rockets in Oxnard

Jaime hernandez grew up in Oxnard, California, the largest city in Ventura County, located about sixty miles northwest of Los Angeles. His childhood home lies in the middle of one of Oxnard's suburban neighborhoods, which surround the old downtown and are in turn surrounded by farms on the outskirts of town. Oxnard is known for "agriculture and surfers," as Hernandez puts it, and by mid-century there was a large influx of Japanese and Mexican immigrants looking for work in the burgeoning agriculture industry. Oxnard is also home to Point Mugu Air Station, along with a naval base in Port Hueneme.

Hernandez remembers hearing as a kid, "If the bomb ever comes, you'll be the first to go."

Approached by local roads (rather than the interstate, which takes you directly into town) through vast strawberry fields and the sweet breeze from the Pacific, Oxnard's rural area feels far away from the endless suburbs of Los Angeles. Hoppers, home of Maggie, Hopey, and the *Love and Rockets* crew, is based in large part on Hernandez's south-side neighborhood, and this relationship, which encompasses the low postwar houses, buildings, socioeconomic and cultural divisions, as

The Hernandez siblings, c. 1967.
Clockwise from upper left: Mario, Gilbert, Richard, Lucinda, Ismael, and Jaime. "Dad passed away just before I turned eight, and Mom did her darnedest to singly raise six brats. Mario didn't have to force my ears out, they already stuck out like vanilla wafers."

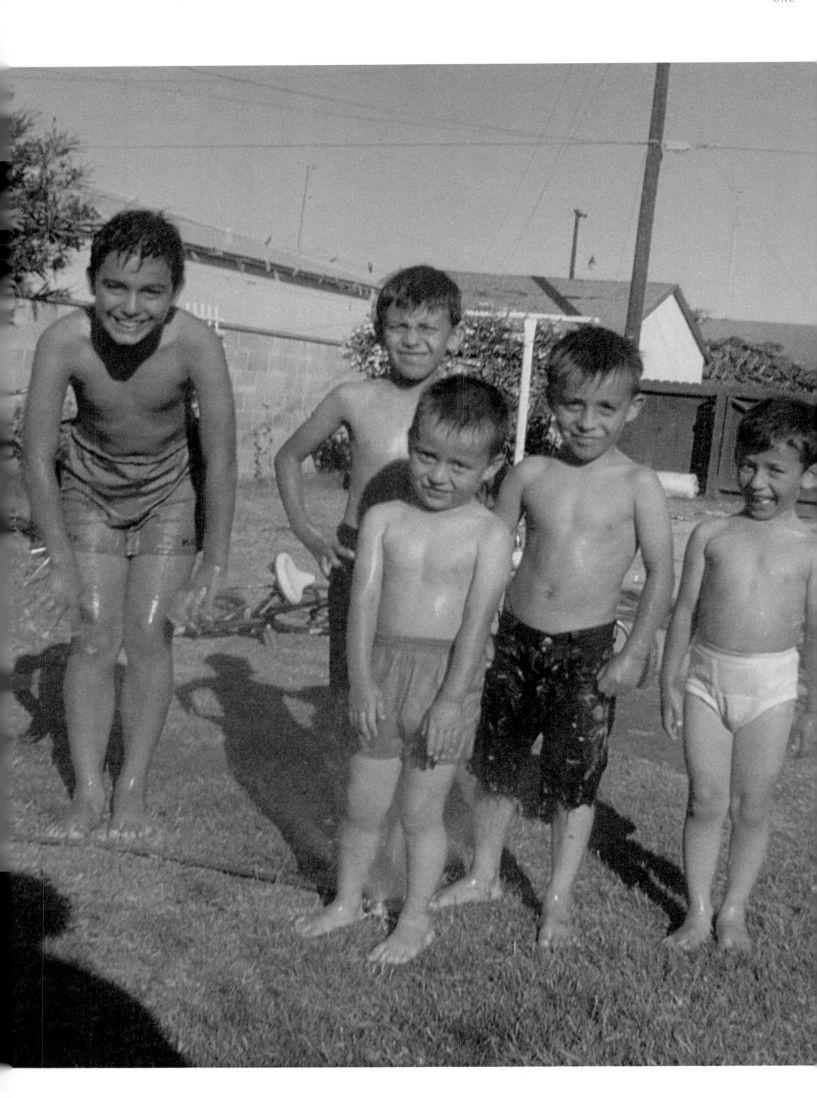

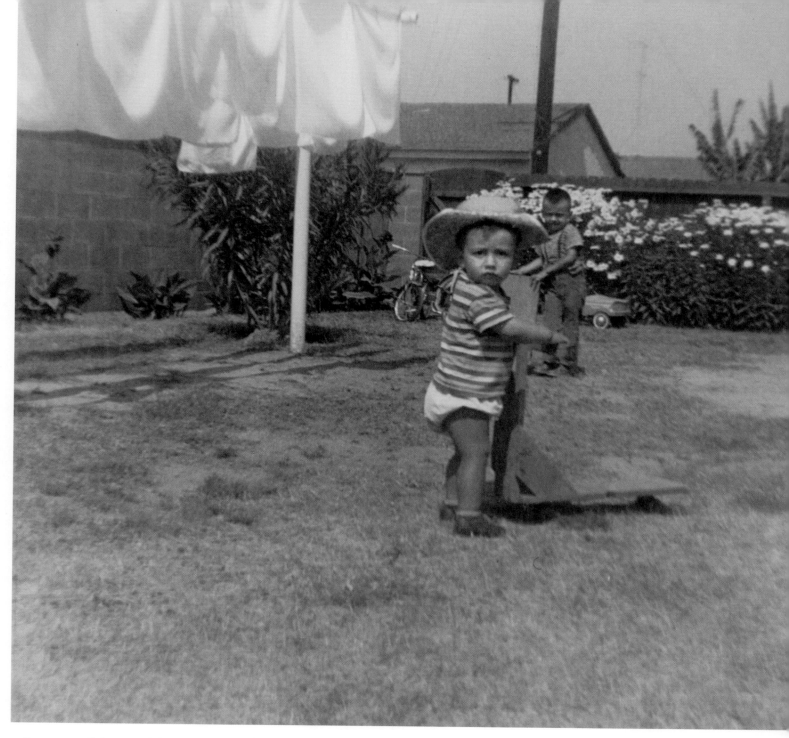

well as an overall character, is immediate. As Hernandez described the city in a 1988 interview for *Greed* magazine, "It's like every town from San Francisco to San Diego. There's a big, big Hispanic population here, and every place has its little barrio. Oxnard is surrounded by beaches. When I meet people they'll say 'You're from California—what part?' and I'll say Oxnard. 'Oh, I have a boat in Oxnard!' We're surrounded by fancy marinas and boatyards for the rich people. They don't know about us poor people inland. They never hear about it."

Born on October 10, 1959, Hernandez is one of six siblings: oldest brother Mario, followed by Gilbert, Richard, Jaime, Ismael, and the youngest, sister Lucinda. His mother, Aurora, who arrived from El Paso, Texas, in 1945, and father, Santos, who had come from Mexico in 1941, met while working in the fields and packinghouses. Hernandez grew up in the family's three-bedroom, two-bath home with many relatives living nearby, including six cousins next door. During the boom period following World War II, many new houses and kids sprouted up in the racially mixed, working-class neighborhood, and

there were always children around the house playing, if not in the alley, then in their backyard, which was the biggest on the block.

Hernandez's kindergarten, elementary, junior high, and high schools were all within walking distance, and a block away were a number of small markets, beauty salons, his uncle's barbershop, cleaners, auto garages, funky metal former barracks (where an old lady lived), and stores, including, importantly, a few with comic book racks. The most striking aspect of the neighborhood is its compactness, with a layout seemingly ideal for kids: close-knit neighbors, a park with baseball fields, and a diverse group of businesses (many of which would make later appearances in his comics) all within a block or two. The young Hernandez was sent to the store almost every day to get milk and bread, and he and his siblings mostly stuck to their neighborhood, with the family occasionally taking a trip to visit relatives or to the beach.

Jaime was always interested in local history, which would serve as one of the major inspirations for his comics, and his mother, who lived in their house until a few years ago, shared great stories about the

left
The Hernandez brothers in their backyard, Oxnard, c. 1964.
"From left: Mario, Gilbert, Ismael, Richard, and some kid in his choners. 'What'sa matter, couldn't you afford bathing suits?'"

above
Hernandez, with Gilbert in the background, c. 1960.

history of Oxnard and its jazz days past. Hernandez lived in the family house on and off until the mid-eighties, and while the neighborhood had gotten a bit rundown and suffered the homogenizing Home Depot treatment—the "back to downtown" movement has completely changed old Oxnard, one of the fastest-growing cities during the 1990s—the ambience remains.

His father died when Jaime was just about to turn eight, so the children were raised exclusively by their mother, with help from aunts and cousins. Memories of his father as "a living, moving person" remain, though the younger children have only static recollections or none at all. The kids were aware of their Mexican heritage, but while their parents spoke Spanish, the children didn't, not atypical for the time: "My dad thought it would be a better idea if we learned English so we wouldn't be made fun of when we went to school. One of my relatives told me that we spoke Spanish when we were really little, and one of my cousins who lived next door told me recently that she remembers her mother telling her when she wanted to come over to our house that 'they don't speak English, only Spanish.'"

Hernandez was raised Catholic and was a self-described "terrible" student, bored and unable to concentrate, since he was perpetually drawing and worrying about hiding his cartoons. A good part of

his youth was spent making up stories, many of which involved the extraordinary in the ordinary, such as transforming two disused sewer tanks in the park into "Frankenstein's Grave"; mythologizing the back-story behind a huge ocean liner washed up on its side off the beach; trying to find the golden spike on local railroad tracks; and feeling a young friend's theory that Mount Rushmore was carved on the distant mountains barely visible from town might be plausible. His mother's family was nearby, but the one attempt at a trip to Texas and Mexico to see their other relatives ended after a day with their car breaking down outside the tiny desert town of Westmorland in southeastern California. The five boys (his mother was then pregnant with his sister) had to wait on the side of the road while their father hitchhiked into town for help. True to character, Hernandez looks back on the foiled trip as an adventure: "I don't know if this happened every year, but the town was overrun by crickets. You couldn't make a step without running into one. So for a four-year-old kid, in this town I'd never heard of—I'd never been that far away from home—I thought, this is the rest of the world! We were only there overnight, but it seemed like a month."

Hernandez and his tía Cuca, who had just graduated from beauty college, c. 1962.

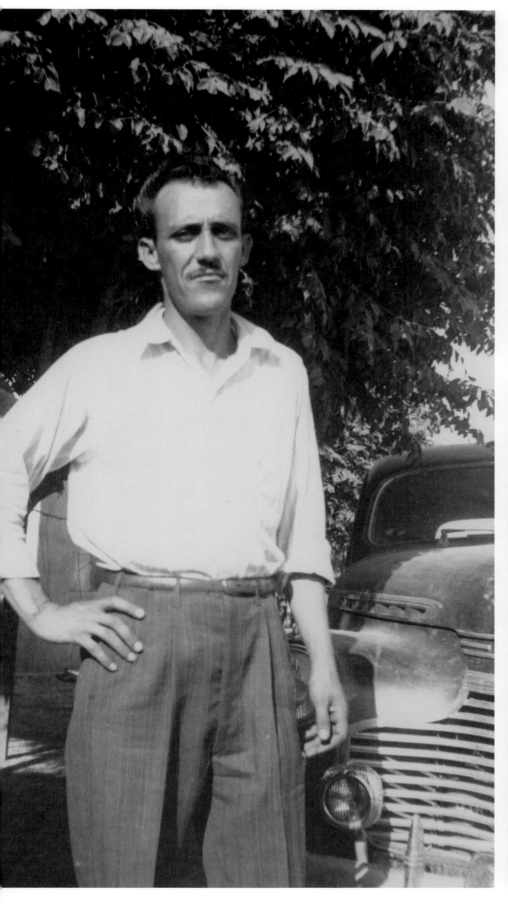

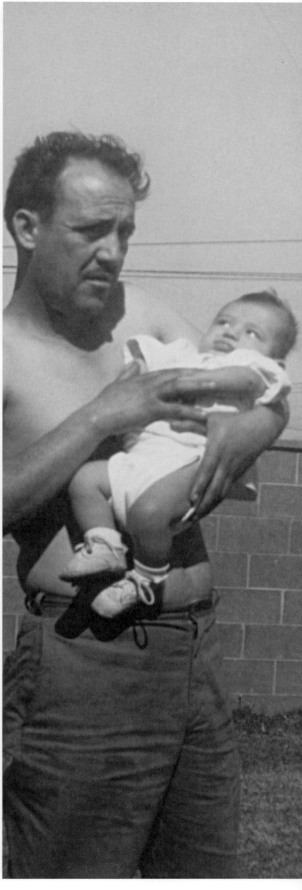

left
Hernandez's father, Santos, c. 1953.

right
Hernandez and his father, 1959.
"By 1959 I come along, smelling like dirty peta. Notice
how carefully Dad holds me?"

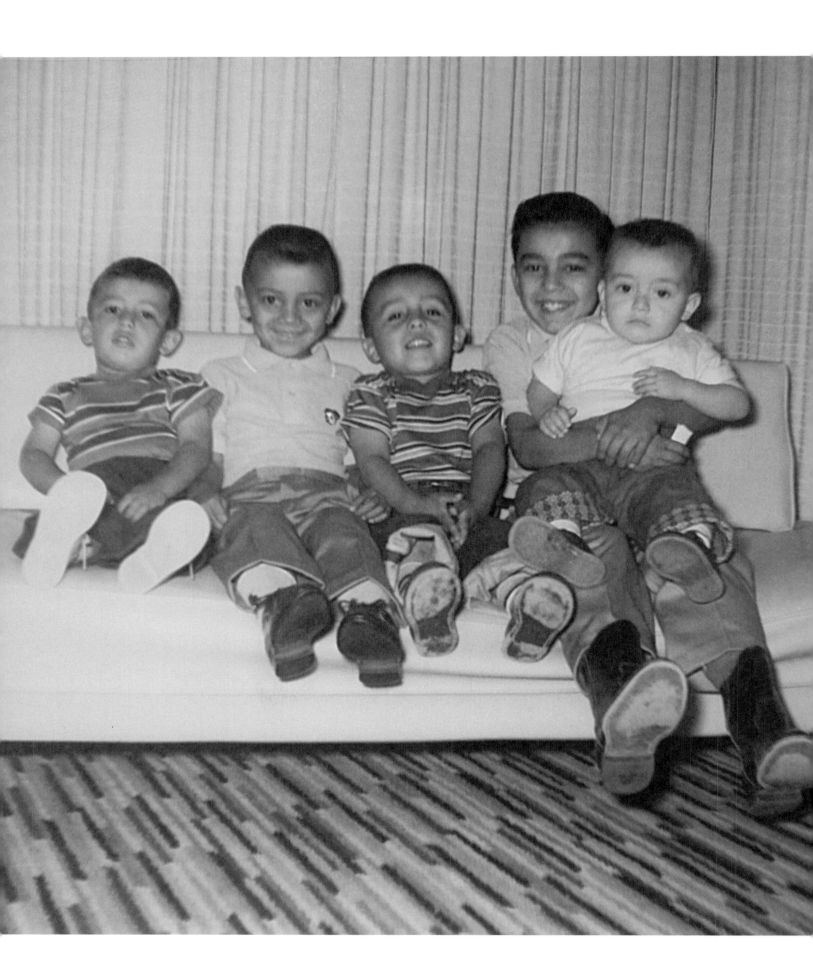

Hernandez and his brothers, c. 1962.
"Growing up in the Hernandez house. There I am on
the left with my brothers, Beto (Gilbert), Richy, Mario,
and Ismael. All born comic readers and artists."

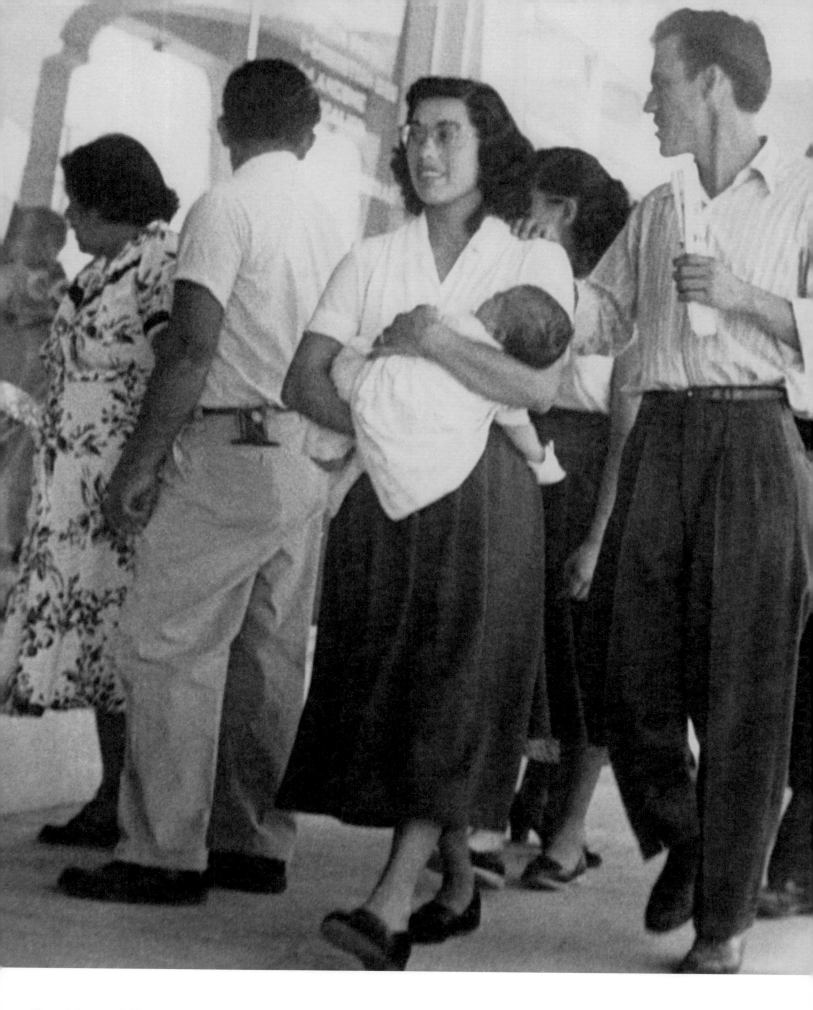

Hernandez's parents holding Mario in Mexico,
captured by a street photographer, 1953.

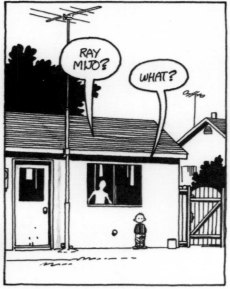
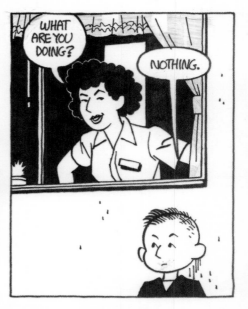
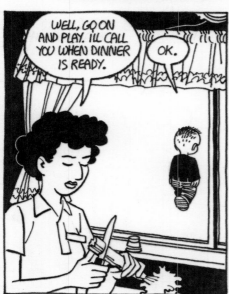
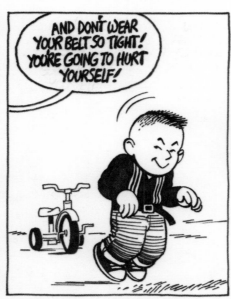

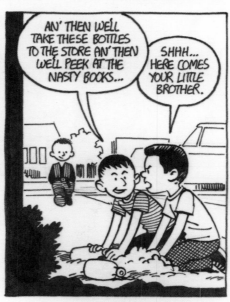
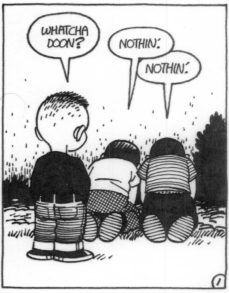

9

above and following pages
Original artwork for "Li'l Ray," complete four-page
story, Love and Rockets no. 28, 1988.
The important role that Hernandez's childhood plays
in his comics is beautifully shown here: "That's me.

That's my house, Gilbert and his sweater, and Richie
with the bottles. My backyard, when my mom is
doing dishes and I'm standing under the window with
my tight belt obsession."

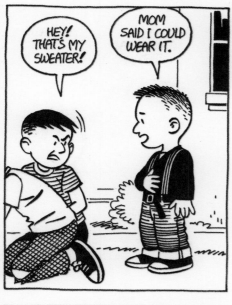

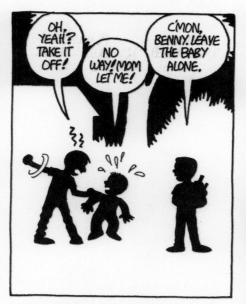

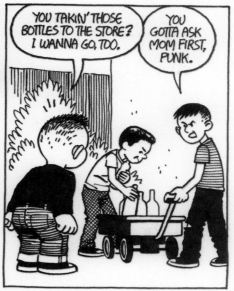

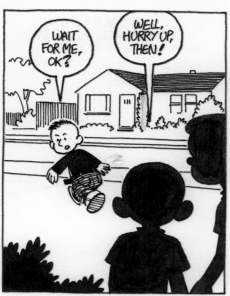

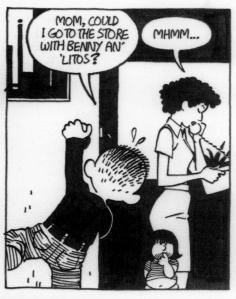

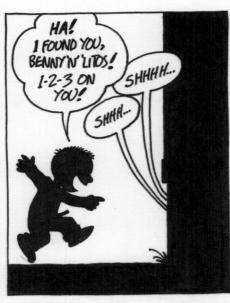

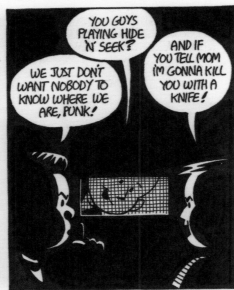

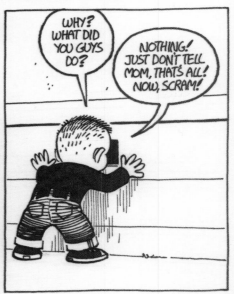

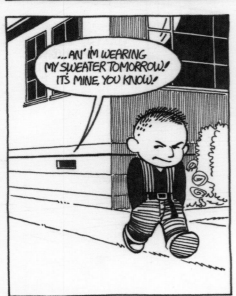

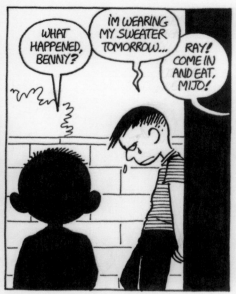

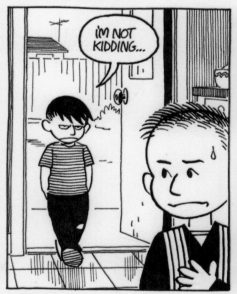

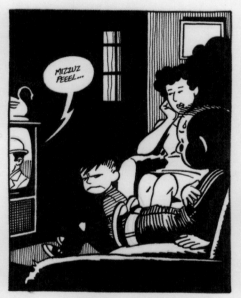

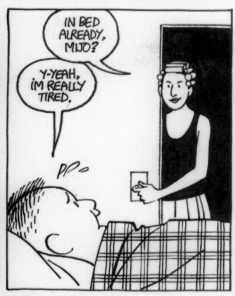

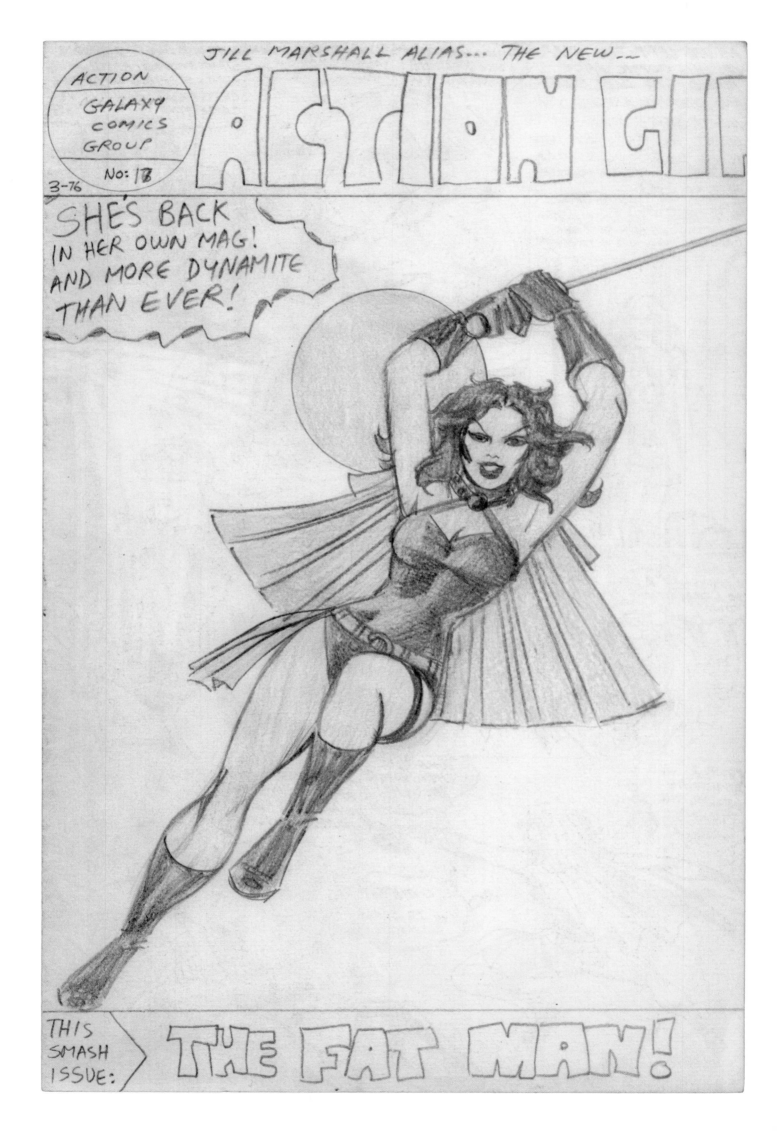

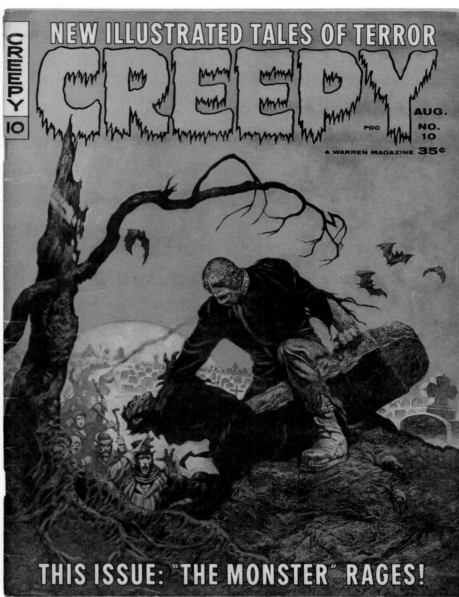

"Junk" Culture

Our saving grace was TV, comics, and crummy movies.
Mario Hernandez
from an interview in *Comic Book Artist* (2001)

CHILDHOOD INTERESTS were dominated by American popular culture, and Aurora Hernandez encouraged her kids' comics reading and collecting. She'd been an avid fan in her youth and, though she had thrown out her collection years before, her enthusiasm remained. She also drew portraits of her favorite Golden Age comics characters, from Superman to the more obscure Doll Man, Captain Triumph, and the Black Terror, which in their strange iconic power had a huge impact on Hernandez's love of the medium. The visual potency he felt as a youth has never been lost—Hernandez vividly recalls his older brother Mario's agonizing days spent pining over two twenty-five-cent, hundred-page annuals with painted covers through the smudged window of a closed store until it finally reopened after a family emergency. All of the children also made their own comic books from the earliest time Hernandez can remember. He was born into a comic book house and loved them before he was even able to read: "and even when I learned to read, I still wouldn't read a lot of them—I'd look at the pictures and follow them." Being exposed to comics so much in his pre-reading years influenced his view of them as a visual narrative for the rest of his life, and Hernandez still alternates between reading and "visually reading" them today.

opposite
Action Girl, homemade comic, 1976.
"My first female super hero with a new costume."

left
Dennis the Menace Television Special no. 2 (Fawcett, 1962).
The comic book version of Hank Ketcham's long-running newspaper strip was one of the Hernandez brothers' favorites growing up, particularly those issues featuring stories by ghost cartoonist Owen Fitzgerald.

right
Creepy no. 10 (Warren, 1966). Cover painting by Frank Frazetta.
A young Hernandez greatly admired the artists assembled by publisher Jim Warren for the early issues of his horror magazines, notably Frazetta, who provided the most memorable covers.

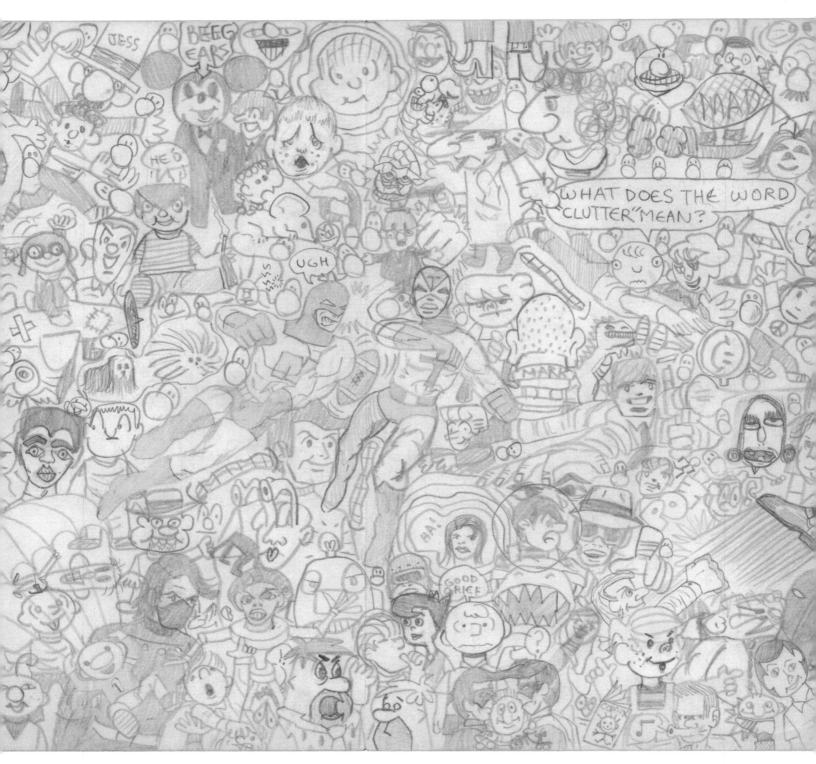

Crucially, from his older brothers, Hernandez inherited a history of comics virtually at his fingertips. There wasn't a period of "graduating" from one type to another (funny animals to super heroes, say) as he was exposed to all genres simultaneously through their collections. The most influential titles give an excellent primer on the history of the medium. The siblings all loved Ogden Whitney's rotund *Herbie* and most of the Harvey titles, such as *Richie Rich, Hot Stuff the Little Devil, Stumbo Tinytown, Little Dot,* and *Little Lotta.* John Stanley's *Little Lulu* comic books weren't around much, but the Stanley-edited *Ghost Stories* no. 1 had a huge impact and is remembered by Jaime as "one of

the greatest, wackiest comics ever." Carl Barks, the other established kids' comics great, was only read in small doses by the young brothers, though they treasured the Gold Key–published *Uncle Scrooge and Donald Duck* reprinting of the Barks masterpiece "Only a Poor Old Man." Perhaps the biggest continual influence on Hernandez was the inviting worlds of *Archie* by Dan DeCarlo and ghost artist Harry Lucey, and of *Little Archie* by Bob Bolling. Of particular impact were the myriad ways in which the characters interacted and the deft subtlety of body language and pacing. The seemingly simple unfolding of a perfectly contained story, loaded with surprising emotional resonance,

"What Does the Word 'Clutter' Mean?" original drawing, c. 1970.
"Me and my brothers used to do clutter drawings. You would start in the corner and just add until you filled up the whole thing."

opposite top left
The Adventures of Little Archie no. 28 (Archie Comic Publications, Inc., 1963).
Hernandez counts cartoonist Bob Bolling as one of his greatest influences.

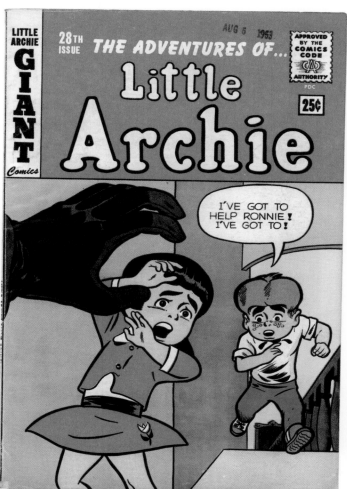

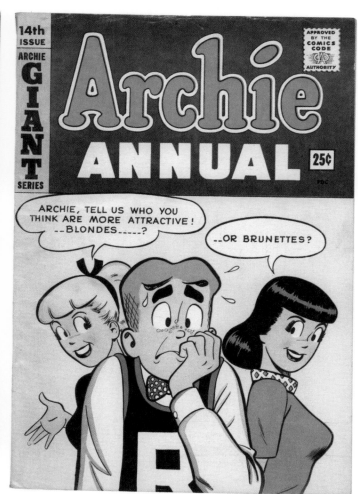

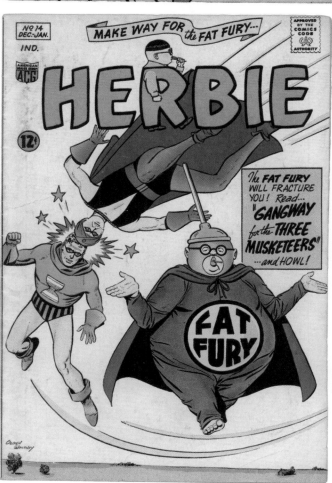

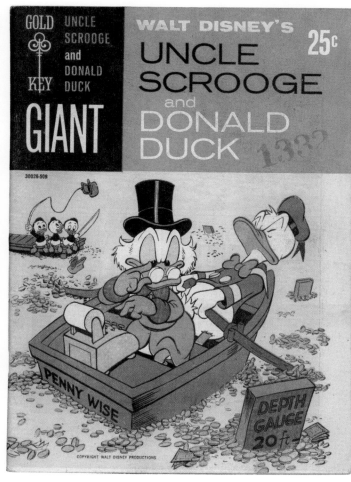

top right
Archie Annual no. 14 (Archie Comic Publications, Inc., 1963).
Dan DeCarlo—the most beloved *Archie* artist—was appreciated by Hernandez, but ultimately overshadowed by ghost Harry Lucey.

bottom left
Herbie no. 14 (American Comics Group, 1965–66). Cover by Ogden Whitney.
As one of the most idiosyncratic commercial comics ever published, the *Herbie* series opened Hernandez's eyes to the possibilities of genre-bending storytelling.

bottom right
Uncle Scrooge and Donald Duck no. 1 (Gold Key, 1965). Contains reprints of the classic Carl Barks stories "Only a Poor Old Man" and "The Mummy's Ring," which were favorites of Hernandez.

GRUMBLA

AROD

FUMBLA

ANNETE

TOMMY

KUDDLY

WHITEY

BUED

WASHER

GOGGLA

PROF. FICKLESNOOT

PROF. BANANA-NOSE

MR. RICHARDSON

JEAN

MR. McBOUNCE

BARKOS

SPISHOO

SANDMEN

Early character designs, mid-1960s.
"These are drawings that I did of Ismael's 'Johnny' characters, as well as my own."

opposite top left
Superman no. 149 (DC Comics, 1961). Cover by Curt Swan and Stan Kaye.
"The Death of Superman" was one of the most potent stories published by DC during the Silver Age, and one greatly enjoyed by a young Hernandez.

lodged in Hernandez's mind. He first discovered another favorite, *Dennis the Menace*, in comic book form, and he still prefers the stylings of ghost cartoonist Owen Fitzgerald to creator and newspaper panel artist Hank Ketcham. Jaime also got hooked on Charles Schulz's *Peanuts* not from its home in the newspaper, but from the animated television cartoons—the "fake versions"—which he loved, such as the now obscure early specials, *Charlie Brown's All-Stars* and *You're in Love, Charlie Brown*.

Of course, the most dominant mainstream comics subject is the super hero, and the brothers devoured the adventures of all the stalwarts, including Superman. *Superman* no. 149 (November 1961) was a particular favorite: "Superman dies. And in the end, he's dead. Supergirl then comes and kicks everyone's asses. And there's no question about her being a woman taking over or anything." But their favorite characters were those brought to life by the two undisputed masters of the early 1960s Silver Age: Jack Kirby and Steve Ditko. Mario bought all the monster and subsequent super hero titles that kicked off the Marvel Age of comics, starting with *Fantastic Four* no. 1 in 1961. Though the boys initially viewed the new Marvel super-hero line—*The Amazing Spider-Man*, *The Incredible Hulk*, *The Avengers*—as "B"

bottom left
Fantastic Four no. 1 (Marvel Comics, 1961). Cover by Jack Kirby.
The collaborative team of Stan Lee and Jack Kirby reinvigorated the super-hero genre with this issue, changing the rules of commercial comic book

storytelling forever—though by the time Hernandez began his mature work, what had started as revolutionary had become increasingly mannered and formulaic. As he puts it: "The comic that started it all . . . and eventually ruined it all!"

right
Captain Marvel no. 3 (M.F. Enterprises, 1966). Cover by Carl Burgos and Carl Hubbell.
One of many "off-brand" 1960s super-hero comics that appealed to the Hernandez children.

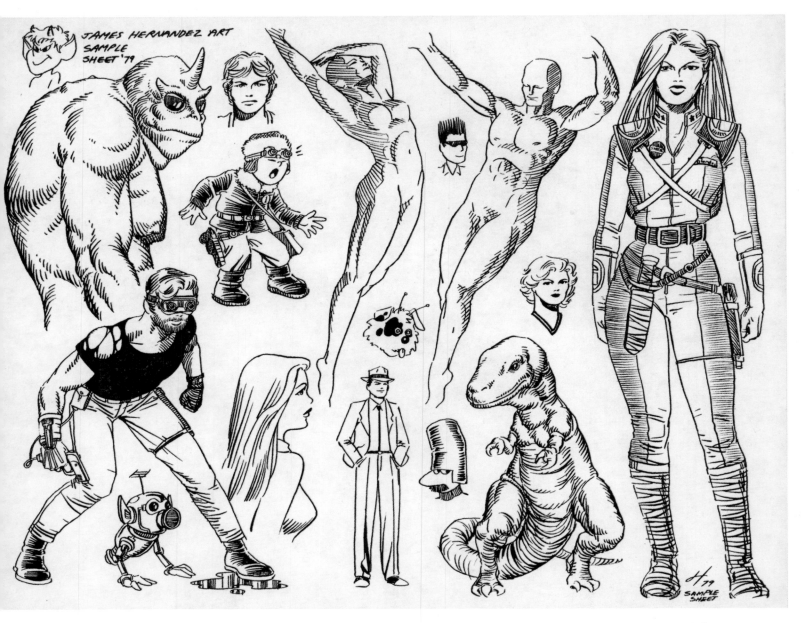

comics compared to DC's slick, bigger-budget and better-printed tales, when Marvel got revved up, DC couldn't compete for their attention. The august publisher, continuing to expand on heroes introduced twenty-plus years earlier, had a much more established approach and polished visual language by that point, and in response to the crass upstart, began conniving increasingly convoluted and zany stories to reach the young kids, featuring such out-there characters as "jungle master" B'wana Beast and rock band the Maniaks. Hernandez recalls that "in a way, I can now appreciate that even more."

In addition to the big two, the brothers enjoyed the less celebrated (and often more "cut-rate") super heroes and kids' comics put out by publishers such as Charlton and Standard. Surprisingly, the only genre of comics the kids didn't have around the house was romance, which Hernandez didn't start reading until much later. *MAD* Magazine was also always a big deal, with Mario buying every issue off the stands as it came out. Its topical nature was as important to Hernandez as the acclaimed irreverent humor: "That's how I knew who Kennedy was." When Jaime and Gilbert (who is two and a half years older) were big enough, they would traipse all over downtown Oxnard to get new comics; since distribution was so poor, they had to really scour

the various newsstands. Gilbert served as a huge influence on Jaime, particularly in the ambition, range, and work ethic displayed in his homemade comics:

Growing up under Gilbert, he was the only one that would do comics regularly. Everyone else drew, but wouldn't really finish issues or follow through. Richard would draw comics, but then go out and play baseball or something. Gilbert was the only one who would sit there for hours and just create worlds. He'd encourage me by saying, "let's draw," and of course looking up to him a lot, I'd always look at what he was doing and hope mine were as fun. My place was just to do my little kiddie versions of his. Gilbert always seemed to know what he wanted to do; I never knew what I wanted to do. When he put in his mind that he was going to do a comic series about people who were trapped under the earth, he would do the whole thing. I'd think, "I want to do that too!" And I'd do a cover and part of the first story, and think, "I don't know what I'm doing. How should I end this?" I'd start a Batman comic and the last page would always be "Pow! Zam! Now take him away!" But Gilbert seemed to have some kind of vision to really make something. He thinks back on these as being poor attempts, but they meant a lot to me. He taught me that if you're going

Character sample sheet, 1979.
"When Gilbert and I were trying to break into fanzines, we were advised to do sample sheets so they could see what we could draw and what we couldn't. It's kind of like your portfolio. We just wanted to be published."

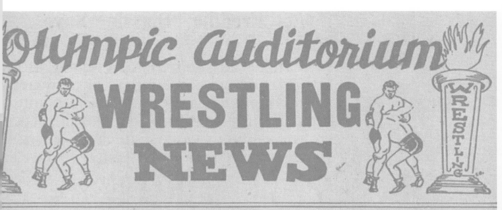

to do this, you'd better follow through, which was important for me as a teenager trying to create my own super-hero world. I created a bunch of male super heroes and just had one female super hero. I was really horny and only wanted to draw her, but realized that I had to create stories for the males as well, develop their world, because they wouldn't be famous super heroes without having anything to back it up. So I felt a big responsibility even in these stories, that if you're going to do this shit, you've got to back it up.

Based on the emphasis of his mature work, it should come as no surprise

that Jaime Hernandez was particularly interested in depictions of women in comics, and those featuring prominent female protagonists were burned into his mind at an early age, with the *Archie* triumvirate of Betty, Veronica, and Josie the most appealing and beautifully rendered. Jaime's attachment quickly seeped into his own comics as he was "head over heels over women, period, so it just made sense—if I'm going to do stories, why not put women in them so I get to draw them?" Raised by his mother, with aunts and other female relatives always pitching in, women were the most powerful adult presence in his life, though he didn't consciously articulate the impetus behind the strong females

left
Olympic Auditorium Wrestling News, May 1, 1963, featuring Los Angeles fan favorite "Classy" Freddie Blassie.
Hernandez avidly followed LA-area wrestling during the sport's golden age.

top right
MAD no. 59 (E.C. Publications, Inc., 1960). Cover painting by Frank Kelly Freas.
MAD served as a springboard into more adult humor for many young readers.

bottom right
Tales Calculated to Drive You Bats no. 1 (Archie Comic Publications, Inc., 1961).
One of Hernandez's favorite issues of a comic book from his youth.

in his comics until later. "There was no game plan. It wasn't until people started telling me I was doing them right that I started to think about it."

For the Hernandez kids, comics were the most important, though far from the only, mass cultural sustenance during the 1960s. Watching movies on television was a dominant pastime, and Oxnard had a few theaters downtown, such as the Vogue, which older brothers Mario and Gilbert used to frequent. It was here that Jaime saw his first movie, *Snow White and the Seven Dwarfs*, and where Mario used to catch bizarre double bills, such as the stunning 1964 pairing of *Dr. Strangelove or: How I Learned to Stop Worrying and Love the Bomb* and *The Incredible Mr. Limpet* starring Don Knotts as an animated fish—a radical mixing of artistic-minded and eccentric commercial sources that would later become a hallmark of the Hernandez brothers' comics. Kids' television

shows were also a huge source of entertainment for Jaime, particularly *Shrimpenstein* (a nickname he picked up in the third grade); Japanese anime cartoons such as *Astro Boy, Gigantor, Prince Planet,* and *Marine Boy*; and his favorite, *Winchell-Mahoney Time*, featuring Paul Winchell and his dummies Jerry Mahoney and Knucklehead Smiff. Other perennials included reruns of *The Three Stooges* and *The Little Rascals*, the *Our Gang* shorts packaged for television that, in their gender and ethnic equality, prefigure Hernandez's comics.

The kids were addicted to monster movies ("the sillier the better"), mainly on independent channel KHJ, and they loved the wildly popular Seymour, host (and humorous critic) of various Los Angeles creature-feature broadcasts beginning with *Fright Night* in 1968. Seymour was a big local celebrity who delighted kids with frequent personal appearances, as did other hosts such as Engineer

Hernandez with camera, early 1970s.
"Preteen years. Still reading comics and drawing my own. Still too scared to draw girls, let alone talk to real ones."

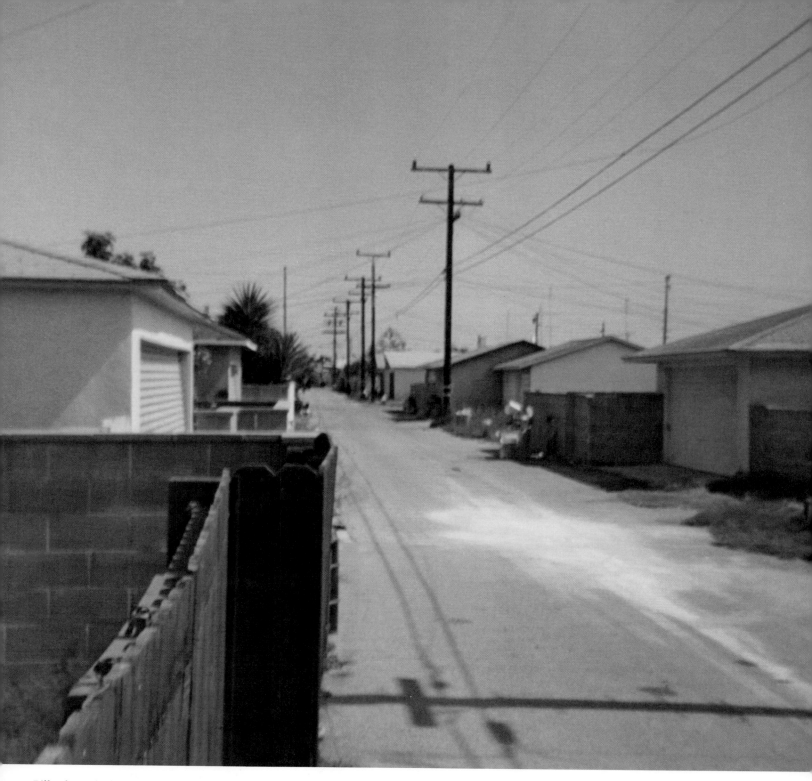

Bill, whom the brothers saw when he came to the parking lot of their Food Fair. Hernandez has fond memories of all sorts of area events that incorporated popular culture elements, such as the opening of new department stores, shopping malls, fast-food restaurants, and car dealerships; in his words, "the best stuff was the local," a preference that would remain with him. Hernandez was lucky in that his youth coincided directly with the early- to mid-sixties horror craze, not only in television, but also in the Warren-published magazine *Famous Monsters of Filmland* and horror comics *Creepy* and *Eerie*, which were must-haves from the beginning. "Warren was a big, big influence on me. Those and the *Mars Attacks* cards were the first time that I saw blood and gore. It was a little disturbing as a five-year-old kid, but at the same time I realized that there was something more to comics than super heroes and *Archie*. And I really liked their spooky aspect.

To this day, I think the early Warrens are some of the best illustration work in comics."

Wrestling became another mid-sixties obsession, with a tradition of regional "stars," similar to the television horror movie hosts, whose merits the whole block of kids would excitedly debate. Hernandez's first exposure came from watching televised matches from the Grand Olympic Auditorium in Los Angeles, and favorites included "Classy" Freddie Blassie, the Destroyer, and African-American pioneer Bobo Brazil. While Jaime was too young to attend, his friends from the neighborhood saw matches live at the Ventura County Fairgrounds; all the brothers later attended smaller matches at an Oxnard community center. The sport's appeal was in large part due to it being "fun and funny at the same time. Something about wrestling's sense of humor has stuck with me and I've loved it ever since: that boastful arrogance

The alley behind the Hernandez house, Oxnard, 1972.
"A lot of inspiration came from there as that was the first place I was allowed to explore away from the house outside of the backyard."

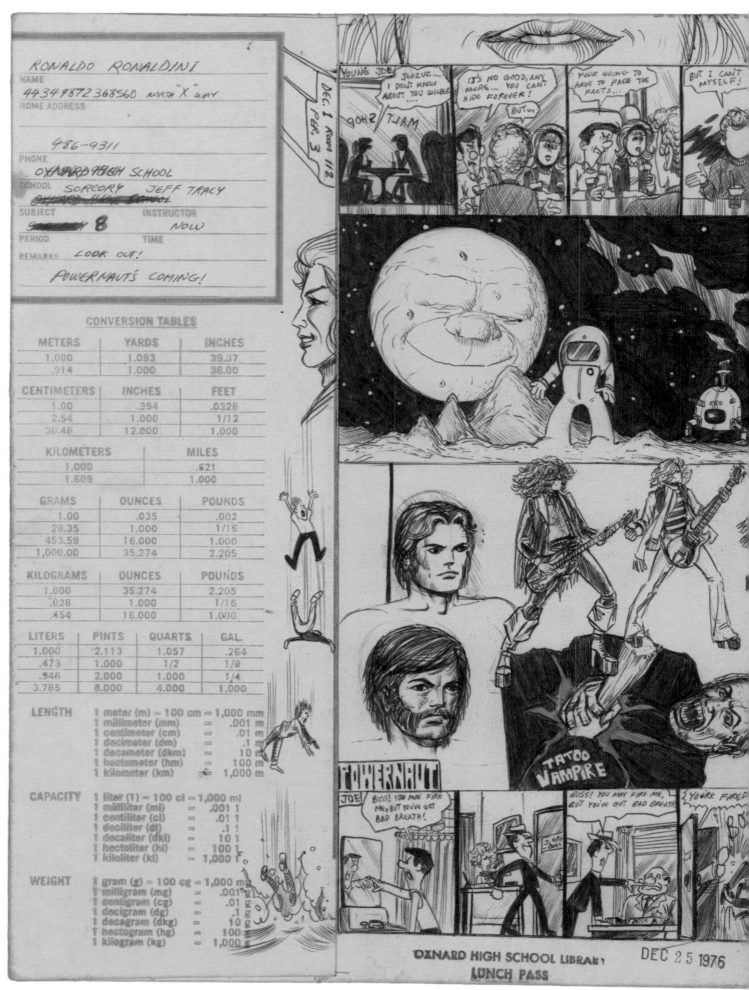

The inside of Hernandez's high school Pee-Chee folder, 1976.
Included are very early images of Maggie and Rand Race.

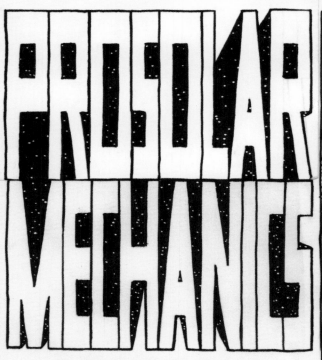

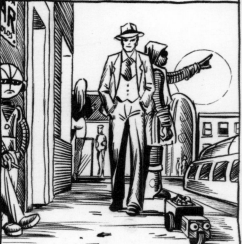

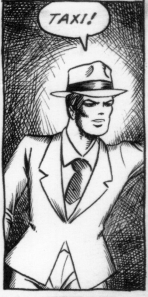

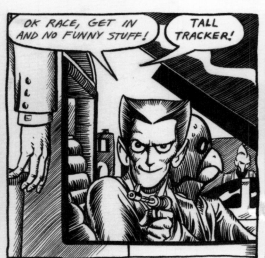

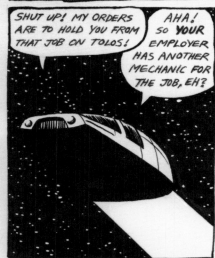

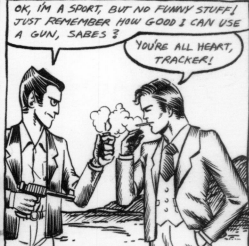

Original fanzine artwork for "Prosolar Mechanics,"
splash page, 1977.
"Originally, it was called 'Popular Mechanics,' but
Gilbert mentioned that I might get sued or something.
I lettered it with a ballpoint pen."

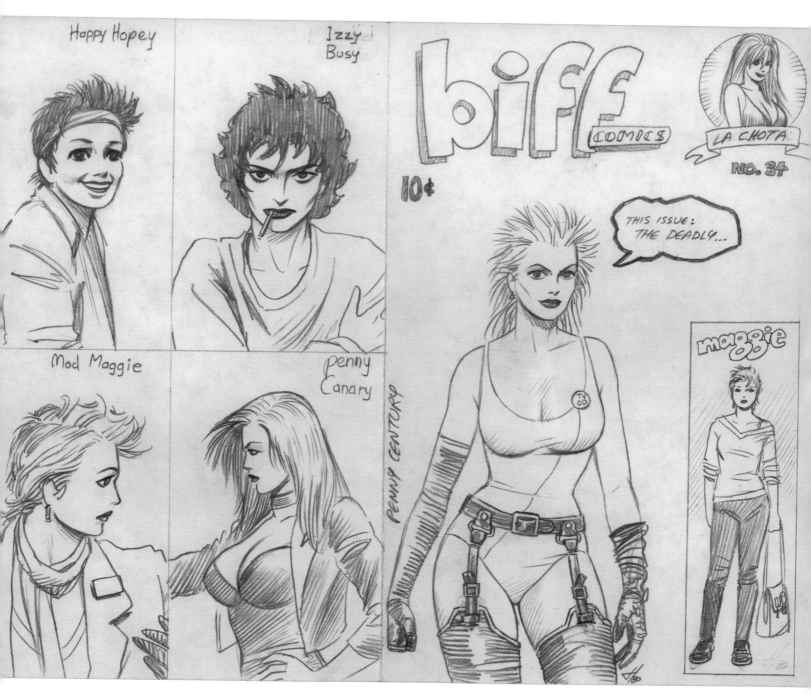

with the touch of silliness behind it, which cracks me up." Like comics, wrestling was another love passed down to the kids by their mother, who recounted lore about earlier villains from television broadcasts she watched in the 1950s. Mexican masked wrestler Santo made movies from the early sixties to the late seventies, and these were the children's first exposure to south-of-the-border fare, found dubbed into English when flipping channels. The Mexican combination of wrestling and monsters was perfect and absolutely irresistible, and 1962's *Samson vs. the Vampire Women* was a moment of pure revelation: "This guy's a wrestler, a super hero, and he fights monsters. This was everything we ever wanted in one movie!"

An even more potent reaction came when Hernandez and his brothers discovered another early sixties gem, *Doctor of Doom*, depicting women tag team wrestlers who fought monsters: "Now girls?! It was everything I wanted!" Wrestling provided some of the earliest Latino images the

brothers were exposed to, as American pop culture–immersed kids. While Hernandez didn't view his entertainment through such a lens, he does recall "identifying with Dennis the Menace's little pal Joey, who had black hair. I thought he was the little Mexican kid." Gilbert explained the appeal of *Tarzan* comics to kids of his generation in a 2007 interview with cartoonist Adrian Tomine: "All I remember is that those late fifties/early sixties Dell, then Gold Key, comics were around the house, Tarzan being the favorite 'super hero' of Latinos at the time. Up until high school, the few 'super hero' comics the Latino kids at school looked at were jungle adventure comics. I noticed if a Latino was reading a comic book on the bus, it was almost always a *Tarzan* comic book. I don't know if that's at all significant, or because my world was pretty small at the time, but there it is. It's possible I identified with those Jesse Marsh *Tarzan* comics because characters looked Latino to me. . . . It was a big deal to me and other Latinos, I'm sure. . . . It was all

Biff Comics, homemade comic, 1980.
This showcases pre–*Love and Rockets* "Locas" on
the front and back covers.

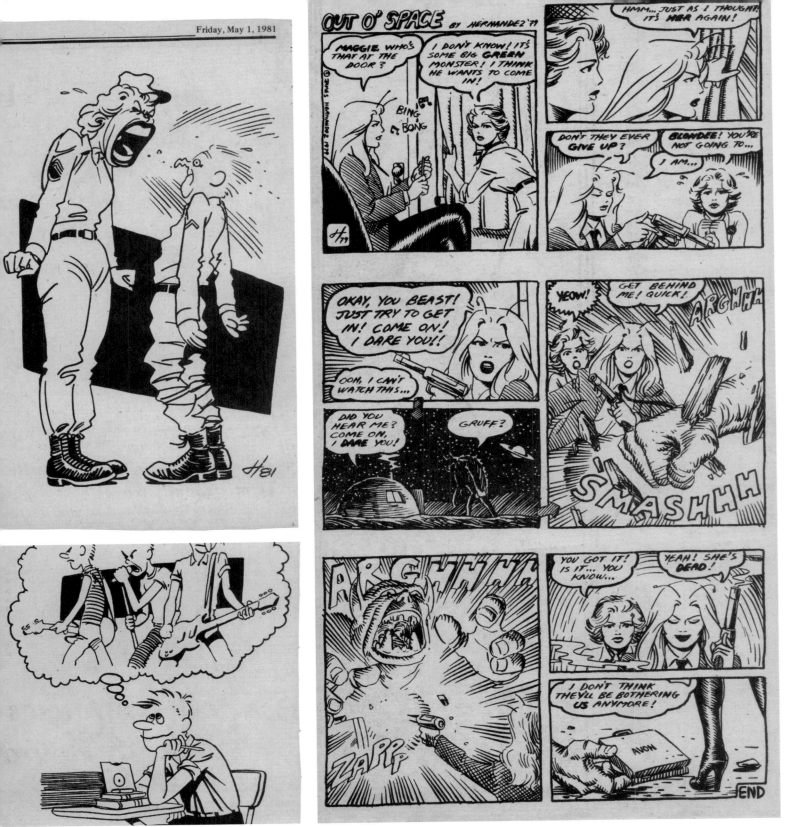

projecting, of course. Role models were always looked for, and I took that very seriously."

As Jaime grew into adolescence in the early 1970s, his own super-hero comics were often dominated by powerful women whose defining characteristics would later coalesce into Maggie and the *Love and Rockets* cast. At the same time, Jaime continued to experience the changing world of comics—and youth culture in general—secondhand from his older brothers. Foreign and American trends in film were gradually absorbed, and when he saw their underground comics at a too-early age in the late sixties, Jaime was put off by the adult content and feared

that his mom would discover them, particularly when coupled with the skin mags (or "naked books" as they called them) the older brothers also snuck into the house. Mario was into Ed Roth's defining surf culture graphics and comics in *CARtoons*, and both Mario and Gilbert were in awe of Robert Crumb's first issues of *Zap Comix*, though, again, Jaime was still too young to process the jolt of the wider counterculture world: "I remember Gilbert telling me, 'They're not called beatniks anymore, they're called hippies,' and thinking that [Gilbert Shelton's] *Wonder Wart-Hog* was just a crude *MAD*—I didn't understand where it was leading." While *MAD* had given Jaime an early introduction to

top left
Ventura College Press cartoon, 1981.
Hernandez's college newspaper.

bottom left
Ventura College Press cartoon, 1980.

right
"Out O' Space" strip, *Ventura College Press*, 1979.
Note Penny Century with antennae: Here she is named "Blondie," but Hernandez later changed it after the band turned disco.

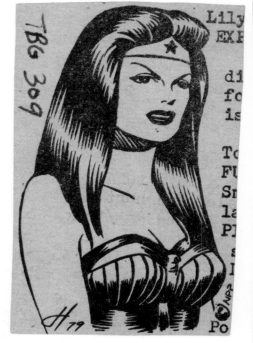

contemporary culture, as his horizons broadened, the undergrounds would eventually shed light on an entirely different way of making comics. The transition of the medium from genre entertainment to an adult art form was waiting for him as soon as he could digest it, but the fact that these pioneering comics were readily available at such an early age is hugely important when assessing Hernandez's own comics.

Since his older brothers were collecting rabidly, Hernandez never had to buy comic books, but when Mario moved out in 1974, he took his collection with him and the free ride was over. Jaime began buying new Marvel and DC titles on his own, as well as re-buying favorite departed back issues (as well as favorite rock records). He and Gilbert would go downtown once or twice a week to make the rounds of the newsstands, and Jaime chose specific titles that he would begin actively collecting, namely *The Fantastic Four* and *The Avengers* from Marvel, and DC's *The Legion of Superheroes*—he liked super teams, since you got to see more women in costumes. Both brothers continued making their own comics through adolescence; as Jaime recalls, "the whole time Gilbert was really doing his own thing, and I was doing the low-budget version of what he was doing because I just wasn't as good." While building their knowledge of comics history and current trends, Jaime's older brothers had also gone nuts over the homemade fanzines that documented the

culture (and sported the occasional bare-breasted female barbarian on their covers), such as the *Rocket's Blast Comicollector*.

As important as the 1960s undergrounds undoubtedly were in demolishing content restriction and allowing for myriad voices—notably, those of women—these comics were also crucial for pioneering creator-owned, rather than the traditional publisher-owned, characters and content, and establishing an alternative system of distribution outside of the newsstands used exclusively by mainstream comics companies. Head shops acted as key early outlets, and by the early seventies, specialty comic book shops catering to collectors began popping up. While generally located in back rooms of "regular" bookstores, a few comic shops devoted to older issues dotted the landscape of the 1960s. But the true arrival of the comic book shop in the mid-1970s was made possible by a new method of distribution that allowed stores to order current titles from a source other than the notoriously unreliable and Byzantine conventional distributors, where comics were lumped in with all other periodicals. In 1974, fandom and convention trailblazer Phil Seuling established Seagate Distribution, which sold to specialty shops exclusively, offering a larger discount off cover prices in exchange for ending returns of unsold copies, following the model established by the underground publishers. This system—

top left
Wonder Woman illustration, *The Buyer's Guide for Comic Fandom,* 1979.

bottom left
College-era Maggie drawing, 1979.

right
Ventura College Press illustration, 1981.

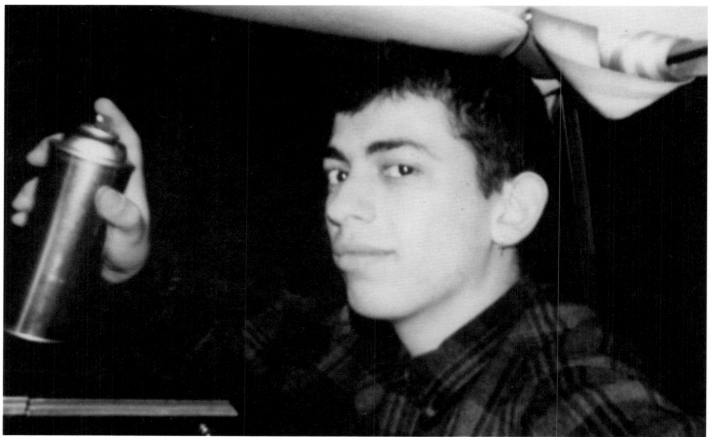

the beginning of what came to be known as the "direct market" and was eventually populated by a number of independent distributors— gave stores more reliable access to new comics and also established a niche for small publishers, particularly those with more "adult" content. With comics being sold exclusively in venues devoted to their target audience, print runs could be much smaller and thus the risk to startup companies greatly decreased.

While not as radical as the majority of undergrounds, new self-published or small-publisher comics during the time also sought to explore subject matter beyond the restrictions imposed by regu-

lations introduced by the Comics Code Authority in 1954 to quash "inappropriate" content. Early examples of what came to be known as "ground-level" titles included Wally Wood's anthology *witzend* (1966–1985), and Gil Kane's self-published *His Name Is . . . Savage!* (1968). The year 1974 saw the release of the anthology *Star*Reach*, edited by Marvel writer Mike Friedrich, and *The First Kingdom* by Jack Katz, followed by Dave Sim's *Cerebus* in 1977 and *ElfQuest* (first published in *Fantasy Quarterly*) by Wendy and Richard Pini in 1978. By this time, the dominant super hero comics had lost their innovative exuberance, becoming more and more mannered to the point that they seemed to

top
Three color drawings from 1980, showing *Love and Rockets* characters taking shape.

bottom
Hernandez with a can of spray paint, late 1970s. "Out of high school. Young Oxnard punk rocker driving to LA with can of spray paint in hand, up to no good."

Jaime "dead in the water; foolish, and no longer fun, the way Marvel was handling them. But being such a big fan of the idea—people in colorful costumes—I was really waiting for anything interesting. 'Come on, give me something!' And it just never came." So the brothers started looking more to the newly prominent genres of science fiction and fantasy, "which at least tried to be imaginative." Marvel even attempted to tap into this older demographic by introducing "mature" magazine-format comics (in order to bypass the Code, which only applied to the comic book format) such as *The Savage Sword of Conan* (1974). *Heavy Metal*, a reprint of the French publication *Métal Hurlant*,

beginning in 1977 delivered to an American audience contemporary European comics by artists such as Jacques Tardi, along with like-minded American artists such as Richard Corben, both of whom Hernandez liked. For Jaime, French cartoonist Moebius (Jean Giraud) had a big effect:

> I liked how Moebius didn't follow any rules. He'd include so much detail that there'd be something funny in the background, which didn't have anything to do with the story. I really liked that. Besides his talent, his draftsmanship, I just loved how he played with everything; when an

Punk coming into focus: The top drawing is Hernandez's imagined view of a gig, c. 1978; the bottom drawing is from 1980, after he had attended numerous shows.

College notebook with self-portraits, c. 1980.
Note the drawing of the stick man with the arrow near
the top. This cave art image makes appearances
throughout Hernandez's comics and also became
a tattoo design.

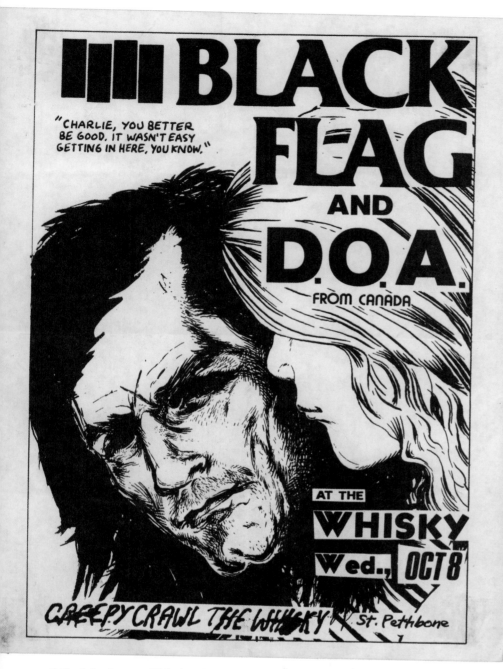

artist is obviously an established professional but also lets that childhood quality in there, I appreciate it more than almost anything. Something that I've always liked about certain artists from when I was a kid—why I liked [Conan the Barbarian artist] Barry Smith, and why I still like Frank Frazetta, whose work is almost nothing like mine—was that their art was always very playful and had a sense of humor. Again, I liked what was going on in the background: You think you're supposed to be looking at the boldness of it, but if you look behind it, there's some guy doing something funny. Frazetta would do a big flying thing and two tiny guys watching. I just loved that attention to detail.

These types of comics, even if somewhat limited in scope, at least demonstrated that there was a more personal pulse outside of the mainstream. And the fact that, like the undergrounds, the characters and content were owned by their creators—which was not an option in the work-for-hire system of mainstream super hero comics—was of great importance to establishing a context for the subsequent independent comics of the 1980s. Hernandez augmented his comics

education by accompanying his older brothers, who had been regularly buying back issues at the Cherokee Book Shop and a few other stores in Hollywood, to small conventions in Los Angeles beginning in the mid-to-late seventies. "I wasn't looking for anything too obscure—mostly *Fantastic Four* reprints. I mainly wanted to recapture Kirby." Jaime also continued to keep up with fanzines, subscribing to the *Buyer's Guide for Comic Fandom* (later the *Comics Buyer's Guide*), and began to submit comics stories of his own, often with inking or lettering assistance by Gilbert and Mario, to those zines that published fan art. Working his way through current art styles and various permutations of sword-and-sorcery and sci-fi tropes, between 1978 and 1980 Hernandez signed submissions to fanzines "James Hernandez," indicating that he felt some trepidation about his Mexican-American heritage in light of the overwhelmingly white "boy's club" landscape of fan culture, a youthful error in judgment that he regrets today.

Published in venues such as *Potboiler* and *Fandom Circus*, when read from the vantage point of Hernandez's later mature work, these drawings demonstrate a nascent storytelling ability and skill at

left
Black Flag flyer, c. 1980. Artwork by Raymond Pettibon.
Pettibon's jarring juxtapositions of image and text on flyers and record covers made him the most recognizable artist from the punk era.

right
Planning Maggie's life, c. 1979.
"She was supposed to have disappeared by age thirty-four."

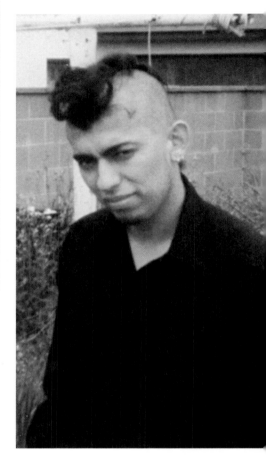

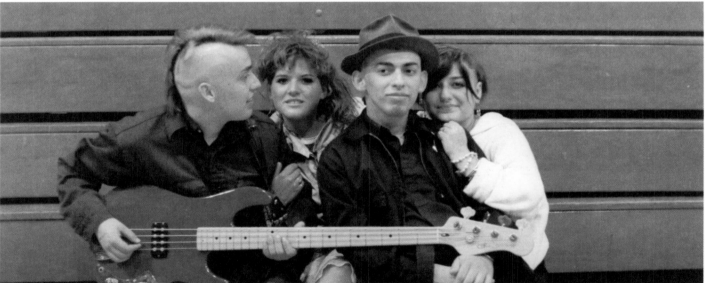

juxtaposing character types, as well as an overall charm. But the results were somewhat typical teenage pastiches, borrowing an inking style from one source, a sense of composition from another, all the while searching for his own voice. Following these labored strips Jaime looked back to an earlier, much more personal way of making comics, and these contain a greater sense of the eventual *Love and Rockets* spirit: "My comics done when I was little were fun because I didn't understand how real comics worked, so I could do it my way. It wasn't until I was in fourth grade that I started to get influenced, and started to worry, 'Well, my comics aren't like *real* comics, and I can't do it their

way.' So that was kind of a low point in my imaginative years because I started to get too influenced by the current artists and started to become like everyone else. I was influenced by what was *supposed* to be good; I find that a real low point in my creativity."

Drawing his way through school, Hernandez graduated Oxnard High in 1977. In addition to his comics world at home, he had another, separate life involving neighborhood friends and lowrider car culture; as he neared adulthood, the world beyond comics began taking on a more important role. Popular music had been a big part of his life growing up—when his mother was in the hospital giving birth to

top left
X, *White Girl*, 7" (Slash Records, 1980). Hernandez saw X play dozens of times around LA during the band's heyday, witnessing their evolution from local favorite to one of the most important American groups of their generation. Their aesthetic, more than any other, came to define the cultural moment.

top right
Hernandez with fresh mohawk, c. 1983.

bottom
"Everybody wanted to be in a band. Hanging with brother Ismael (mohawk) of Dr. Know and friends," c. 1983.

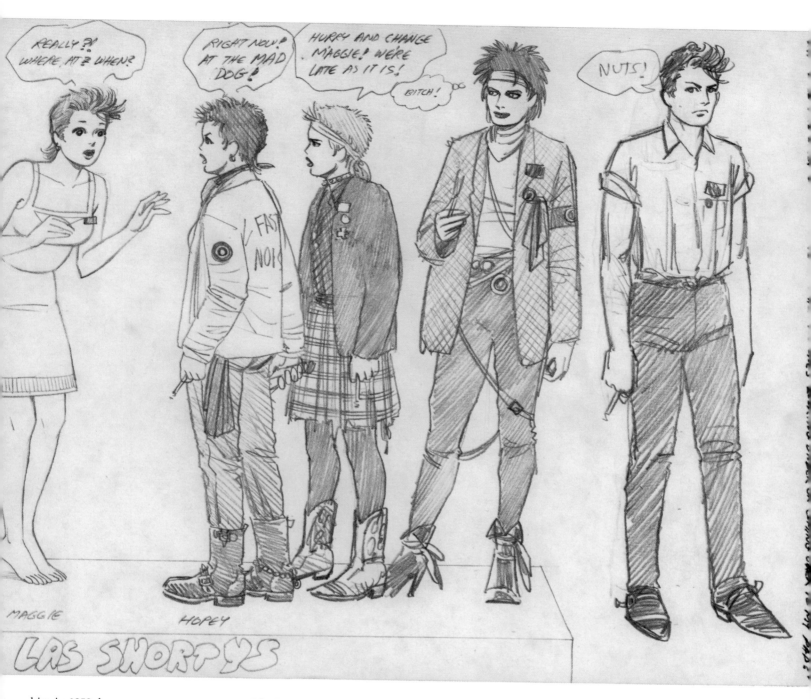

Forming: Characters continue to come into focus.
"Las Shortys," 1980.

him in 1959, her roommate was a teenage girl who always had local pop station KRLA tuned in, which got Aurora interested in popular as well as traditional Mexican music, so both were played constantly in the Hernandez home. During adolescence, music, like much else, was largely determined by the tastes of his brothers, who went through various hard rock and glam phases. But when the first wave of British and American punk came along in 1977 in the form of singles by the Sex Pistols, the Hernandezes' enthusiasm quickly accelerated to a fever pitch. Los Angeles was immediately on the map as an important epicenter for new bands, and the diverse scene that sprouted up around the city and outlying areas provided an immediacy in the same way that local conventions and fanzines did with the world of comics, quickly and profoundly changing Hernandez's life a year or so after graduation.

In 1978, Gilbert saw the seminal LA punk band X for the first time and was blown away, but it took Jaime until '79, as gigs were notorious for getting canceled due to the perceived threat of violence posed by first-generation bands like the Germs. X became a fast favorite, and a preferred venue was the Hong Kong Cafe, where Gilbert and Jaime saw most of the important bands of the time. In 1980 things really boomed, with Black Flag (before singer Henry Rollins) "destroying LA—in a good way." They had a "comeback" show at the Starwood, due to the fact that no venues would book them, and Hernandez recalls it as "the first time I saw the pit go all the way to the back wall. Anyone who stood had to be against the back wall. I remember thinking, 'My God, it's the end of the world and I love it.'"

By the early 1980s, Oxnard had a thriving hardcore (or "Nardcore," from the city's name) punk scene, spawning bands such as Agression, Stalag 13, Ill Repute, and Dr. Know, for whom Jaime's younger brother Ismael played bass. Makeshift venues, mainly rented-out halls or

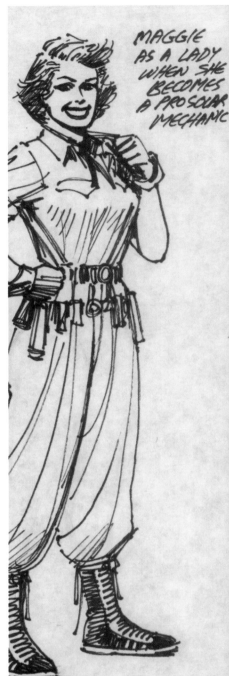

house parties, sprung up around town, so the brothers were able to see bands without having to drive into Los Angeles. Surrounded by mountains and beaches, Oxnard and Ventura were a strange mix of economic classes and varied geography: the seedy strip of tattoo parlors where sailors hung out and the working-class neighborhoods were a sharp contrast to Mandalay Bay, the marina where the very wealthy had summer houses. Hernandez recalls that lots of Oxnard punks were surfers, who "liked us because we were Mexican guys. We were from the streets and the surfer guys were the trash of culture, down and dirty. They got kicked out of high school and all that. They were the mean kids who had this whole 'locals only' attitude, and immediately took to us because as Mexicans, we understood. Oxnard was kind of a mean scene, and there were a lot of guys who would beat people up if they got out of line."

Punk coincided with Hernandez dropping his fan-ish aspirations, resulting in a drastic change in his approach to comics, which began to get looser, both in style and subject. Gestural cartooning in marker replaced his laboriously inked fanzine submissions, as Hernandez shed concern over genre conventions in favor of the unbridled spirit he had had as a child: "I was tired of trying to meet the comic world halfway and decided I wasn't going to meet anyone any way. I'd just do whatever I wanted. I didn't even want [my comics] to be printed, and I guess that helped me to loosen up." Jaime also continued to dig deeper into the work of his favorite cartoonists, such as *Archie* artist Harry Lucey, and further back chronologically into the history of comics. Not knowing exactly what he wanted to do, Hernandez decided to attend Ventura College in 1979, since enrolling in school full-time provided around three hundred dollars a month from his deceased father's social security

Three views of Maggie, 1980.

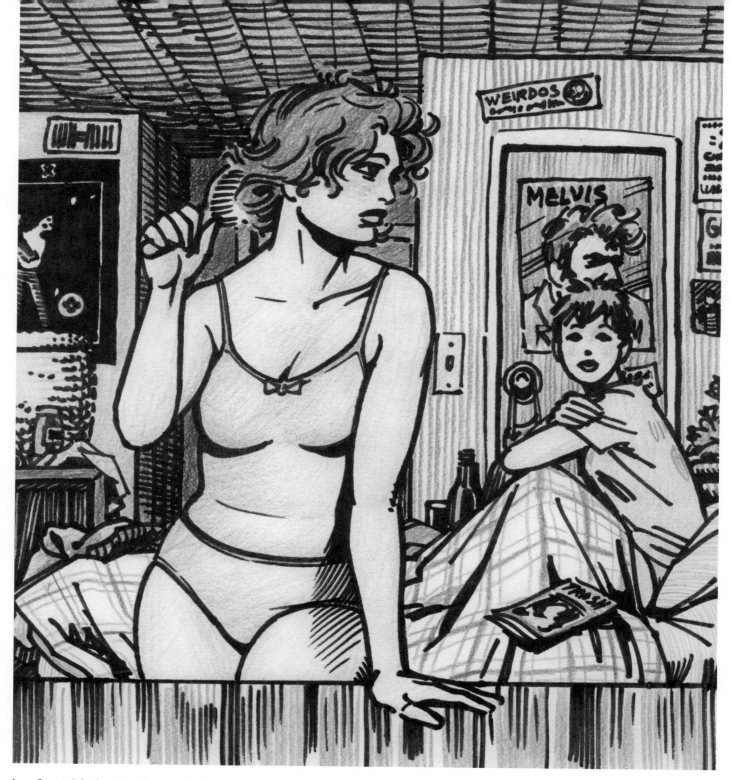

benefits. A life drawing class taught by veteran illustrator Bernard Dietz proved crucial and had a transformative effect on Jaime's art. As Gilbert recalled in an interview with *Comic Book Artist* magazine: "[Jaime] has this innate ability that very few artists have, to be able to draw really well from his subconscious. Somehow, when he went to school, it unleashed that. It's not necessarily that the school taught him how to do that, it helped him unleash it."

Figure drawing and sketching the landscape added another fundamental dimension to Jaime's art that had been previously alien to his work; the language of comics, however, was in his blood, and the act of drawing for him—from the time he knew what drawing was—always meant cartooning. His ambition to devote himself as a storyteller coincided with his expanded range, and "it got to the point that it wasn't about the fun of drawing, but just getting the idea on paper.

The way to do that was by drawing. The drawing became secondary to the idea." Cutting his chops, from 1979 to 1981 Hernandez contributed numerous charming illustrations and comics to the school newspaper, the *Ventura College Press*, that began to reveal a much greater feel for weight, design, anatomy, and "big foot" cartooning shorthand than he had exhibited prior.

Jaime's life and friends in the punk world, continued immersion in the history of comics, newfound understanding of anatomy and life drawing, and a sharpened conceptual understanding of what he wanted to achieve in his comics all pointed in the direction of *Love and Rockets*. Yet it was a future no one could have predicted.

Maggie and Hopey, 1980.
Hernandez considers this the first drawing of his two most enduring characters in their final form: "The very first Mechanics story in the first issue of *Love and Rockets* was based on this drawing."

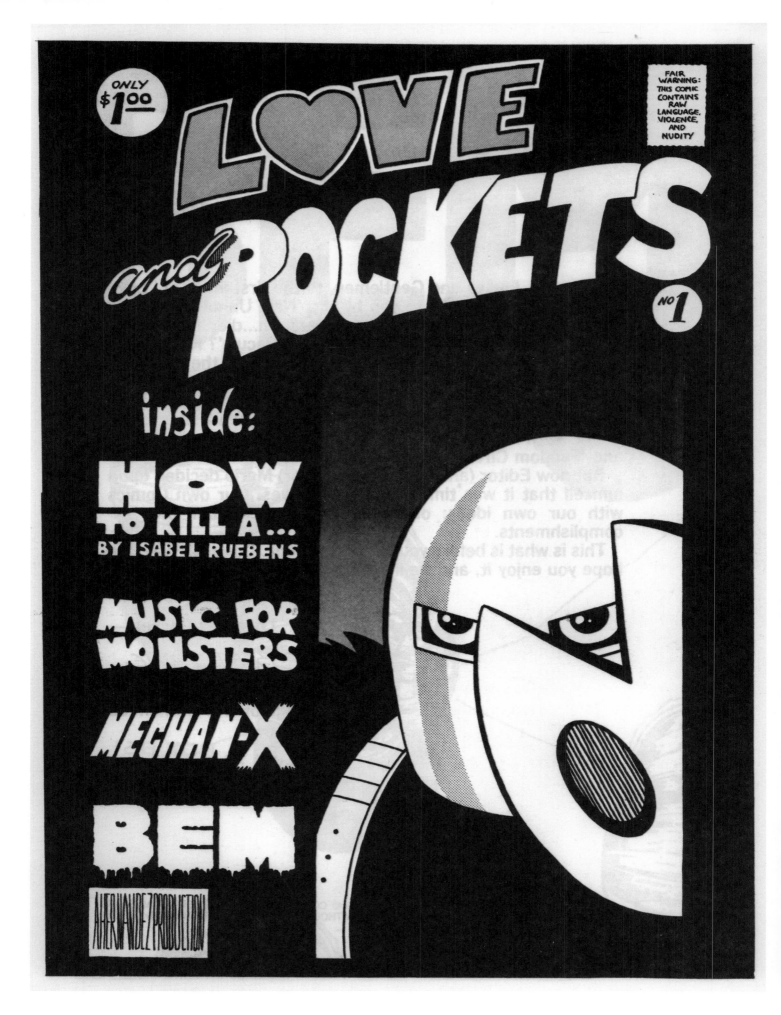

Mario, Gilbert, and Jaime Hernandez, *Love and Rockets* no. 1 (self-published, 1981). Cover by Gilbert Hernandez.

The Cartoonist of Modern Life:
Love and Rockets in the 1980s

He makes it his business to extract from fashion whatever element it may contain of poetry within history, to distil the eternal from the transitory . . . to express at once the attitude and the gesture of living beings, whether solemn or grotesque, and their luminous explosion in space.

Charles Baudelaire
"The Painter of Modern Life" (1863)

Q: *What's your goal with* Love and Rockets, *if you have one? What would you like to accomplish?*
A: I want to make a comic book that people will enjoy reading for years to come. And also another point is that I can die years from now and say that I righted a wrong. You know, if it cleaned up all the shit out of comics...
Q: *So that's your goal—to purify comics.*
A: Yeah, to just make it good, so when someone who reads comics is asked, they won't have to be ashamed. I just want to make them legitimate, not only for the comics fans in their little rooms wishing they were Wolverine or something.

Jaime Hernandez
from a 1985 interview by Kurt Sayenga

WHILE IMMERSING HIMSELF in the burgeoning punk scene, Jaime Hernandez continued to make comics for himself and submit spot illustrations to industry publications such as *The Comics Buyer's Guide* and *The Comics Journal*—which from the get-go succinctly demonstrated his tweaking of expected comic book conventions. Gilbert had been continuing along the same path. In 1981, after seeing his younger brothers continuing to develop and refine their cartooning, oldest brother Mario had the idea to actually put a sustained body of material together and publish their own comic book. Once the decision had been made, Gilbert came up with the title. As he recalls:

"I was sitting around putting words together that might sound cool, words that represented what our comics were all about. Emotion and technology were the two themes that I ended up with (after a moment of calling it 'Blue Food,' from an old George Carlin routine: 'notice there is no blue food?'). 'Robots and Romance' was the closest thing, but too genre specific. 'Love and Rockets' was a little more abstract, something people could project on what the meaning might be. 'Love': sweet emotion or a biological survival mechanism; 'Rockets': technology or a pet name for intense romantic love."

The phrase itself could not be more perfect, both as an evocative title

One of the first *Love and Rockets* promotional photos: Jaime, Mario, and Gilbert Hernandez, c. 1982. Photo by Carol Kovinick Hernandez.

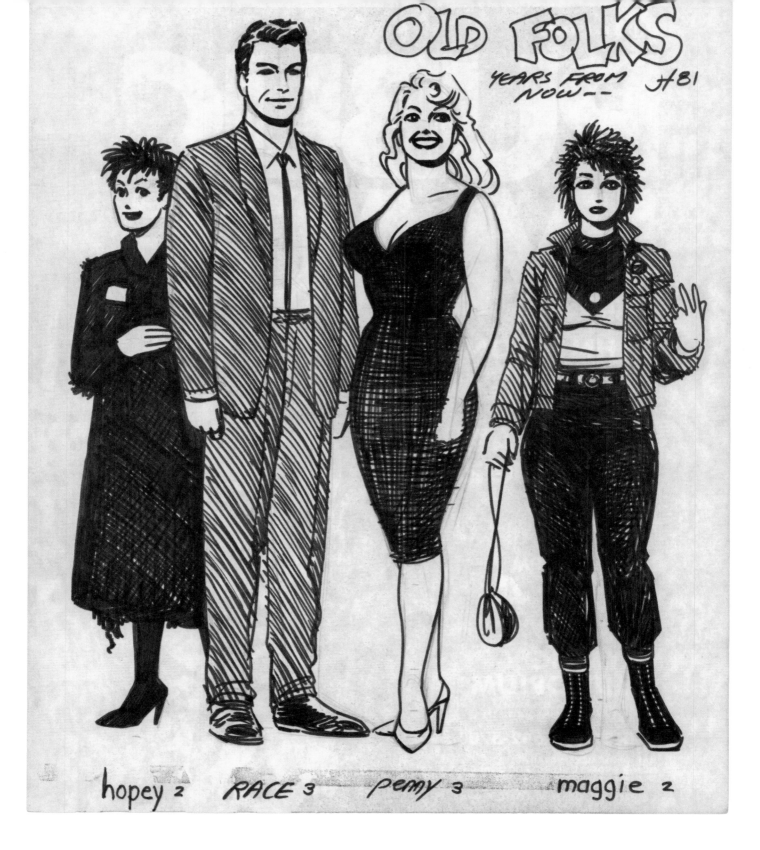

OLD FOLKS

YEARS FROM NOW -- JH 81

hopey 2 RACE 3 pemy 3 maggie 2

and as a dead-on description of the range of material the brothers were pursuing. As Jaime recalls that time: "I was working on my pages for the first issue, and at the same time Gilbert was just going bonkers with all this designing in addition to his pages. It tells the story of him to this day—he's just constantly moving." As for Jaime's contributions, Mario recalls his shock at his younger brother's remarkable advancement: "That bastard blew me away! His style had progressed light-years, from good fanzine art to something that I knew had to find an outlet and was totally original (I had always been somewhat of an amateur

scholar of the form and read everything I could get my hands on on the subject since I was a kid. So I really knew what he had)." And when Gilbert saw Jaime's stories for the first issue, the leap in ambition was also immediately evident: "When Mario came to us to start *Love and Rockets*, we knew Jaime was always a good artist, but when seeing his new stuff, it was pretty surprising. From one look I could tell here was some of the best art comic books had ever seen. I mean that in the true sense, as in communicating as art. There's lots of good art in comics but very little from a truly human standpoint. The perfect communion

"Old Folks, Years from Now," 1981.
Another example of Hernandez refining his characters at the time of the self-published *Love and Rockets* no. 1.

HERMANOS HERNANDEZ 1242 So. "H" Street, Oxnard, CA 93033 USA

of, say, Leonard Starr with R. Crumb, and nothing superficial or forced about it. Totally organic."

Under a cover by Gilbert (who signed his work " 'Bert," later "Beto"), the self-published *Love and Rockets* no. 1 was printed in an edition of approximately eight hundred. The humble, black-and-white magazine straddled the space between the fanzine culture that the brothers had been involved with for a number of years and the do-it-yourself energy born of the punk world. Their introduction spells out their approach: "We, the brothers (Jaime, 'Bert, and Mario) Hernandez, have tried to get into the comics jungle for a few years now, but could never seem to make the right connections. . . . But now Editor (and future contributor) Mario decided upon himself that it was time to do it ourselves. Our own comics with our own ideas; our own mistakes, and our own accomplishments."

The immediate feel of the comics, with their hand-ruled borders influenced by animator and cartoonist Owen Fitzgerald, was in direct opposition to mainstream fare where each task is assigned to a different person. This all seemed a given from the outset to Jaime: "Our approach was more homeschooled. Doing black-and-white comics came out of economy; it wasn't an artistic choice, really. Not till we found out it could be successful. Then color was offered, but

by then I didn't think I needed it. I got my pen and my paper, I don't need anything else—kind of using the cards I was dealt. . . . I think the Warrens also helped me with my approach to black-and-white comics. It's fun using the black to 'color' it." The world of *Love and Rockets* is perfectly rich in stark black and white: Jaime beautifully balances numerous approaches to panel composition, shadows, and expansive landscape with texture, patterning, and a variety of shading styles, from hatching and crosshatching to his trademark clean contours.

While many of the brazenly individualized characters and narrative springboards had been percolating in shorter unpublished strips and sketchbooks of his over the years, Jaime's characterizations and audacious creation of a brave new comic book world are nothing short of shocking. His two contributions to this first issue are seemingly disparate: the six-page "Mechan-X," which introduces teenage Maggie Chascarrillo and Hopey Glass (as well as Rand Race and Penny Century), and the more overtly experimental four-page "How to Kill a . . . by Isabel Ruebens," in addition to a back cover illustration of Maggie, Hopey, and Penny.

"How to Kill a . . ." introduced Isabel "Izzy" Ortiz (Ruebens was her married name) and was redrawn from an earlier fanzine piece that he'd lost. The story is much more explicitly formal in its word/

top
"Hermanos Hernandez" letterhead, c. 1982. Artwork by Jaime, Gilbert, and Mario Hernandez.

bottom
"How to Kill a . . . by Isabel Ruebens" splash page detail, *Love and Rockets* no. 1 (self-published, 1981).

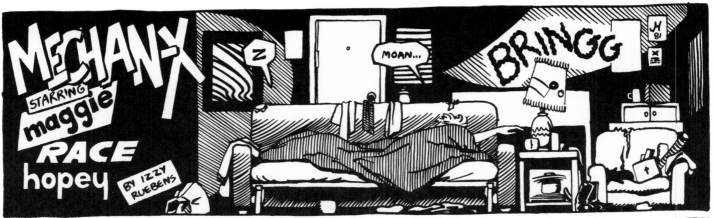

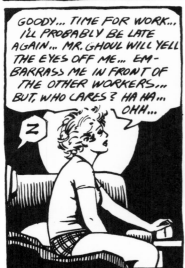

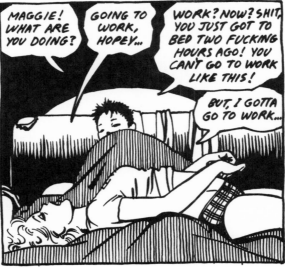

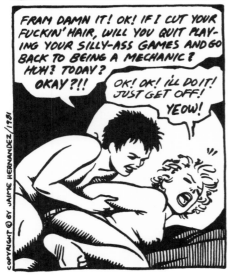

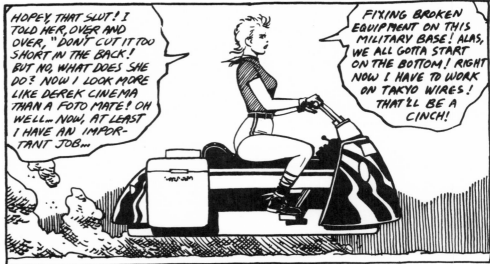

74

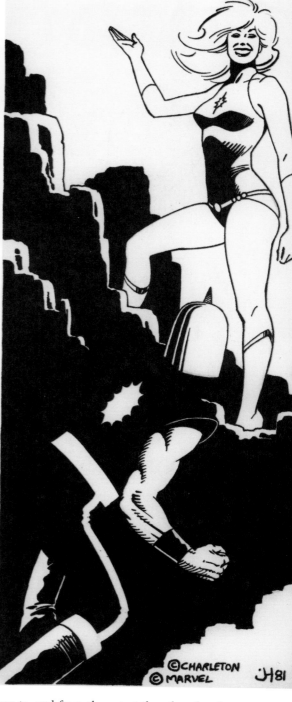

image relationship than in his subsequent work, and it was the images (such as the house leaning on a cliff in the first panel, taken from an old Bugs Bunny cartoon) that began to define Izzy as a character for him. The elliptical visual language he employs here, which straddles psychological and physical space, is typical in his handling of her throughout the series.

"Mechan-X" employed certain genre trappings—Maggie was a Mexican-American mechanic prodigy working in the science-fiction-tinged world of the "Prosolar Mechanics"—but the focus is on the tangled, intertwining lives of Maggie and Hopey, and their wide-ranging and interconnected stories of joy and heartbreak, which would define Jaime's work for the next twenty-five years. Hernandez has said on many occasions that Maggie and Hopey are his Betty and Veronica (or Batman and Robin), and his stories are intentionally never "high concept," but instead about people and how they live. Both Gilbert and Jaime were always impressed by comics continuity and aging characters

whom readers could return to, and from the outset they thought of their comics as enduring. Not surprisingly, Maggie was brewing for many years before her first published appearance:

When I was young, all my characters were still white. Maggie was "Maggie Chase." Around the punk days, we just started thinking, "What are we doing? We should be doing stories about ourselves." When we were kids, we all had our own comics and sets of characters. My younger brother Ismael had a set of kids he used, sort of his own *Peanuts*, but he was too young to understand how it was supposed to go, so it was goofy, like all of our stuff. This was the one comic that all the members of our family drew issues of—me, Gilbert, Mario, Richard, maybe my sister. It was called "Johnny," and was sort of a staple in our household. We gradually stopped, though Ismael would occasionally still do one. When Ismael and I started hanging out with the lowrider guys and were a part of that world, we saw a lot of violence and shit going down. He decided to do another "Johnny"

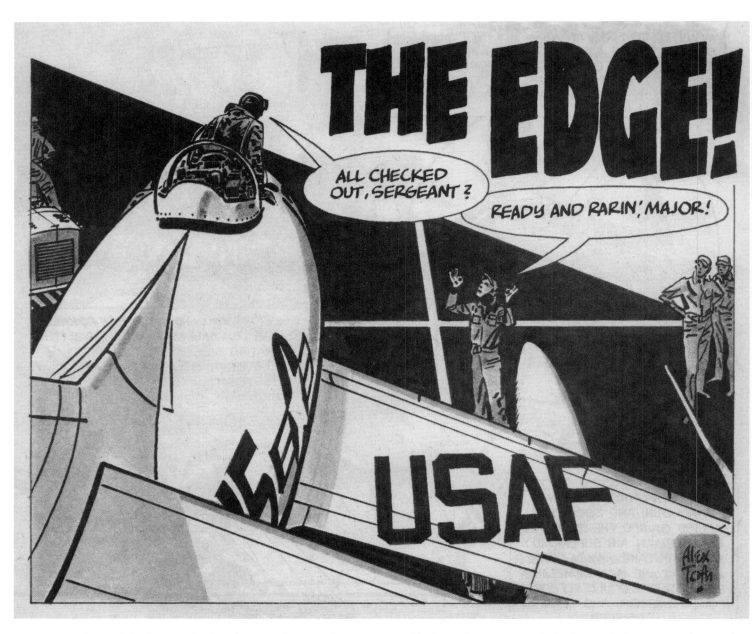

comic and turn all the characters into homeboys—the language, the situations. I remember Gilbert and me thinking it was the funniest thing, but also feeling like: "This is our world—not that other stuff. What are we doing?" It was conscious for me, then: "Wait a minute. Maggie's a Mexican girl." And punk happened right when I was growing into an adult, so this questioning and the importance of knowing other cultures was happening right alongside. What was interesting about punk when we got into it, was that it was PC for us. It's hard to think that now, since it's gone so many directions, turning homophobic and sexist, this and that, but for us in the late seventies, punk was being politically correct. You were breaking down that shit. Though it eventually turned out to be escaping just like everything else, punk to me was finding the truth. When the time came to do the comic, my idea was "Now it's time to straighten people out here." It was kind of our mission.

Influences are naturally more overt at this time than they would be a scant few years later (see the Moebius-like hatching in the clouds throughout "Mechan-X"), and while still a little schizophrenic, the gestalt of Jaime's strips was entirely his own—immediately, and amazingly, for such a young cartoonist, his voice was preternaturally assured. By the time they had arrived, both Jaime and Gilbert intuitively understood the limitations of the vast majority of comics—which couldn't contain their stories. As the explosively deconstructionist undergrounds demonstrated (and as pioneered in the Harvey Kurtzman–edited 1950s issues of *MAD*), comics are an inherently self-reflexive medium. So for an artist as immersed in the form as Hernandez, he used any and all commercial and artistic genres—romance, science-fiction, super-hero, "real-life" character types—in these early comics, and quickly transcended all at once, reconfiguring them to create an expansively poetic inner reality. Jaime's stories were a combination of his newly exhilarating life and the popular culture loves of his childhood, all roiling around in his mind; everything sensibly fits together in the surprisingly seamless world in which Maggie resides. But as Jaime recalls, they created the comic because there was no other venue where all of these things coexisted: "Not even punk could cover everything. When I'd talk with someone at a punk show who was into comics, it was still just like comic book people who didn't get where I was coming from; punk people didn't get it either. So I could take the joy of punk, but I still had to create this thing myself. It became narrowed down to this world where only Gilbert and I understood. Not even Mario understood after a while, because he was married and leading a civilized life."

above
Alex Toth, "The Edge," splash page detail, *Blazing Combat* no. 4 (Warren, 1966).
Alex Toth's bold approach to designing a black-and-white comic page had a lasting impact on Hernandez's work.

opposite
Fantagraphics advertisement for the expanded *Love and Rockets* no. 1, 1982. Artwork by Jaime and Gilbert Hernandez.

NOT YOUR AVERAGE BUNCH OF COMIC BOOK HEROES...

MEET THEM IN

LOVE & ROCKETS #1

68 Pages of Way-Out Fantasy from Los Bros. Hernandez!

The brothers shopped around copies of the first issue at conventions and consigned a handful to their local comics shop in Ventura. Soon after they had the issue in hand from the printer, Gilbert decided to mail a copy to Gary Groth, editor of *The Comics Journal*, hoping for a review in the notoriously critical magazine. Groth quickly replied with a letter—according to Gilbert, "very polite and uncharacteristic of what I thought Gary might be like"—asking if the brothers would like Fantagraphics to publish the comic, to which they quickly agreed. As Jaime recalls Groth's reputation at the time: "I didn't know his background, I only knew he was the mean guy in comics, and I liked that. It was like *Creem* magazine . . . or punk—that snottiness. When

I went to meet him, I thought he'd be some punk guy, so I was a little surprised that he was so removed from my world."

Groth had begun publishing and writing for fanzines as a teenager in the late 1960s, and in 1976 he took over the fan publication *The Nostalgia Journal* and transformed it into *The Comics Journal*, which future Fantagraphics co-publisher Kim Thompson would join in 1977. Both Jaime and Gilbert had spot illustrations published in the magazine over the years, so while Groth was familiar with their humorous takes on super heroes, the first issue of *Love and Rockets* was a bombshell. Reviewing it in *The Comics Journal*, he summed up his response: "I wasn't prepared for the literate, witty humor and carefully crafted

Original artwork for the cover of *The Comics Journal* no. 80, 1982.
"At first they wanted a super-hero guy, then when they got it said, 'Not your best stuff. Why don't you make it some kick-ass monster?' So I made a photocopy, cut

out the super-hero guy, and drew in the monster. It ended up being printed two inches high on the cover. And they always held it against me, saying, 'When you do work for other people, you don't do it as well.'"

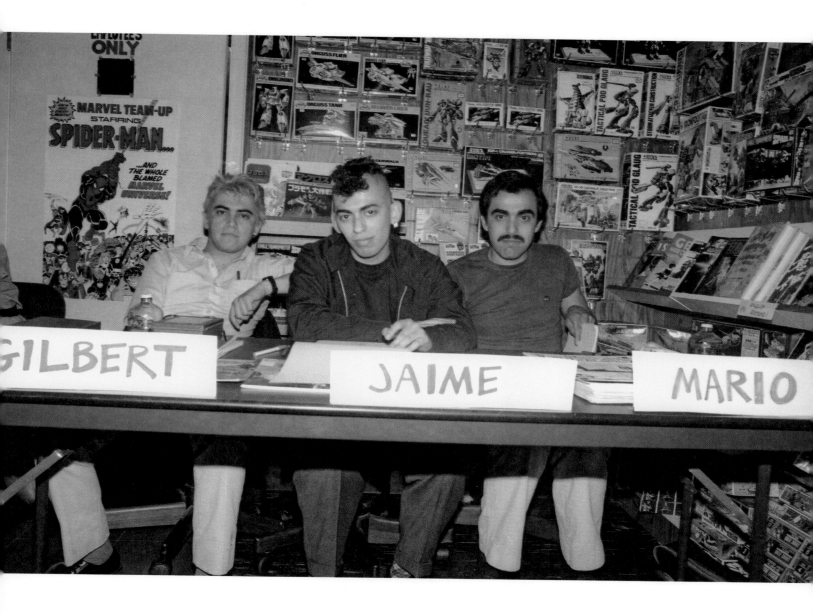

eidetic style. There are three very important elements that separate this fine, 'amateur' effort from the galloping mediocrity littering the comics stands these days. First, *Love and Rockets* is the work of genuine imagination; a very individual, idiosyncratic, and energetic imagination. Second, both Jaime and 'Bert deal with ideas, *not* pretentious nonsense or regurgitated pulp trappings. Finally, they've got the technical wherewithal that's always the necessary complement to the imagination." Groth goes on to rightly designate the importance of Jaime's dialogue rather than story construction in his early efforts, feelings he expands on and more fully articulates in his introductory remarks that ran in the first two Fantagraphics-published issues (titled "Comics Can Be Art and Here Are Some of the Reasons Why").

By the late seventies, the original and second wave of underground cartoonists were published more and more infrequently, and the climate seemed fairly barren after the 1976 demise of the Art Spiegelman and Bill Griffith–edited anthology *Arcade*. Two publications that continued to expand on the underground's promise of artistic invention were the anthologies *Raw* (which began in 1980), edited by Spiegelman and Françoise Mouly, and *Weirdo* (from 1981), edited by legendary cartoonist Robert Crumb (who also contributed covers and new strips). While united in their quest for comics well beyond

mainstream notions, the two publications staked out oppositional views surrounding the medium's cultural position; *Raw* was self-consciously avant-garde in content and presentation, while *Weirdo* reveled in the illicit trashiness and outsider status of the medium's history. Hernandez was (and is) a fan of a number of the cartoonists featured in both publications—notably Crumb and *Raw* mainstay Charles Burns—but when conceiving his *Love and Rockets* universe, which had been coagulating in sketchbooks, assorted drawings, and short strips, contemporary comics "had no effect on me. We just wanted to do a comic. We weren't competing with anyone. The only thing we reacted to was what we thought was dumb about comics."

The underground's "art for art's sake" motto was far more relevant to what the Hernandez brothers were seeking in their stories, but *Love and Rockets*' specific moment was seen as part of a wider "independent" boom. Concurrent with the rise of comics specialty shops, small publishers such as Pacific Comics and First Comics sprang up in 1981 and 1982, respectively. And while most of their fare was along the lines of the seventies "ground-level" comics, by offering creator-owned titles they did attract some of the most talented writer/artists, including industry veterans Steve Ditko (the first of his Missing Man stories appeared in *Pacific Presents* no. 1 in 1982) and Jack Kirby (whose

Gilbert, Jaime, and Mario signing at Comics & Comix, Berkeley, 1984. Photo by Clay Geerdes.
This same trip featured the Hernandez brothers' first appearance as convention guests at the Petunia Con (organized by Dave Sim as a *Cerebus* gathering) in Oakland, and Jaime meeting Robert Crumb for the first time at Crumb's home in Davis, California.

DEAR HOPEY AND GANG,

ALOHA! OR AS THEY SAY HERE IN FUNNY, SUNNY, RIO FRIO... KAMANA-WANALEYA! MAN, THEY SURE DON'T WASTE TIME HERE, I TELL YA. ONCE YOU STEP OFF THE PLANE, ≧ CACHOING ≧ YOU'RE ENGAGED OR SOMETHING. BUT YOU DON'T HAVE TO WORRY ABOUT THIS ONE, JACK. I'VE GOT MY EYE ON SOMETHING A LITTLE CLOSER TO HOME, AND HIS INITIALS ARE RANDALL RACE. TELL PENNY I KNOW THAT HE'S JUST A MACHO CREEP AND I JUST LIKE HIM BECAUSE HE'S A PROSOLAR MECHANIC. WELL, MAYBE, MAYBE NOT. WE SHALL SOON SEE.

ANYWAY, THIS JOB WE'RE ON CALLS FOR ONLY TWO MECHANICS. A PRO MECH AND (KAFF KAFF) HIS ASSISTANT. THAT'S RIGHT, BOYS AND GIRLS. IT'S JUST RACE AND I LET LOOSE IN THIS STRANGE, STRANGE, EXOTIC LAND. OH, HOW WILL WE EVER MANAGE?

WELL, TO TELL YOU THE TRUTH I HAVEN'T REALLY SEEN MUCH OF THE STUD SINCE WE GOT HERE. HE'S BEEN OFF TALKING JOB (AS USUAL), SO I'VE JUST BEEN HANGING AROUND THE BEACH GETTING FAT LIKE ALL THE OTHER LAME TOURISTS. BUT, MY TIME SHALL COME, BABY.

LOVE YOU,
MAGGIE

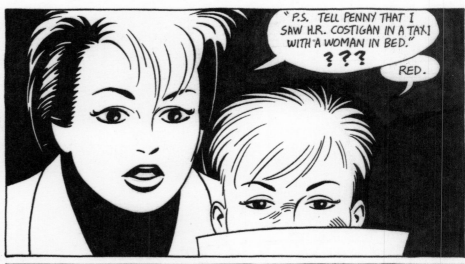

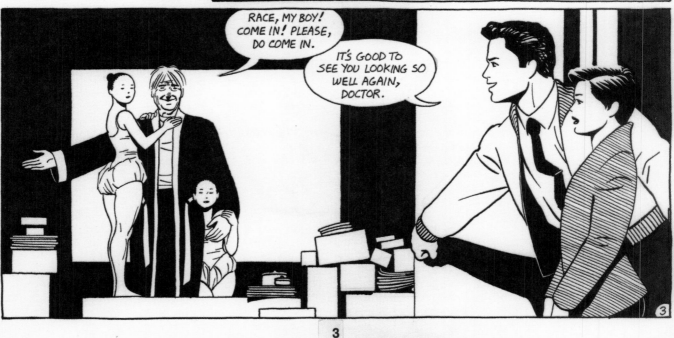

Original artwork for "Mechanics (Part Two)," page 3,
Love and Rockets no. 7, 1984.
"I was still telling parts of the story through Maggie's letters, a device which kind of died away after awhile."

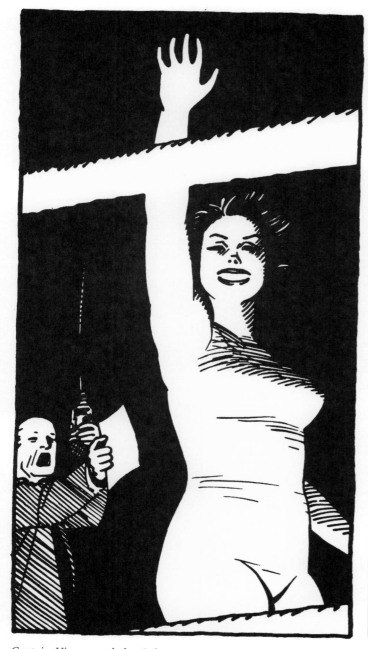

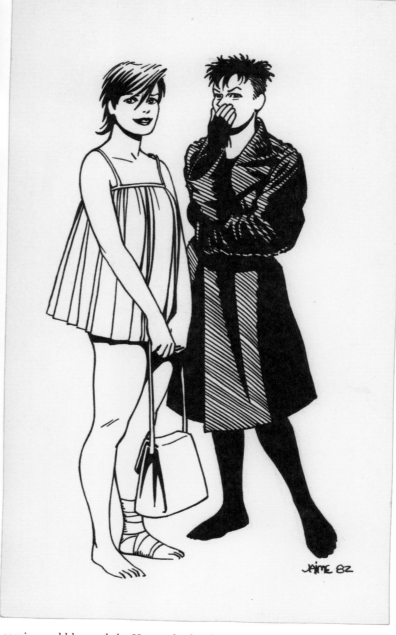

Captain Victory and the Galactic Rangers, which was published by Pacific from 1981 to 1984, and *Silver Star*, from 1983 to 1984, turned out to be his last significant projects). Most of the comics by the burgeoning independent publishers offered little more than a slightly personalized twist on mainstream genre formulas, but they at least provided a bit of diversity; following the small publisher's lead, Marvel and DC began designating "direct sales only" titles in the early 1980s in an attempt to keep up with the changing zeitgeist of the comic shop culture.

At the time Groth received the first issue of *Love and Rockets*, Fantagraphics had only published a few comics, none of which indicated a firm direction forward within the transitional landscape of the time. Groth and the Hernandez brothers came from a fan culture armed with an awareness of high-water marks in comics history, and each strove to elevate the medium. The timing was perfect, and their shared sensibility made for an ideal fit, providing the young publisher a title that reflected *The Comics Journal*'s goal of advancing the critical discourse caround the form (while it lambasted the vast majority of genre dreck). *Love and Rockets* was the manifestation of what Groth felt

comics could be, and the Hernandez brothers were in turn provided with an immediate intellectual context for their work, which truly had no context.

After it was agreed that Fantagraphics would publish the comic, Groth asked Gilbert and Jaime to double the page count and come up with a new cover, and the fleshed-out *Love and Rockets* no. 1 was published in 1982. While Groth was listed first as editorial coordinator, then subsequently as editor, there was very little actual content editing going on; rather he provided a guiding force (a defining distinction for Hernandez between *Love and Rockets* and work for other publishers that he has done over the years). As Jaime describes it: "[Gary] told us what he liked and thought worked. His response was pretty much, 'All right, this is great, let's do it.'" Groth wanted the comic to remain in magazine format in order to immediately stand out from the masses of generic comic books: "People warned us, it won't fit in comic boxes or on the racks, and that kind of excited us. At the same time, we just wanted our share, to be in there with the rest of the comics. We didn't want to kill them, we just wanted to be in there."

left
Rena Titañon, from "Mechanics," page 15, detail, *Love and Rockets* no. 2 (Fantagraphics Books, 1983).

right
Unpublished ink drawing of Maggie and Hopey, 1982.

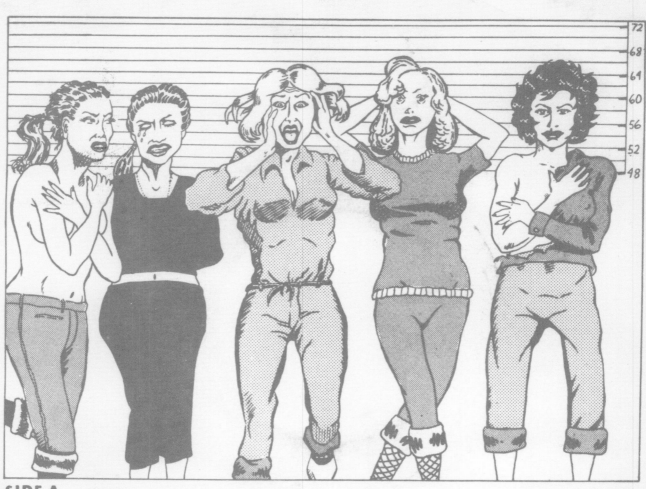

SIDE A
NERVOUS BREAKDOWN
SIDE B
FIX ME
I'VE HAD IT
WASTED

Recorded at Media Art Studio, Hermosa Beach, Calif. Jan. 1978.
Engineer---Dave Tarling
Produced by BLACK FLAG
For a copy of "Captive Chains" comic book, by our artist Raymond Pettibone, send $1.50 (postpaid) to SST Publications, P.O. Box 1, Lawndale, Calif. 90260
Mailing List---SST Records, P.O. Box 1, Lawndale, Calif. 90260

Jaime drew the cover for the new edition of no. 1, which was inspired by LA artist Raymond Pettibon's back cover for Black Flag's *Nervous Breakdown* 7" EP from 1978. As Hernandez recalls his concept:

When we were trying to get ideas for the cover layout, we thought "Let's do an image where we have everything in one cover." I don't know if it was me or Gilbert who said, "Let's do it as a lineup like that one [Pettibon] drawing, and we'll put all the aspects in there: the super hero, the barbarian, science-fiction, and then we'll have this normal lady in her curlers." We were just thinking of irony and contradiction, we were not

thinking about this as the future direction. I was just thinking that this represents the range of what we were doing, and the lady in the robe is the ironic aspect. The kind of cute, punk joke: "You think you know what you're getting, but we're going to give you something else." At the time I was drawing it I was very interested in putting normal things in fantastic settings, so I made one woman smoking; the postures showed that they were real people underneath these fake images.

The cover wound up as nothing less than a manifesto for the entire series, encapsulating a history of character types and alter egos while

Black Flag, *Nervous Breakdown* EP, back cover (SST, 1978). Artwork by Raymond Pettibon.
Pettibon's police lineup inspired Hernandez to use the motif for several of his most powerful covers, beginning with the expanded version of *Love and Rockets* no. 1, opposite.

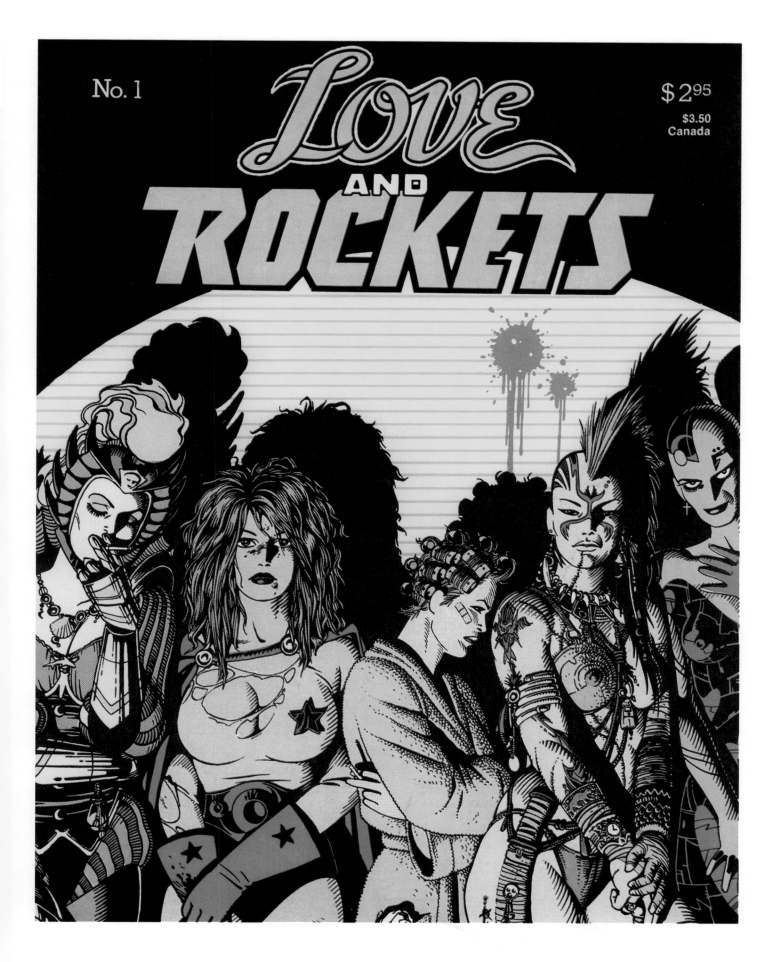

Hernandez's cover for the expanded *Love and Rockets* no. 1 (Fantagraphics Books, 1982).

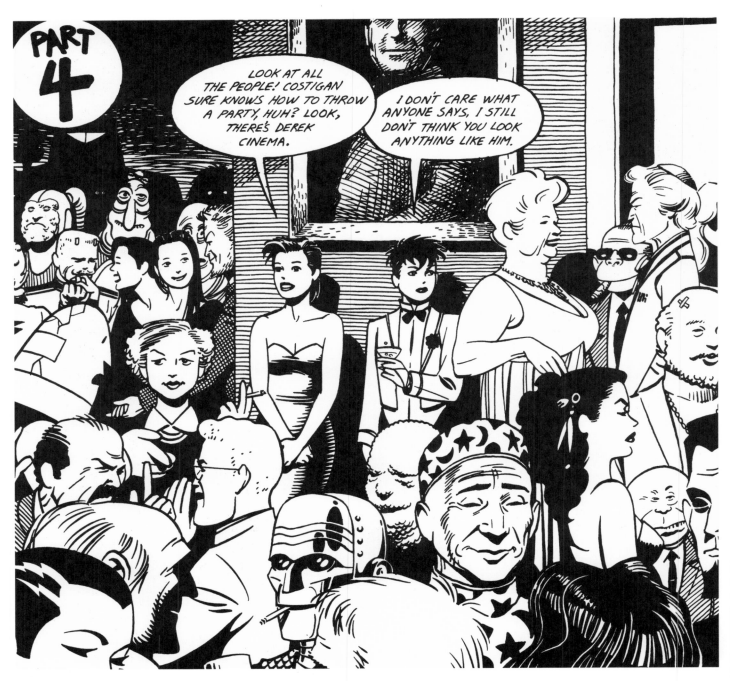

jumbling them all. Fantagraphics realized the comic needed a color cover to sell (and presumably a professional logo, which Groth hired veteran comics letterer Todd Klein to design). Jaime provided a color guide for the cover, but the final result wound up as an introduction to the necessarily collaborative nature of publishing, as it "came back this atrocity. I hated it so much. It was sloppy; the person who colored it wasn't very well trained. I drew the woman smoking as a black woman—I wanted to show right away this was an ethnic book. It was important for me to show that it was racially mixed right from the start, to show the world what kind of comic this is. And they made her yellow, like a fish woman! I realized what sort of things I now had to deal with and learned I had to stay on top of things." (The error was subsequently corrected in the third printing.)

The early issues of *Love and Rockets* alternated frequency and page count in an attempt to most effectively serve and enhance the readership of the title, a demographic that was truly being invented along with the comic. According to Kim Thompson, the early print runs were at most four thousand copies (though the early issues would be reprinted and repackaged as book collections numerous times over the years): "It started off as a sixty-four-page magazine which we thought we'd get out every half year or so. After four issues we changed to the thirty-two-page format (as I recall, retailers militated for cheaper and more frequent), which we stuck with for the rest of the run—it was advertised as 'bi-monthly,' but that turned out to be a pipe dream: It became basically 'as fast as they can draw it,' which ended up around two or three, sometimes four, issues a year."

In this initial burst of creativity, the early issues are immediately refreshing in their heft and the fact that the production, while nicely done, is decidedly no-frills. In contrast to today's lavish packages, the focus is always on the meat of the matter—the stories. This was a conscious decision, as Jaime states: "About a year or two before, Gilbert and I had the idea that 'Wouldn't it be cool to put out a five-

"Locas Tambien: 100 Rooms," page 17, detail, *Love and Rockets* no. 4 (Fantagraphics Books, 1983).

Love and Rockets no. 2 (Fantagraphics Books, 1983).

hundred-page comic, with just comics from page one till the very end with nothing else in there?' Funny comics, serious comics, everything. Of course we thought it'd be impossible to do, but having the early issues so full of comics probably comes from that idea. So it was a little tricky when they'd try to dress us up; that was something I'd never concentrated on, which had to do with punk as well. I only got into thinking about the production end later when it became a financial thing—we better make this a nice package if we're going to sell it. I was forced to think that way. In the early days, Fantagraphics didn't think a lot about that stuff either. It was a learning experience for all of us."

Jaime, Mario, and Gilbert Hernandez, 1984. Photo by Carol Kovinick Hernandez.

Mario, the principal organizer, had two stories in the first few issues, but quickly bowed out, leaving the younger brothers to concentrate on their solo work, which was increasingly impressive to him. While displaying their comics roots by burning through various genre landscapes, both Jaime and Gilbert realized a firm groundwork early on, interweaving stories centered around a handful of attractive female characters. Gilbert moved quickly toward politically infused stories surrounding the fictional Central American village Palomar, specifically avoiding the topical punk stories of Jaime's world.

The brothers, for the most part, read the work of the other only upon

Love and Rockets no. 4 (Fantagraphics Books,
1983). Cover art by Jaime and Gilbert Hernandez.

completion, but their ingrained sensibilities symbiotically fed and played off each other, including on a practical level, as they'd trade off page counts. In the first issue, Gilbert had a forty-page epic, so Jaime asked to have forty pages in the second issue, which became the lengthy "Mechanics." Of their working relationship, Gilbert explains, "I simply tried to keep up with my half of the book because, rightly so, Jaime's work got such good response for both his great drawing skill but also his honesty with his characters. I would look pretty weak just doing another version of what was already there, even though I would have done it closer to the Palomar stories, except with hot punk chicks in

America instead. Nonetheless, it wasn't necessary." Jaime recalls, "the only time I consciously thought about it was when he really started taking off and doing serious work—I thought, 'Oh my god, I better step it up,' 'cause he was obviously really serious. But at the same time, he was the big brother, so I expected that. A lot of times, I was just following along."

Most of Jaime's early stories center around adventures: "Mechanics" (1982–83), "100 Rooms" (1983), and "Las Mujeres Perdidas" ("The Lost Women," 1984–85) follow Maggie through a journey in which her personality begins to be defined, gender roles are upended, and

"Mechanics," page 37, detail, *Love and Rockets*
no. 2, (Fantagraphics Books, 1983).

"TOROMBOLO IS THEIR GOD OF HOPE. THE LEGEND SAYS THAT A THOUSAND YEARS AGO, HE CAME DOWN TO RID THE LAND OF ALL BAD THINGS GOING ON, AND IF HE EVER HAD TO COME BACK, THEY WOULD SURELY PERISH. SO THEY THOUGHT YOU WERE HIM RETURNING TO WASTE THEM."

FLEE, MORTALS! FOR I AM TOROMBOLO!

realistic characters intermingle with cartoon archetypes. From the beginning, Jaime's stories tweak and humanize these stock character types, thus deepening an entire history of popular culture "throwaway" entertainment, fusing text and subtext. In all of these stories the "adventure," which entertainingly frames and moves the narrative, also serves to place the characters in unfamiliar situations, thus challenging ingrained preconceptions and an entire world of received wisdom, both in comics and otherwise. "That was a conscious thing in the comics: to change the rules for the better. It can be fun and honest at the same time." Beauty, truth, and art are found all over the map, and "Mechanics" includes homages to the two pioneering Silver Age super hero greats: Steve Ditko, by way of some machinery borrowed from the cover of *The Amazing Spider-Man* no. 33 (February 1966), and Jack Kirby, via a fearsome god Torombolo (Kirby is also referenced in the form of the galactic villain Maniakk in another early story, "Maggie vs. Maniakk," 1982–83).

"The early comics were done mostly as I went along. I was still coming off that idea that I wanted to do comics where there were a million things going on in the background, but as I was doing the first stories, I got so into doing the characters that they just gradually took over. Pretty soon, doing the characters was so important that I lost interest in any of that; eventually all the backdrop stuff just disappeared." This transition began to take place virtually from the get-go, as the characters' lives in the foreground and the super heroes in the background began to separate. The early single-page "Penny Century, You're Fired" (1981) contrasts Penny's daydreams about being a super hero with the reality of her assembly-line job, and demonstrates a distancing from the conventions of comics, as the fantasy elements shift back and forth between the physical world and characters' heads. A large panel near the close of "Mechanics" spells out the conversion: as Maggie and crew escape an imploding, sinking island, Penny exclaims, "Wow, that's the stuff comics are made of!" signaling that the cacophonous world will be gradually left behind as an overt component, though it will linger on as an informing sensibility.

The Jack Kirby–inspired Torombolo: "Mechanics," page 27, detail, *Love and Rockets* no. 2, (Fantagraphics Books, 1983). "Torombolo was the name of Jughead Jones in the Mexican version of *Archie* comics."

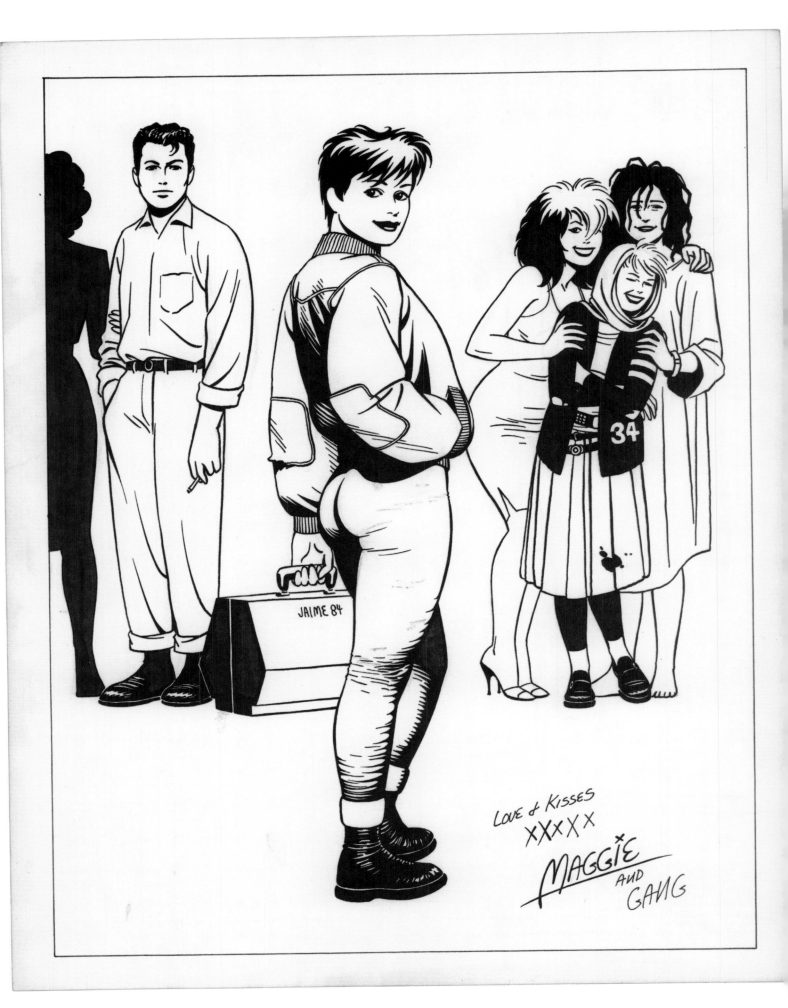

Original artwork for unpublished pin-up of Maggie and friends, 1984.

Maggie, Hopey, and the Gang

WHAT TRULY MADE Jaime Hernandez's comics stand head and shoulders above those of his contemporaries was the characterization—the truth and humanity found not only in his dialogue, but in his cartoonist's eye for detail. Hernandez's decision to focus on making his two most fundamental characters, Maggie and Hopey, as well rounded as possible once again came from the fact that Gilbert's strengths were so apparent early on that Jaime realized he had to find his own:

Ever since I was a little kid doing comics, my limitations were always screaming at me. I could always see both the limitations and things I was

good at side by side, so when I was drawing something, I always knew that what I was seeing in my head was better than what was coming out of my pencil. When *Love and Rockets* came out, Gilbert seemed to know where he was going and I didn't. I liked the idea that he wanted to get serious—it seemed important and very much worth pursuing. I'm not a very educated person; I can't think in certain terms, so I just decided right then to concentrate my work on what I was good at. It's almost like all my work is disguising my limitations to make it look like I knew what I was doing all along. I guess I paid attention to my strengths: My first wife, Coco [Shinomiya], once told me, "You're a good judge of character, you can tell

Love and Rockets no. 39 (Fantagraphics Books, 1992).

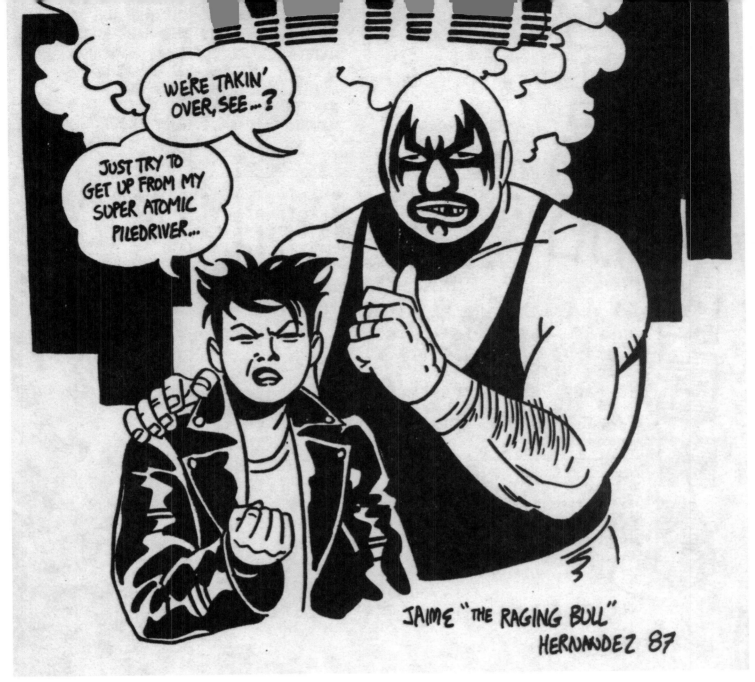

JAIME "THE RAGING BULL" HERNANDEZ 87

what people are like," so I concentrated on that. I took it upon myself to observe people, without scrutinizing or watching, but noticing how people were, whether or not they were honest. I made those things a point in my comics.

Though Hopey and Maggie are best friends, their personalities are, from the beginning, set up as virtual contrasts: Maggie's life is dominated by perpetual introspection and doubt—she is virtually the only character who has a constantly running internal monologue—and Hopey is in constant action. Such strong oppositional definitions slip as their stories grow and expand, as Hernandez has masterfully delineated the quirks, temperaments, and unpredictability in their on-again–off-again relationship, in which the play of image and dialogue is crucial. His emphasis on storytelling through dialogue was formed early on:

> It wasn't so much a conscious thing to pursue; I've just always appreciated good dialogue. I always loved *Alice in Wonderland* for the characters' dialogue, and the same thing goes for those *Dennis the Menace* comics. I loved that Dennis and Joey were just walking and talking about something. That was so wonderful; they're not doing anything else, not out to get a

villain, not out to find out something, they're just there, talking. Nothing else is going on and that's the greatest thing. This goes back to a comic Gilbert did as a kid called *Fantastic Tales*, which was sort of a *Weird Fantasy* kind of comic. He did a story called "Mars," where two astronauts land on Mars—one guy leaves and a Martian takes over his body, and when they go back to Earth the guy eventually confesses he's a Martian. I was so amazed that you find this out in a scene where the two guys are just sitting in a room, exchanging dialogue. Even though it was in this kid's corny voice, that just turned me around completely.

As a teenager, Jaime redrew this instructive comic of Gilbert's and remembers spending a huge amount of time working out the details to make sure all the ways of visually heightening the dialogue—the understated gestures, spatial relationships between figures, angles, and lighting—were perfect. Thinking about these subtleties "was just a revelation to me. I remember thinking 'God, I love doing this!' I didn't know it till twenty years later, but all this led to *Love and Rockets*. That's where it all came from."

Nearly as much a fan of movies as comics, dialogue in that medium was equally important to Jaime, and was the reason that *To Kill a Mockingbird* is a favorite: "I saw the movie a million times, just

Cover for Hollywood Book and Poster newsletter, 1987.

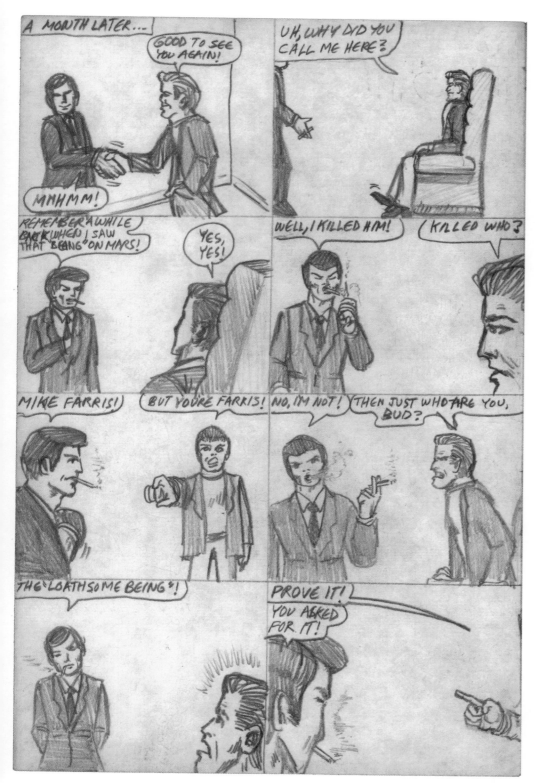

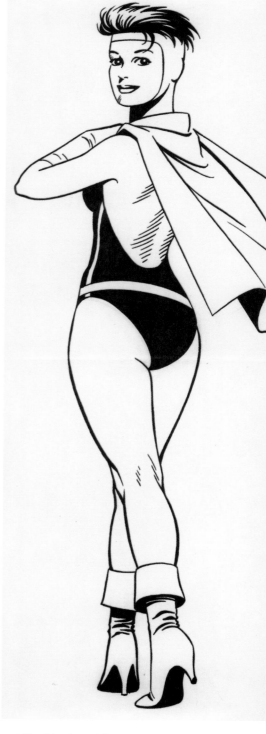

because I loved to hear them talk back and forth; I'd get very excited." What Hernandez accomplished immediately in his comics was the application of varied shorthand cartooning skills (found in the work of classic commercial masters from Charles Schulz to Alex Toth) to further model the emotional range of his reality-based characters. The reader comes to know his cast as they would friends, through spoken dialogue, quirks, facial expressions, and through what is said about them by other people. Thought balloons are rarely used, and narrating captions are even rarer. In Jaime's comics, "research" comes pretty much exclusively from his day-to-day life—if not from direct observation, then from stories told by friends and family ("having me do reference is like pulling teeth").

The perpetual question Jaime gets asked about his work is how he is so deftly able to capture his female characters. And the answer is that he doesn't know. His approach to character comes from creating an internalized emotional core from which dialogue results, not by listening to and repeating conversations.

Hernandez has stated many times that he puts the most of himself into Mexican-American Maggie, and from the beginning he knew less about Hopey, as she sprang from all the young women he'd see from

above left
Page for the story "Mars," from Hernandez's homemade comic *Fantastic Tales* no. 3, early-1970s. This is Jaime's new version of an earlier comic by Gilbert, which had a big impact on Jaime's love of dialogue.

above right
Original artwork for unpublished pin-up: Maggie as Go-Go Girl, c. 1982.

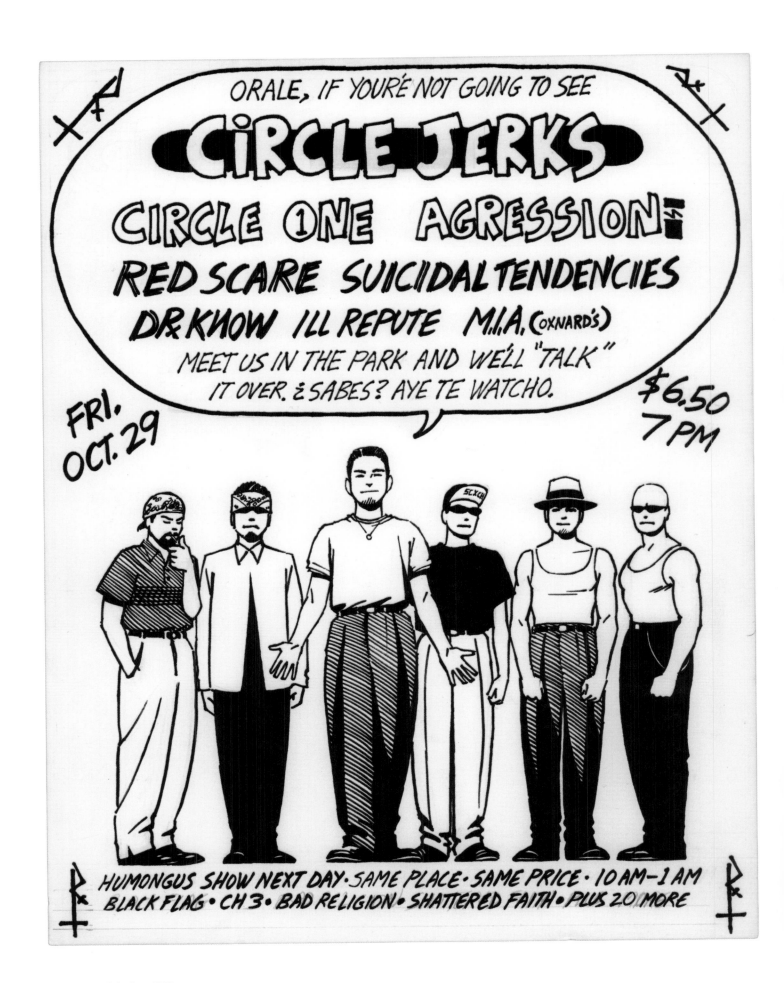

Original artwork for flyer, 1982.
"Sometimes my brother Ismael would commission
me to do these. He always tried to keep a socially
conscious attitude since hardcore punk by that time
had become very right-wing and homophobic."

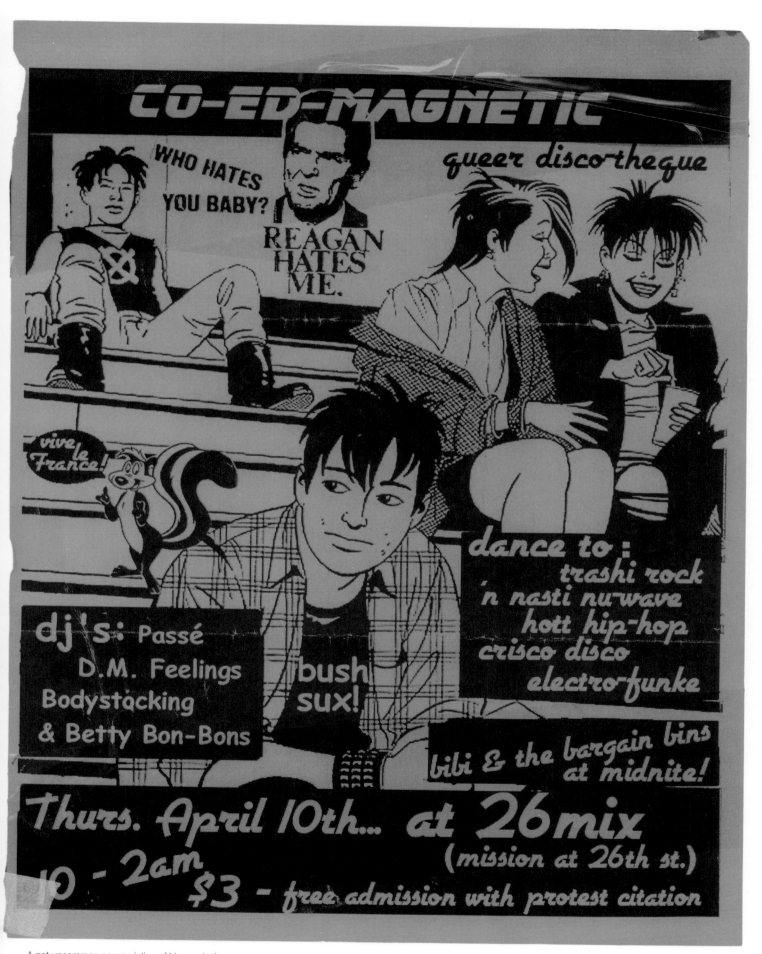

A not uncommon appropriation of Hernandez's
artwork for a flyer; the source is a *Love and Rockets*
calendar image, c. 1989.

afar at punk shows (including Jane Wiedlin from the Go-Go's) as well as his friends in the scene, in particular Meg Bradbury, whom Hernandez eventually married in 2001. Bradbury recalls how Hernandez captured their life in the early eighties:

> I love the way, for example, Jaime's X-ray eyes saw how we used to be with one another, us punk girls. We were hands on, silly, reckless, and fell in and out of love with each other every day. Not necessarily sexually (and actually, in my generation of Los Angeles punk, it was almost dangerous to be out of the closet), but more spiritually. The ways you see Maggie and Hopey and all the girls running around in clubs, holding hands, sitting on each other's laps, flipping off the cops, sitting outside on the curb at 4 AM, dancing and singing, drinking quarts of malt liquor with straws (gets you drunk faster!), panhandling for cigarette money, living in bedroom closets, digging through the trash at Oki Dog for dinner, piercing each other's noses, fucking each other's boyfriends, and sticking your fingers down your best friend's throat to help them throw up that entire fifth of vodka? That all happened, and that was our every day. Jaime got not only the look and the attitude, but he somehow captured and still captures the feeling. Impeccably.

above left
Jaime and Gilbert Hernandez's band the Beer Guts, c. 1983. Photo by Carol Kovinick Hernandez.
"All dressed up and nowhere to go."

above right
Original unpublished artwork of Maggie, 1984.

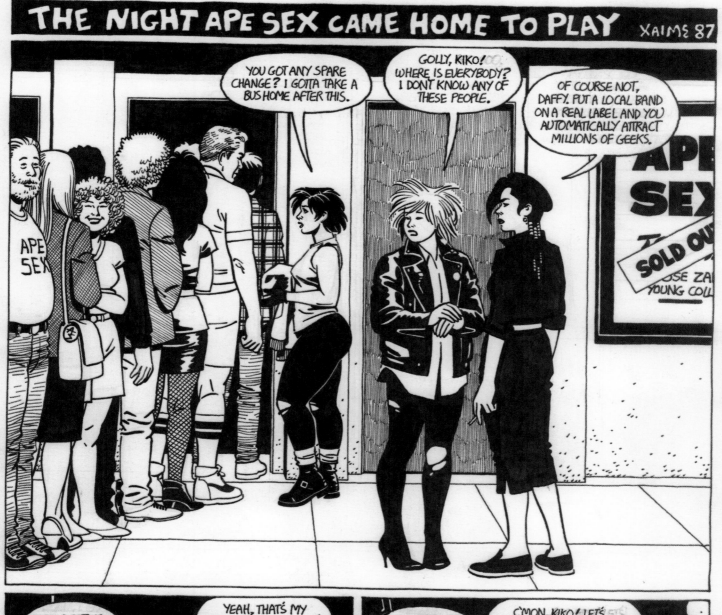

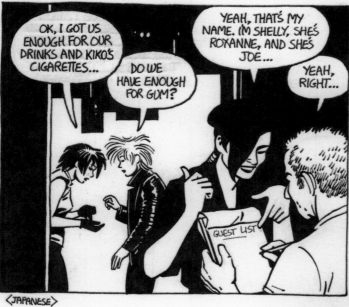

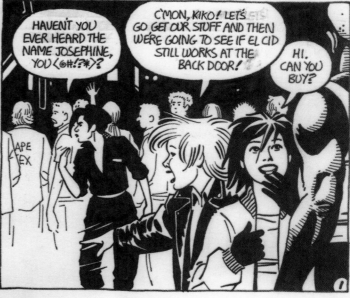

Original artwork for "The Night Ape Sex Came Home to Play," splash page, *Love and Rockets* no. 24, 1987.

LONDON BRIDGE IS FALLING DOWN • NO MORE PUNKS JUST FLASHY CLOWNS • LA'S BURNING JUST THE SAME • NEW YORK'S JUST TEN TIMES AS LAME

Flyer, c. 1982.
"I remember being so broke that I sold the original of this for ten dollars to the drummer of Dr. Know. I had plans for the money, groceries, things I needed. The guitar player was there too and said 'Where you going? Let's go get some beer.' So I guess the money went right back to the band. Where was my little brother that night? He was in the band, too."

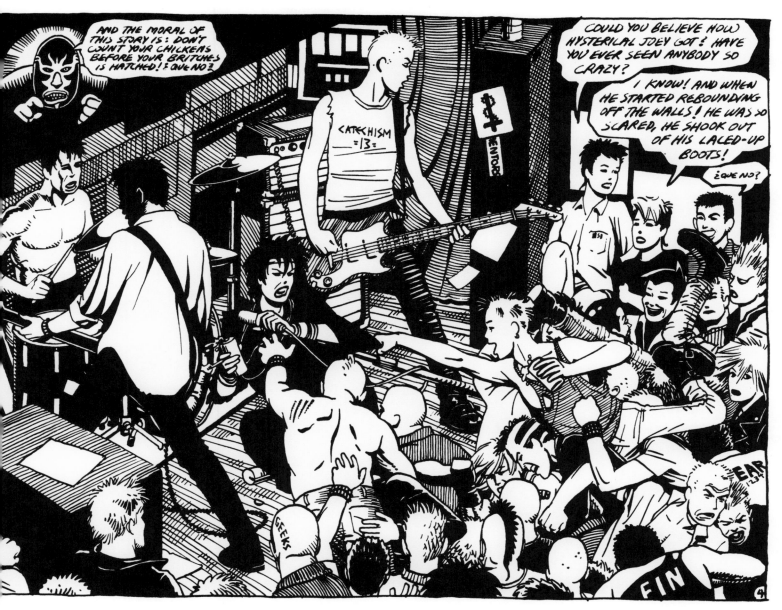

The world of punk was at the heart of his comics from the first issue, in ways both obvious—such as the chaotic gig scene in the final panel of "Locas Tambien" (1981) and subplots surrounding Hopey's band—and as an overall worldview in the lives of Maggie and Hopey. But Hernandez devoted himself to chronicling the lifestyle at the close of "The Lost Women" (the last of the big adventures, this time teaming Maggie with Rena Titañon): "By the time I was done, I knew what things I wanted to pursue, what things I didn't, and how I wanted to do it. I had put myself in a situation that I didn't really like being in, and it was becoming hard to balance the believability. While that story is happening, I keep going back home, doing all the band stuff, and it probably becomes increasingly obvious that that's where I really wanted to be. I had fun with it and felt a responsibility to make a good story, but part of me just wanted to go home and stay home."

Hernandez knew that his focus would be Maggie's and Hopey's lives in the predominantly Mexican-American Hoppers and their punk world. Mirroring the ease with which he populated his comics with ethnically diverse women, he was the first—and by far the best—to treat the punk subculture in comics, refreshingly rejecting prevailing stereotypes. In the Los Angeles scene, there was an important Latino and female presence from the outset in such bands as the Bags (specifically,

singer Alice Bag), the Plugz, and the Zeros. Such a Latino voice in punk was empowering for Hernandez in his chosen field, particularly when faced with the overwhelming lack of diversity in comics. A reciprocal relationship between Hernandez's comics and punk was crucial—for him, anything was possible in either world.

Jaime was able to provide one of the most impressive documents of the punk movement as it was happening because he was living the life, hanging out, going to shows, and playing with Gilbert in the bands the Beer Guts and, later, Suspicion (ironically, the name Love and Rockets, which would have been a natural, was shamelessly stolen by a group of British post-goths). LA punk was in turn wildly creative, liberating, self-destructive, humorous, egocentric, embracing, violent, and deadly serious. But more than anything, its freedom in form and content was inspirational. Hernandez told the stories of the varied characters from this world, but in contrast to the all-encompassing "ratty" line of alternative cartoonist and artist Gary Panter (a more established conjurer of the scene's visual identity through his work in the punk newspaper *Slash*), Hernandez embodied the clear line of the old work-for-hire comics masters to achieve it.

While the precise mastery on view in his art might seem somewhat incongruous with the movement's dominant ideologies, punk's anti-

A definitive scene: "Locas Tambien," page 4, detail, *Love and Rockets* no. 1 (Fantagraphics Books, 1982). That's Hernandez in the back, behind Maggie and Hopey.

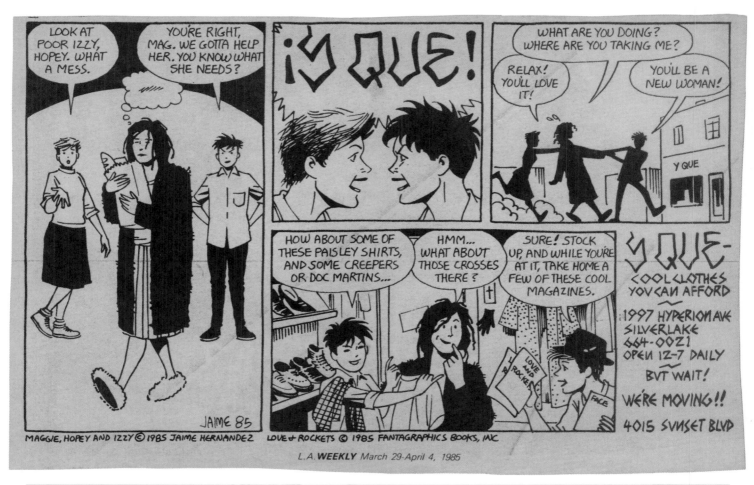

craft wasn't nearly as much a rule as it might seem on first glance. Graphically direct expression, even when informed by many historical (and seemingly incompatible) avant-garde sensibilities, was key; the goal was to communicate and get the point across clearly, and throughout 1982 and 1983, Gilbert and Jaime also drew numerous flyers for local shows, rejecting ornamental excess and employing the quickie tool of the trade, Sharpie markers (which Hernandez also used to "ink" large background areas of his comics in the early days when he was more concerned about saving on ink costs than about the future archival preservation of the original artwork). During this period,

Jaime also created the trademark logo image for Nardcore legends Dr. Know.

Hernandez's back cover for *Love and Rockets* no. 6 (1984) was the first time he depicted Hopey's world back home, visited while Maggie was away on her globe-trotting adventures. This incantatory brew of punk and Catholicism provides a glimpse of the subculture in a manner no less personal and universal than Crumb's conjuring of the hippie subculture through his acid-damaged funny animals. Here is the new world transmogrified through the eyes of a firsthand participant: All the lovingly rendered chaotic energy, splattered with youthful life, is

top
Comic strip featuring Maggie, Hopey, and Izzy done for Y Que clothing store, 1985. One of approximately three ads Hernandez did for the store.

bottom
Suspicion gig in Camarillo, c. 1983.
"Being in garage band after garage band with Beto, we had to make the decision if we wanted to be punk rock stars or cartoonists. Judging from the audience, I think we made the right choice. This is the last band we were in together."

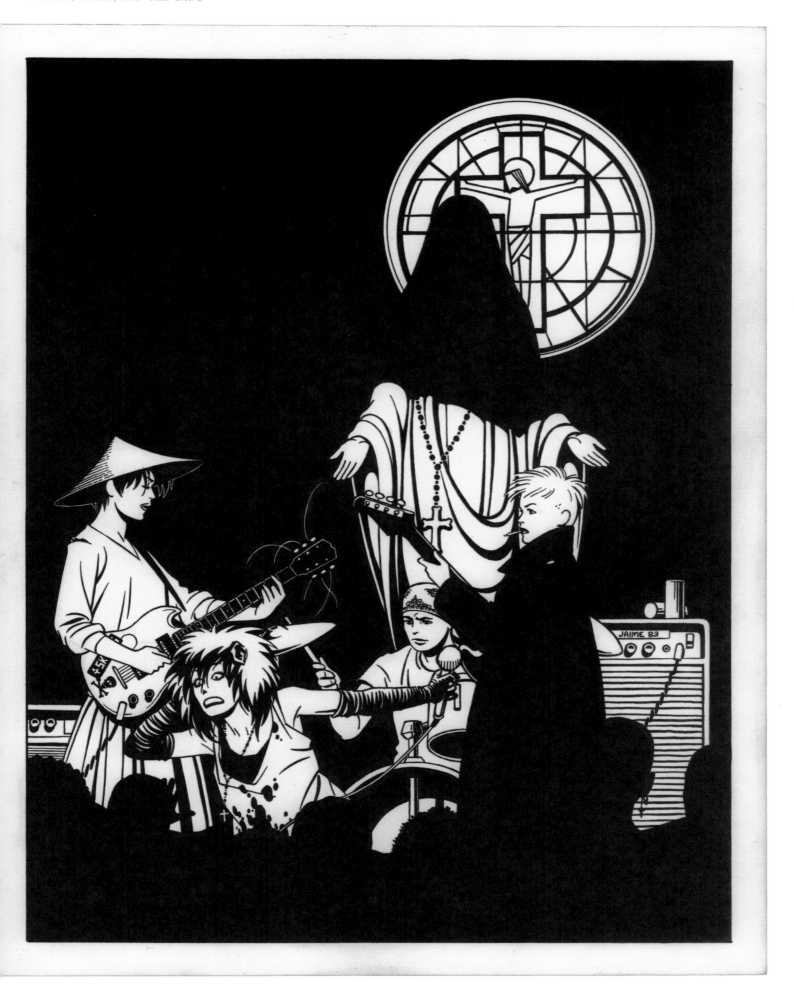

Original artwork for *Love and Rockets* no. 6, back cover, 1983.

"I always knew that Hopey was a fireball in real life, but a dud when she got on stage. She was nervous and shy. She never moves on stage. I didn't know the guitar player was Terry until after the fact. I had seen a band called the Castration Squad's last show and the guitar player was a real ice queen, seeming really into herself—I drew the guitar player with that in mind and when I decided she was Terry, it helped define her as a character."

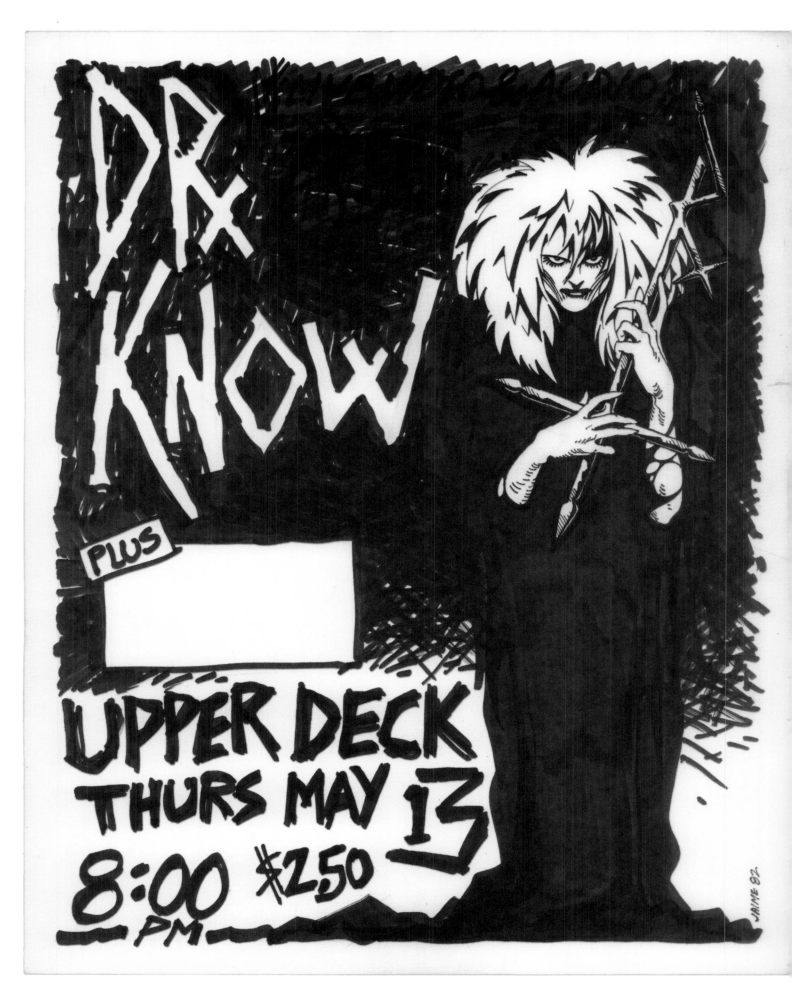

Original artwork for self-rejected flyer, 1982.

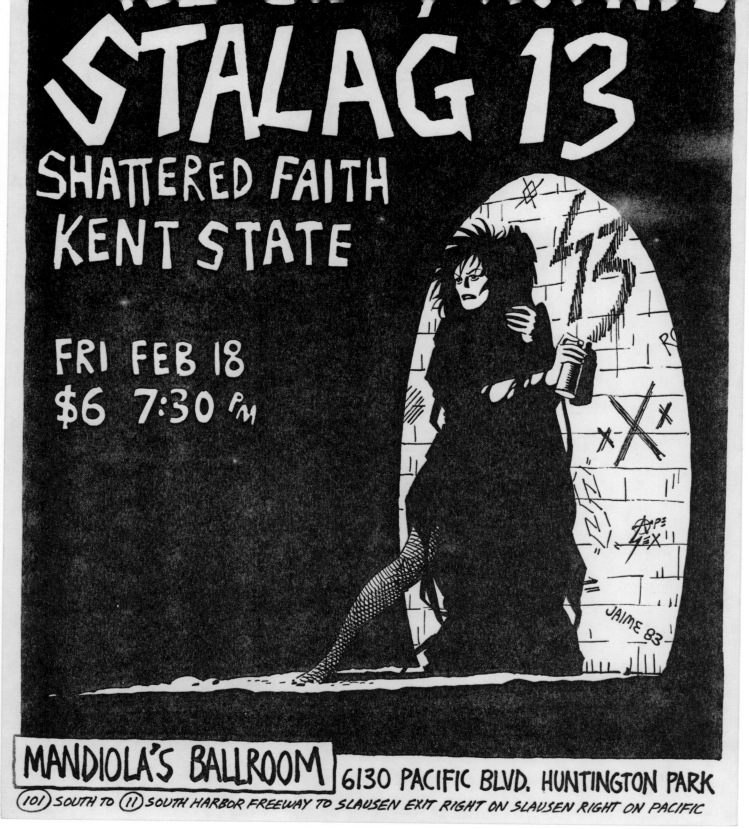

instantly, iconically, delivered as a perfectly composed tableau. This is an image to make young readers drop their comic book checklists and go out and live; this is the "real world" that exists in dreams (though he doesn't remember, he must have felt at least a bit of this intoxication, as a notation is proudly written on the back of the original artwork: "Begun on my 24th birthday, 10/10/83. Finished the next day.").

Striking juxtaposition is key to Hernandez's brand of narrative, whether in stories or single images: "It was that irony—everything I drew had to have that contrast, without it being a gag. It wasn't enough to have the band playing in a club: we were all these crazy Catholics,

scared to death of Hell, so being punk rockers, the thing to do was capitalize on this." Such iconography was prevalent in the scene, with X singer Exene Cervenka draping the band's image in cheap Virgin Mary statues and votive candles, and Dr. Know utilizing the same in their lyrics; in Jaime's comics, Izzy Ortiz embodies this spirit of lapsed Catholicism and tangled punk signifiers, her external look leading Hernandez to her complex backstory. LA punk was a great commingling of the do-it-yourself philosophy, social awareness, and reveling in junk culture fun, and with this image Hernandez has conjured his own all-encompassing, perfectly composed universe with an economy of means

Flyer, 1983.
"The band would usually tell me what they wanted, but this was the first one where I was able to create my own design. What the fuck did the skate punks want with a sexy death-punk chick?"

on a single sheet of paper. With virtually each story in these early days, panoramas expanded through his pen; Jaime's deepening world and increasingly assured inking were being honed at the exact same rate. It was a world that was new to comics, and Hernandez's imagery has since come to define the zeitgeist well outside of comics, appropriated for use by everything from queer discos to Beverly Hills clothing shop windows.

As he did in his treatment of ethnicity and the contemporary punk world, Jaime also depicted sexuality—and sex, which, as he says, is "usually drawn bad, therefore not very attractive"—in a light never

before seen in comics. Maggie and Hopey's relationship was "vague at first because I wasn't sure myself," and when he worked it out, their relationship was gracefully grounded in larger ways of living, depicted humanely. Graphic depiction is beside the point in his comics, and Hernandez rejects the over-the-top shock value found in the undergrounds. Like the depiction of these women's lives, the depiction of sex did not stem from a projected male fantasy (intended to be enjoyed by men, as in the majority of undergrounds and the whole of the ground level "fantasy" comics); instead, Jaime opted to "show it like it's normal life—like it is, to take away taboos associated with it."

Window display at Maxfield, Beverly Hills, California, late 1980s, employing a blown-up 1987 panel from "The Death of Speedy." Photo by Carol Kovinick Hernandez.
"A friend who was a window designer at Maxfield asked permission to use the image in the display.

Gilbert and his wife, Carol, were on a trip through Beverly Hills and stopped to take photos of this (you can see Gilbert's reflection in the lower right corner). She only got to take two shots before a security guard came out of the store and stood in front of the window to block her shot."

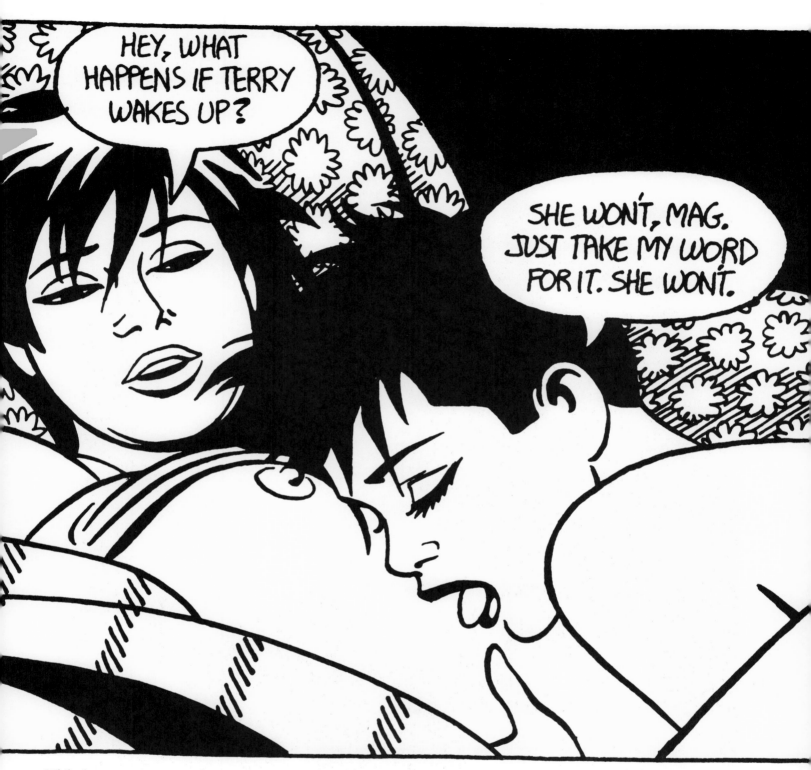

While there were scores of precedents for sex in comics, there was no precedent for Hernandez's treatment of it. In an interview with Ana Merino published in a 2003 history of Fantagraphics, Gary Groth described his first impression of this aspect as "liberating . . . It was the first comic that I remember seeing that didn't view sex as a taboo to be smashed, but as a natural part of life." Hernandez only made Maggie and Hopey's physical relationship overt (in "Locas 8:01 AM," from 1986) when he felt it made sense to their characters, a strategy tellingly consistent with his overall approach—one which never deals in mainstream comics' language of stereotypes, a narrative sensibility that relies on climactic moments. Depicting Maggie and Hopey in a sexual relationship was in itself a political act, a statement of equality in the political climate of 1980s Reagan conservatism, and both Jaime and Gilbert contributed drawings to publications promoting homosexual rights, including AARGH (Artists Against Rampant Government Homophobia). Hernandez was the first to represent women as fully formed characters outside of what men wanted that to mean (see the entire history of the "empowered super heroine" mold), paving the way for myriad nuanced views of sexuality in the medium.

The first panel of Maggie and Hopey having sex: "Locas: 8:01 AM," page 16, detail, *Love and Rockets* no. 18 (Fantagraphics Books, 1986).
"For some reason, the layout of sex scenes is always more successful than anything else. This is probably why the wrestling scenes in *Whoa, Nellie!* worked so well for me: I guess interlocking bodies are a great way to learn composition."

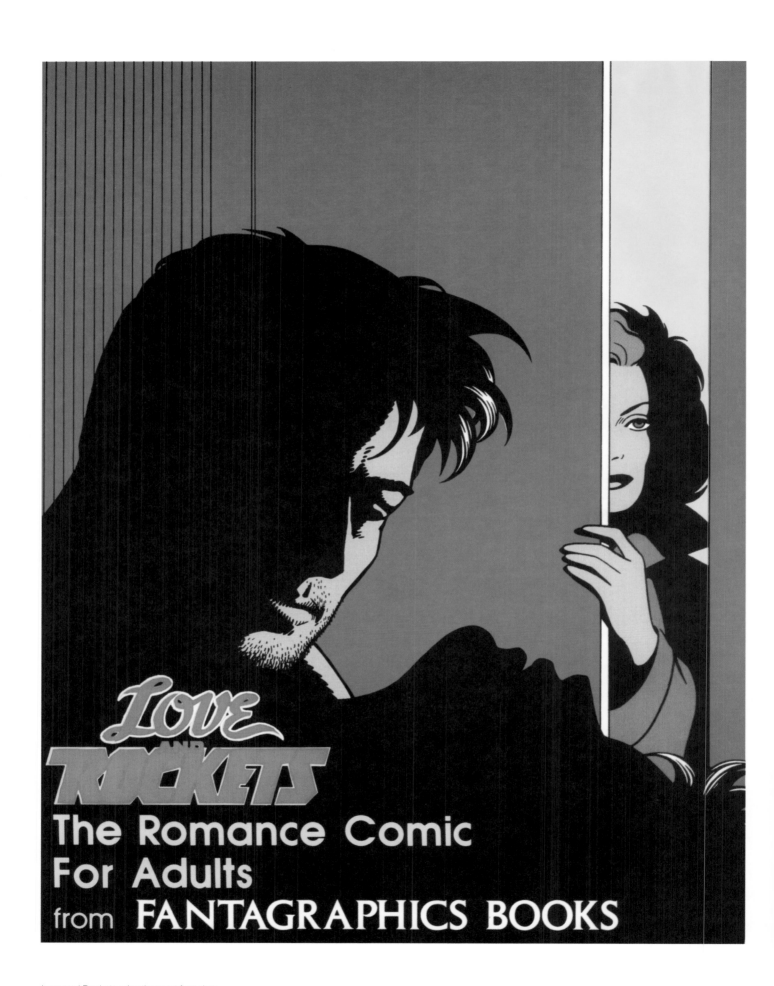

Love and Rockets advertisement featuring
Hernandez's unpublished cover art for no. 8, c. 1984.
"This was rejected for the cover because you
couldn't tell who the characters were supposed to
be. Oh, well."

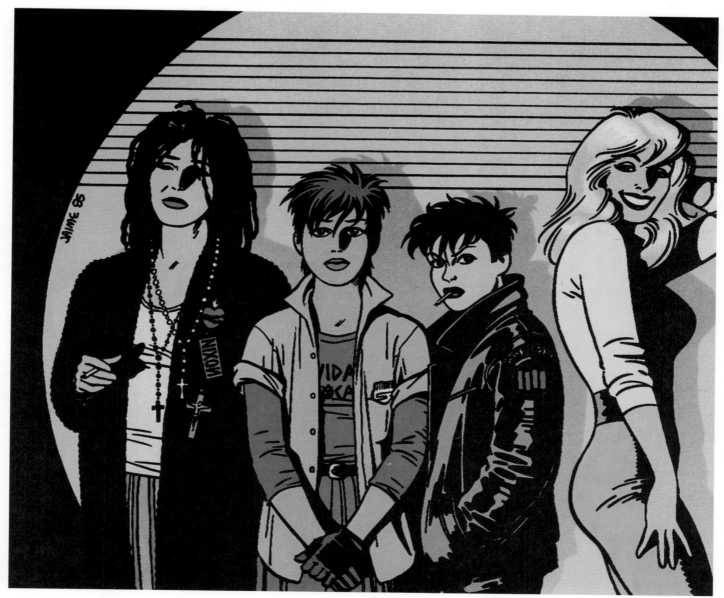

Comics Publishing, Reception, and Peers

By the mid-eighties, *Love and Rockets* had become one of the most critically acclaimed contemporary comics. In 1985, Fantagraphics pioneered the method of collecting serialized stories into book, or "graphic novel," form (which is now an accepted comics publishing norm), packaging the first two issues of *Love and Rockets* in a 1985 album. They also repackaged the first "Mechanics" story in a color comic-book format miniseries, with glowing introductions by many of the most influential mainstream talents of the day in an effort to reach the stubborn comics buyers who just wouldn't make the leap from comic book to magazine, or from color to black and white. The stories'

new look is a mixed bag—Hernandez drew the comics to be printed in black and white, and the color that was added to his earlier, denser drawing style didn't quite work; new stories for the series drawn in an open style designed to accommodate color made much more sense.

In addition to the ongoing *Love and Rockets*, Hernandez was also working on other projects during these early years, including providing the artwork for the first four issues of Dean Motter's *Mister X* (Vortex Comics), which Mario and Gilbert co-plotted and Gilbert scripted. Jaime also drew occasional short stories and covers for a number of comics, including *Silverheels* (Pacific Comics) and the anthology *Vortex*

Love and Rockets advertisement from 1985 featuring the headline "The Best Comic of the '80s?" The artwork is from Hernandez's cover for *Music for Mechanics: Love and Rockets Book 1* (Fantagraphics Books, 1985).

"I guess I really liked the police lineup thing, because I used it a lot. I've always had an obsessive impulse to chart my girls' heights."

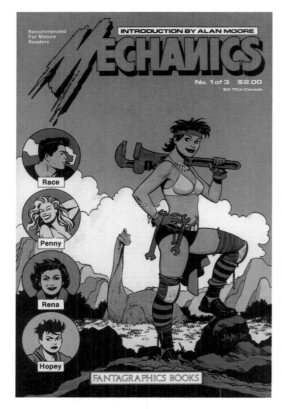

(Vortex Comics), as well as a new color Maggie and Hopey story for the anthology *Anything Goes!* (Fantagraphics). Jaime also contributed some art assists for Dave Stevens's *The Rocketeer* (Eclipse). By augmenting *Love and Rockets*, Jaime was picking up paying gigs in the industry, but had no illusions about work outside of *Love and Rockets*: "If I'm doing my own characters, it's me. If I'm hired to do a *Superman* cover, I know it's not me, and there's only part of my heart in it. In the early days, I had that dream like everyone else that I would do the greatest *Wonder Woman* comic of all time if they gave me the chance. Now that's over. I wouldn't even want to do those characters. It's not that I have anything

against them, it's just that I've created my world so much, everything else is B-list. Recreating the myth means nothing to me—Maggie's a much better character."

In his willful rejection of fixed genres, but mostly in his immersion in the world in which he was living, Hernandez used the medium to create a language that didn't belong to the comic book environment of the time, predicated on escapism and idealization. His stunning artwork, though, immediately appealed to one and all: virtually every single review of Hernandez's work, whatever the overall tone, positively gushes over his draftsmanship and cartooning ability. As a

result, he has been one of the only "independent" cartoonists whom fans and industry professionals alike could see making the leap to more financially lucrative projects. However, Jaime never viewed his comics as a stepping-stone to mainstream work: "That's not the next step. *Love and Rockets* is the *last* step. I 'made it' when we did the first issue. Everything else—the *New York Times*, even making a movie—is lesser than *Love and Rockets*, as far as I'm concerned, and everyone else should treat their work that way. If it's your own work, it should be treated as the last thing, not the first thing."

Although obviously intended for mature readers, it was immediately apparent that *Love and Rockets* was miles apart in intent from the "mature" trend in eighties mainstream comics, which centered around a move toward more "realistic" subject matter in such DC titles as *Watchmen* (written by Alan Moore and drawn by Dave Gibbons) and *Batman: The Dark Knight Returns* (written and drawn by Frank Miller). In spite of the relative ingenuity of these comics at reworking the old super-hero formulas, they were still super-hero comics, no matter how deconstructed or grimly violent they were (their "realism" an "excuse to make more fight scenes," as Hernandez stated in a 1989 *Comics Journal* interview). But *Love and Rockets* had no formula. Hernandez succinctly articulates the difference: "Gilbert and I never wanted to

escape humanity, we wanted to seek it out." From the outset, readers without preconceived notions of what comics should be appreciated the revolutionary nature of *Love and Rockets*, and response was generally overwhelmingly positive. Critical voices, such as Harvey Pekar (*American Splendor*), questioned the realism in Hernandez's work, but the criticism was mainly because of the champion wrestlers, the physical appeal of the young women, and the lingering presence of their exotic adventures.

Indeed, reading Hernandez's work as realism is complicated by the subtle shifting over the years of how characters function in his world: some exist predominantly on only one level, and as such go by the wayside; others are gradually deepened, such as Penny Century. While Rand Race has been around from the beginning, rather than learning much about his personality or psychological makeup, we learn about him through the way he's seen by others—Rand exists as an icon, the way idols exist in everyone's lives, so Hernandez felt it was "better to keep him in the background as the mythical movie star." In articulating the seemingly disparate worlds in which his characters travel, the overwhelming sense was that home is "reality," while the doldrums of work exist as fantasy. Hernandez, however, had to consciously reconcile these worlds, "because it was getting very close

Unused publicity shot of Jaime and Gilbert Hernandez, c. 1986. Photo by Carol Kovinick Hernandez.
"What were we, some Kraftwerk-style project?"

to the reader not being able to tell what was real and what wasn't. It was never my intention to fool anyone with it; it was my intention to go into characters' minds, but after a while I was worried I was starting to fuck with the reader, which is not my intention at all. I never want to tell the reader what to think, I always want to give them a scenario and let them make up their own minds." Hernandez's realism, then, shifts with story and character—after all, realism exists in the daydreams, fantasies, and false impressions within the heads of characters as much as it does in their physical actions. Emotion is where Jaime's realism lies.

The overwhelming reader response to *Love and Rockets*, including

fellow cartoonists, is that upon first discovery the comic changed their lives. Cartoonist Daniel Clowes—whose *Eightball* became as influential and important as any post–*Love and Rockets* comic book— recalls his first reaction: "I remember there was a guy at the local comic store in New York who was a really fishy character with horrible taste in everything, and he was always raving about *Love and Rockets*, so I made a point to avoid it for the first several issues (thanks, douchebag). It wasn't until I decided to send one of my Lloyd Llewellyn stories out to a few publishers that I finally checked it out. I was immediately hooked and went back for all the old issues. This would have been around

R. Crumb and Hernandez, Dallas Fantasy Fair, c. 1984.
"Starting to be invited to comic conventions and rubbing elbows with my comic book idols. See how delighted Mr. Crumb is to have me around?"

issue no. 5 or so, but it's hard to remember because I bought them all within a few days of each other. I remember being totally amazed (and spiritually crushed) when I discovered that Jaime was only a few years older than me. I figured he had to be at least forty to draw like that."

Sales of *Love and Rockets* continued to climb during the mid-eighties, according to Fantagraphics co-publisher Kim Thompson, peaking "at somewhere just under 20,000 when it was in the number 20s or 30s." By this time, *Love and Rockets* was widely influential, and publisher Fantagraphics had begun to establish the field of "alternative" comics around the Hernandez brothers' work, effectively creating its own context: in 1985, Peter Bagge's *Neat Stuff* no. 1 debuted, and Clowes's first published Lloyd Llewellyn story was included in *Love and Rockets* no. 13 (although, as Clowes remembers, "It definitely wasn't my idea. Who in the world wants to have their first half-assed attempts at drawing comics placed in the context of the best in the business?"). In the next few years, cartoonists such as Chester Brown, Carol Lay, Seth, and Julie Doucet also contributed important work in this changing landscape. But this was not yet our world of comics and fiction happily coexisting in mainstream bookstores, so the only outlet for the Hernandez brothers and younger like-minded cartoonists was the comics specialty store, which, ironically, with an emphasis on

collecting and firmly entrenched super heroes, was perhaps one of the venues least likely to appreciate their art.

There was also predictable resistance from mainstream comics industry professionals, as well as the inherent polarizing force of publisher Gary Groth, whose essays and interviews in *The Comics Journal* were a perpetual lightning rod for controversy. Hernandez was always keenly aware that he and Gilbert were outsiders to the insulated world of most comics, both in their subject matter and personal background: "Coming in, it was very strange because we entered into this world with open arms: 'Look at us, we have a comic too! Isn't this industry cool?' And then finding out that we were not treated the same, not because of our nationalities so much as how the comic was presented and accepted by the mainstream. It wasn't mainstream fare, but it also wasn't those silly, druggy undergrounds. And we were punk rockers. In those days, to the comic industry, punk rock was the Disco Dazzler [laughter]. . . . There were instances where we were referred to as 'thugs'! You think using that word is pretty harmless, but do you know how loaded it is?"

To some degree, the freedom of the Hernandez brothers must have been respected by a segment of career mainstream artists who either longed to pursue their own vision but didn't have the creativity, or who

top
Gilbert and Jaime Hernandez, c. 1986.
"Hanging in London, acting like rock stars. Judging by our fan response there, we darn near felt like the real thing."

bottom
Hernandez's most important male character, Ray Dominguez. Original artwork for "Boxer, Bikini, or Brief," page 4, detail, *Love and Rockets* no. 28, 1988.
As shown here, Ray is frequently the vessel for thoughts Hernandez doesn't want to give Maggie.

Gilbert and Jaime, c 1986.
"This was at a tiny con in San Diego."

were scared financially to make the leap. As Hernandez says, "It took me twenty or so years to find out that a lot of the mainstream guys were supporting us privately—we were miles apart, but they'd been reading our stuff since the beginning. I was humbled by that a little bit." But while some mainstream creators graspingly felt a kinship (delusional as it may have been) with the brothers' approach, it was impossible for Gilbert and Jaime to relate at all to mainstream comics at this point, and in 1989 when they voiced their disdain for rehashing the old formulaic approach in their first major interview for *The Comics Journal*, the schism became undeniable: "I got the feeling that we broke the hearts of some of the mainstream, because they still thought we were all in this together."

Both Gilbert and Jaime were very much in the comics' public eye, such as it was. One perk of doing endless store signings and convention appearances was the ability to bypass middlemen critics and actually meet their readers, in particular a large percentage of women, which was definitely not the industry norm. Because of their singularity in the comics world, journalists expected both brothers to be the comics spokespeople for virtually everything outside of the super-hero world, particularly punk and Latino culture. But to Hernandez, "The only [demographic] I consciously thought about was the female readership, because that was the only aspect of the comic I really didn't have control over—I mean the punk thing, I lived it, so you can't tell me I'm doing this wrong. I'm Chicano, so the same thing there. But I'm not a woman, so I did want to make sure I wasn't stepping on toes. Not that it prevented me from doing anything, but it made me think about things before I put them out there. To this day, before Maggie makes a decision, I do think, 'Is this a woman's trait, or not a woman's trait, or is it something I have to work around?' That's the only conscious decision I make in terms of what I'm representing." And while his characters derive in large part from his own life, Jaime strives for a broad appeal: "I know that in the beginning I wanted everyone in the world to like it. I wasn't making it for only one readership. When we got good responses from women, I was very excited because that was such a rarity in comics. I was very grateful for it and took pride in the fact that a lot of women read our comic and not others." While Maggie and Hopey remained the fulcrum, many other female characters were introduced early on, and giving them voice was synonymous with Hernandez's rejection of comics culture; Gilbert and Jaime were appealing to the people whom they wanted to appeal to.

For the first eight issues, the vast majority of letters were from male readers, but once the comic had been around for a few years and

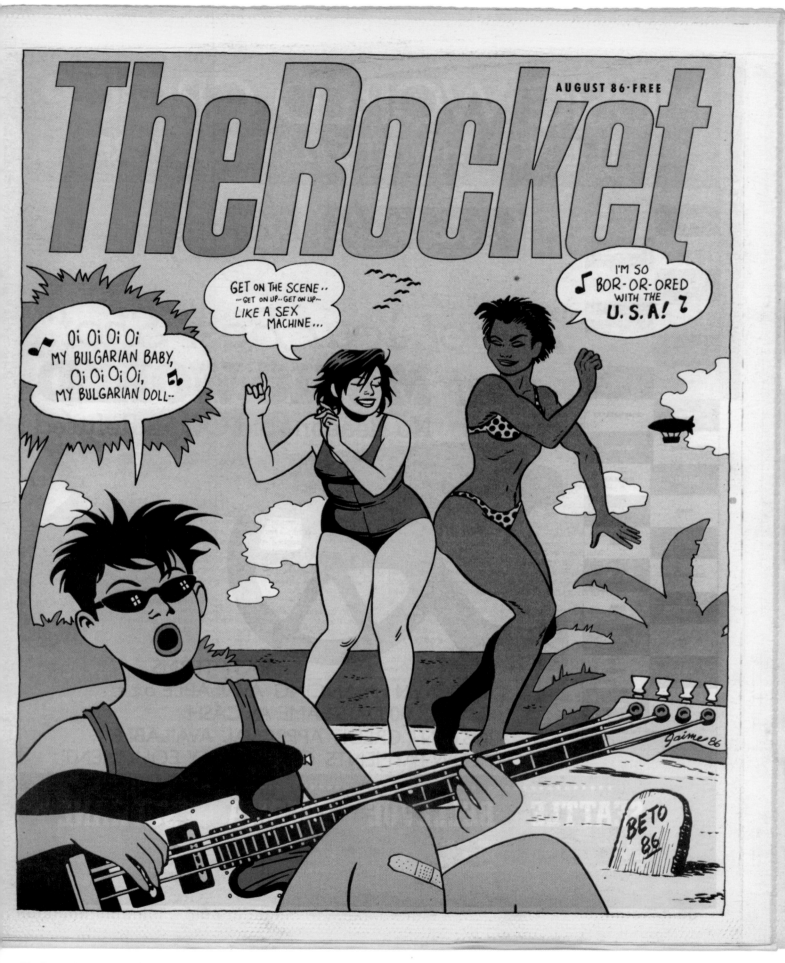

The Rocket (August 1986). Cover by Gilbert and
Jaime Hernandez.

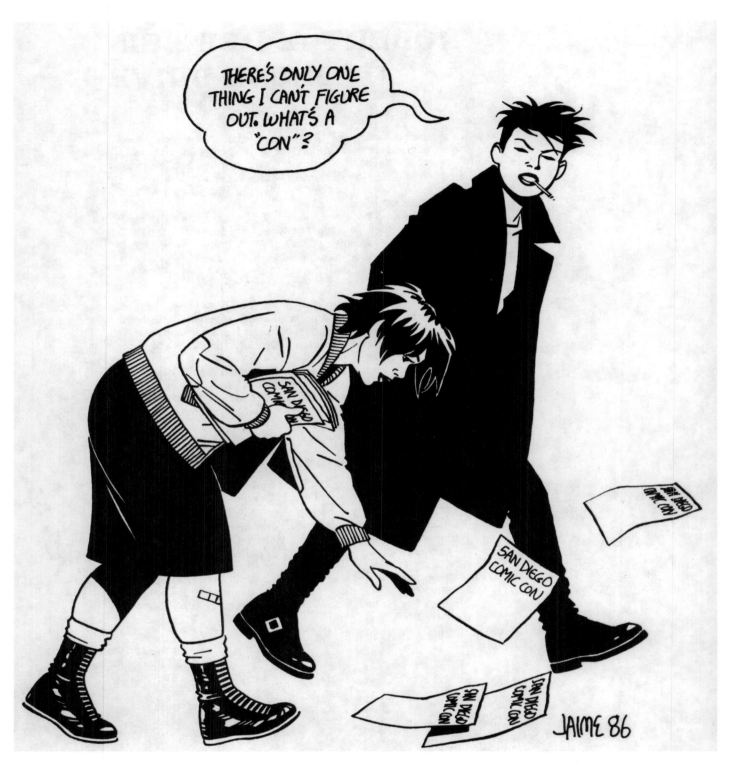

more women began discovering it, responses evened out gender-wise. Maggie and Hopey naturally struck the hardest, and both men and women loved the characters, finding them empowering or wanting to date them—or both. In issue no. 9, Karen Weiss (and her friends) from Washington, DC, struck a universal tone in her letter, writing that: "We consider Maggie, Hopey, Penny, Izzy and the rest: a) our friends b) our role models c) great feminists. Cool, beautiful, fun, intelligent, talented—they're just like us! It's incredible that Jaime, by all accounts a male, should have such insight into female friendships, feelings, and fashions." Such viscerally personal (adult) connections to comics characters were radical in a fan world predicated on escapism and social isolationism. Jaime, as a man, was able to create such rich female characters—particularly Hopey and Maggie, now established as two of the most influential and endearing in comics—because, as Meg Bradbury states, they are "all quite human to him; they're family just as I, our daughter, and his siblings are." Though eschewing the gargantuan proportions of most female protagonists, it certainly didn't hurt the response that Hernandez's women were undeniably attractive (after all, one of Hernandez's main impetuses for developing early versions of the characters is because he loved drawing cute girls). But

Illustration for the San Diego Comic-Con program, 1986.

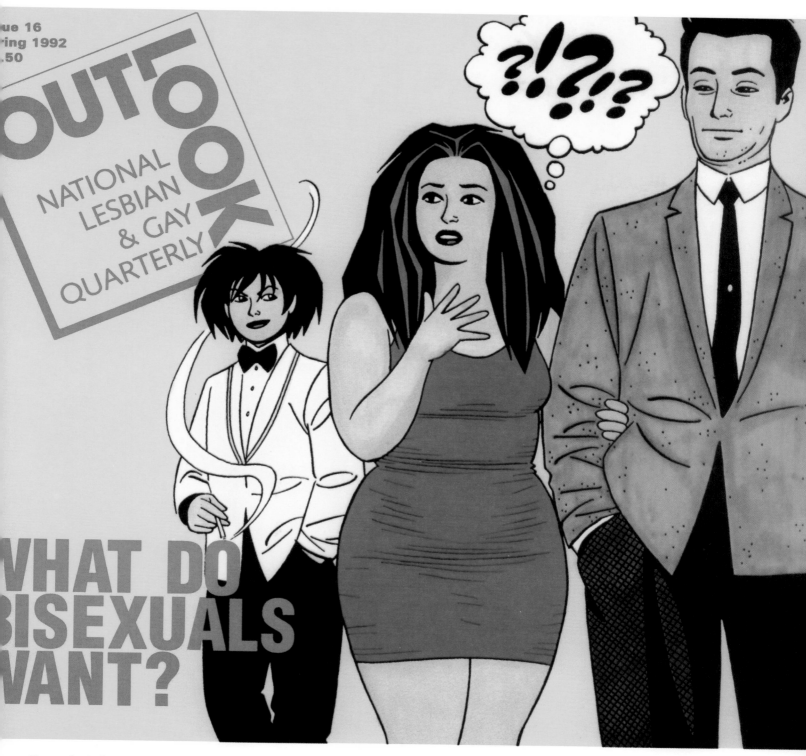

Hernandez is about moving lives, not cheesecake on pedestals; it's just his curse that he happens to be better at drawing women than anyone else. Bradbury explains his comics' remarkable allure:

Whenever I'm asked about Jaime's uncanny knack for female patter and pattern, I say, and I mean this: I have never been involved with anyone, male or female, more centered in their femininity than Jaime. Now, this is not to say Jaime is effeminate, nor is it to say he even has any control over it. It just is. Jaime understands women because he simply is able to cleanly place that side of himself into his art and his storytelling. Jaime

also loves women, loves all women, with a respect and an appreciation that informs every minute of his every day. The physical, absolutely; how can you look at just one Maggie panel and not know immediately that Jaime is in love with her shape and her style? But there's also the emotional thing, the essence of being intimately aware of how and why women act and react the way we do. And I think most women have responded positively to Jaime's work because they are able to see themselves there, in the panel, under Jaime's nib, acting, reacting, in ways sexy and salacious and sinister and ridiculous and unbearable. Jaime lets his girls fuck up.

Outlook no. 16 (Spring 1992).

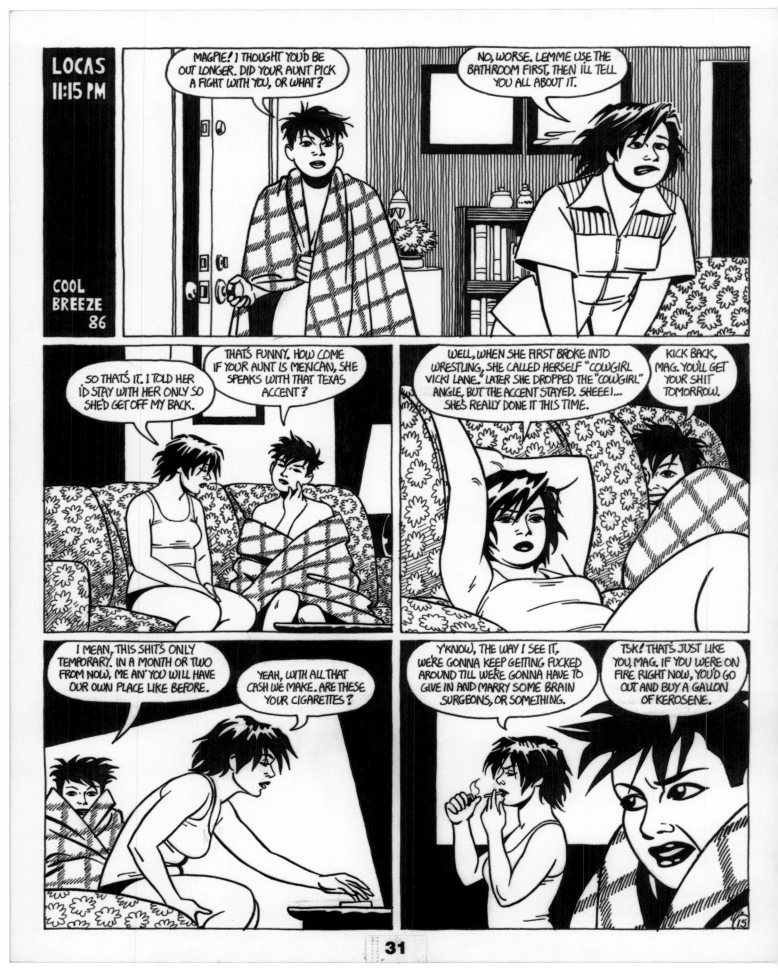

Original artwork for "Locas: 8:01 AM," page 15, *Love and Rockets* no. 18, 1986.

Maggie, Hopey, and the gang opened up a vista outside the male-super-hero-dominated comics world, allowing space for not only female characters and female voices, but for all manner of disparate subjects and approaches. Unlike many artistic-minded cartoonists, whose protagonists often seem to be thinly veiled stand-ins for the author's viewpoints, Hernandez allows his characters to be contradictory and fully modeled—he is warmly accepting, never embarrassed of foible, and never proffers one-dimensional moralizing judgment. His characters refuse to be defined, and refuse to bow down to what the readers want them to be. You could use the cliché "free-spirited," but that only tells half the story, as they are just as bogged down with the crap and vicissitudes of life as everyone else.

Jaime's characters don't ingratiate, and his comics as a whole truthfully reflect a world, but never in expected superficial ways, instead openly flouting any commodified depiction of "punk" or "Los Angeles." His stories never grasp for easy sentiment or "message"; rather the message resides in the little things that make up his characters. Jaime never falls back on the old entertainer's trick of making the readership feel superior to his characters, but he also never allows the reader to get too close or comfortable. Hernandez always respects the reader, while at the same time cautioning: "You may love Maggie, but you have to remember that she may not be from your world. I always got the response of 'I love Maggie and Hopey and if I met them, they would be my best friends.' I think that's all great, but at the same time I had to remind them that these are two punk kids with good hearts, but to outsiders they might be pretty snotty and make you feel alienated. So don't get too comfortable with them. Which is a lesson—you love them, but they're not from your world, so doesn't that help us all understand each other?"

Hernandez at his drawing table, c. 1990.

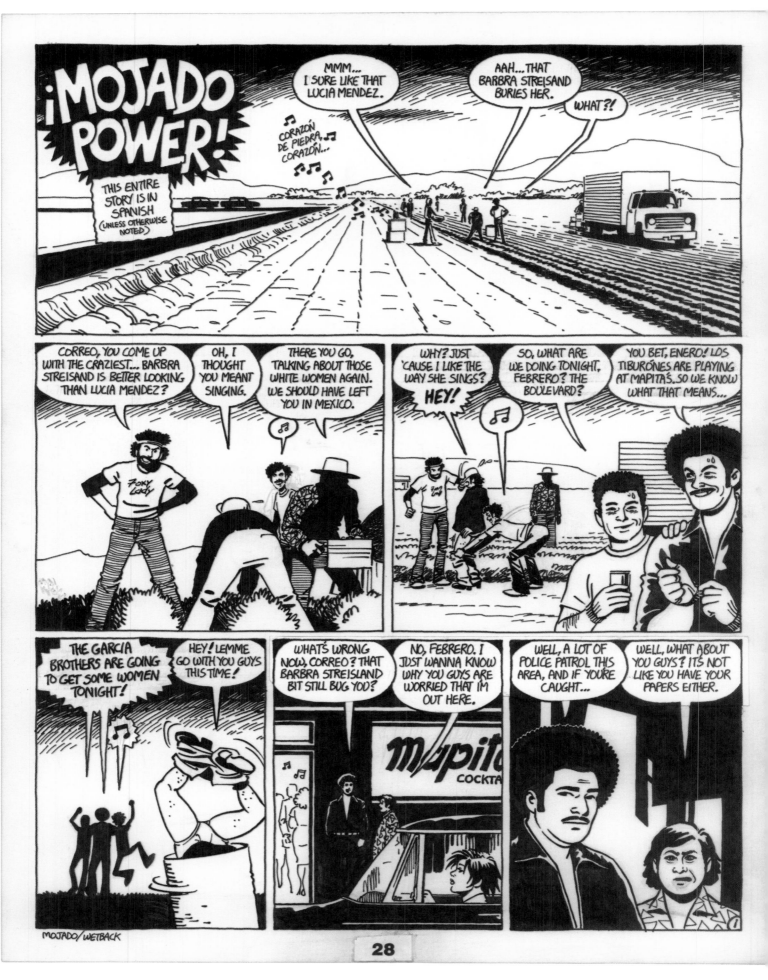

Original artwork for "¡Mojado Power!" complete two-page story, *Love and Rockets* no. 19, 1986.

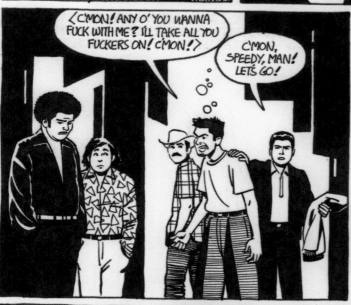

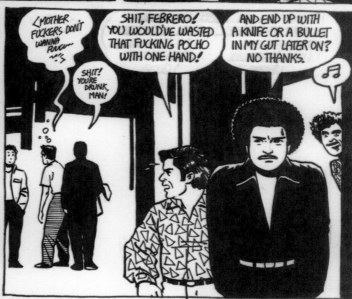

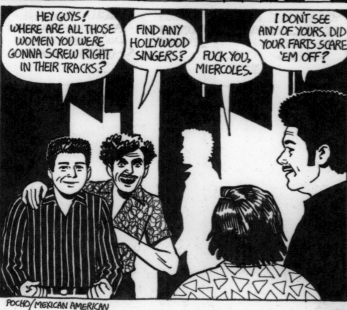

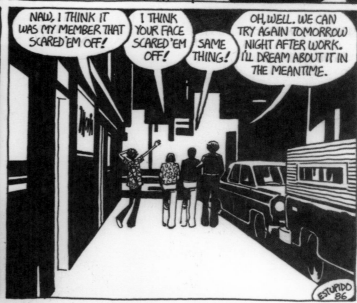

POCHO/MEXICAN AMERICAN

29

119

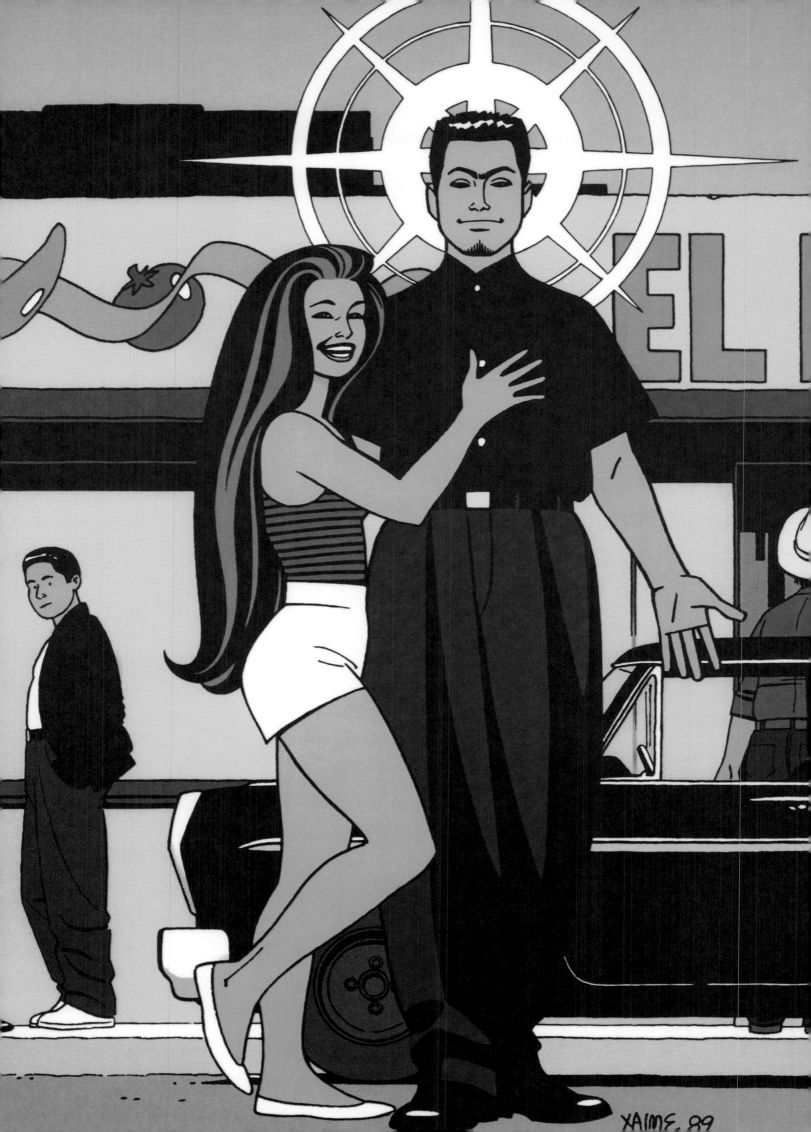

The "Death of Speedy" Era

WITH *LOVE AND ROCKETS* NO. 13 (1985), Hernandez devoted himself to alternating between day-to-day "Locas" stories starring Maggie and Hopey and tales surrounding the world of professional wrestling, which culminate in "The House of Raging Women" (1984–86). Here, wrestling provides another subculture for Hernandez to complicate and humanize, and wrestlers replace the super heroes of the first ten issues. The "rockets" are still evident, but they're grounded in how one projects "mythic" qualities onto characters such as champion Rena Titañon. Her portrait on the cover of *Love and Rockets* no. 15 beautifully embodies the magically iconic power of the super hero

likenesses Hernandez's mother had drawn as a teenager, while also signifying the shift from fantasy to the realm of reality. But even though the characters are leaving behind the world of "comics" in favor of the "real world," the manner in which Hernandez tells his stories never forfeits the unreality of the comics language.

At this point, Hernandez's art was quickly becoming cleaner and bolder, reaching new heights in the character-driven and more emotionally complicated shorts (with beginnings and endings, "Betty and Veronica–style," as he puts it). These issues have been criticized as the time when "nothing happened," but are at the heart of who

opposite
The Death of Speedy: Love and Rockets Book 7
(Fantagraphics Books, 1989).

above
"Vida Loca: The Death of Speedy Ortiz," page 5, detail, *Love and Rockets* no. 21 (Fantagraphics Books, 1987).

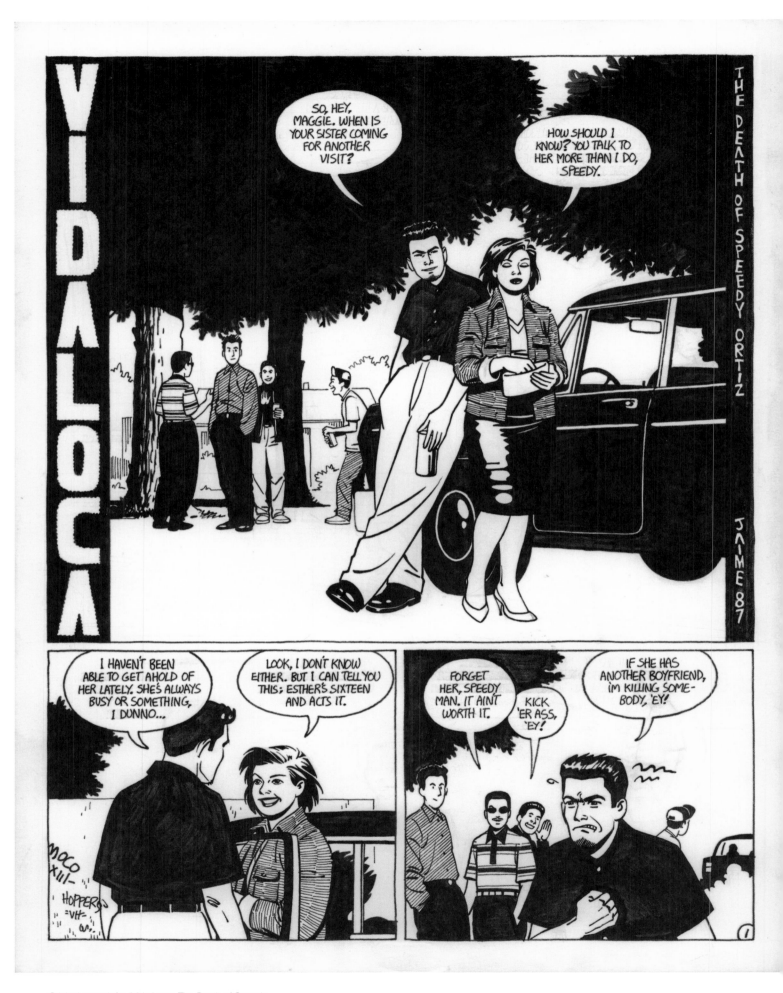

Original artwork for "Vida Loca: The Death of Speedy
Ortiz," splash page, *Love and Rockets* no. 21, 1987.

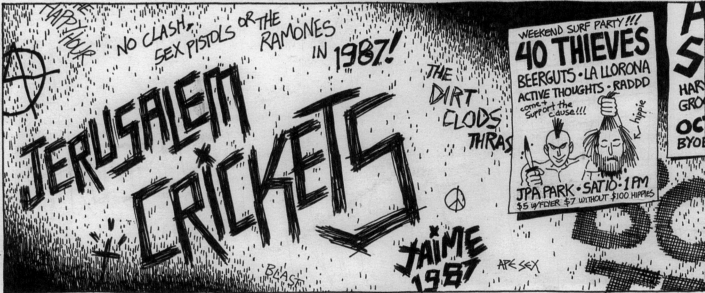

the characters came to be—Maggie struggling with her weight and menial jobs, Hopey's on-off participation in band life, and the telling details that define the rest of the ethnically diverse cast: Izzy, Terry, Penny, Daffy Matsumoto, Danita Lincoln, Ray Dominguez, and Doyle Blackburn, among many others.

In 1987, Hernandez's work took another substantial leap with two concurrent stories: "Jerusalem Crickets," which detailed Hopey's life on the road, and the three-part "The Death of Speedy," unquestionably among Hernandez's finest moments. Here he continues to depict the "other" in America, focusing specifically on Latino gang culture in Hoppers. The narrative surrounds Izzy's younger brother, Eulalio "Speedy" Ortiz, a member of one of Hoppers' gangs who winds up in a relationship with Maggie's younger sister, Esther, who's living with their mother in the neighboring town of Montoya, where she also dates a gang member. Her romantic duplicity sparks violence between the town's rival gangs, and as the title immediately provides the story's grim conclusion, narrative suspense is replaced by a creeping inevitability; Speedy's demise is writ through a dream logic of his own making. But as the title provides only the bare bones of the events and

their emotional effect, so as in all of Hernandez's stories, attempting synopses fails miserably to convey their intricate beauty: the plot itself becomes nearly secondary to the moving manner in which the story is told, here more ambitious, tightly structured, and emotionally moving than anything Hernandez had attempted previously. As he remembers this time: "I was ramping it up. I guess I felt that I needed to get serious because Gilbert had been—that was a good period. The period where I knew what I was doing."

Speedy had been around since the beginning of the comic, but like other characters who come into sharper focus then recede from view, his story was told only when readers had lived with him for a while. Hernandez explained his strategy in a 1989 *Comics Journal* interview: "I was making up people like that [Speedy], because I knew I'd bring them in later. Then you'd say, 'Oh, that's the guy they're talking about!' And it almost makes it like you've known that guy for a while, and you're comfortable with it. I did a lot of that because I didn't have enough room to put all those people in, so I only introduced them by word of mouth, and then later showed them."

After living on and off in his family house in the early eighties,

Original artwork for "Jerusalem Crickets," splash page, detail, *Love and Rockets* no. 21, 1987.

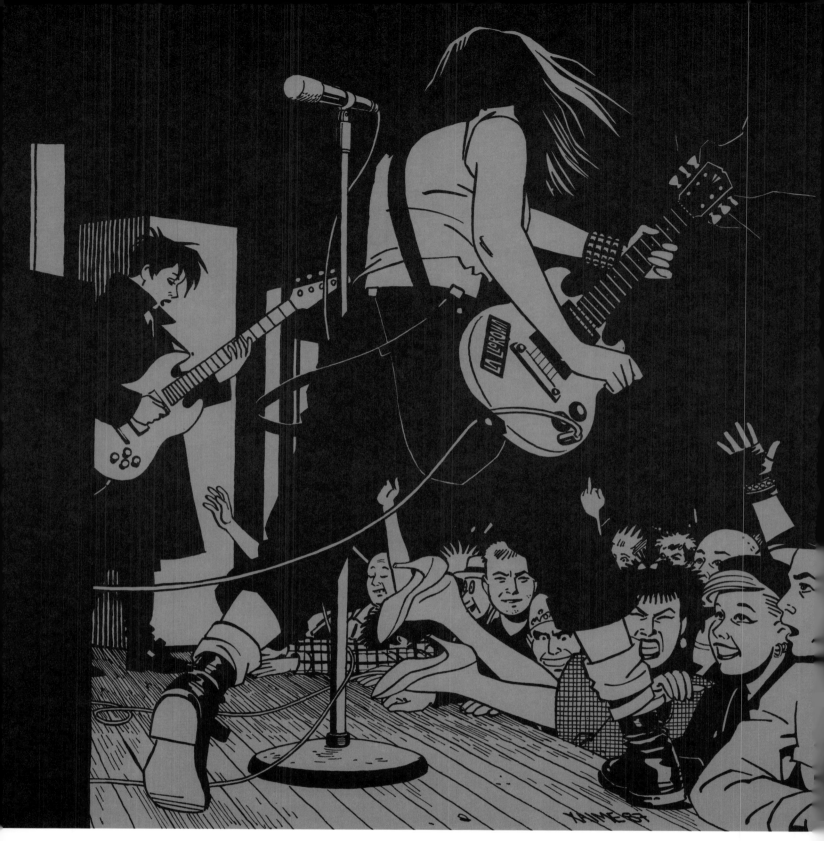

Hernandez continued to live in apartments in Oxnard until 1991. "The Death of Speedy" is a personal shaping of his pre-punk life into comics, and he was excited by the opportunities such a story provided:

> I remember thinking to myself: "I've had two really cool lives—my punk life, and before that my lowrider life." Before punk, I came from lowrider culture. All my friends were involved in it and I can appreciate that as their culture—it's their very own. The thing about Mexicans, like a lot of Latin cultures, is that we're very family oriented, so anyone outside our family is not as good. Those Mexicans over there aren't as good as my Mexicans.

That's why there are so many rivalries. You're taking care of your own; you can say that about many cultures. What I was drawing from the whole time was my own family and my life. I didn't look outside of that because other Mexicans didn't understand my work. That's the way I looked at it. It sounds silly and maybe self-serving, but that's the way I work a lot of the time. Like I'm the only guy here.

Thus the role of family, in the large sense, informs both his approach and his characters' motivations; Maggie and Hopey both come from broken homes, and Hernandez knew that the punk scene represented

Love and Rockets no. 24 (Fantagraphics Books, 1987).
"One of the few times I drew like Jack Kirby would draw—say, he would just start with a fist and turn it into a huge scene, here I started with Terry's foot and thought 'I'm going to make this a really exciting picture of a band.' I drew it in a few hours because I was behind on a deadline."

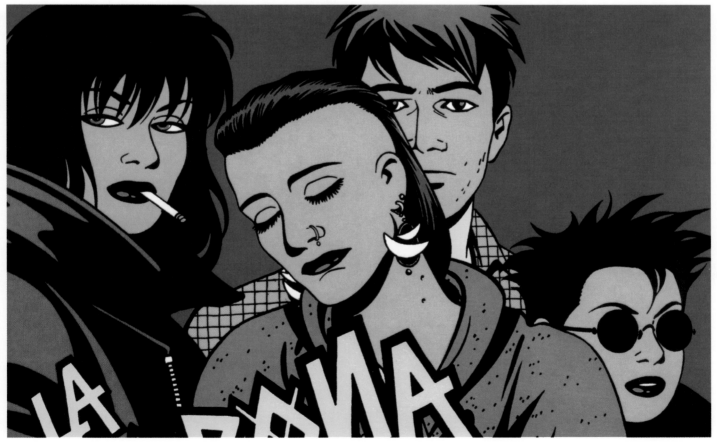

top left
Harry Lucey, "Career Boy," splash page, detail,
Archie no. 139
(Archie Comic Publications, Inc., 1963).
Lucey's mastery of cartoon body language opened
Hernandez's eyes to the expressive power of the
medium, which he expanded upon to portray his
everyday world.

top right
"Locos," splash page, detail, *Love and Rockets* no. 7
(Fantagraphics Books, 1984).

bottom
Love and Rockets no. 22 (Fantagraphics Books,
1987).

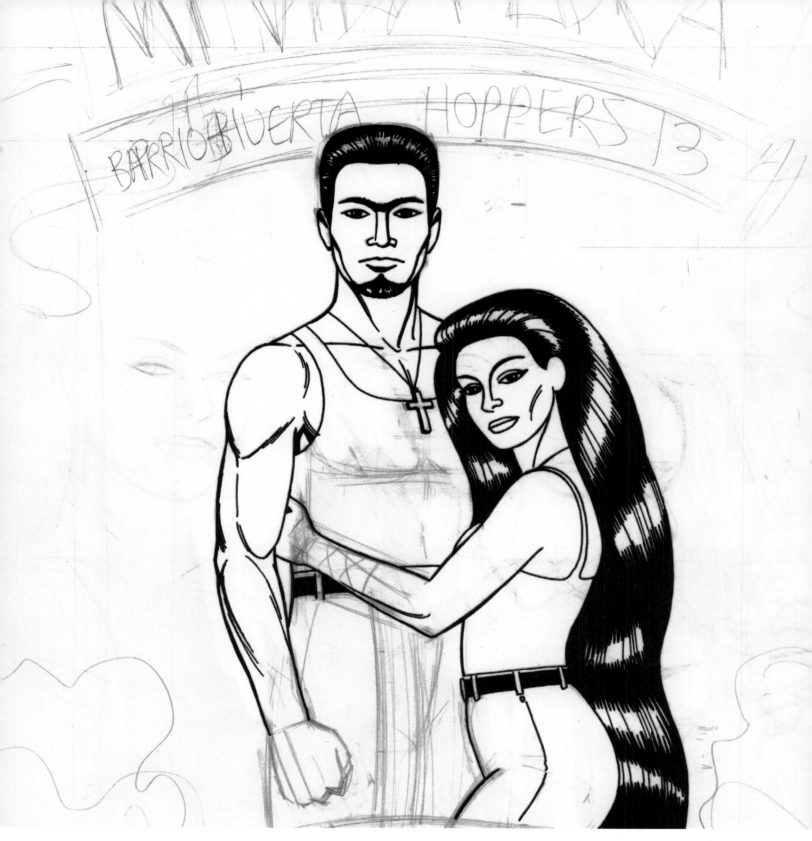

a surrogate family for many. What immediately sets Hernandez's comics apart is perspective, in all senses of the word, which provides the key to this story. Armed with his increasing mastery of comics language, his artwork reflects the gravity of events, which are brought home in stark contrasts with no physical or stylistic distancing from the world: "From the beginning, I decided on a classic style of art, with no extra tricks, because I felt the world [I was depicting] was quirky enough to handle the weird part of it." Instead, there is a resolute clarity: "light" is inextricably tied to Southern California, and black is a color, with night spotlit, shadows and contours solidly static. His observation for telling detail is never more effective than when it's pared down and cleanly defined—clothing textures, the sheen on a cherry lowrider, screen doors, and particularly graffiti propel the story as much as dialogue. Hernandez's "camera" places the reader directly in the action, within the conversation, while he alters the balance of "reality" to heighten the metaphysical weight of the world bearing down: "I don't put the vanishing point at eye level, like you see things in real life, because then you see more ground than sky. I put it around waist level, so you have more negative space of sky."

Original unused artwork for *Love and Rockets* no. 21, back cover, 1987.
Hernandez attempted to draw this image using the visual language of lowrider art, and when he failed to get the effect he was looking for, realized that the velvety shading he sought was achieved by using ballpoint pen.

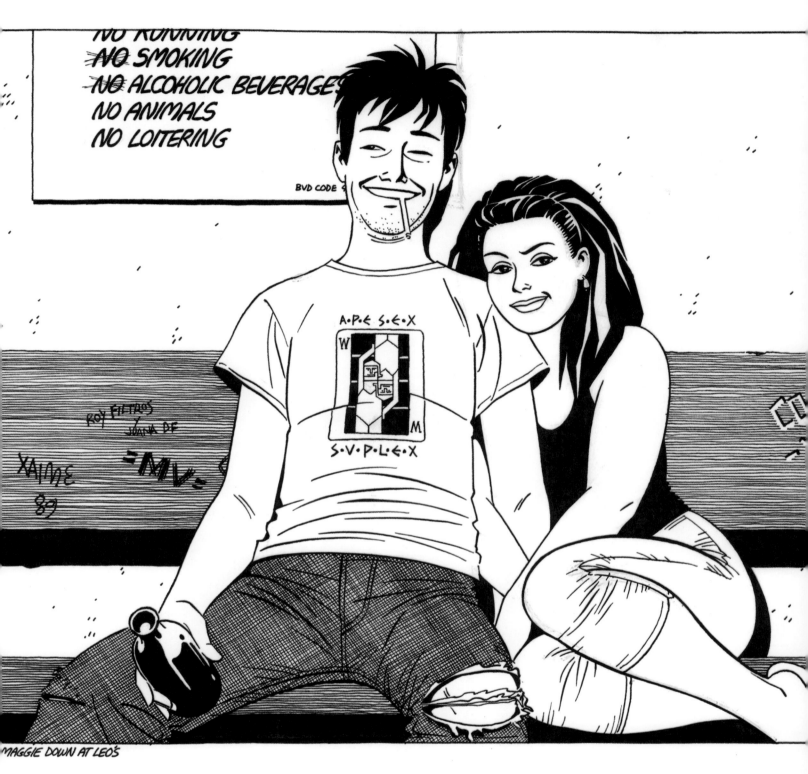

MAGGIE DOWN AT LEO'S

Hernandez's heightened storytelling ambition coincided with the full maturation of his art; while the tone and characters are now given in increasing shades of rich ambiguity, the crisp, perfectly composed artwork sharply delineates Hoppers and its community. This is an inhabitable world, but it's also one that never completely leaves the magic realm that exists only in comics: in a panel near the outset, two dogs chained to a tree comment on Speedy's increasingly self-destructive behavior as he walks by. The story couldn't be told this way outside of comics. But Jaime's depiction of Speedy's death also illuminates how his work differs from the sensibility of mainstream comics. The death itself takes place entirely offscreen, shifting between his friends' realization of the event and the stark illumination of his absence when Izzy opens a curtain in her empty room. The denial of the voyeuristic thrill of the actual death itself is a complete rejection of the history of genre comics' fetishism of the payoff, and it is at this point where super heroes truly go by the wayside.

As always, Hernandez staggers such longer, serialized stories with self-contained shorts that generally offer greater departures in tone and approach to characterization. A major story in this fruitful period is the self-contained "Flies on the Ceiling" (1988–89), which

Original artwork for "Ray and Maggie Down at Leo's,"
Love and Rockets calendar, 1989.

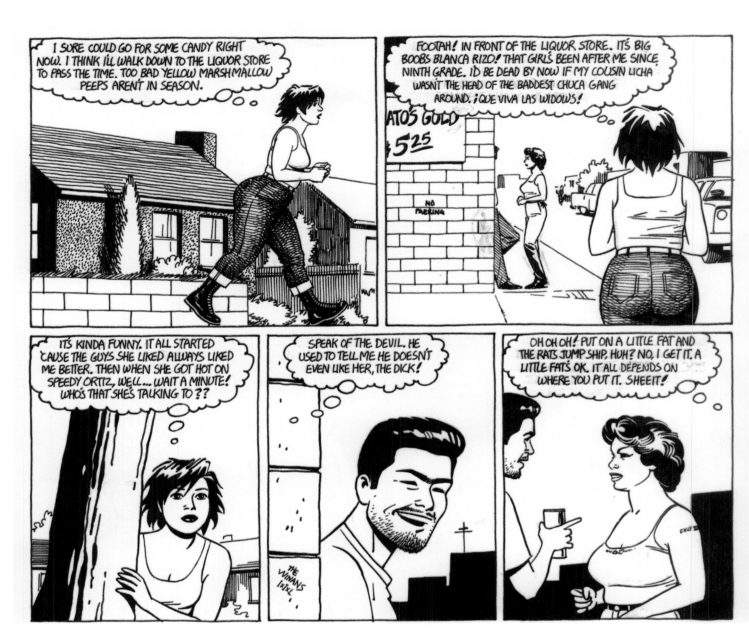

incisively captures Izzy through an effective storytelling departure. Opening with the same imagery as seen in her introduction back in the self-published first issue of *Love and Rockets*, we learn what happened when "she went to Mexico and got all weird." This backstory had been percolating in Hernandez's head for years, and he originally planned it as another three-part epic, opting instead to effectively distill the events into a mostly wordless portrait. As the imagery in her first story led pointedly toward her definition as a character, here her character dictates the visual manner in which the story unfolds, slipping between her hallucinatory thoughts and the physical world; this is a folktale about guilt and the possibility of redemption. Hernandez's visual manifestation of his stories are led by a particular character, and in Izzy's case, her makeup is painted by divergent, subjective points of view that don't necessarily add up to a unified portrait.

This approach is a hallmark of his, with the most blatant example being the short story "Tear It Up, Terry Downe" (1988). Such refusal to moralize necessitates different interpretations without arriving at the "real" person, as in life. "A Date with Hopey" (1986–87), while partly rooted in autobiography, extends this technique by utilizing an outsider to Maggie and Hopey's world as narrator. "That story

was sort of an eye-opener for some, because I showed a weak side of Hopey. I thought humanizing her helped the character, but some people liked her as a cannonball that couldn't be stopped. I try to figure out which characters to leave alone and which characters to pursue going into their brains. I stopped giving Hopey thought balloons on purpose because you're not supposed to know what goes on in her head—you're not supposed to know what's going on inside, just what you see."

Balancing just the right amount of defining information is an ongoing struggle for the artist: understanding, but not liking, that a certain readership focused on the pin-up quality of his work, Hernandez made explicit Maggie's evolution from cute, spunky girl mechanic to heavyset post-punk in "The Adventures of Maggie the Mechanic" (1988). Much to the consternation of a vocal segment, Hernandez was certain that Maggie's weight gain, which began early on, was crucial to her core, and in this short story she reads about—and razzes—her depiction in the earlier adventure stories. In distancing his work from those traditional comic elements, Jaime demonstrates both how far he's come as well as an awareness of his early comics' pin-up attraction and the concordant sexist interpretation of Maggie as a one-dimensional character, pining for a big hunk: "That was

Original artwork for "Locas: 8:01 AM," page 3, detail,
Love and Rockets no. 18, 1986.

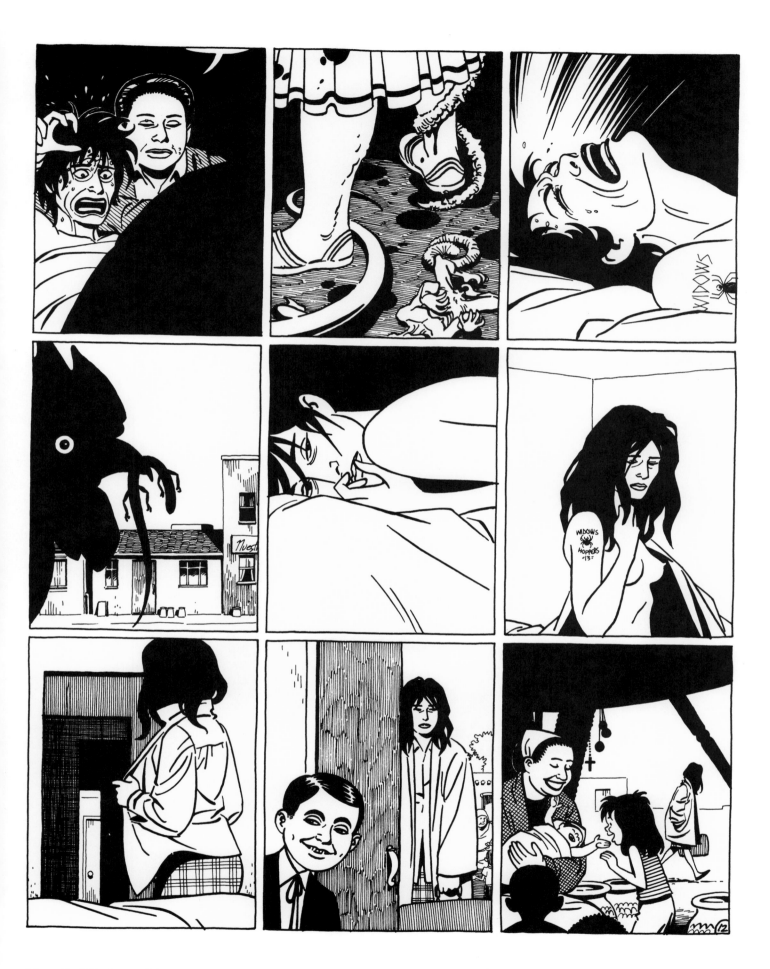

"Flies on the Ceiling," page 12, *Love and Rockets*
no. 29 (Fantagraphics Books, 1989).
"Some of the best comics don't need words—Otto
Soglow's *The Little King* is a perfect example."

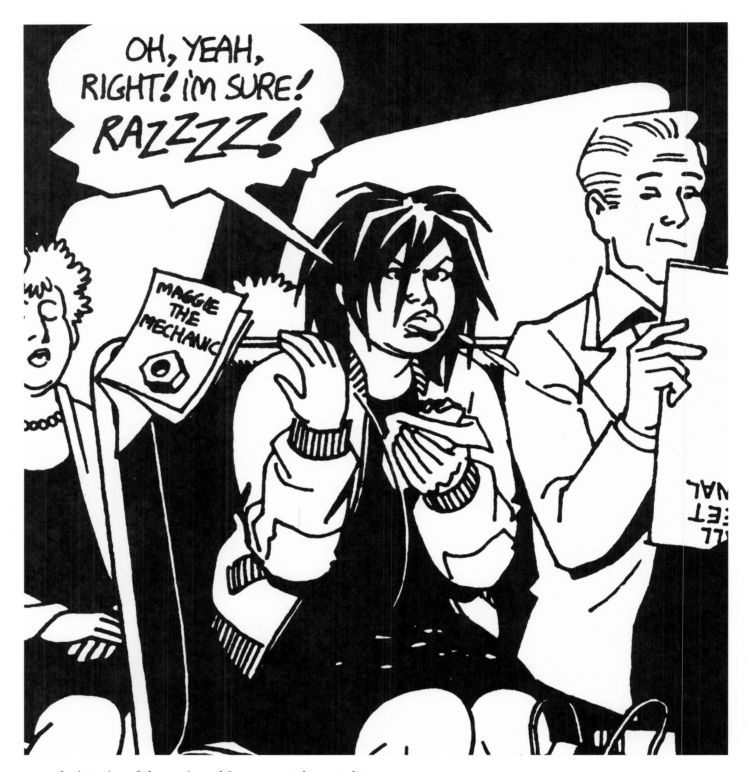

never the intention of the comic, and I never wanted to put that across, so this was kind of telling you 'That's not what I meant!'" Such reconciliation of the two "worlds" Maggie has inhabited, her home life and work, or "science-fiction," life are brought into sharp contrast through Hernandez's overt explosion of comics' idealized body type, which he has helped to redefine.

"The Adventures of Maggie the Mechanic," page 2, detail, *Love and Rockets Bonanza!* no. 1 (Fantagraphics Books, 1989).

OK, LET'S TALK ABOUT ASS-HOLES. THESE GUYS WE'RE TOURING WITH. THE FORTY THIEVES. THEY NEVER LET US STAY IN THEIR MOTEL ROOMS (ALMOST NEVER), NO MATTER HOW COLD IT IS OUTSIDE. OI, TRYING TO SLEEP IN A STATION WAGON WITH MONICA SNOR-ING IN YOUR EAR IS NO FUN AT ALL, THANK YOU.

SPEAKING OF THE WITCH, AT THIS MOMENT I WRITE, MONICA IS ON EVERYONE'S DEATH LIST, NOT JUST MINE. ONE TIME IN MANTA, TERRY WOKE UP ONE MORNING WITH MONICA'S GUM IN HER HAIR. IT WAS A FUN THING TO WATCH TERRY CHASE OL' MONICA FOR ABOUT A MILE IN THE SNOW, WITHOUT ANY SHOES. IT'S A GOOD THING FOR TERRY WE MET SOME HAIRSTYLIST GUY WHO FIXED HER UP PRETTY GOOD. AND IT'S A REAL GOOD THING FOR MONICA THAT TERRY CAUGHT A COLD AND DIDN'T FIX UP MONICA PRETTY GOOD.

ANOTHER NIGHT AFTER A GIG IN BANNON, MONICA FELL ASLEEP IN THE STATION WAGON WITH ALL THE DOORS LOCKED, AND IT TOOK US AN HOUR TO WAKE HER. MAN, IS IT THE ICE AGE EVERYWHERE IN THE DAMN WORLD BUT IN HOPPERS? BRRR...

I'M TELLING YA, I WISH TO HELL MONICA WOULD SET-TLE ONCE AND FOR ALL ON A NAME FOR OUR BAND. JUST WHEN WE GOT USED TO THE NAME "LA LLORONA," SHE STARTS BUGGING US ABOUT "JERUSALEM CRICKETS" OR "JOE E. ROSS ARMY." AND IF THAT AIN'T ENOUGH, SHE THREATENS TO QUIT THE BAND EVERY OTHER DAY. WE EVEN PLAYED WITHOUT HER A FEW TIMES. I SWEAR, IF IT WASN'T FOR HER SHARE OF THE DRIVING, SHE WOULD BE LYING ON THE SIDE OF SOME TEXAS ROAD STRANGLED TO DEATH. MY GOD, WHAT AM I TALKING ABOUT, DRIVING? THE BITCH HAS GOTTEN US LOST AT LEAST SIX TIMES, LET ALONE ALMOST KILLED.

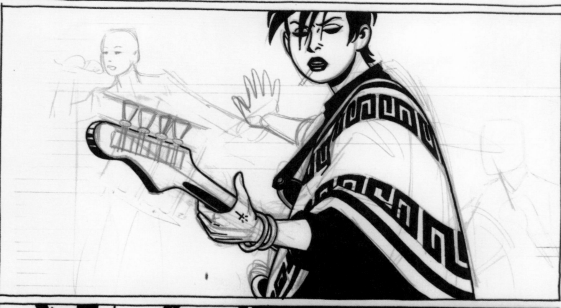

ANYWAY, MAGGOT. I MISS YOU LOADS AND I WISH YOU WERE HERE THIS SECOND.

HUGS AND KISSES,
HOPITA

Original unfinished artwork for "Jerusalem Crickets,"
c. 1987.
"At first the story was supposed to be told through the letter, but I changed it to be about Hopey writing the letter. I changed it because the letter had information we didn't need to know."

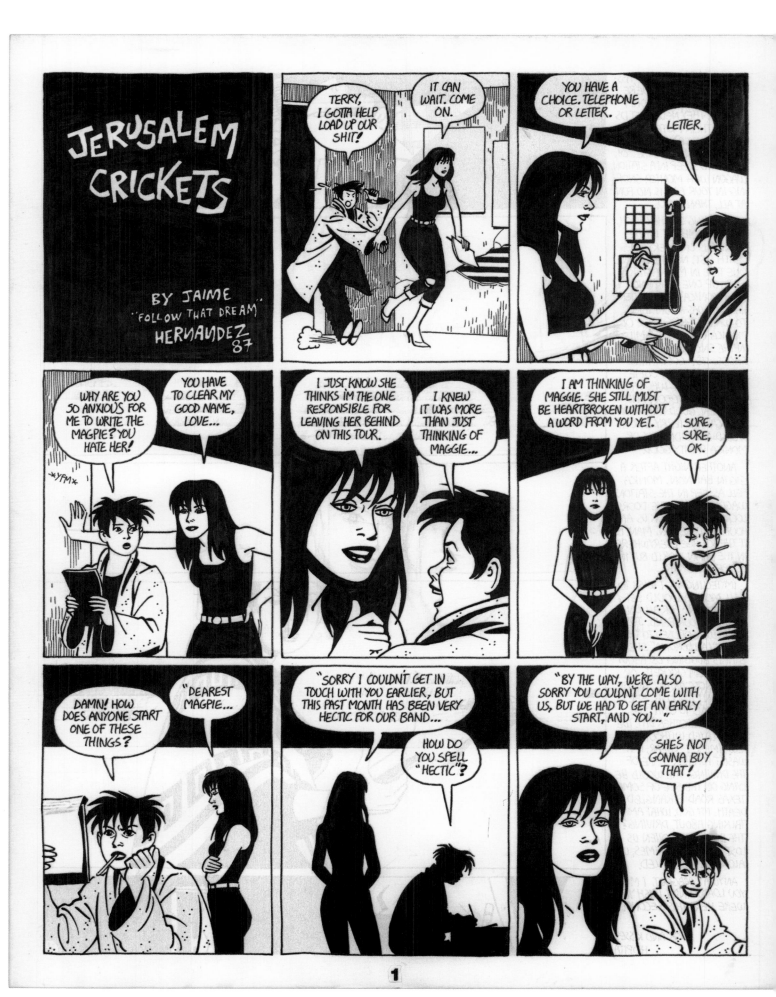

Original artwork for "Jerusalem Crickets," complete
two-page story, *Love and Rockets* no. 22, 1987.

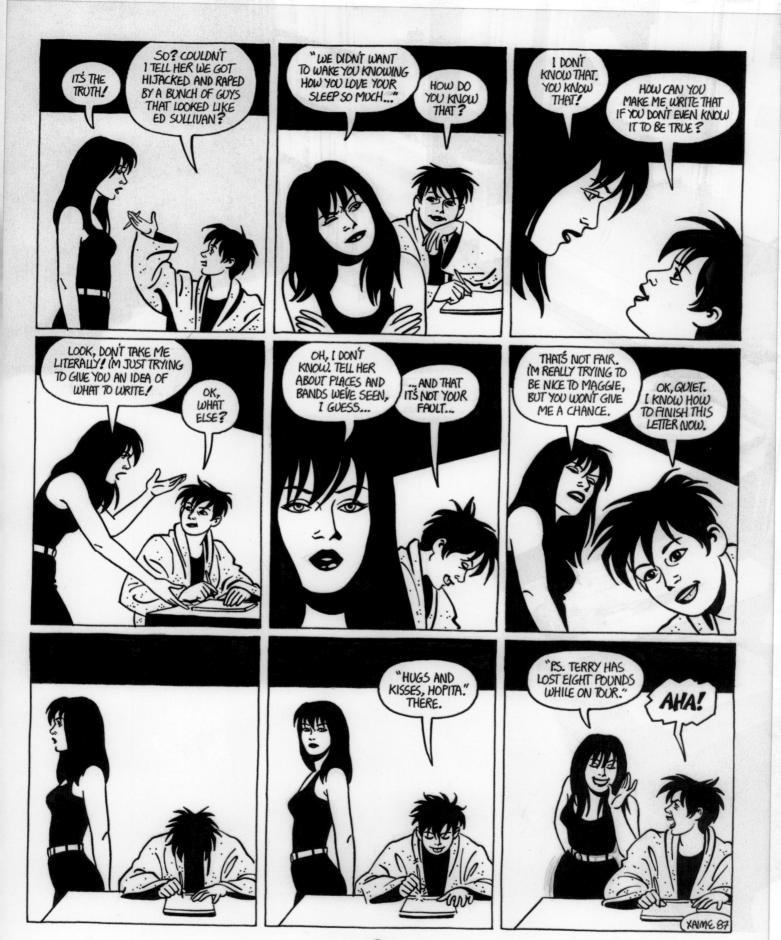

Hernandez's studio, 2009. Photo by Jordan Crane.
"I've only had this setup for the past five years. I could
confess that not even half the art materials are used."

The Art of Narrative: "Spring 1982"

"SPRING 1982" (1989) is a self-contained story depicting a pivotal time in the life of Doyle Blackburn, a friend of Maggie's and Hopey's, who plays a prominent supporting role throughout Hernandez's *Love and Rockets* stories. Hernandez frequently employs short stories to fill in the blanks of complementary characters' histories. Here Doyle returns home from prison and attempts to reestablish his life within a druggie vortex that he quickly realizes he needs to escape. As indicated by both the title and Maggie and Hopey's great cameo, the story is a character study localized to a specific time—a study of the world swirling around him as much as of Doyle the individual, whom Hernandez thought of as a "sad, lost kid from a white trash background who needs people like Ray around to keep himself from sinking." The story formed in his mind as predominantly visual, so he intentionally included no expository captions or thought balloons, only image and dialogue, and much of the narrative is conveyed through subtle expressions, beads of sweat, folds of clothing, and sound effects. Communication with the reader is achieved through visual and verbal communication between the characters.

As with most of Hernandez's comics, stories he hears from friends or family serve as the springboard for narratives that become more involved and alter shape depending on which of his characters seems best suited. In this case, the impetus was a specific conversation:

I'll occasionally go back to Oxnard and hang out with my buddies, drink beer and "Talk about the old days!" One time we were hanging out in my friend's front yard drinking beer, and across the street there was a bachelor party, which was just packed, you know. This guy came out, a white guy, who was obviously nervous in this Mexican neighborhood. You're either nervous and run away, or nervous and talk someone's ear off, you know? He came over: "Can I have one of those beers?" Obviously this guy was not of our world, and he told us this story about how he was there with the strippers to collect the money. He sat there nervously telling us this story, and he was just rambling on and I could tell a lot of it was lies, trying to portray himself as a tough guy: "One time they chased me out of there with a shotgun, and I went back there with my Uzi, and I told them!" Okay, that's a good story, but . . . [laughter] I kind of took the best parts of that and created the story for Doyle. I remember thinking that this was good material: "I'll steal that!" I would say the best parts from my work are stories that I've heard, things that I couldn't even begin to write. They're too amazing . . . and they're real.

The story "Spring 1982" is a fertile example of Hernandez's cunning storytelling, here perfectly self-contained: the title page masterfully sets the tone, the unexpected device of a running toilet providing a metaphor for Doyle's troubled character, reappearing throughout the story, then in the last tier of panels to provide closure. Character and storytelling are always foremost, so visual clarity and readability is the goal. Hernandez saves particularly striking compositions for panels that are important to the narrative, seducing the reader's eye to pause there (see the last panel on page 2). While the early stories bear witness to the process of a young cartoonist figuring out how to make pages work—Jaime describes them as a "free-for-all," with variously sized panels—he gradually developed a more economical way of working using a standard system of panel breakdowns. In a 2000 interview published in *Comic Book Artist* magazine, he explains his lack of interest in tricky panel divisions and formal shenanigans: "The frame, to me, is just the frame. It's the picture you look at, not the panel . . . I've been probably using the same grid, mostly since the sixth issue. Just the basic six-panel or nine-panel, two tiers, three tiers . . . it's all been pretty basic and static, just because the whole layout of the panels is not that important to me, it's the actual pictures you're reading." Lovingly rendered details, graceful shifts in point of view, and telling body language—particularly the concluding panels of Doyle sleeping—work together to tell the reader all there is to know about Hernandez's affection for his characters, in all their fallibility.

"Spring 1982" is printed complete here from the original black-and-white artwork to give a sense of Hernandez's working process and his flawless inking technique. This story is particularly instructive in terms of composition, as paste-ups are visible to indicate where certain panels are repositioned in mid-narrative to alter the story's flow (most of Hernandez's originals are so flawless, they appear to be copies at first glance). Typically bouncing around from page to page, here he began with the last page, which in its leisurely pacing gives an indication that he originally conceived of the story as longer. During this period Jaime couldn't bring himself to throw away drawings, so he occasionally cut and pasted panels in new positions in the story to emphasize important points, rather than discarding them and starting over. Today he lightboxes panels onto a new board once he gets the composition to his liking, having lost his preciousness regarding the disposing of artwork.

Once Jaime established a preferred standard grid system, he began writing initial story concepts and notes on separate notebook paper, though in his new work a good deal of this writing is done directly on the Bristol board. From the beginning, Hernandez has used the same size Bristol (11 x 14 inches for magazine format and 9 1/8 x 14 inches for comic book format) and the same inking tool, a Hunt crowquill number 22 nib. He inks with one nib until the line gets too thick, switches to a new one to achieve a thinner line again, which then gradually thickens, and so on. After roughing out panels in pencil, he letters and hand-rules the panel borders with a Rapidograph pen, traces and draws contours with the crowquill, erases all pencils, then fills in the black areas to avoid fading from the eraser. The final inking, which brings to life his art's nuances and details, comes after all that. Hernandez actually does little penciling in the traditional manner—his pencils function as breakdowns, and much of the reworked drawing is done directly in ink. The "art" is solely in the final, inked line. As he states, "a pencil is a much more intimate tool—you can use three lines to make a really soft line that's full of juice. You put ink down and it's a line. You have to make that one line come to life somehow."

Tools of the trade, 2009. Photo by Jordan Crane. Clockwise from top left: **Ink bottle:** "It's actually a make-up bottle for mixing powder, making your own, from that store in the valley, Naimie's. The well goes straight down. I'd been looking for a narrow well, basically just to keep less ink in the well because of

drying out and all that. This is filled with the blackest ink I could find." **Nib, wooden handle:** "I use it for drawing every line of art on the page. 'Nuff said." **Nib, black handle:** "Same type of nib, just more aged and worn. I use this if I want to draw something big and broad. Usually for illustration work." **Blue eraser:** "For

erasing lettering mostly, because it's thinner, so I can keep the guidelines." **Rapidographs:** "The red one, the no. 2, is for lettering. The green no. 3 is for panel borders, balloons, and blacking in next to the lines before I fill in blacks with my makeshift broad-stroke brush." **Pentel Brush Pen:** "It comes pre-filled with

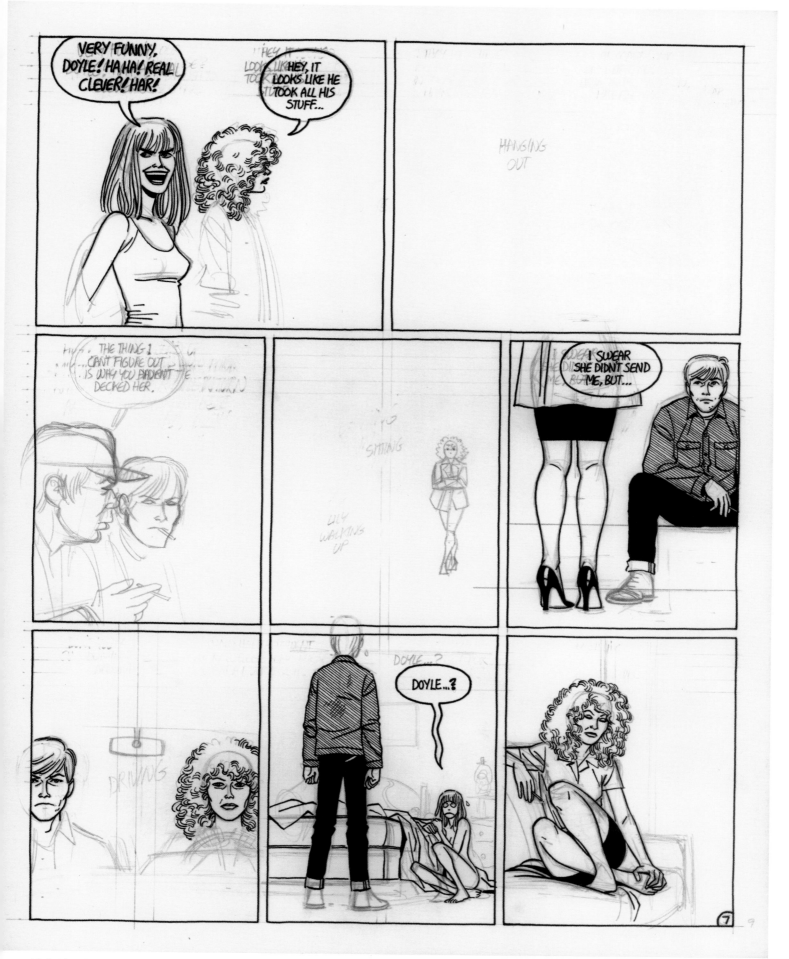

ink, but I use it as a regular dip brush. I use it because it has a cap and I never have to wash it—I can just use it and put it away." White-out brush: "Any thin brush will do. I'll go to Target and get a kid's brush even, because I use it to hide mistakes, not to draw with." Water bottle, thin: "This is for thinning my ink,

because I'm too lazy to go to the sink to do it." Water bottle, wide: "For cleaning white-out brush, lazy. See above." Paper napkin: "I wipe my drawing nib off with it, instead of washing it like real artists." Eraser: "For erasing all the pencil lines." Pencil: "2H, because it doesn't smudge as much as a regular no. 2."

above
Original unused artwork for "Spring 1982," 1989.

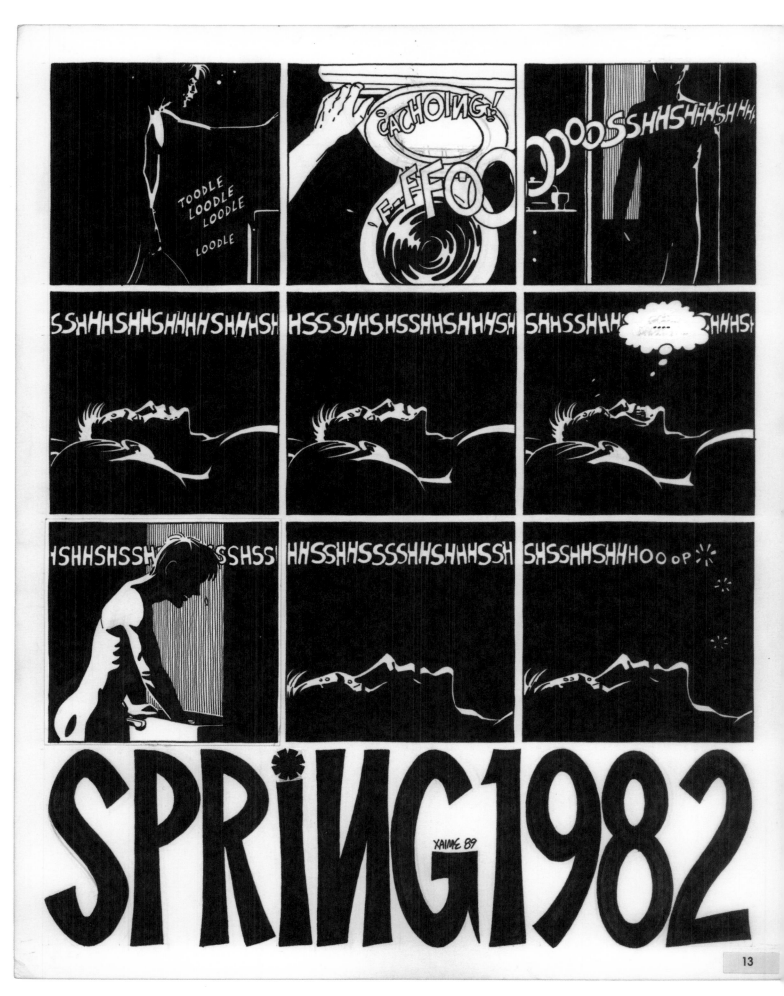

above and following pages
Original art for "Spring 1982," complete twelve-page
story, *Love and Rockets* no. 31, 1989.

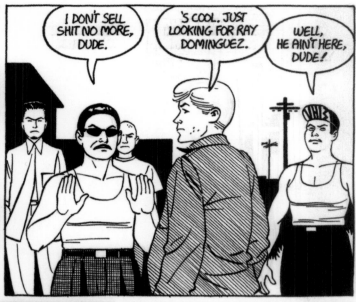

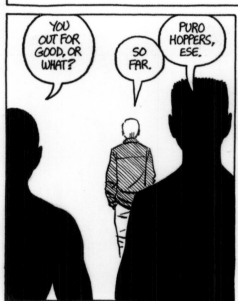

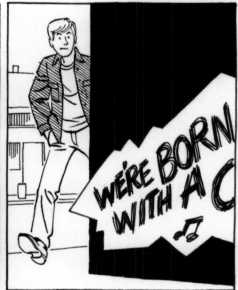

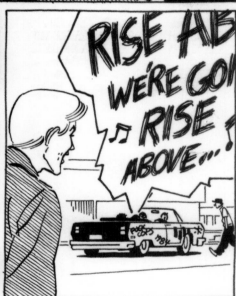

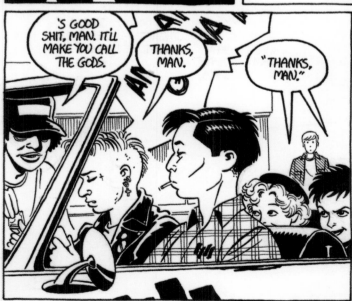

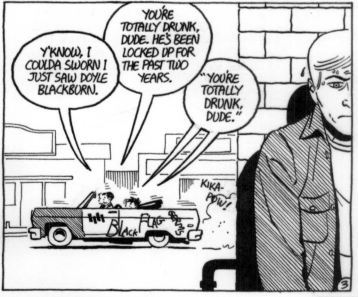

SSHHSHHHSSHHSHH SSHHHSSHHHSHH HSSSSHHSHSHHSS SHSHHHOoooP

OK, SO WAIT OUT HERE THEN! JUST DON'T FORGET TO BREAK US UP AND COLLECT AT MIDNIGHT! OK? OK?

C'MON IN, LADIES. WE GOT THE BACHELOR ALL SET, FRONT ROW CENTER.

JUST LEAD US TO HIM.

HEY, DRUGMAN. 'SUP?

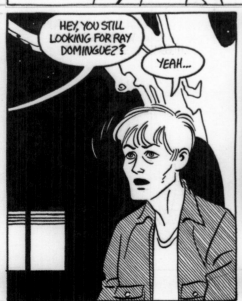

HEY, YOU STILL LOOKING FOR RAY DOMINGUEZ?

YEAH...

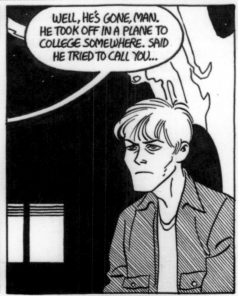

WELL, HE'S GONE, MAN. HE TOOK OFF IN A PLANE TO COLLEGE SOMEWHERE. SAID HE TRIED TO CALL YOU...

HERE WE GO, LADIES!

YEEHAW! ¡AI!

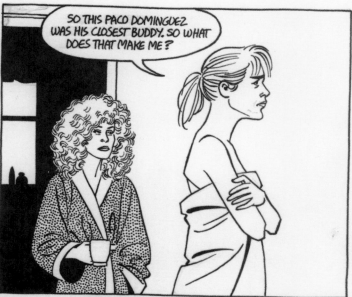

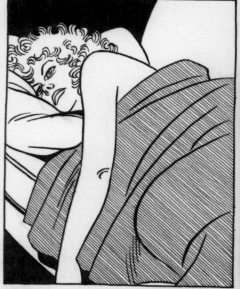

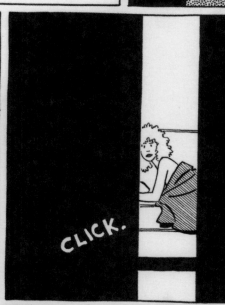

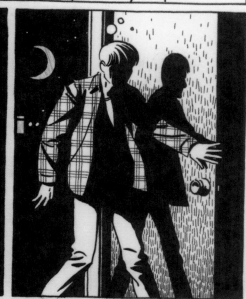

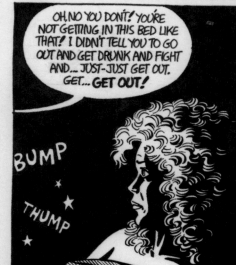

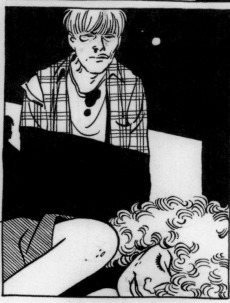

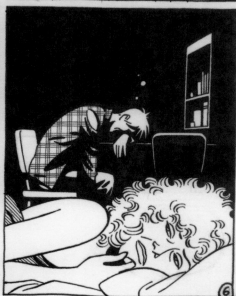

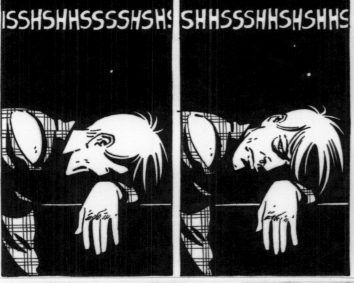
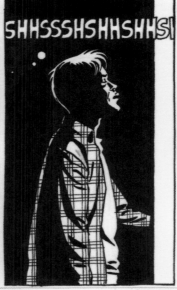
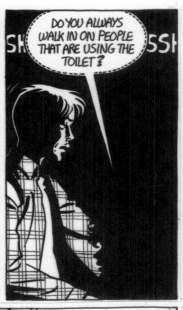
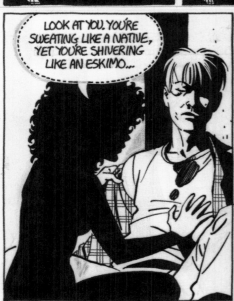

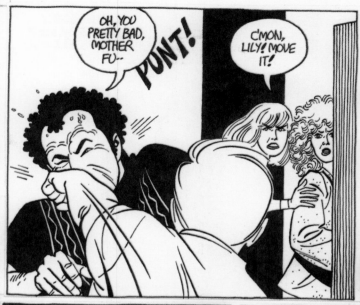

OH, YOU PRETTY BAD, MOTHER FU—

PONT!

C'MON, LILY! MOVE IT!

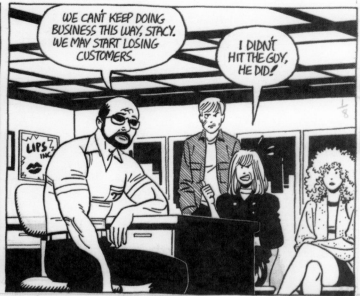

WE CAN'T KEEP DOING BUSINESS THIS WAY, STACY. WE MAY START LOSING CUSTOMERS.

I DIDN'T HIT THE GUY, HE DID!

STACY, DANCING FIFTY-FIVE MINUTES AND CHARGING A FULL HOUR IS OK, BUT FORTY-FIVE MINUTES JUST WON'T DO. DOYLE ON THE OTHER HAND...

TEDDY JUNIOR
OWNER
LIPS, INC.

I LIKE THE WAY YOU HANDLED THE SITUATION. SOMETIMES THESE DEADBEATS HAVE TO BE SHOWN JUST WHO THEY'RE DEALING WITH.

BUT IF I MAY SUGGEST SOMETHING: YOU MAY WANT TO THINK ABOUT PACKING FROM NOW ON. I HAVE A FRIEND WHO CAN GET YOU A GREAT DEAL ON... BLAH BLAH... .38...

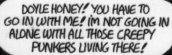

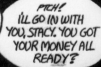

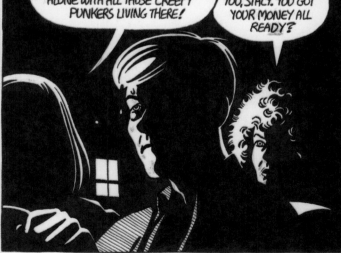

DOYLE HONEY! YOU HAVE TO GO IN WITH ME! I'M NOT GOING IN ALONE WITH ALL THOSE CREEPY PUNKERS LIVING THERE!

PTCH! I'LL GO IN WITH YOU, STACY. YOU GOT YOUR MONEY ALL READY?

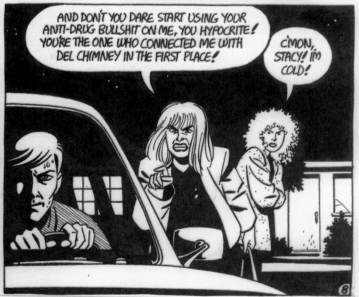

AND DON'T YOU DARE START USING YOUR ANTI-DRUG BULLSHIT ON ME, YOU HYPOCRITE! YOU'RE THE ONE WHO CONNECTED ME WITH DEL CHIMNEY IN THE FIRST PLACE!

C'MON, STACY! I'M COLD!

8

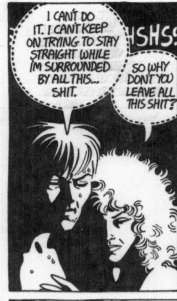

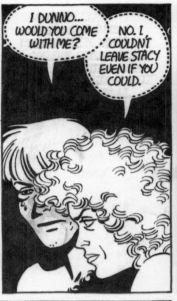

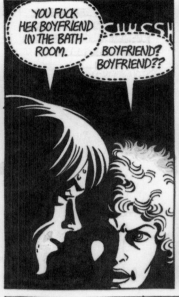

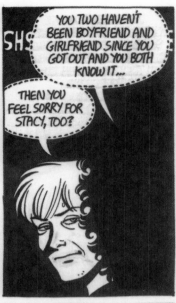

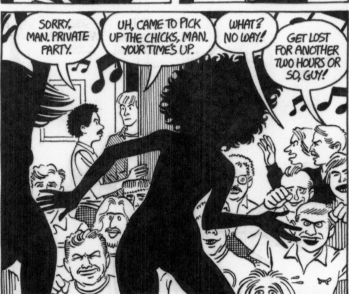

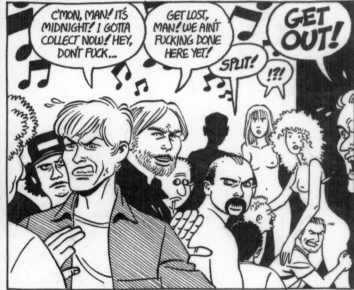

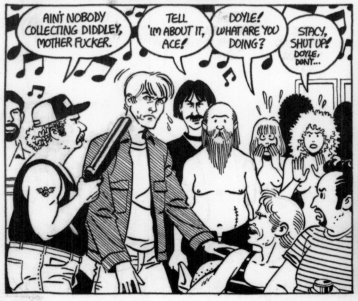

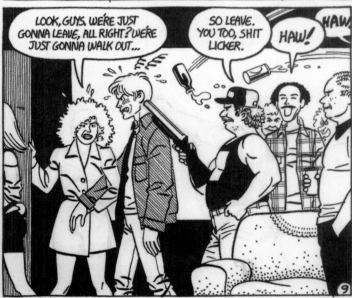

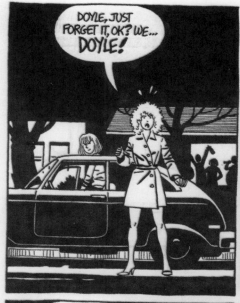

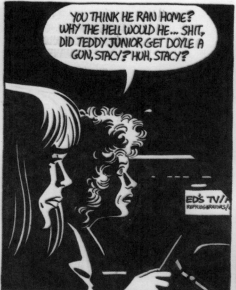

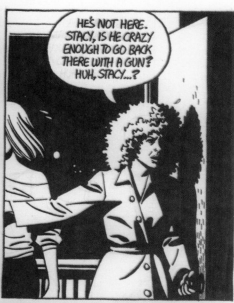

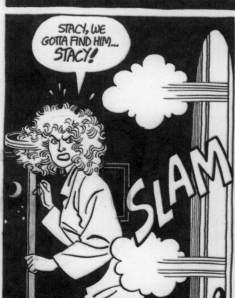

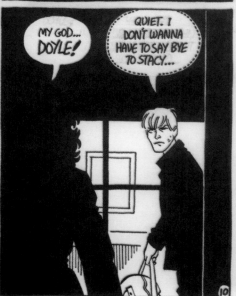

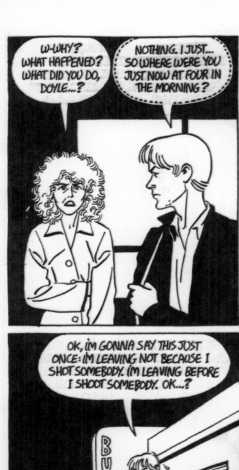
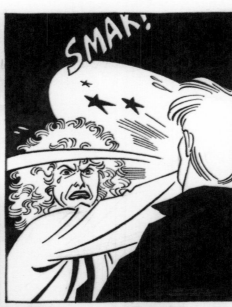
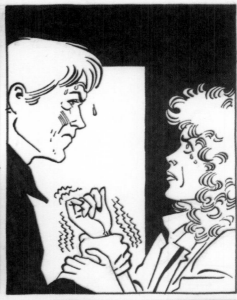
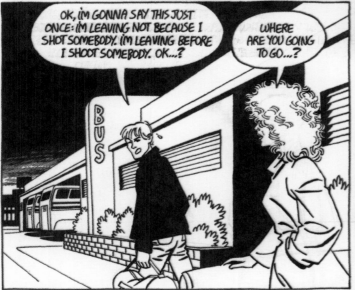
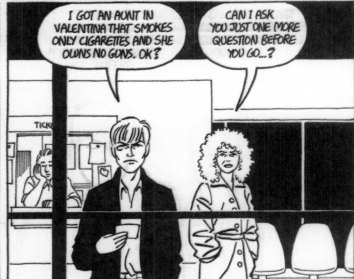
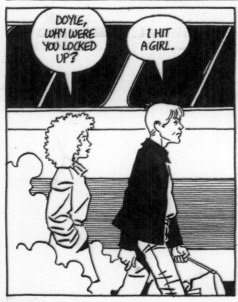
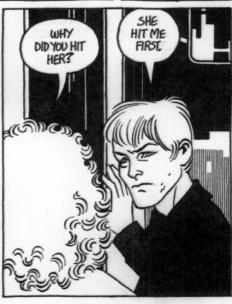

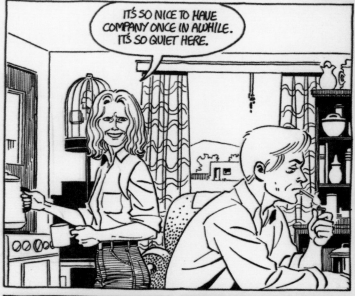

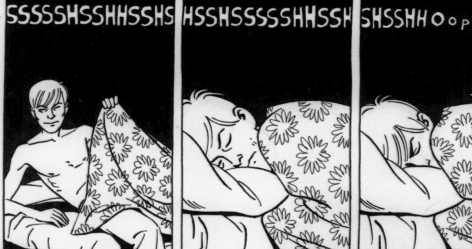

NINETY-THREE MILLION MILES FROM THE SUN

...AND COUNTING

BY the FAKE Santa CLAUS 88

2

Original artwork for "Ninety-three Million Miles from the Sun," page 2, *Love and Rockets* no. 30, 1988.

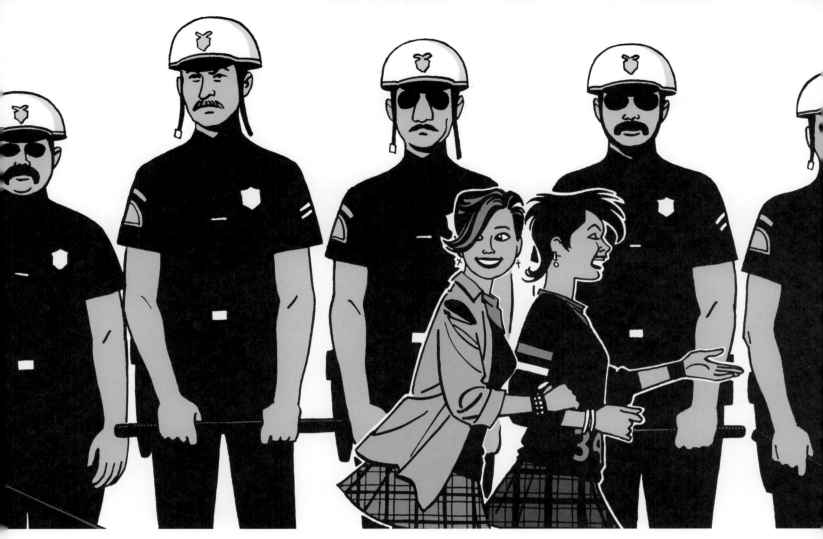

"Wigwam Bam" and "Chester Square": 1990-1996

Not knowing what to do
Not knowing what to do
Not knowing what to do
Not knowing what the fuck to do
Dr. Know
"What to Do" (1987)

I really don't know what punks do after punk.
Jaime Hernandez
from a 1989 *Comics Journal* interview

IF HERNANDEZ'S EARLY STORIES still needed an adventure hook before moving to character-driven narratives, the second half of *Love and Rockets*' fifty-issue span reconfigured such definitions entirely. This dense story arc begins with "Jerusalem Crickets" (1987), which finds Maggie and Hopey separated, and offers a snapshot of the drudgery of a touring punk band that rivals the verisimilitude of Latino gang culture in "The Death of Speedy."

The key transitional story "Ninety-three Million Miles from the Sun" (1988) finds Maggie reunited with Hopey, but their time together won't last long: "There's something in me that I can't keep them

together. And I agonize over it, 'Why can't I?' They're constantly being pulled apart and yet, it's not okay with them. It'd be different if they just went and led their separate lives and saw each other once every ten years, like a lot of old friends do. But there's something that keeps pulling them together, even if they can't be together."

With the subsequent eight-part "Wigwam Bam" (1990–92), Hernandez continued to expand on the ambition of "The Death of Speedy," and characters' histories began filling out and bouncing off of one another kaleidoscopically. By this time the players were familiar enough that Hernandez trusted the reader to keep up with

Love and Rockets no. 33 (Fantagraphics Books, 1990).

above and opposite
Hernandez's childhood and adult versions of page
one from the story "Easter Hunt," which demonstrate
the continued impact of his youthful love of comics
and the influence of older brother Gilbert on his
work. The story actually first appeared in the
homemade comic *Easter Book* (c. 1967) by Gilbert,

and Jaime subsequently re-did it three times: in
his homemade comic *Jimmy & Jeff's Easter Book*
(c. 1969–70) and, shown above, in an issue of
his ongoing *All the Young Dudes* (1973), then,
shown opposite, in *Love and Rockets* no. 42
(Fantagraphics Books, 1993).

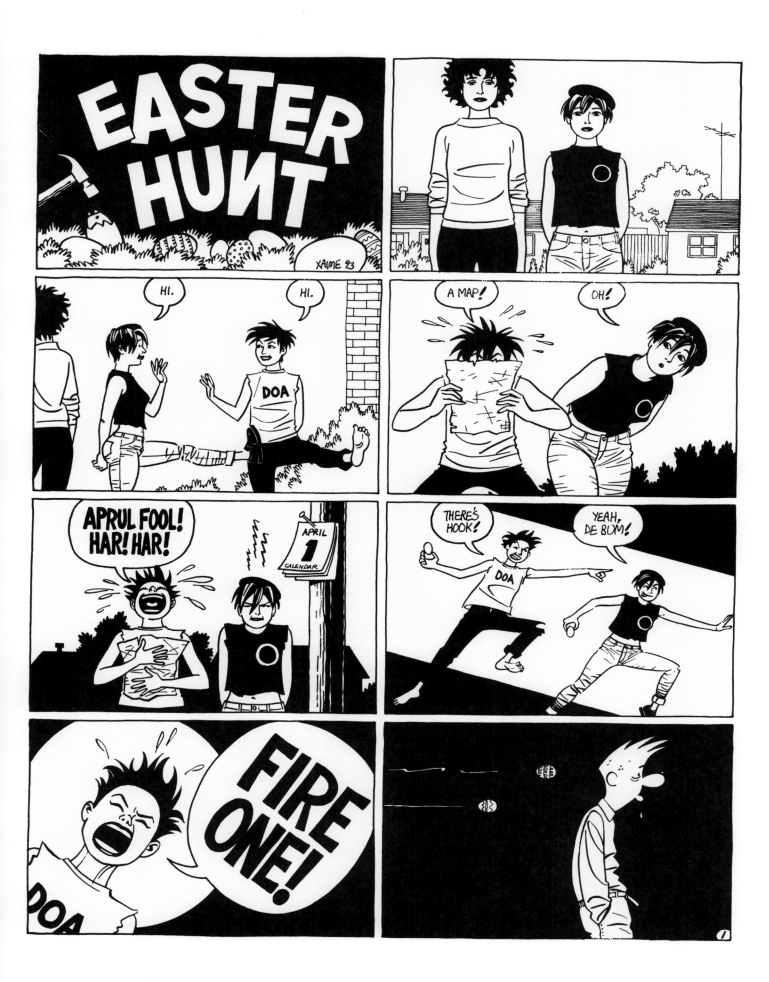

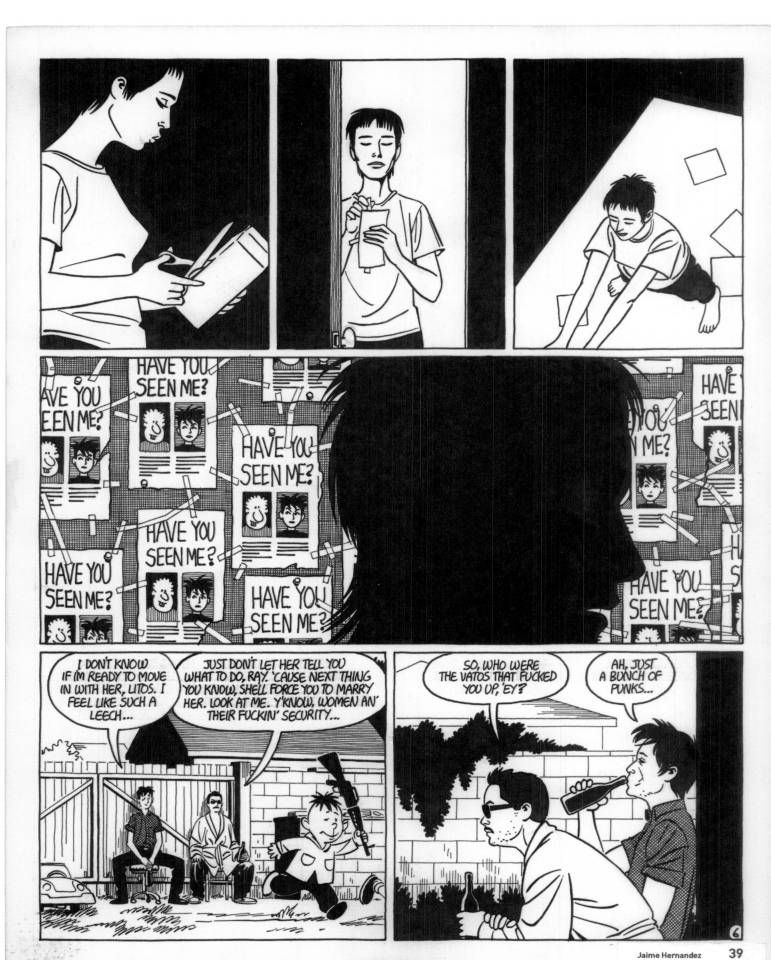

Original artwork for "Wigwam Bam, Part 3," page 6,
Love and Rockets no. 35, 1991.
Note Izzy's face in the middle panel: "At first she was
looking directly out, but I overworked the rendering,
which didn't work in the context of the page, so I
blackened it out and made her in profile."

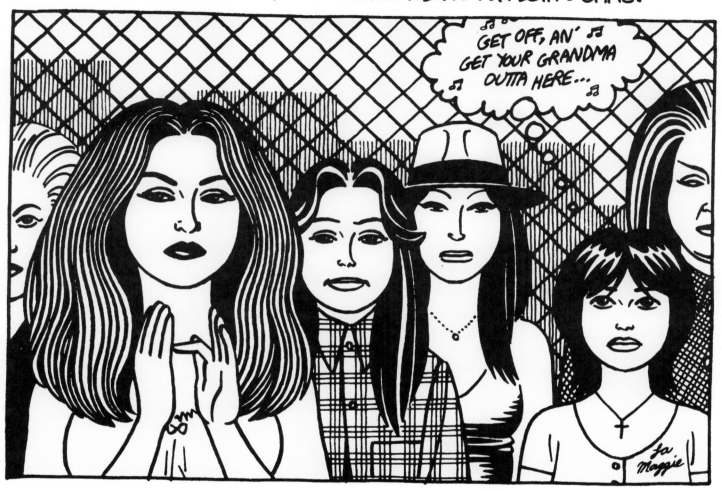

increasingly more radical flashbacks and switches in locale. The story's considerable length was an accident, evolving into something unplanned, and a gamble, as individual issues didn't offer easy access to such a complex narrative. Hernandez had now arrived at a densely interlocked world, and this sprawling epic is arguably his most impressive self-contained story to date—a panoramic meditation on absence.

The travelogue begins with Maggie and Hopey's haphazard arrival on the East Coast and continues to follow Hopey's life there once Maggie abruptly bails out, while also beautifully fleshing out the characters left at home in Hoppers. In the stories leading up to this point, the transformation of the original wave of LA punk into ever more calcified hardcore is delineated through understated cues that point to Maggie and Hopey's vanishing place in that world with every passing year. By dislodging Maggie and Hopey from home, Hernandez writes the moving first chapter in a definitive reflection of the confusing formlessness of punk's demise; both Gilbert and Jaime got out of the increasingly cliquey and violent scene by the mid-eighties—as Hernandez says, "I got into punk because I *wasn't* a jock!"—so the passing of this life had a personal resonance.

Location is a dominant character in *Love and Rockets*, and

Hernandez chose a nameless East Coast city as the setting because he wanted them to be as far from Hoppers as possible, while still in the United States. The examination of ethnicity in different locales is an important underpinning, and characters are brought into sharper focus through conflicting reactions to their loss of cultural footing: "Some people allow their lives to change and others don't. It's obvious Maggie's a small town kid and all she wants to do is get home. Hopey is raised as a big city girl, and also was basically raised white, so the world is sort of her oyster. Maggie's not white, and so growing up, society is not her oyster—she's just allowed to live in it."

Hernandez's titles are always both iconic and insinuatingly evocative. "Wigwam Bam" is taken from a 1970s pop hit by the Sweet and provides a pop culture springboard that magically evokes a deeply personal flashback. The centerpiece is an entry in Maggie's diary that Izzy reads while searching for her—to the young Maggie and her friend Letty, the song was a metaphor regarding cultural difference and identity, and in particular the mythic proportions that such childhood experiences take on later in life, themes that Maggie will continue to question throughout her stories. While abundantly engaging, as only the most complex art can be, Hernandez's comics are also great entertainment. His formal virtuosity is in the service

"Wigwam Bam, Part 8," page 9, detail, *Love and Rockets* no. 39 (Fantagraphics Books, 1992).

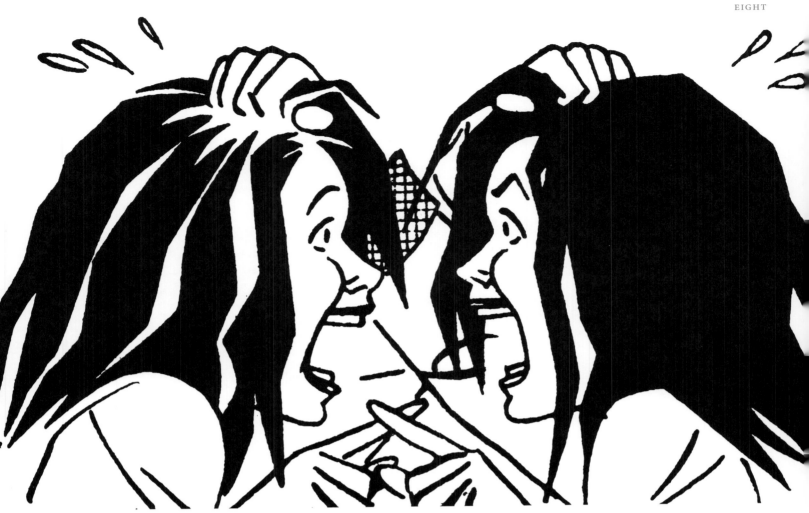

of characterization, altering one's perception of the world while the full range of humanity dances on and below the surface of the page.

During this period, Hernandez's cartooning begins to reincorporate the detail of his early work within the starkness of the last few years, but in a way that has virtually nothing to do with the dense shading of the early issues, and doesn't in any way refute the pinpoint clarity of "The Death of Speedy." Here, detailed hatching, used judiciously, becomes a framing device, pushing forward and back in the panel plane. As Jaime described in a 1995 *Comics Journal* interview, readers "don't know how hard it is *not* to put in a lot of lines. I just noticed as my art progresses—or regresses—that it's becoming more abstract in that all the lines are beginning to go somewhere. Where in the early days the lines just fit the drawing. Now I'm balancing a lot of little lines in one corner, and putting less lines in the other corner. I'm actually paying more attention to composition, where I used to just put it down unconsciously. Now I guess with less lines to work with, the more I put them to work." Or as he states more simply, "I've always drawn in the way I felt fit the story." A single page from the first chapter of "Wigwam Bam" touches on nearly all of the formal and narrative elements found in his work, providing great insight into his refined comics storytelling.

By gradually draining background detail, the first panel fades into a flashback by Hopey. As she turns from Maggie in the second panel, the narrative also pivots away from the temporal and physical space leading up to the exchange, and the deftness with which the switch occurs is merely one example of Hernandez's constant polyphonic mastery, which harmoniously juxtaposes two or more simultaneous narrative threads, be they visual, verbal, or both. Riot-gear-clad Los Angeles policemen replace the hallway of an East Coast apartment building as 1980 replaces 1990. The transition is simultaneously gradual (linked by the urban backgrounds), and decisive, abruptly completed in the large center panel, the background emptiness replaced by a swarming mass of punks taunting and facing off against the police; stark white is

replaced by seething black. Contrasts abound in the page, yet visual and textual links bridge time and space. In no other medium could these scenes be interspersed and produced to the same effect. In no other medium could the reader/viewer experience the same collision of time and locale, emotional involvement, and formal and conceptual flow. Yet Hernandez, as always, foregoes superficial formal experimentation in favor of reader interaction with the characters and narrative progression: his layout is exactly symmetrical, and the focus is within the panels rather than on the structure of the panels themselves (which relies on his standardized traditional comic book grid of three tiers, each composed of either two or three panels).

Deceptively simple black-and-white lines define space and weight, and extreme backgrounds are predominantly solid black or white, foregrounding the emphasis on characters and their interactions (or lack thereof). There are no hard melodramatic breaks, and the story washes out beyond the panel borders. The structure is intentionally repetitious, without splashiness, only slight variation, always inexorably moving forward, toward life's uncertain future.

The sprawling middle panel dominating the page is a contemporary frieze, wonderfully exploiting the larger horizontal dimension of the magazine format (as opposed to the taller, more narrow format of the comic book). The smaller surrounding panels incorporate word balloons, providing interaction, while the center panel is entirely devoid of text—language—and thus reduced to pure image. The reader's eye lands squarely in the middle of the action where spotlit figures heighten the inherently iconic stature of the cleanly inked comics image. A single character stands apart from the crowd, pushed even further forward in the picture plane, his scale punctuating the tight band of figures behind him. Despite the cramped inclusion of at least nineteen clearly delineated figures, the image is static, and the potential rioters do not interact, rather react simultaneously to the off-page presence of the police mass. As in the most successful comics,

"Ninety-three Million Miles from the Sun," page 13, detail, *Love and Rockets* no. 30 (Fantagraphics Books, 1988).

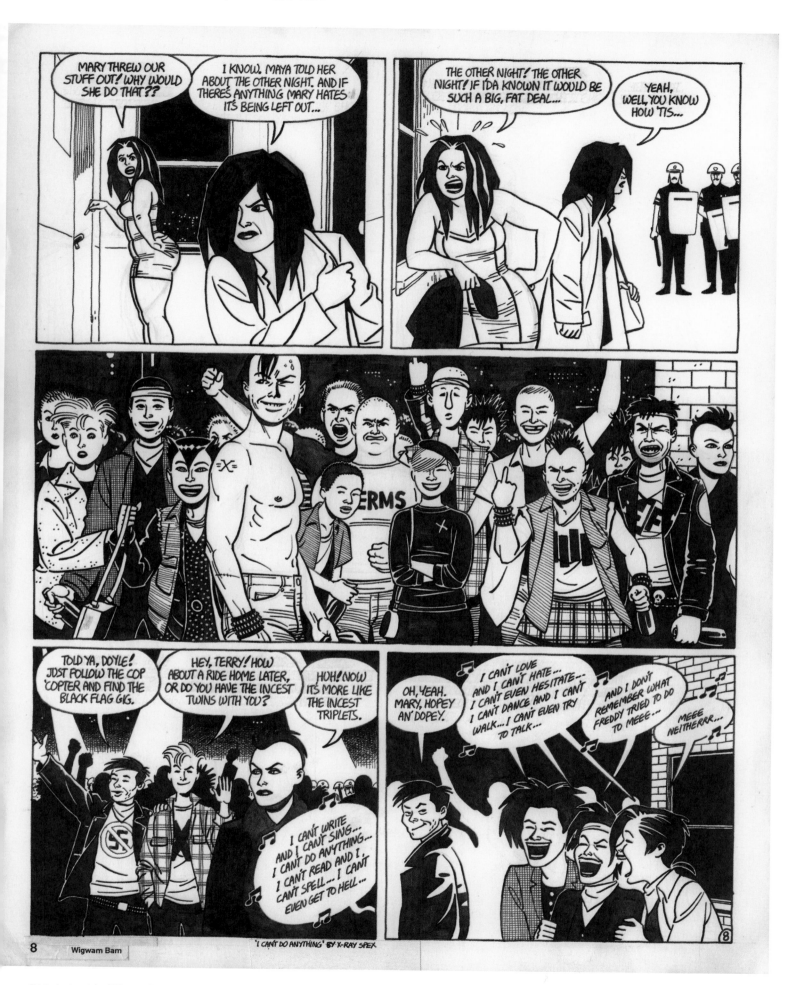

Original artwork for "Wigwam Bam," page 8, *Love and Rockets* no. 33, 1990.

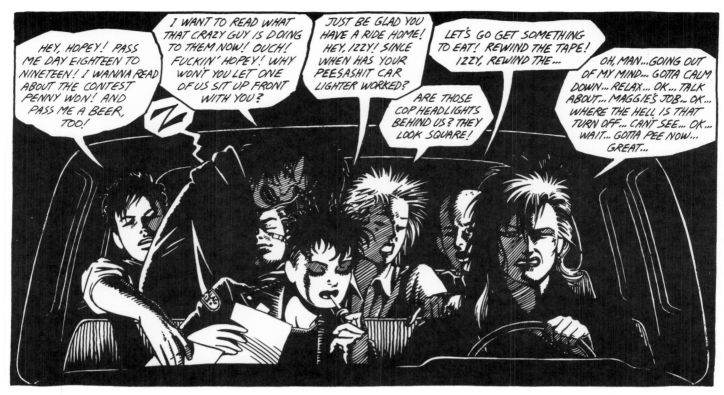

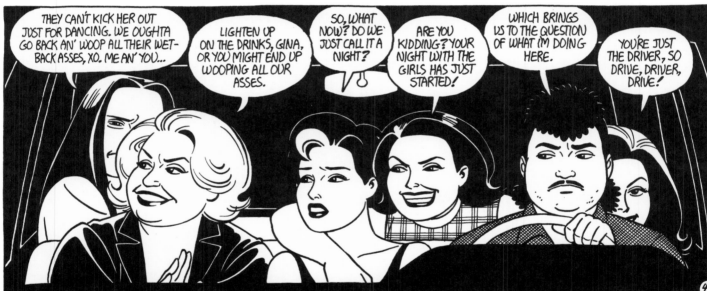

temporality is halted in a manner unique to comics, not in isolation but in both narrative and "real" time. Fixed expressions and gestures are framed and rendered immovable, and each, expertly composed, lurches the eye to a halt even as it is led, faster or slower, through the narrative, paced by the empty gaps between panels—the implication of the before and after always lurking. Here the gaze of every figure strikes directly out at the viewer, activating the scene. Space is flattened and pushed forward to the extreme of the panel surface; the viewer is thrust into the foreground, the space between the implied police threat and the wall of expressions ranging from arrogant, antagonistic, and fearful to bemused and disinterested.

Hernandez is able to tell extremely complex stories through comics' unique interplay between image and text, and the always carefully rendered minutiae in his art—folds of clothing, the gleam of leather,

and the slightest arc of an arm or swing of a hip—blossom into indeterminate narrative offshoots. Notice the hatch line delineating the jeans of the center panel's leading figure, swiftly rendered with a swagger that matches the combative stance of the jeering young man (compare this no-frills-impact blast to that of Crumb's fuzzed-out, noodly inking style for his spiritual-questing hippies, and the conceptual underpinnings of the form are immediately evident). While the art reads fast and slow simultaneously—fluttering between the traditional commercial prerequisite of moving the story along and the art of forcing the eye to linger on telling/symbolic details—Hernandez's narrative rhythm is never interrupted. He, more than any contemporary cartoonist, has harnessed the ability of a previous generation of craftsmen to delicately exploit the perfectly rendered, slickly expressive line to create a world unimaginable outside of comics:

Two panels of a similar scene, ten years apart, demonstrating Hernandez's evolving approach.
top: "Mechanics," page 18, detail, *Love and Rockets* no. 2 (Fantagraphics Books, 1983).
bottom: "It's Not That Big a Deal," page 4, detail, *Love and Rockets* no. 44 (Fantagraphics Books, 1993).

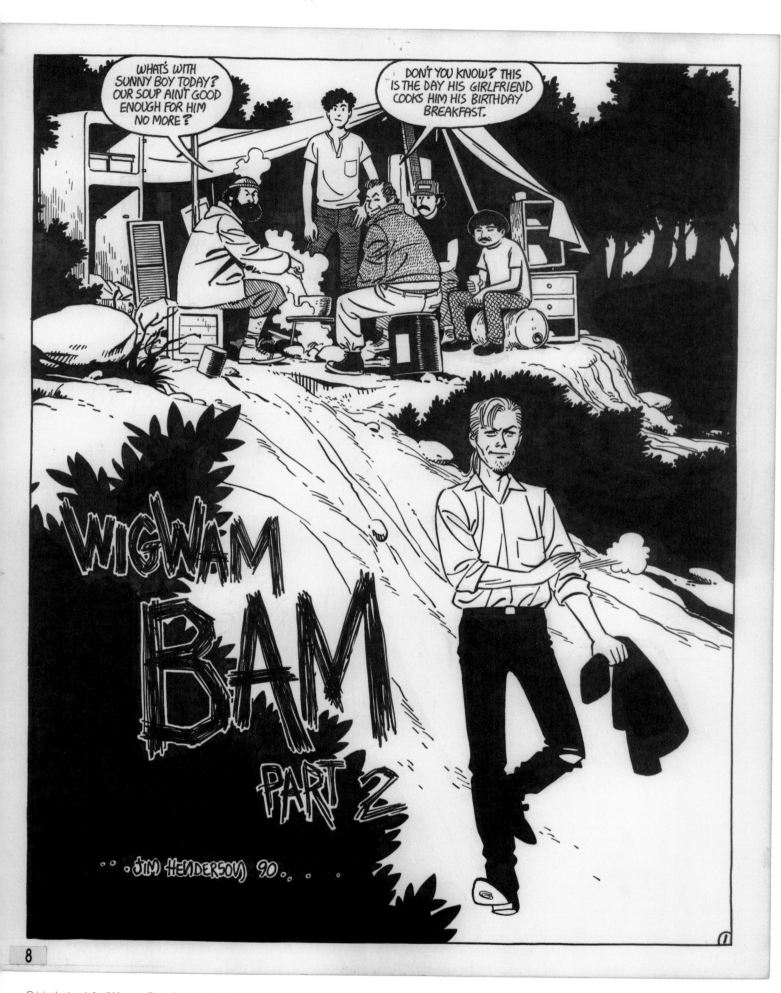

Original artwork for "Wigwam Bam, Part 2," splash page, *Love and Rockets* no. 34, 1990.

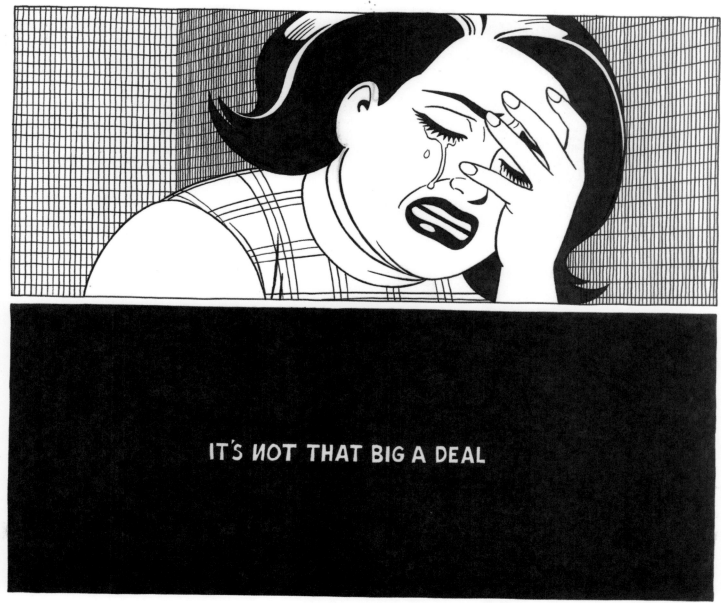

"I felt if one line could do the same job as a hundred it would make a far more impressive image. It's like growing older. There are just some silly details in life that don't matter as much as they did when you're younger. I'd like to think my line has matured over the years, for lack of a humbler anecdote." The details that do remain practically vibrate with emotional intensity, transcending the functional goals of mere illustration.

In "Wigwam Bam," as in all his work, Hernandez movingly weds multilayered narratives with radical fissures of time, place, and point of view. Entire histories are implied by understated visual cues, triggered by slight marks on paper, subplots as deftly integrated as the history of a house told through an errant newspaper lying forlorn on its roof. The abrupt switches in locale and compositional density from panel to panel are achieved through harsh black-and-white contrasts that create a disjunctive swirl through positive and negative space. Each panel activates the oscillating psychological space between characters as a physical presence, representing the challenge of the medium: to visually depict the nonvisual—thoughts and memory—by using the form's collectively remembered, standardized techniques, incorporating genre clichés in the creation of radically new subject matter and stylistic invention.

Hernandez's ultimate achievement in this story, and his overall subject matter, is a wide-ranging and nonjudgmental empathy. The recurring subtext of Hernandez's work for the last decade has been the reconciliation of youthful idealism (punk) and blind faith with the humdrum world of workaday normalcy. Crucially, Hernandez continues to tell stories after their superficial appeal has passed, detailing lives once the excitement of youth and all that goes along with it has faded to memory. How much of life after a given period is made up of remembrances and reactions to that time? The seeming formlessness or lack of a firm narrative direction in "Chester Square" (1993–96) and the related follow-up stories to "Wigwam Bam" that wrap up the first *Love and Rockets* series is exactly the point.

"Chester Square" picks up Maggie's travels after leaving Hopey, and the issues of class (geographical, economic, and cultural) continue to bubble to the fore in an exploration of have-nots that dovetails with a new generation of Mexican-American wrestlers along the way. In its graceful contours, play of floating images, and stark positive and negative space, the cover for the 1996 "Chester Square" collected edition is a rich summation of Maggie's befuddled journey. A 1994 panel from this last story arc revisits a nearly identical composition from 1982's "Mechanics," demonstrating how Hernandez's approach to defining

opposite
Original artwork for *Chester Square: Love and Rockets Book 13*, cover, 1996.

above
Original artwork for "It's Not That Big a Deal," splash page, detail, *Love and Rockets* no. 44, 1994.

1 — SO, HOW'S THE LAUNDROMAT BUSINESS?
— PROBABLY ABOUT THE SAME AS THE NEWSTAND BUSINESS.

2 — THERE SHE IS, RIGHT ON TIME.
— UH HUH.

3 — SOMETHING SHOULD BE DONE ABOUT HER.
— SO WHERE'S ALL THAT SECURITY WE PAY FOR?
— RIGHT HERE!

4 — AND WHO ARE YOU?
— MY FATHER HAS THE FLU, SO I'LL BE IN HIS PLACE TODAY. I'M TITO, JR.

5 — WELL, THEN GET TO WORK, TITO JR.
— I WON'T LET YOU DOWN, SEÑORAS.

6 — WHO KNOWS, MAYBE HE'LL DO A BETTER JOB THAN TITO SR...
— A FROG COULD DO A BETTER JOB THAN... ?!

7 — NOW WHAT?

8 — THIS PLACE IS GOING TO THE DOGS!
— TITO!

9 — WHAT'S GOING ON?
— OH, THE LADY WANTED TO KNOW WHEN THE NEXT BUS COMES.
— I'M SURE SHE DID...

10 — THOSE GOD DAMN WHORES WON'T GET AWAY WITH THIS...
— SHOULD I CHECK HER OUT, SEÑORA?
— WHAT DO YOU THINK?

12 — (SPYING ON MAGGIE) 11 — FOLLOWING MAGGIE

13 — (WALKING UP TO DOOR)

14 — (SNEAKING UP TO DOOR)

15 — OH!

16 — HEH...

17 — HEH!

18 — (GUY BUMMED + MAG COMING OUT)

1	2	3
4	5	6
7	8	9

②

10	11	12
13	14	15
16	17	18

③

Handwritten notes for "Chester Square," c. 1992.

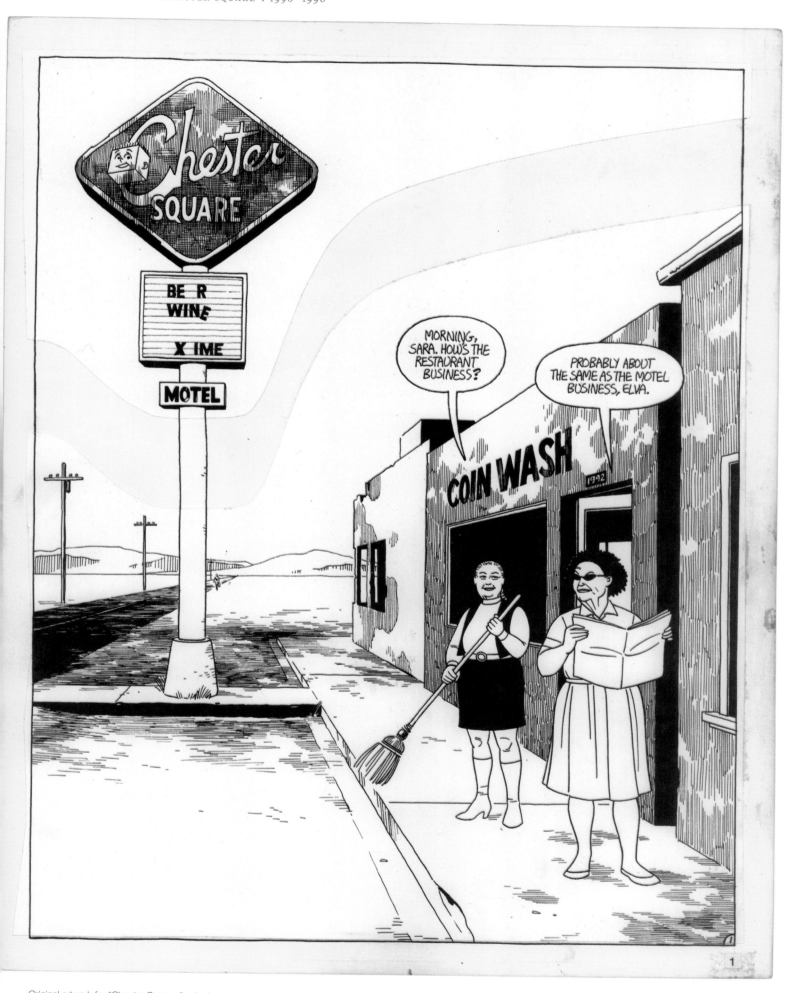

Original artwork for "Chester Square," splash page,
Love and Rockets no. 40, 1993.

mise-en-scène has evolved: contrasts are now defined by pure solids rather than shading hatch lines, and an economical precision defines expressive body language. But his heart remains the same, creating palpable mood by foregrounding the interaction and relationship between characters. Jaime also continues to throw in occasional nods to forebears, as always providing extra layers to ponder: "Chester Square" was a character in *Archie's Madhouse* from the early sixties, and that Steve Ditko Spider-Man squashing machinery is again put to use in this story. While Maggie's picaresque journey ends with a reunion with Hopey (now in a new band), Hernandez insists that their relationship will never be stable. "I have a big rule that I use for myself—if you're going to have a big syrupy ending with a cherry on top, you better earn it. Or it's schmaltz—it's almost every mainstream comic."

Earn it they did, and in their contrasts and complements, Maggie and Hopey are vitally necessary to each other, particularly when apart. While *Love and Rockets* continued to garner fan, mainstream, and academic praise—a panel devoted to *Love and Rockets* took place as part of a joint conference of the Popular Culture Association and the American Culture Association in 1996—both Gilbert and Jaime began to feel constricted by the accumulated history of the title. They were no longer the hot young Turks, and sales of the comic weren't quite

as strong by the mid-1990s, letters got fewer, and both brothers felt an increasing sense of isolation due to the comparative lack of feedback. According to Kim Thompson, while *Love and Rockets* "was always our best selling continuing comic throughout the eighties," at this point the print run had gone down a bit from a high-water mark in the late eighties and early nineties, "into the mid-teens as it went through issues forty to fifty." By this time both Jaime and Gilbert were exhausted by their lengthy, increasingly complex, serialized stories, and needed to try something new.

Love and Rockets no. 48 (Fantagraphics Books, 1995).

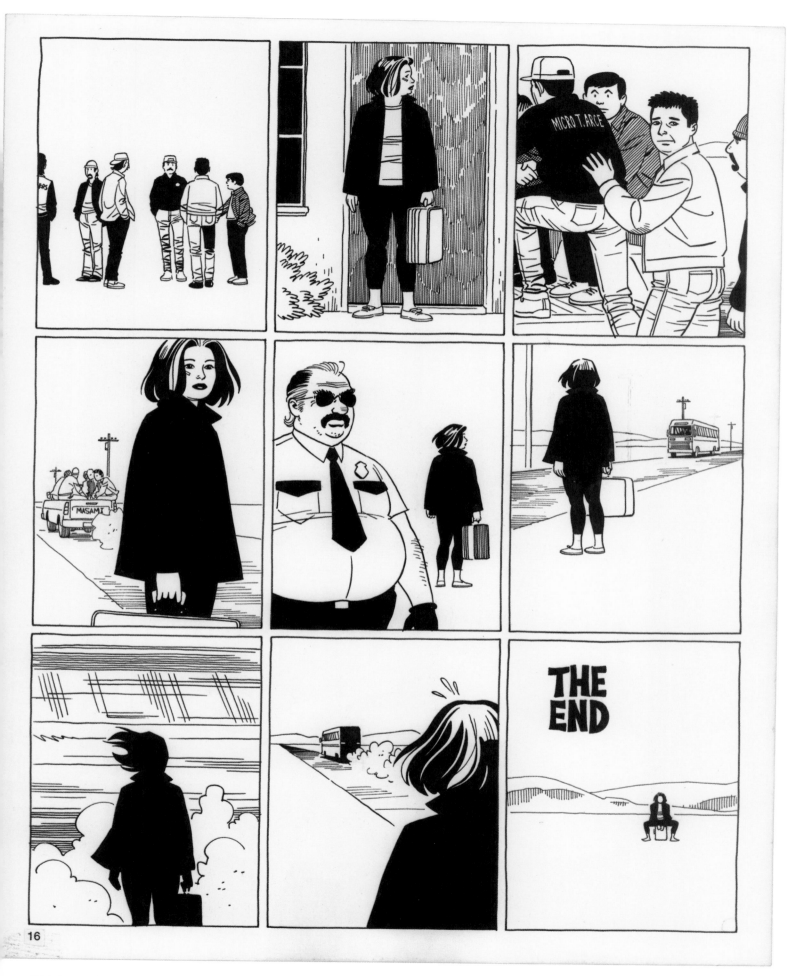

Original artwork for "Chester Square," page 16, *Love and Rockets* no. 40, 1993.

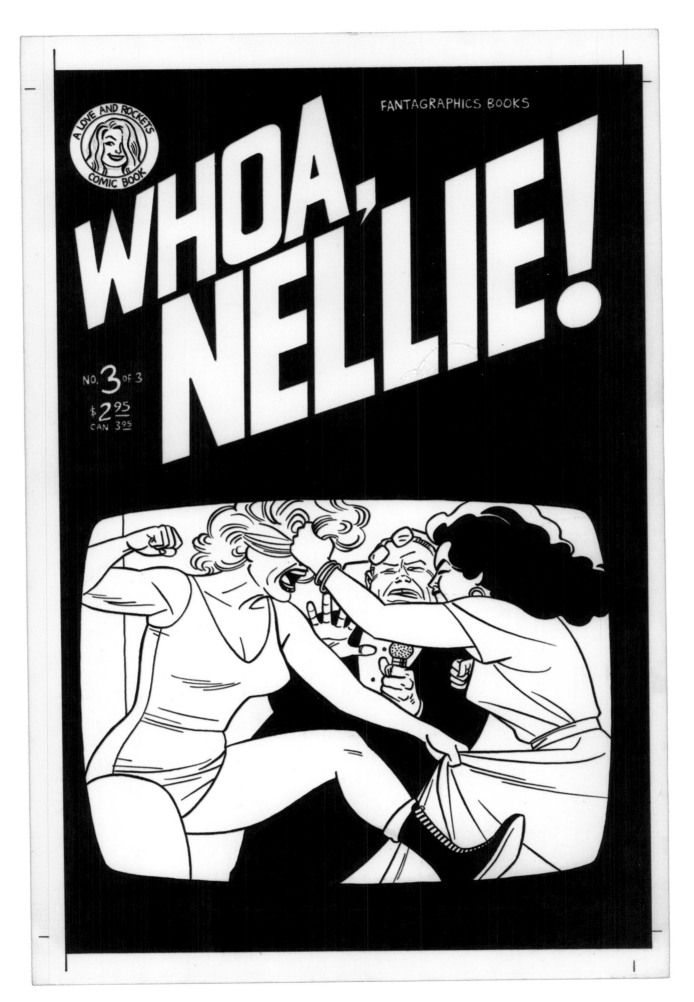

Original artwork for *Whoa, Nellie!* no. 3, cover, 1996.

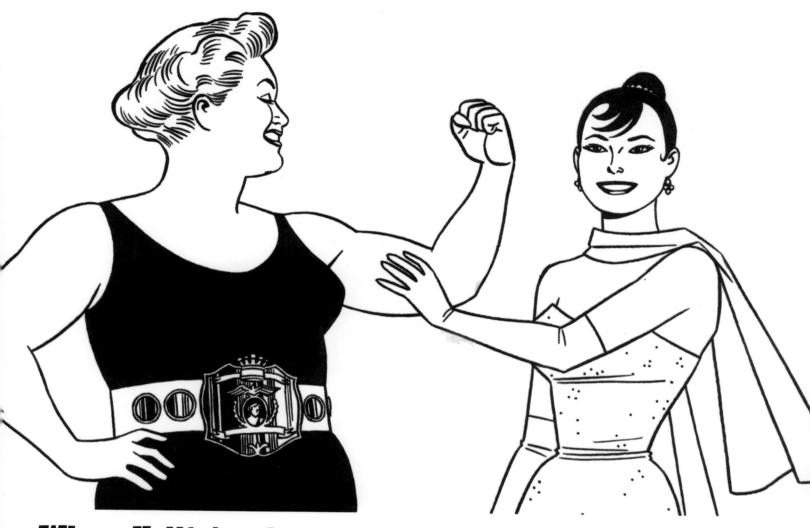

Whoa, Nellie! and Penny Century: 1996-2000

Leaving nothing in the shade, each action discards all parasitic meanings and ceremonially offers to the public a pure and full signification, rounded like Nature. This grandiloquence is nothing but the popular and age-old image of the perfect intelligibility of reality. What is portrayed by wrestling is therefore an ideal understanding of things; it is the euphoria of men raised for a while above the constitutive ambiguity of everyday situations and placed before the panoramic view of a univocal Nature, in which signs at last correspond to causes, without obstacle, without evasion, without contradiction.

Roland Barthes
"The World of Wrestling" (1957)

They look like superheroes. Lady superheroes, Xo!

Gina
Whoa, Nellie! no. 2 (1996)

AFTER *LOVE AND ROCKETS* ENDED with issue no. 50, Jaime and Gilbert each immediately launched separate solo titles in the standard comic book scale, thinking the new format might provide a refreshing change of pace. Jaime delivered the three-issue miniseries *Whoa, Nellie!* (1996), which again placed the world of wrestling in the limelight, this time with a fresh group of up-and-comers in the significantly lower rungs being trained by Maggie's aunt Vicki Glori, complicating the facade and imbuing compassion to the realm viewed predominantly with condescension. Hernandez had kept up with the sport over the years, beginning to watch Mexican wrestling in earnest on cable in the 1980s.

Whoa, Nellie! is entertaining, lighthearted fare, a buoyant break from the heaviness of the last several years of *Love and Rockets*. And while not as structurally complex, the story makes for great comics, showcasing Hernandez's command of comic action as well as his pitch-perfect insight. He describes it as "a breath of fresh air. I did it because the wrestling thing was almost taking over *Love and Rockets* at the end and I thought I'd give it its own comic and blast all of that out and maybe never do it again. So it was like taking a vacation, getting rid of certain baggage, and having fun. At the same time, when I was doing it, it started to become something, so I worked just as hard on it as my 'regular' work

Original artwork for *Whoa, Nellie!* no. 2, back cover, 1996.

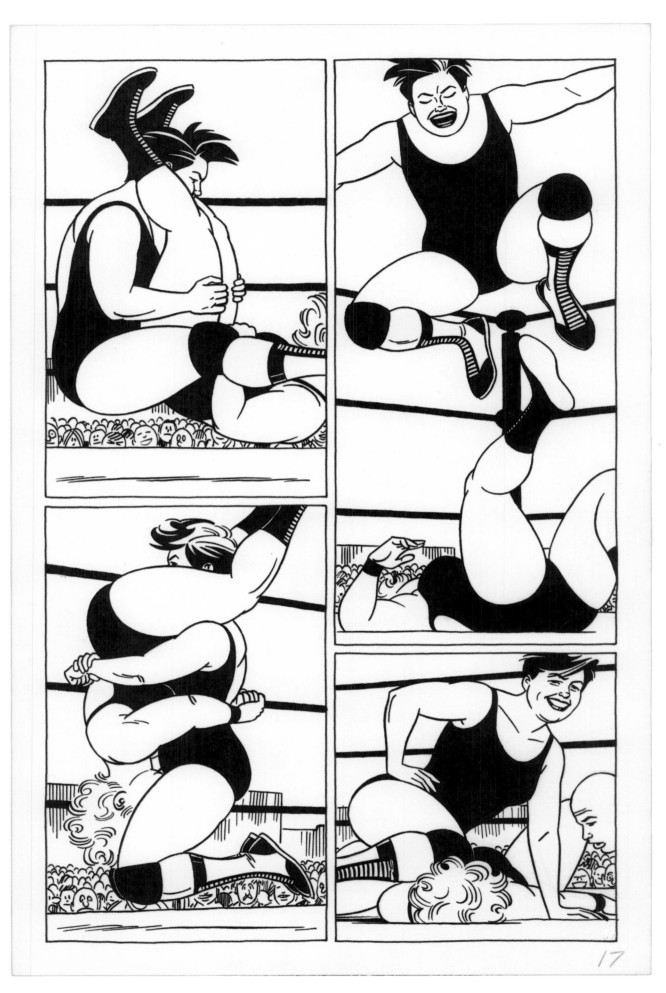

17

Original artwork for *Whoa, Nellie!* no. 1, page 15, 1996.

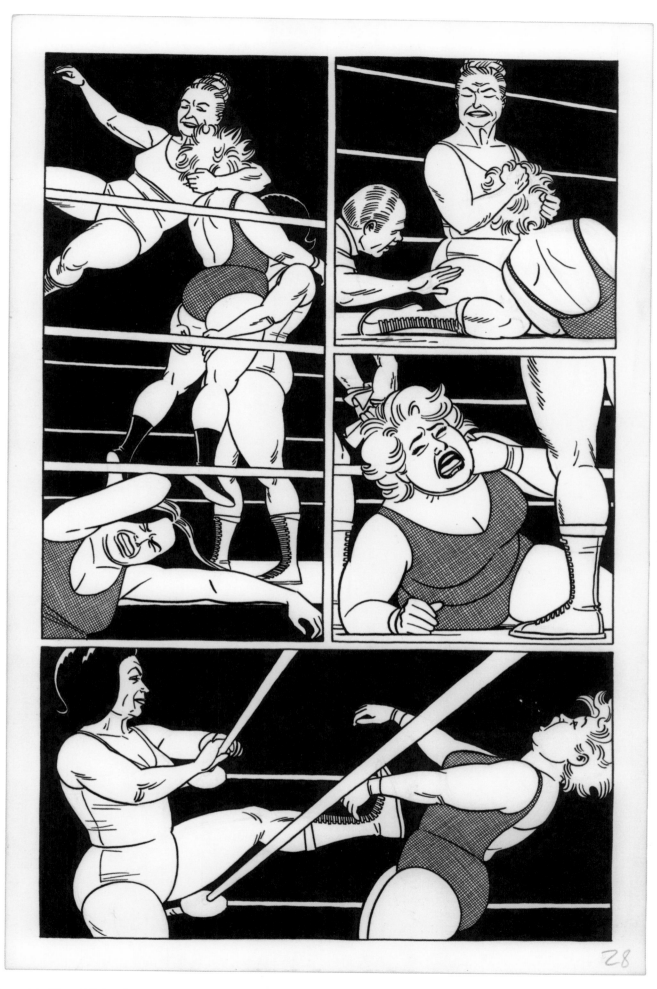

Original artwork for *Whoa, Nellie!* no. 2, page 5, 1996.

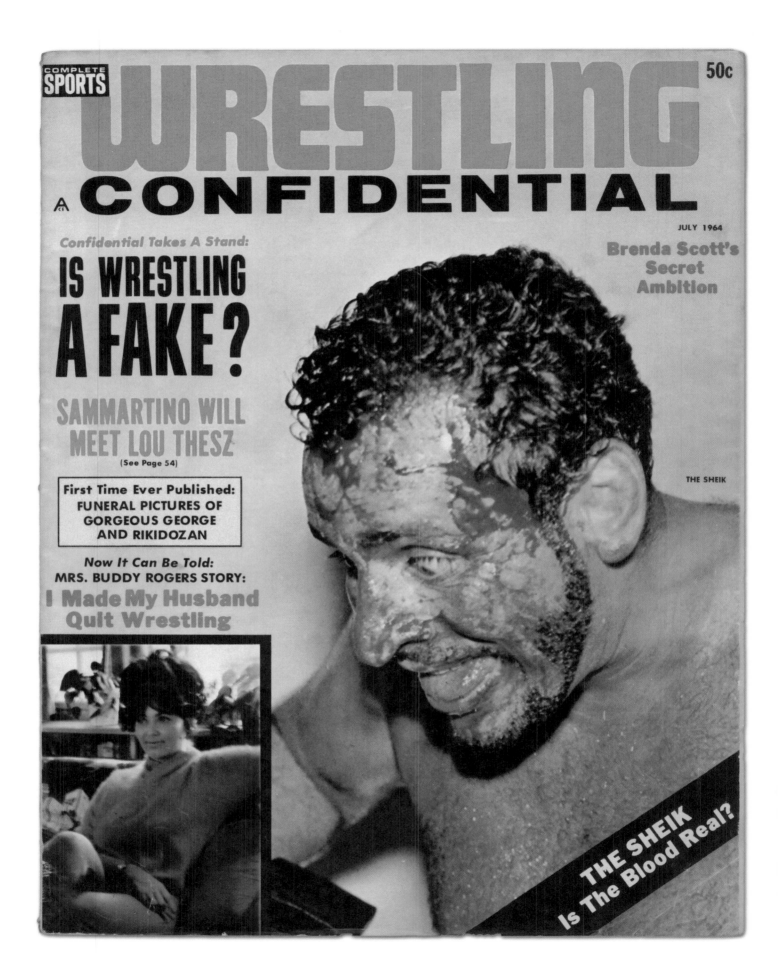

COMPLETE SPORTS

WRESTLING CONFIDENTIAL

A

50c

JULY 1964

Confidential Takes A Stand:

IS WRESTLING A FAKE?

SAMMARTINO WILL MEET LOU THESZ
(See Page 54)

First Time Ever Published:
FUNERAL PICTURES OF GORGEOUS GEORGE AND RIKIDOZAN

Now It Can Be Told:
MRS. BUDDY ROGERS STORY:
I Made My Husband Quit Wrestling

Brenda Scott's Secret Ambition

THE SHEIK

THE SHEIK Is The Blood Real?

Wrestling Confidential (July 1964).
The over-the-top graphic design of vintage wrestling magazines influenced Hernandez's approach to the packaging of his miniseries *Whoa, Nellie!*, which followed the lives of female wrestlers.

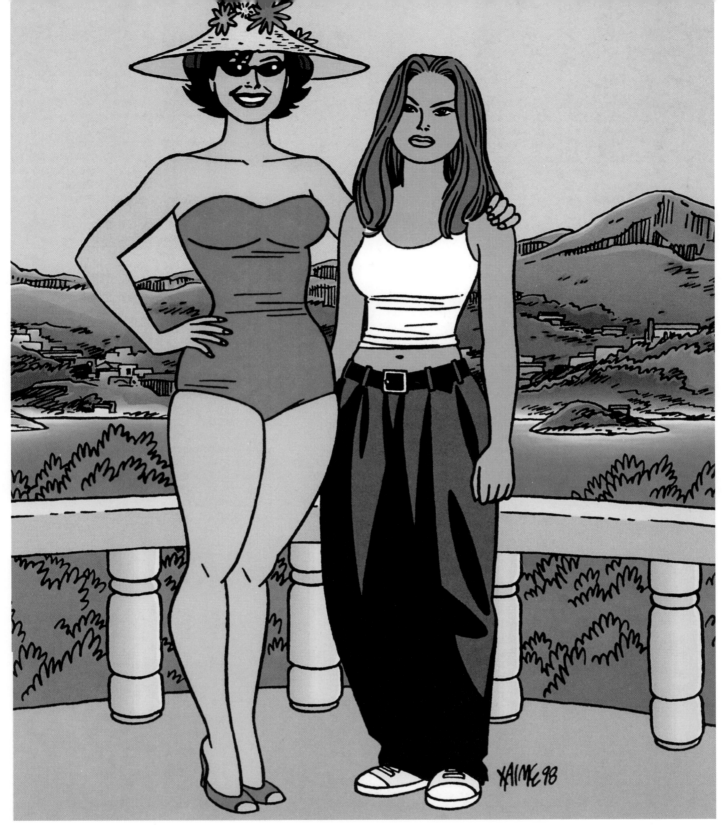

and I'm actually very happy with what it became story-wise and how it all intermingles. I was really proud of it, but some of the reaction was that it was all indulgence." Regardless, it's immediately apparent reading these issues that Hernandez was having a blast: The visuals draw direct inspiration from the wrestling fan magazines of his youth, and he populates the pages with inspired grapplers. In wordless action sequences, Hernandez reduces cartooning to pure visual storytelling movement, but as opposed to wordless super-hero fight scenes, which take over the narrative, Hernandez's action remains in service of a story contrasting wide-eyed contenders and wily, grizzled vets.

Whoa, Nellie! was followed quickly by the seven-issue *Penny Century* (1997–2000), the title chosen as "a banner that anything in the Jaime world could go into." The character of Penny had functioned as an encompassing symbol for disparate aspects of his work from the beginning, from realism to fantasy, representing his range as a storyteller: "I always looked at Penny as a cutout from a comic book that was placed in Maggie and Hopey's real world. Her past is being created as I use her more—she started off as a piece of paper and the more I do her, the more human she gets. Her life is almost going backward instead of forward."

Penny Century no. 4 (Fantagraphics Books, 1999).

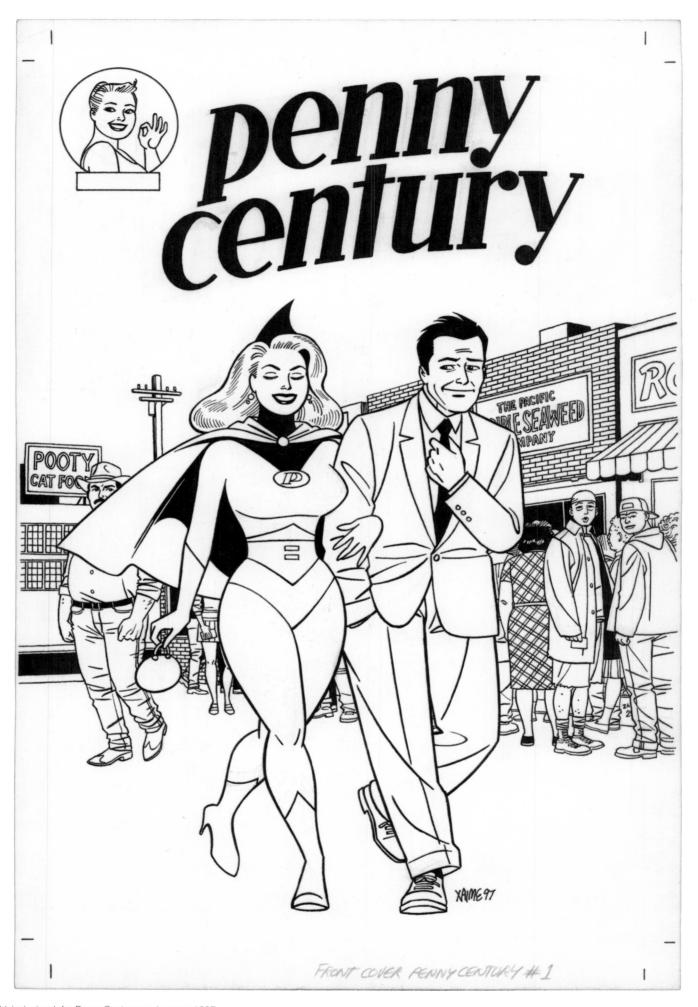

FRONT COVER PENNY CENTURY #1

Original artwork for *Penny Century* no. 1, cover, 1997.
Ray's running monologue in the lead story from this
issue was directly inspired by Robert Crumb's 1967
"Ducks Yas Yas" from *Zap* no. 0.

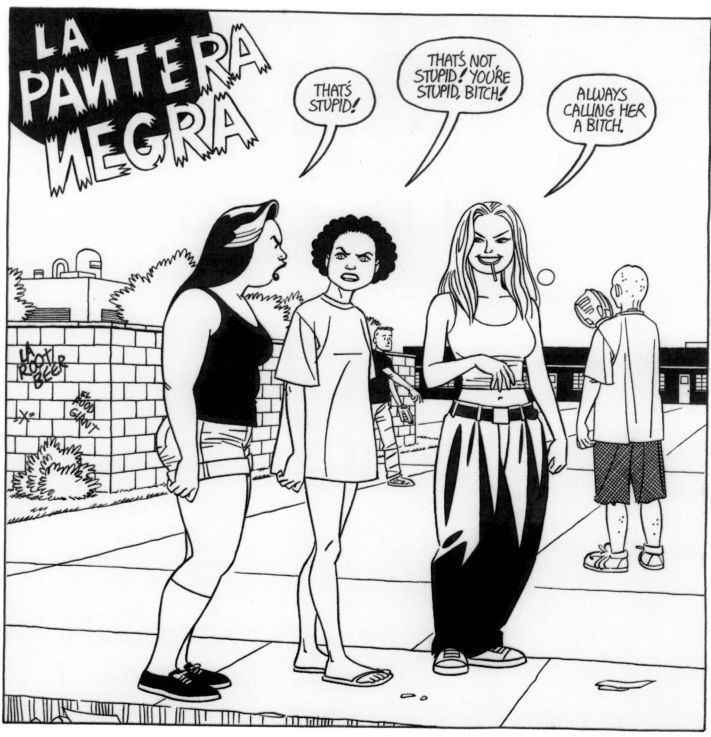

Hernandez expanded Penny's background in "Chester Square," and she's constantly vacillating back and forth between fleshed-out character and symbol, depending on the particular narrator. When Ray Dominguez has sex with her, the scenes are especially potent as it's the closest he'll get to having sex with a female super hero (in fact, she's dressed as a super hero on the cover of issue no. 1), complicating further those pesky definitions of "realism." Ray plays a prominent role in Hernandez's comics from this time on, and he's "maybe the first character I created who had a real purpose. Maggie I created because I wanted to draw her and give her adventures. Ray, I made up for the purpose of having a male Maggie. I had a lot of thoughts I couldn't put into Maggie, and I decided to put them into him. I hadn't had any main male characters. I was a little afraid because usually, the more I plan the more something fails—it's the accidents that usually succeed. But he was a calculation that succeeded."

While Hernandez's *Love and Rockets* offered periodic short stories as breaks from the longer, serialized narratives, in *Penny Century* this diversity of story rhythm and type became the rule, and the first issue is a perfect comic book in this balance, reveling in its comic book lifeblood and the heritage of various genres: there's a Ray and Penny story; a two-page humorous folktale; a Locas Maggie story; a great story introducing Negra, old Penny Century–flame and horned

Original artwork for "La Pantera Negra," splash page, detail, *Penny Century* no. 1, 1997.

La Blanca
A TRUE STORY

XAIME 99

BACK IN THE THIRTIES, IN THE TOWN OF YSLETA, TEXAS STOOD AN OLD ADOBE HOUSE BUILT ALONG THE RAILROAD TRACKS.

FOR MANY YEARS STRANGE THINGS HAPPENED IN AND AROUND THE HOUSE. THE WALLS FREQUENTLY ECHOED WITH THE SOUND OF HUMAN TAPPING.

ONE MORNING ONE OF THE INHABITANTS OF THE HOUSE WOKE TO FIND HER BED TURNED TO FACE THE OPPOSITE SIDE OF THE ROOM. THERE WAS NO SIGN THAT ANYONE ELSE HAD ENTERED.

ONE DAY SOME KIDS PLAYING IN FRONT OF THE HOUSE HEARD A BELL-RINGING SOUND UNDER THE GROUND. IT SEEMED TO LEAD THEM TO THE RAILROAD TRACKS. THEY FOLLOWED THE SOUND ALONG THE TRACKS TILL IT DISAPPEARED.

ALL OF THESE ODD OCCURENCES WERE BLAMED ON A NEIGHBORHOOD GHOST THEY CALLED LA BLANCA, A BRIGHTLY LIT FIGURE OF A WOMAN HIDING HER FACE UNDER A SHAWL. THE CLICK OF HER HEELS COULD BE HEARD AS SHE WALKED.

Original artwork for "La Blanca," complete two-page story, *Measles* no. 2 (Fantagraphics Books, 1999). "A family ghost story from my mom's old neighborhood in Texas."

ONE NIGHT IN THE OLD HOUSE THE MOTHER THOUGHT SHE SAW HER DAUGHTER SITTING ALONE IN THE DARK. WHEN SHE CALLED OUT TO HER THE FIGURE, WHO WAS NOT HER DAUGHTER AT ALL, GOT UP AND SILENTLY WALKED INTO THE SHADOWS.

ONE WITNESS SWORE HE SAW THE WHITE ONE REMOVE HER SHAWL AND SHAKE IT OUT.

ONE NIGHT A MAN COMING HOME LATE FROM THE BARS SPOTTED THE APPARITION AND DECIDED TO FOLLOW HER TO ASK HER WHO SHE WAS. BUT ONCE HE CAUGHT UP TO HER SHE DISAPPEARED THEN RE-APPEARED SEVERAL FEET AHEAD. THIS WAS REPEATED SEVERAL TIMES TILL THE MAN FINALLY GAVE UP.

LA BLANCA'S DISPLAYS EVENTUALLY BECAME COMMONPLACE. AFTER EACH MANIFESTATION, WITNESSES WOULD GO BACK TO THEIR BUSINESS, ALBEIT WITH A NEW STORY TO TELL AT THE MARKET.

YEARS LATER, AFTER THE FAMILY HAD MOVED AWAY FROM THE HOUSE, IT WAS SAID THAT THE NEW OWNERS HAD THE STRANGE OCCURENCES INVESTIGATED.

THEY BROKE OPEN THE WALL WHERE THE TAPS ALWAYS ENDED AND FOUND A SMALL HIDDEN TREASURE OF CASH. AFTER THAT, LA BLANCA WAS NEVER HEARD FROM AGAIN.

THE END

A TIP OF THE HAT TO MOM HERNANDEZ FOR A GREAT TALE...

billionaire Herv Costigan's daughter (which provides Hernandez both the opportunity to return to Hoppers without Maggie and Hopey, and to revisit the lives of teenagers, whose dialogue is as good as any he's ever written); a Hopey single-pager; and the back cover strip "To Be Announced," the first in a series of beautiful shorts featuring young Jaime stand-in Li'l Ray. The stellar issue-length "Home School" (1998) is one of Hernandez's masterpieces, and gives the fullest portrait to date of the Oxnard of his childhood. These kids' comics are an important aspect of Hernandez's work, offering a counterpoint both in tone and style: his self-consciously slick "cartoony" artwork references his favorite masterpieces of the genre, specifically Charles Schulz's *Peanuts*, Hank Ketcham's *Dennis the Menace*, and Bob Bolling's *Little Archie*.

During this period, Hernandez also contributed kids' stories to the children's comic anthology *Measles*, which Gilbert edited in an attempt to recapture for a new generation the joyful immersion in comics the brothers felt as kids. The stories featured "Los Supersonicos, California's #1 Super Family" (a strikingly similar precursor to the 2004 Pixar animated film *The Incredibles*).

Hernandez is unique in his ability to conjure the most entertainingly fertile comic book masters through the poetic quality of his clipped comic language and the beautiful visual rhythm of his bold ink lines. Indeed, his artwork continues to surprise in this new taller, narrower comic book: The bravura passage used to pace a night-driving scene from "Chiller!" (1997–98) is a minimalist masterpiece that outshines legendary cartoonist Alex Toth. And as in every period of his work, Hernandez hits an undisputed home run: the issue-length "Everybody Loves Me, Baby" (2000) flashes back to Maggie and Hopey's early punk days to explicate Maggie's short-lived marriage. There's a bittersweet, life-affirming joy that runs through this story—a summing up of the resignation that the glow of reckless youth has passed.

Original artwork for "Home School," splash page, detail, *Penny Century* no. 3, 1998.

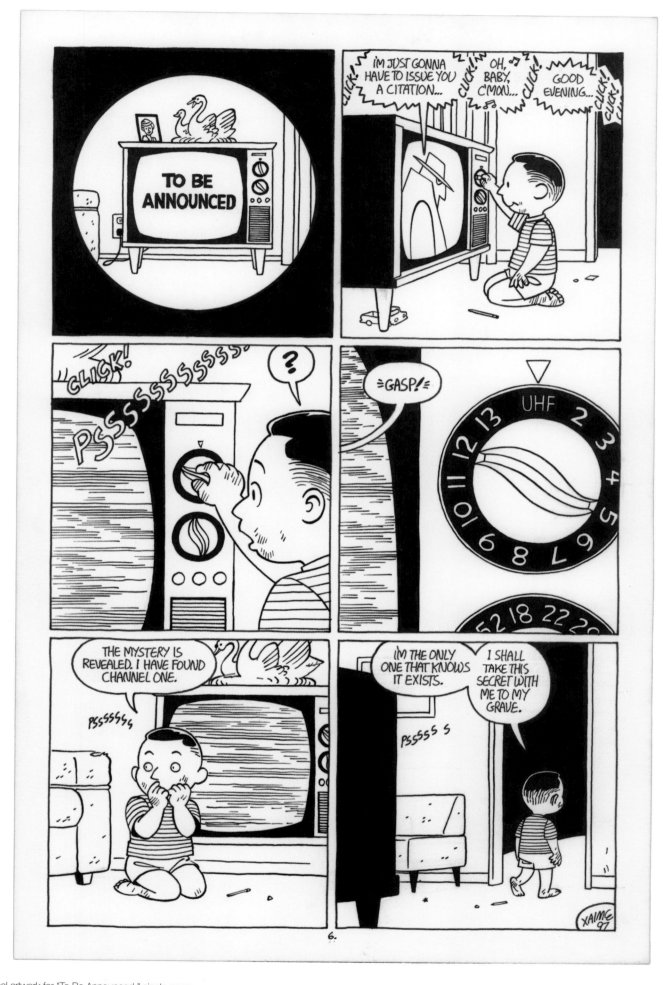

Original artwork for "To Be Announced," single-page
story, *Penny Century* no. 2, 1997.
"My younger brother, he was turning channels, hit
UHF, and discovered channel one."

Original preliminary artwork for *Love and Rockets*
volume 2, no. 1, cover, 2000.

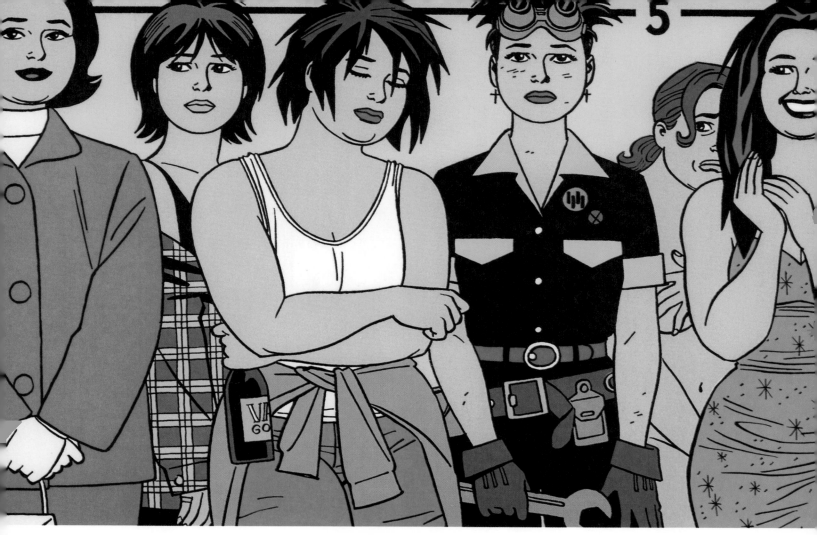

Love and Rockets Vol. II and New Stories: 2000-Now

Between where you are and where you are going to be is a no-man's-land.
Gavin Lambert
The Slide Area: Scenes of Hollywood Life (1959)

IN 2000, GILBERT AND JAIME REUNITED for a new incarnation of *Love and Rockets* in the comic book format each had been working in for the last few years. Their juxtaposition once again in the same pages was refreshing and an acknowledgment that the title—their brand name—carried with it a good deal of weight and was necessary for readers to continue to follow their work. As Kim Thompson describes, "we kept on having comics fans telling us they loved *Love and Rockets* and it was their favorite magazine of all time and were the Bros. doing any comics, because they really, really missed them—it was as if *Penny Century* and

Gilbert's various comics (all of which actually said 'A *Love and Rockets* comic' on the cover) were totally off their radar."

If Jaime's stories in the last twenty issues or so of the magazine-size *Love and Rockets* were about Maggie and Hopey's struggle to find out the meaning of life after punk, these new stories were about starting over after that period of transition.

Hernandez lived in Studio City from 1991 to 2001, and the contrast between Hoppers (Oxnard) and Los Angeles's San Fernando Valley frame the action. While acknowledging outside views and

Love and Rockets volume 2, no. 1 (Fantagraphics Books, 2001).

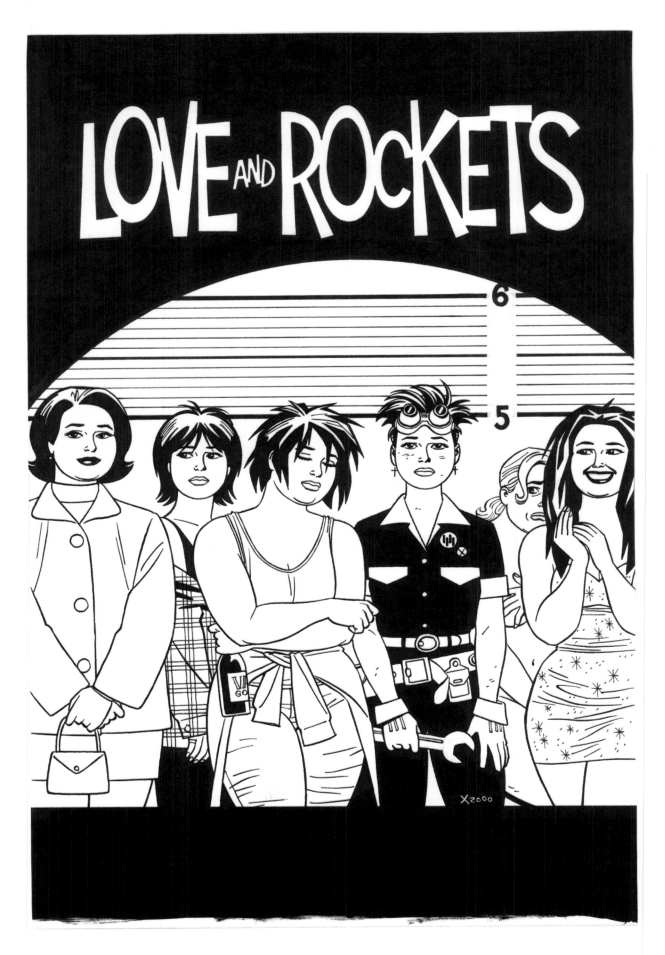

Original artwork for *Love and Rockets* volume 2,
no. 1, 2000.

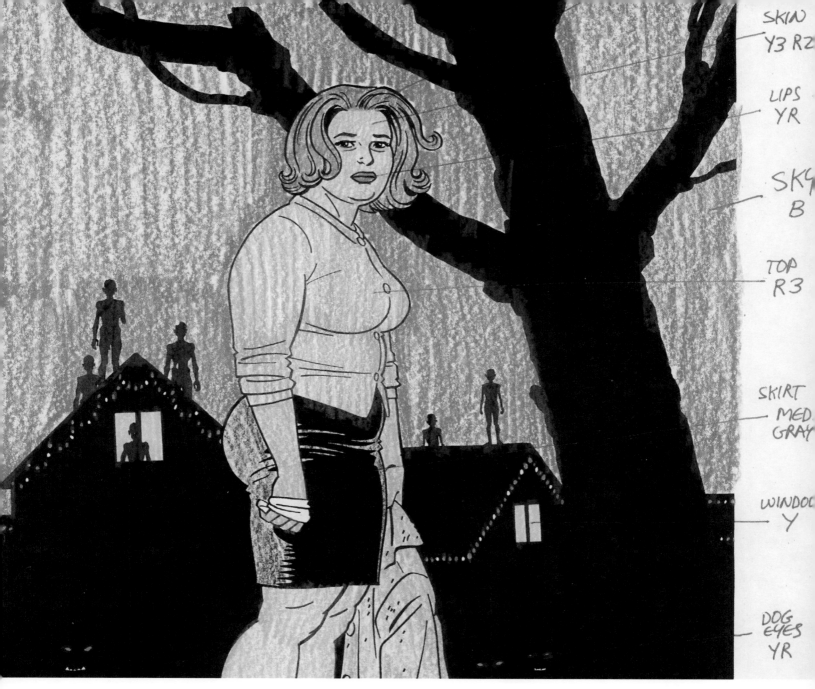

SKIN
Y3 R2

LIPS
YR

SKY
B

TOP
R3

SKIRT
MED.
GRAY

WINDOW
Y

DOG
EYES
YR

preconceptions, positive and negative, overwrought and nuanced, Hernandez's view of this world is inescapably one of home. The braided structure and fringe-dwelling characters reflect a totally "other" Los Angeles—the marginal culture of the Hollywood working classes, strippers, bartenders, bit players, forgotten actors on the outskirts, and public-access cable TV show hosts living in the vast (and vastly dismissed) Valley, off the beaten path, yet not picturesquely squalid enough to titillate. These are the in-between—socially, economically, culturally—parts that don't fit into any public image. So Hernandez finds another misunderstood world, another dismissed subculture, and another surrogate family, here the community of old Hoppers ex-punks trying to earn a buck.

The cover for the new *Love and Rockets* no. 1 gives an updated version of Hernandez's police line-up from the original, but this time all five portraits are of Maggie at various stages of her life. In her growth as a character, she has come to embody the disparate approaches of Hernandez's early comics. She has grown so multi-faceted that her role in the series is fluid: "I always pictured Maggie as the girl you see on the street and think 'I wonder what she's up to.' She's stumbling because her shoes hurt or something you notice in a fleeting moment. Then she's gone out of your life. But for half a minute you're thinking about her,

maybe where she comes from, where she's going. That's always been a balancing act to give the reader—you're in Maggie, you see the world through her eyes, but you're also watching her in this way." Hernandez opens the new series with the first chapter of a new Maggie story, which would later be collected under the title *Ghost of Hoppers*. One of his most successful "graphic novels," the story proves that Maggie can't go home (to Hoppers) again, and provides the possible conclusion to Izzy Ortiz's increasingly unstable mental state.

As Hernandez explains, every time he goes back to Oxnard he returns home armed with fertile story ideas: "I've rarely read about Mexican folktales; all the imagery comes from family. The dogs came from hearing stories about seeing 'the black dog,' which meant the devil. But what inspired me specifically was, back in Oxnard, a friend's little boy was playing in his front yard one night. Another little kid from the neighborhood was also playing in the yard and then walked home to his house where he saw a wounded black dog laying on the lawn. The dog looked up at him, then got up on his hind legs and hopped away—the kid started screaming and his grandmother said that it was the devil, and screamed 'Get into the house!'"

The fact that this incident had taken place mere days ago, rather than passed down from generations, really struck him, as did the seeming

Original color guide artwork for *Ghost of Hoppers:
Love and Rockets Book 22*, cover, 2005.

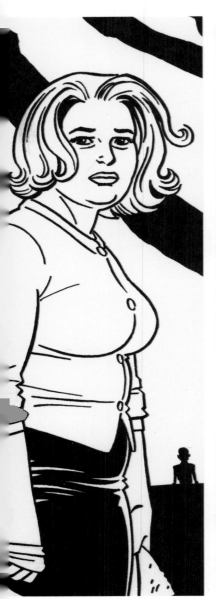

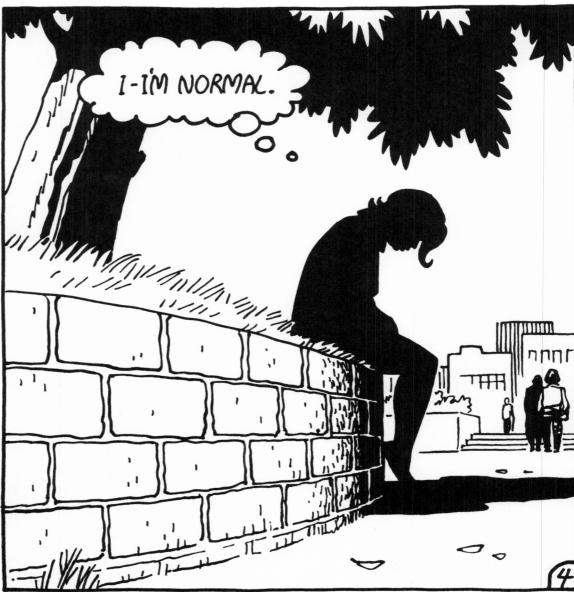

normalcy of it—that it wasn't more fantastic was all the more striking, and he worked on translating this feeling into the story for a year, having no idea how to get the subtle creepiness on the page. Hernandez's artwork is now noticeably inkier and more reductive, with many solid black or white backgrounds bordering on abstraction, and even fewer lines used to define characters. But his hard-edged rigor never devolves into icy formalism. The black dogs and other manifestations of the devil—Izzy's sideways link to Mexican folktales and damaged Catholic imagery dominate—appear to Maggie, who receives the stigmata from a broken crucifix, and the funereal tone foretells Izzy's fate.

Hernandez's "black" extends to noirish stories surrounding Ray, Doyle, and Vivian Solis ("The Frogmouth"), an important new character whose blunt presence counterbalances the heaviness of the setting and subject. Once again, Hernandez creates someone who is generally reduced to a "type" in our culture (here a stripper) and complicates her without merely changing her into the opposite of expectations. She also leads into the world of comic and junk culture fandom, which certainly qualifies as another marginalized world to humanize, and one Hernandez knows as well as any, going back to his early days trying to break into the industry.

The concurrent major serialized story is "Day by Day with Hopey,"

informed by Jaime's present life as much as by the punk milieu in his early days. Since 2001, Hernandez has lived in Pasadena with wife Meg and stepdaughter Carson, and is armed with an intimate knowledge of the world of teacher-parent conferences that Hopey is now experiencing as a grade school teacher-in-training: "For most of the characters, I never felt comfortable creating occupations for them. Later, I had to start—they had to live responsibly. It's time for my characters to do something with their lives or *not* do something with their lives." While this world is unavoidable, the dearth of specifics up to this point has always struck as a heartwarming stance against what mainstream culture dictates as "success." Here, characters are just trying to find a way to live, and Hopey's world is as incongruously unpredictable as ever. Her day-to-day friendships and lesbian relationships may have lost their youthful glamour, but gain in humble resonance. "People are universal, no matter how old, just as long as they're speaking—communicating."

As if designing a perfectly balanced page of comics, Hernandez offsets the serious (black) serialized pieces with the levity found in occasional short (white) lighthearted "genre" pieces. The essential "Who is Rena Titañon?" makes a perfect counterpoint to "La Maggie La Loca," depicting Rena in her wrestling heyday as symbol for

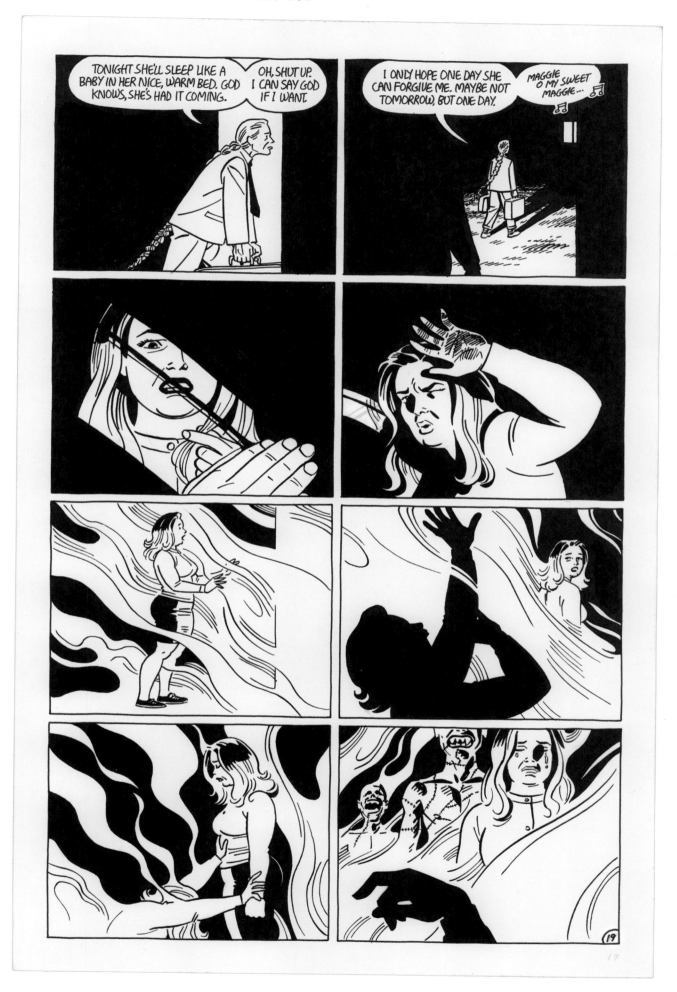

Original artwork for "Maggie," page 19, *Love and Rockets* volume 2, no. 10, 2004.

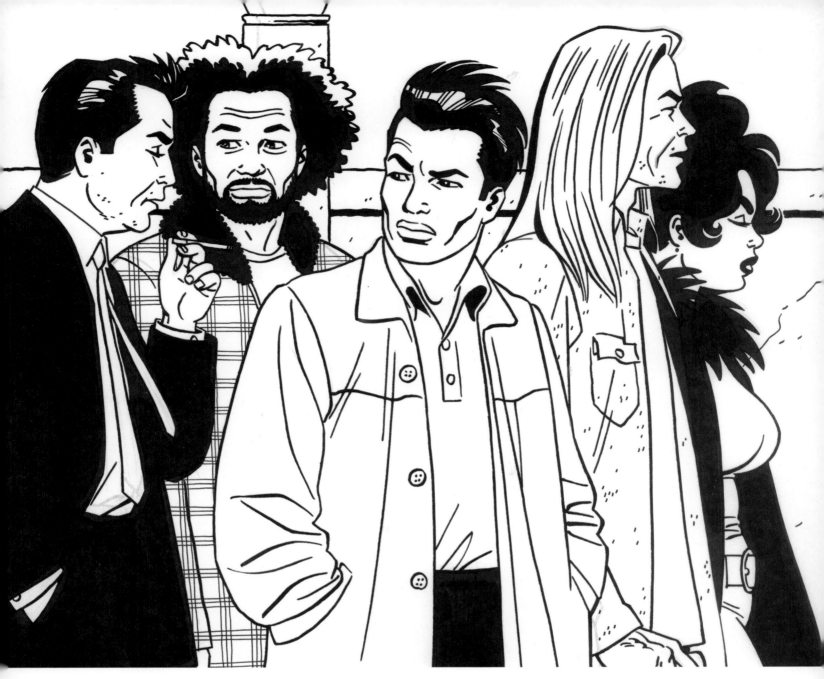

disparate causes. Strong new characters such as the Angel of Tarzana are introduced to complicate the established attractions and breakups. The continued growth of Hernandez's revolving cast of characters is one of the greatest achievements in fiction, comics or otherwise. In the creation of a separate, breathing, serial universe, Hernandez has no peer. His characters live in and interact within a fully realized environment (rather than remaining perpetually wide-eyed commentators, an unfortunate trend in comics). Jaime's interest is to distill the poetry from the seeming minutiae of the everyday, as Charles Baudelaire lauds the "painter of modern life," who only by being immersed in our messy modern world, embracing it without averting one's eyes, can achieve the eternal: "And so they run on, those endless galleries of high and low life, branching off at intervals into innumerable tributaries and backwaters . . . He has everywhere sought after the fugitive, fleeting beauty of present-day life . . . Often weird, violent and excessive, he has contrived to concentrate in his drawings the acrid or heady bouquet of the wine of life."

In summer 2008, the first new format *Love and Rockets: New Stories* was published, introducing a hundred-page annual to serve the new bookstore-friendly culture of comics. And just when you think you've figured out the trajectory of Hernandez's work, that certain approaches to genre have become established, the first two issues offer a wonderfully

full-blown, self-contained super hero story, featuring the Ti-Girls, a few of whom who had been appearing on the margins of recent stories. The dense tale is rich with everything Jaime loved in the commercial comics of his youth, particularly the freewheeling exuberance, excitement, and unabashed fun—unfortunately, qualities that are quite rare today in the medium.

When the Hernandez brothers began *Love and Rockets*, they were literally creating their own world to house their stories, but now it seems virtually any space imaginable exists for comics. Jaime Hernandez's work is lauded in glowing reviews everywhere from the mainstream to the fringes, and the cultural moment has obviously changed in large part because of *Love and Rockets*. But as the comic's complete overhaul of past traditions was misunderstood in the early years, Hernandez's approach to character and narrative may also be misunderstood within the current climate's infatuation with technical flash and elaborate production: while many contemporary cartoonists are invested in controlling all aspects of production, Jaime's involvement is exclusively about producing drawings on page, not on what happens to them after that:

I still do the work for the same reason, yet the obstacles that surround the work are different ones now. In the beginning we were creating something

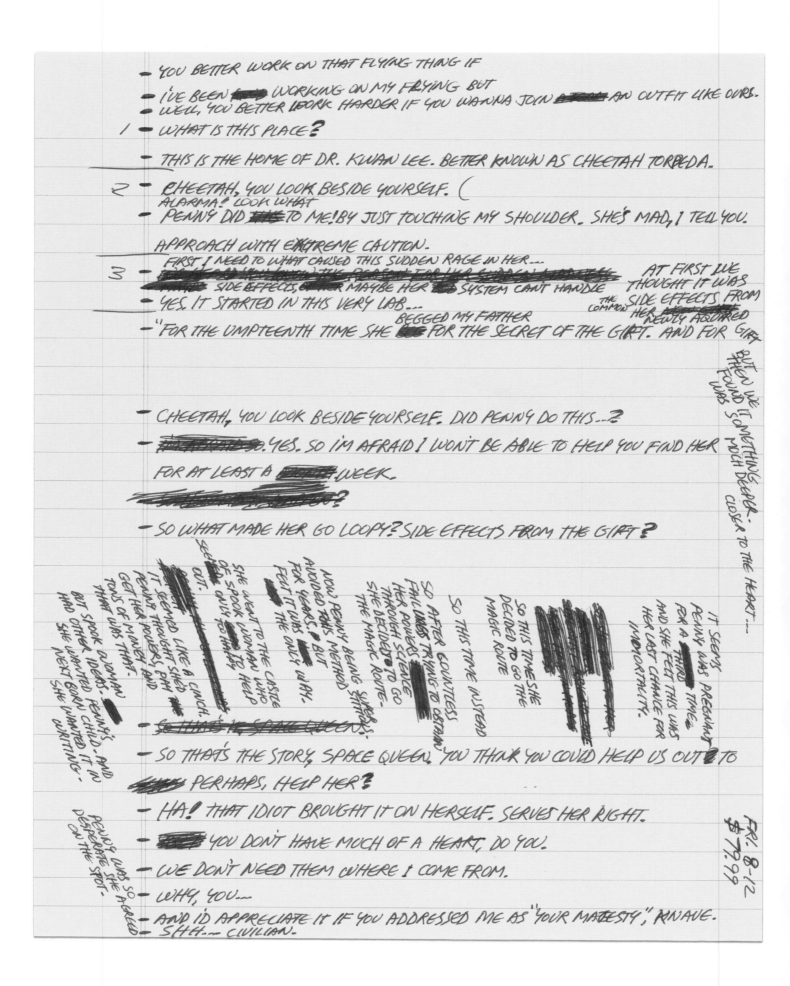

- YOU BETTER WORK ON THAT FLYING THING IF
- I'VE BEEN ~~████~~ WORKING ON MY FLYING BUT
- WELL, YOU BETTER WORK HARDER IF YOU WANNA JOIN ~~████~~ AN OUTFIT LIKE OURS.
1 - WHAT IS THIS PLACE?

- THIS IS THE HOME OF DR. KWAN LEE. BETTER KNOWN AS CHEETAH TORPEDA.
2 - CHEETAH, YOU LOOK BESIDE YOURSELF. (
 ALARMA! LOOK WHAT
- PENNY DID ~~███~~ TO ME! BY JUST TOUCHING MY SHOULDER. SHE'S MAD, I TELL YOU.

APPROACH WITH EXTREME CAUTION.
3 - FIRST I NEED TO WHAT CAUSED THIS SUDDEN RAGE IN HER... AT FIRST I'VE THOUGHT IT WAS
 ~~████████████████~~ SIDE EFFECTS, ~~██~~ MAYBE HER ~~██~~ SYSTEM CAN'T HANDLE THE COMMON SIDE EFFECTS FROM HER ~~████~~ NEWLY AQUIRED GIFT
- YES, IT STARTED IN THIS VERY LAB... BEGGED MY FATHER
- "FOR THE UMPTEENTH TIME SHE ~~██~~ FOR THE SECRET OF THE GIFT. AND FOR

- CHEETAH, YOU LOOK BESIDE YOURSELF. DID PENNY DO THIS...?
- ~~███████~~. YES. SO I'M AFRAID I WON'T BE ABLE TO HELP YOU FIND HER
 FOR AT LEAST A ~~████~~ WEEK.
 ~~█████████████~~?
- SO WHAT MADE HER GO LOOPY? SIDE EFFECTS FROM THE GIFT?

- SO THAT'S THE STORY, SPACE QUEEN. YOU THINK YOU COULD HELP US OUT TO
 ~~███~~ PERHAPS, HELP HER?
- HA! THAT IDIOT BROUGHT IT ON HERSELF. SERVES HER RIGHT.
- ~~████~~ YOU DON'T HAVE MUCH OF A HEART, DO YOU.
- WE DON'T NEED THEM WHERE I COME FROM.
- WHY, YOU...
- AND I'D APPRECIATE IT IF YOU ADDRESSED ME AS "YOUR MAJESTY", KNAVE.
- SHH... CIVILIAN.

BUT THEN WE FOUND IT WAS SOMETHING MUCH DEEPER. CLOSER TO THE HEART...

IT SEEMS PENNY WAS PREGNANT FOR A THIRD TIME, AND SHE FELT THIS WAS HER LAST CHANCE FOR IMMORTALITY.

FRI. 8-12
$79.99

PENNY WAS SO DESPERATE SHE AGREED ON THE SPOT.

Notes for *Love and Rockets: New Stories* no. 1, 2006–07.

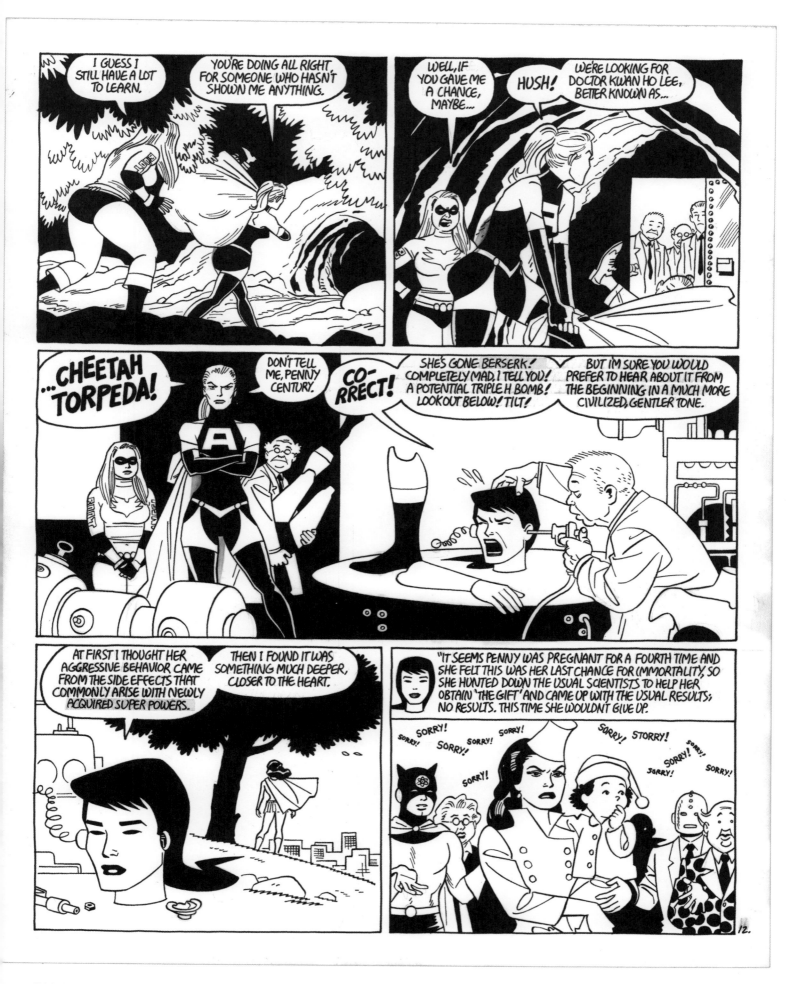

Original artwork for *Love and Rockets: New Stories*
no. 1, page 12, 2006–07.
Note the return to the page format from the original
series.

that kind of had no place. But as long as we could create, that was okay with us. Then by the late eighties/early nineties it got really competitive, turning into "you're only good if you're the new hip thing," and if you weren't that, you were kind of tossed aside. But as long as we could continue, that was still okay. Now, there's been so much water under the bridge, and viewpoints of what makes good comics have shifted to the point that ours is outdated in many circles. It's not the style of what you would call "a good graphic novel." It's not a clean package with a new approach. It's still straight fifties-style comics with a different subject matter, but as long as it's okay that I can still do it, that keeps me going. If I'm able to continue, that's all I can count on—it's all I've ever been able to count on.

left
Hernandez in his studio, Pasadena, California, February 2008. Photograph by Eric Kroll.

right
Original sketch of proposed Ti-Girl Maggie from *Love and Rockets: New Stories* no. 1, c. 2006. "Originally the character Espectra was Maggie, but it didn't work out for the story, so I had to rearrange . . ."

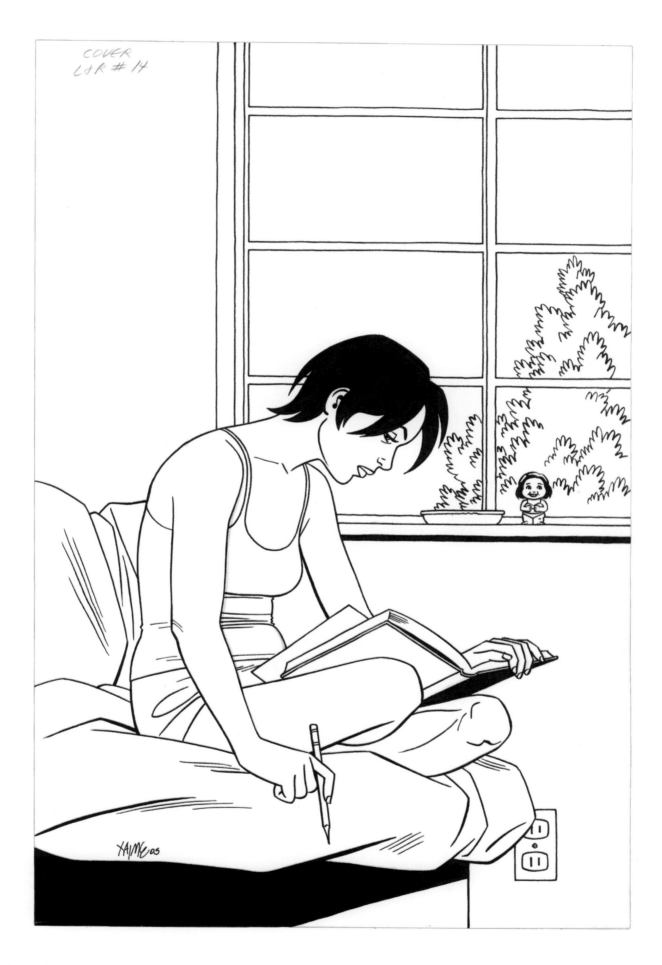

Original artwork for *Love and Rockets* volume 2,
no.14, cover, 2005.

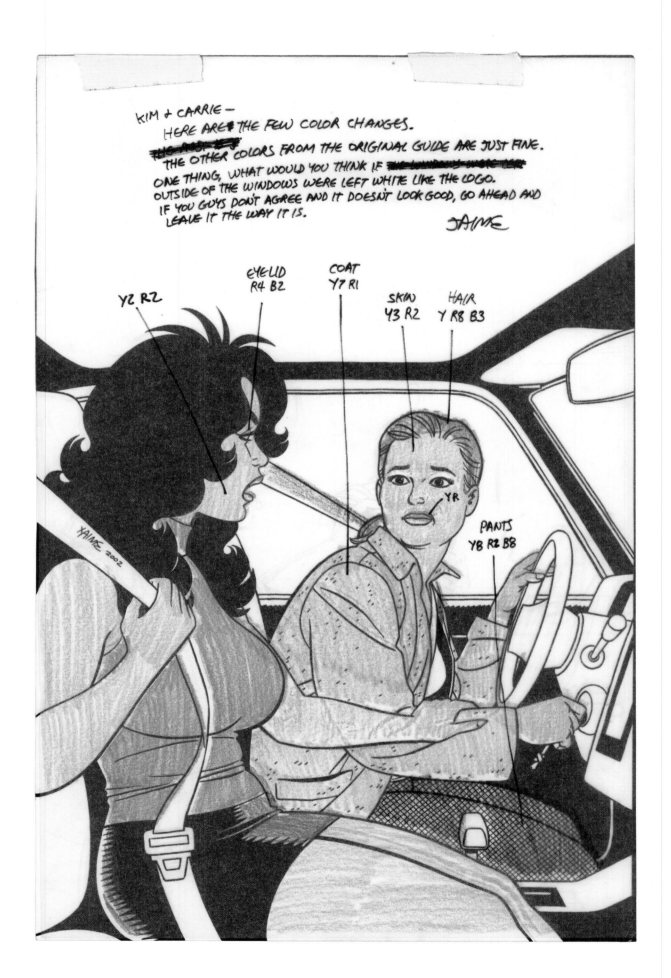

Original color guide for *Love and Rockets* volume
2, no. 7, cover, 2002. The color guide is on tracing
paper overlaying the original artwork.

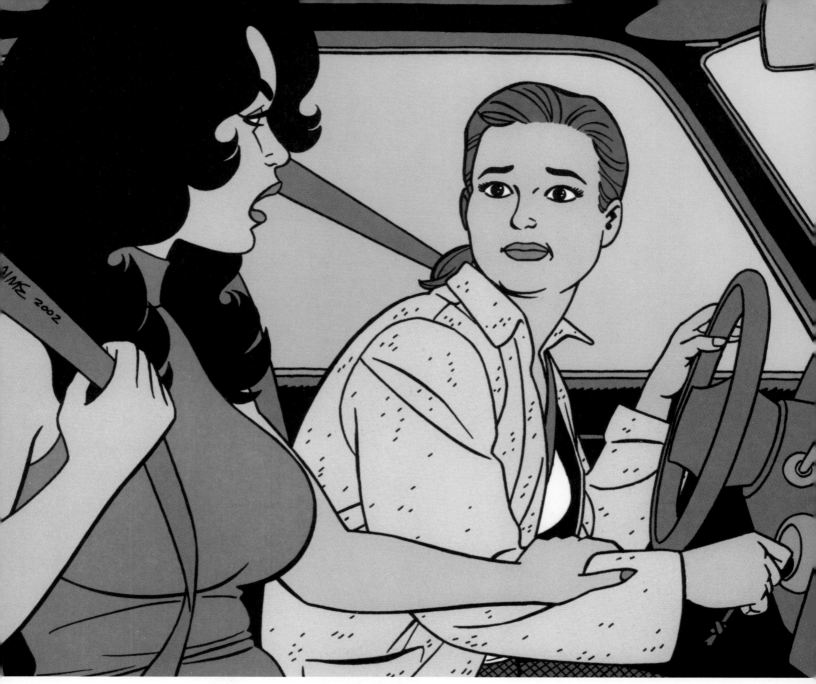

Illustration: The Narrative of Art

IN ADDITION TO COVERS for *Love and Rockets*, which he continues to alternate with Gilbert, and the occasional outside comic book, Hernandez has drawn interior magazine illustrations, album covers, posters, flyers, DVD covers, and all manner of commercially and privately commissioned imagery throughout his career. His clean, crisp style, wielding an undeniable iconic power, is particularly suited to single-image illustrations. The spirited ink drawings reverberate because they stem from his narratives, always suggesting stories. Hernandez's comic book covers do not attempt to capture a specific scene, but to bring an image to life that embodies the larger tone of the

contents. In his comics, the identities of characters, no matter their physical attractiveness, are never overshadowed by a pin-up quality, but his single images betray an obvious fondness for the history's exuberant depictions. Hernandez's initial thought process always revolves around composing a striking image, and that inevitably leads him to the favorite comic covers hardwired into his brain: "In my work, I'm always in search of the perfect comic book cover. But based on my intentions, in my mind I fail nine out of ten times because it turns into something other than what I initially wanted."

Hernandez was never a great fan of classic single-image cartoons

Love and Rockets volume 2, no. 7 (Fantagraphics Books, 2003).

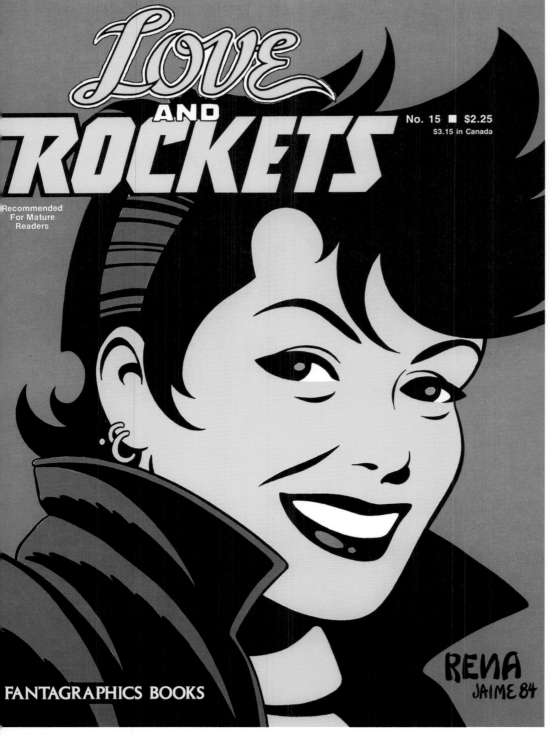

in the "slicks" such as *Collier's* or the *New Yorker*, though he loves the humor and implied narrative in the work of Charles Addams and Virgil Partch. Despite occasional homages, specific influences do not lead him when composing an image; the phase of yearning to imitate a favorite cartoonist was drained out of his system by the time *Love and Rockets* began. Therefore, his love for Mexican poster painter, caricaturist, and all-around artist Ernesto Cabral, for example, shines through not in any stylistic or compositional tics, but in a sweepingly playful approach to composing an image. "I don't want to draw like him, I want to be him—I want the energy of him, the life and soul of him to be inside me. I'm not looking to reproduce the specifics, but the feel. It's the speed, the impact, the energy level that inspires me." As Hernandez advises young artists: "Don't study it, live it. I go look at [the comic strip] *Wash Tubbs* for a dose of life and soul from Roy Crane. Not for reference, but for inspiration, but to get religion. To get the spirit." This relationship to the history of comics and related illustration offers up a telling distinction in how Hernandez and his brother Gilbert approach their comics, in opposition to the labored regurgitations of many "students of the form."

above left
Love and Rockets no. 15 (Fantagraphics Books, 1986).

top right
Canteen Kate no. 2 (St. John, 1952). Cover by Matt Baker.

bottom right
United Comics no. 17 (United Features, 1951). Cover by Ernie Bushmiller.

top
Original preliminary artwork for *Love and Rockets*
volume 2, no. 16, cover, 2005.

bottom
Love and Rockets volume 2, no. 16 (Fantagraphics
Books, 2006).

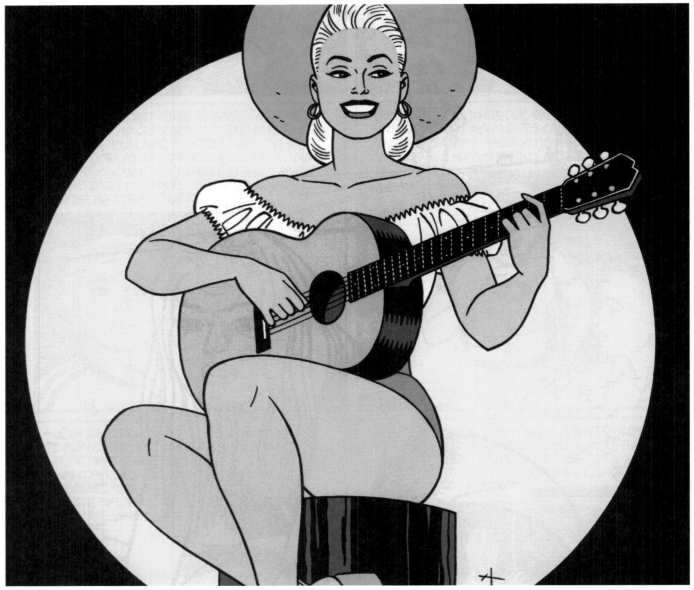

top
Two preliminary sketches for *Penny Century* no. 5 cover, the one on the left from 1980 and the one on the right from1998.

bottom
Penny Century no. 5 (Fantagraphics Books, 1999).

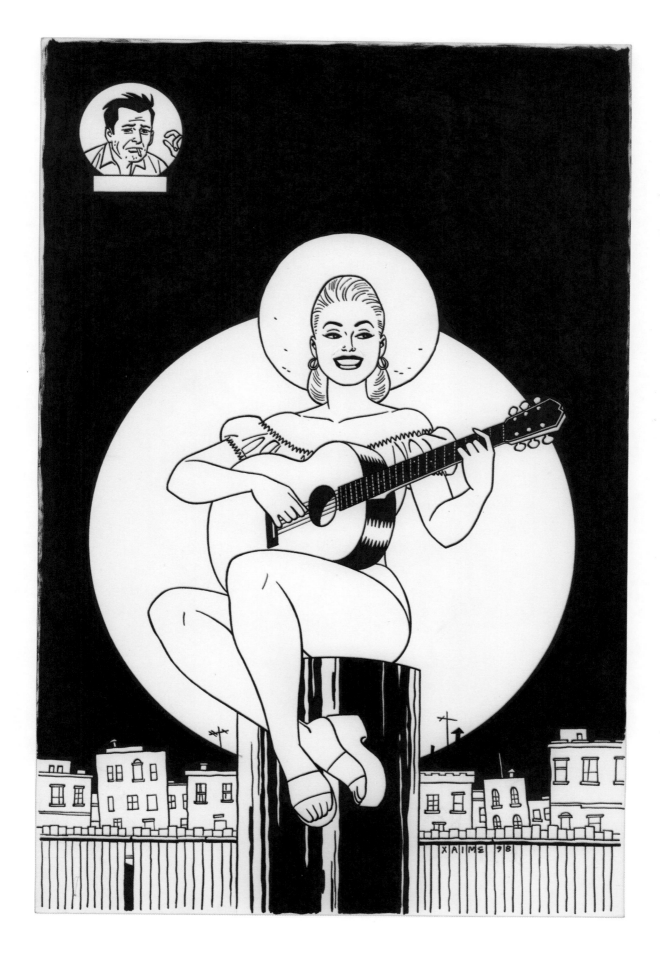

Original artwork for *Penny Century* no. 5, cover, 1998.

Illustration to accompany the story "Adams," by
George Saunders, *The New Yorker*, August 9 & 16,
2004.

Hernandez is widely visible as an illustrator, continuing to alternate between work for small punk labels and mainstream bands, magazines from *Hustler* to the *New Yorker*, and many spots in between. His first *New Yorker* illustration was published in 1993 and, echoing the recent transition of comics into the realms of the mainstream art and literary worlds, he's continued to contribute interior full-page and small spot illustrations up to today. When allowing for color, his line is even sparer than in his comics. In his mind, there exists a vast and inexorable gulf between *Love and Rockets* and a hired illustration:

> Unless I'm hired to be me, which is rare, I care less when I do them, so maybe that shows. I can sense so much missing when I do something for someone else. The little details that make my work are all after the fact, they're not planned, they come later—that doesn't happen with

hired work. It's hard to put something really personal in there, because if it's personal to me, it's not to them, so any of those details will just be something to edit like everything else. In many cases, the editorial process strips it of any soul and I think this comes through—though a lot of people don't, they think it's a beautiful image. They don't realize how much is taken out from the beginning to the final product. And I think "This is the rest of the world." In any medium that deals with editing, a lot of art is stripped down to this soulless thing. Luckily, over the past few centuries, we've had illustrators and cartoonists who were talented enough where their stuff could sneak through.

Luckily, Jaime's soul sneaks through vibrantly in these uniformly effusive images, which do not bear witness to the artist's qualms with the nature of the commercial beast.

above left
Illustration to accompany the story "A Rich Man" by Edward P. Jones, *The New Yorker*, August 4, 2003.

above right
Illustration to accompany the story "Sophie's World" by Rebecca Mead, *The New Yorker*, October 18 & 25, 1999.

PIETRO GERMI'S

DIVORCE
ITALIAN STYLE

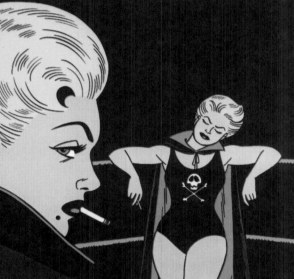

top left
Punk Planet no. 46 (November/December 2001).

top right
Original artwork for the Shame Idols, *I Got Time* LP,
c. 1995.

bottom left
Lung Leg, *Maid to Minx* LP (Vesuvius, 1997).

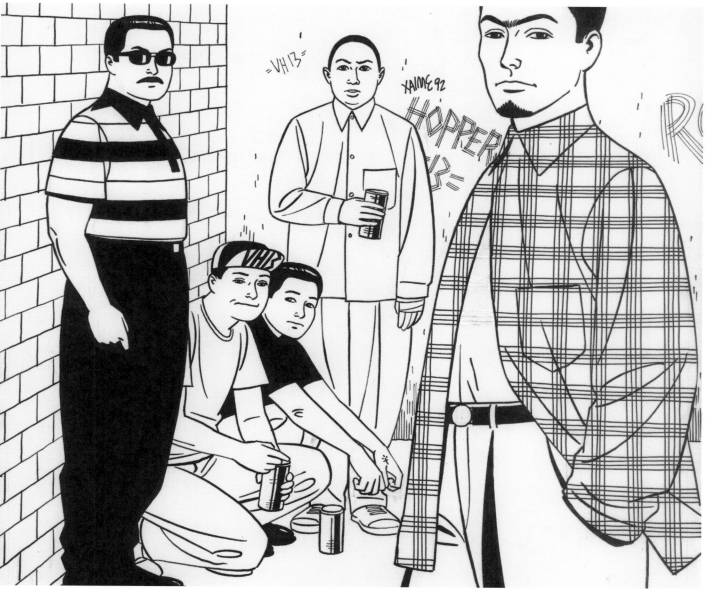

opposite bottom right
Pietro Germi, *Divorce Italian Style* (Criterion, 2005).
Cover design by Eric Skillman.

top
The Makers, *Tear Your World Apart* EP (Estrus, 1997).

bottom
Original artwork for rejected *Deadline* cover, 1992.

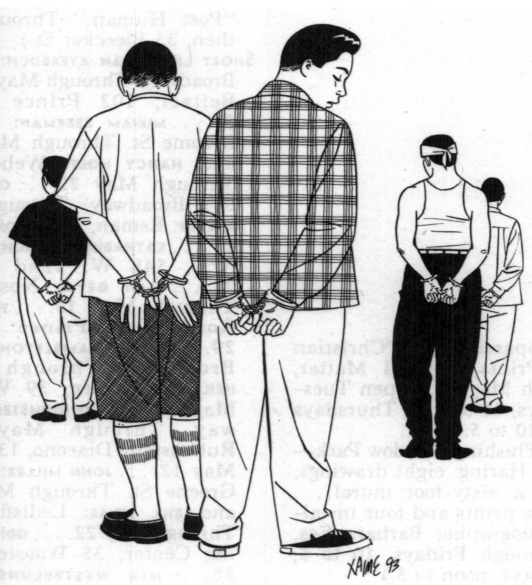

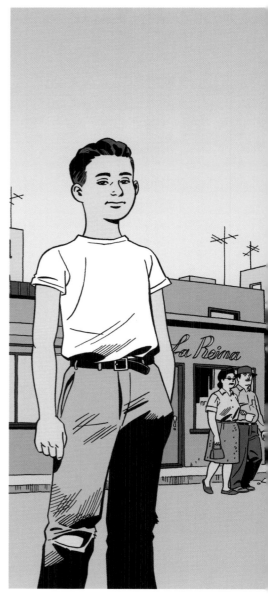

top
Los Lobos, *The Town and the City* LP (Hollywood Records, 2006).
Art Direction: Louie Pérez, Al Quattrocchi, and Jeff Smith.

bottom left
Calendar listing for a Latino art exhibition, *The New Yorker*, 1993.

bottom right
Cover for the young adult novel *Downtown Boy* by Juan Felipe Herrera (Scholastic Press, 2005).

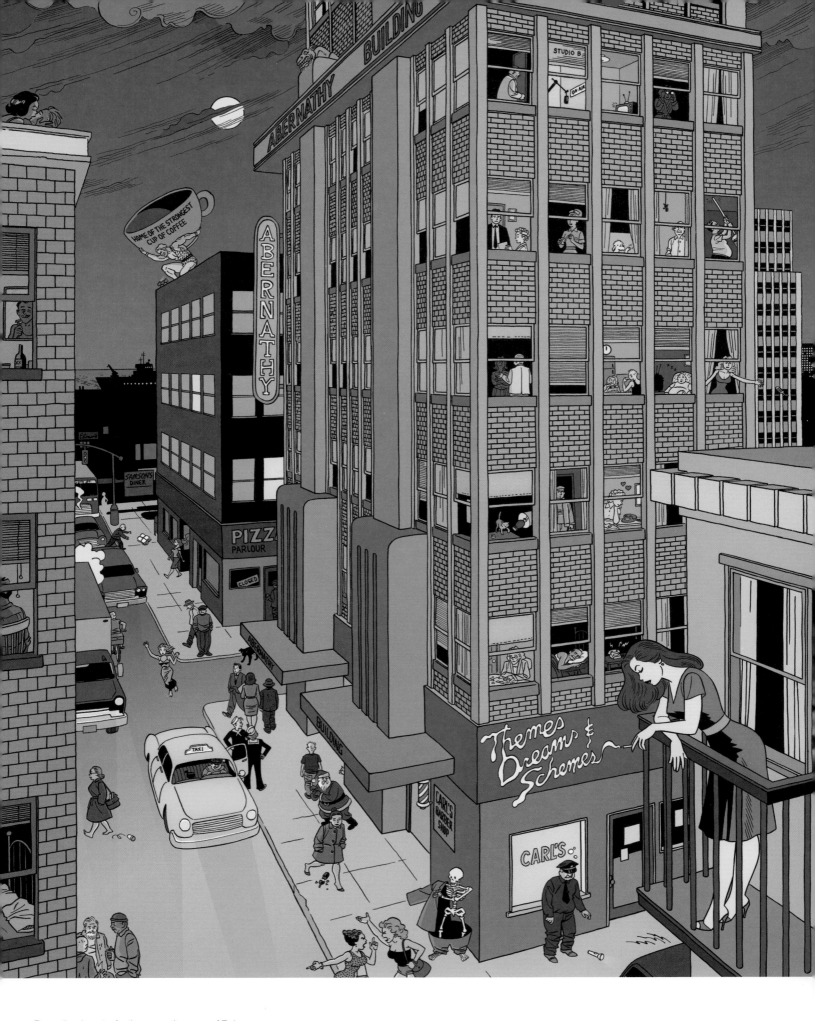

Promotional poster for the second season of Bob Dylan's XM satellite radio show "Theme Time Radio Hour," 2007. Commissioned by producer Eddie Gorodetsky, every detail in the poster is a reference to a specific vignette spoken by actress Ellen Barkin in her introduction to each weekly episode.

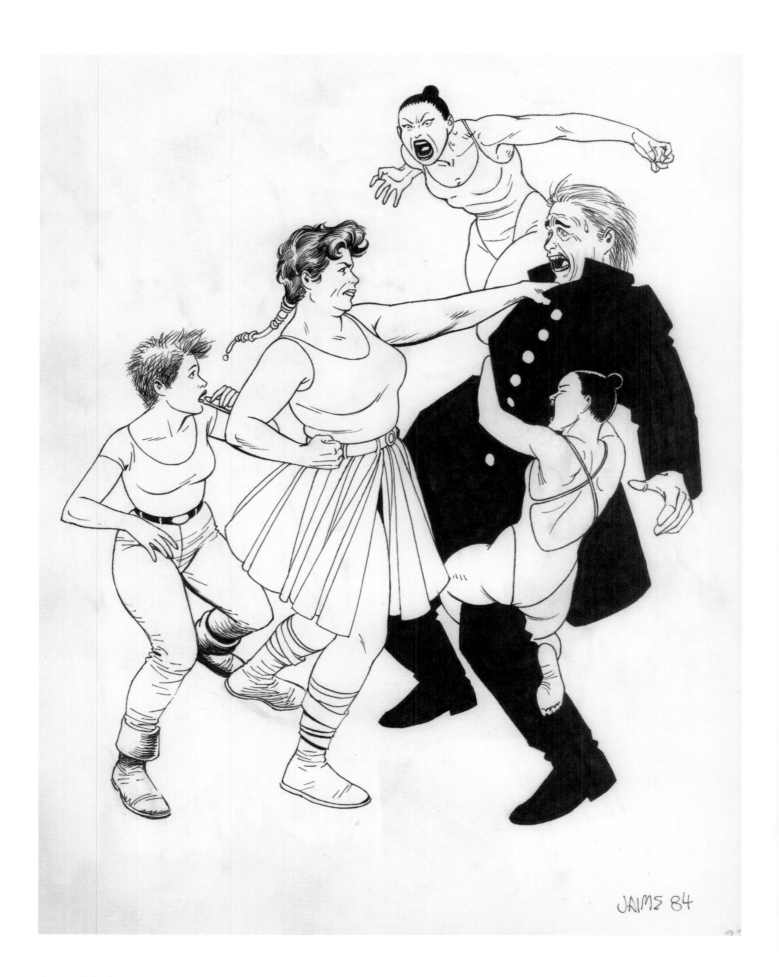

JAIMS 84

above and following pages
Selections from Hernandez's sketchbooks, spanning
1984 to 2007.

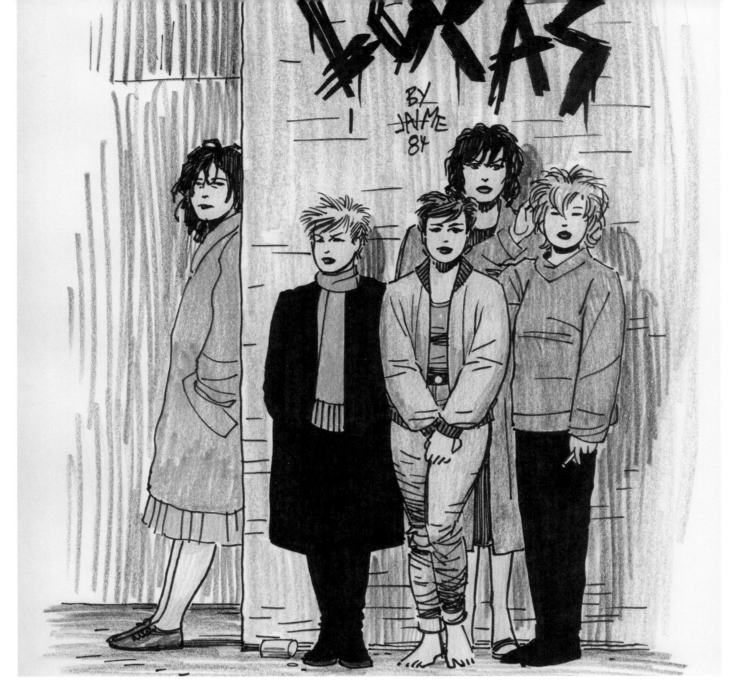

Sketchbooks

HERNANDEZ HAS KEPT A SKETCHBOOK ever since he was required to for college art assignments in 1979. He uses his sketchbooks for multiple purposes, from life drawing, character studies (including many first impressions of those who will later show up in *Love and Rockets*), comic book and page layout designs, single-page compositions, and groupings of smaller images. Also fluid are both his intent, running the gamut from serious to humorously playful, and drawing style, which is closely related to the various drawing tools used: graphite, colored pencil, marker, and numerous types of pen, brush, and crowquill.

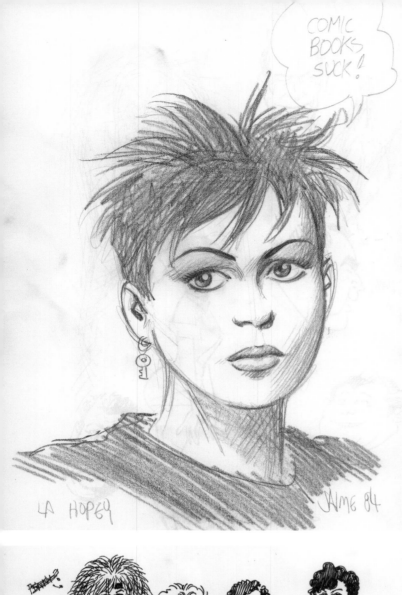

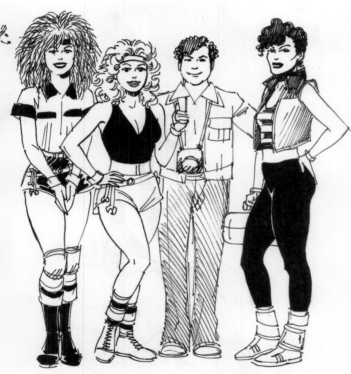

NOPE, NOPE! TOO TALL! WE HAVE TO MAKE THIS AUTHENTIC!
WE'LL USE THE SHORT ONE! BUT WE'LL HAVE TO SHORTEN HER HAIR!
MORE PUNKIER! RACE'S OLD ASSISTANT WAS MORE PUNKIER!

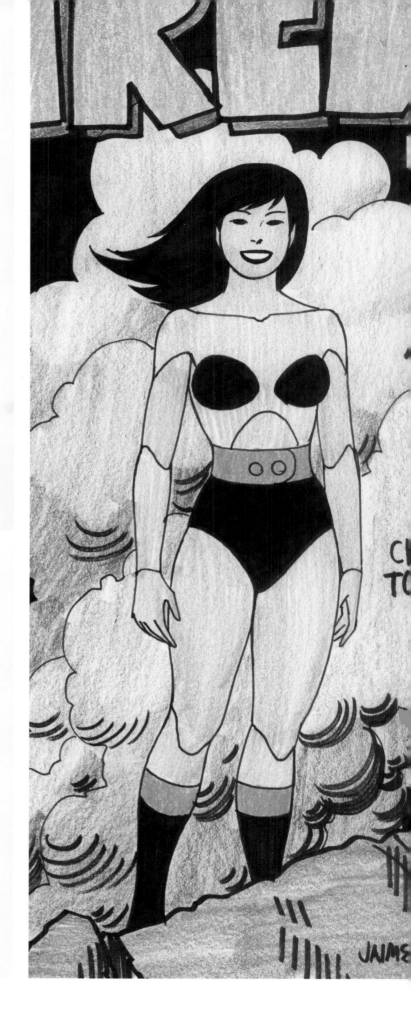

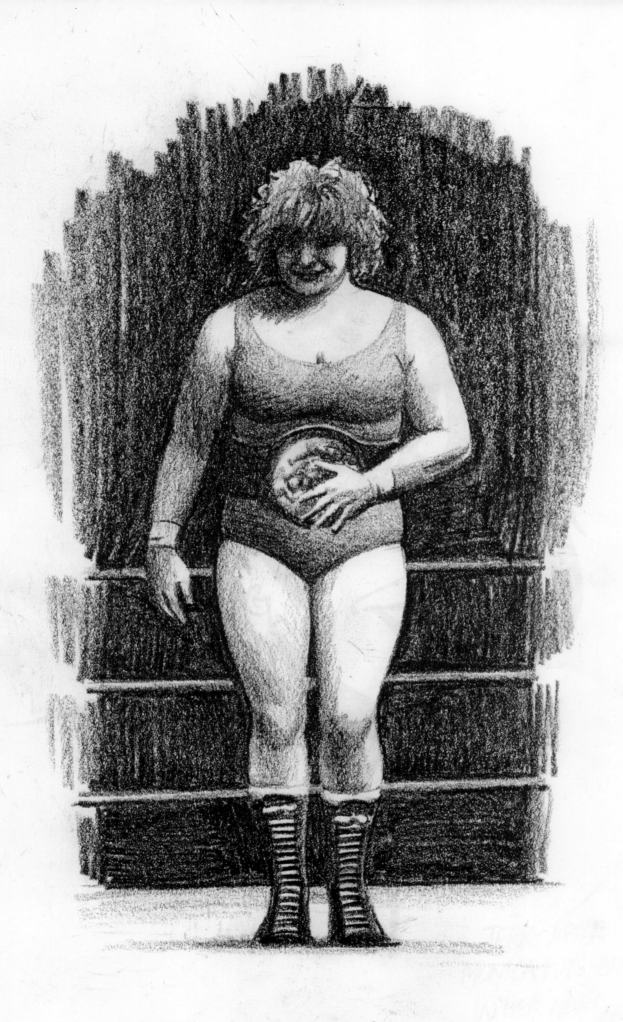

4/14/86
RENA REGAINS TITLE

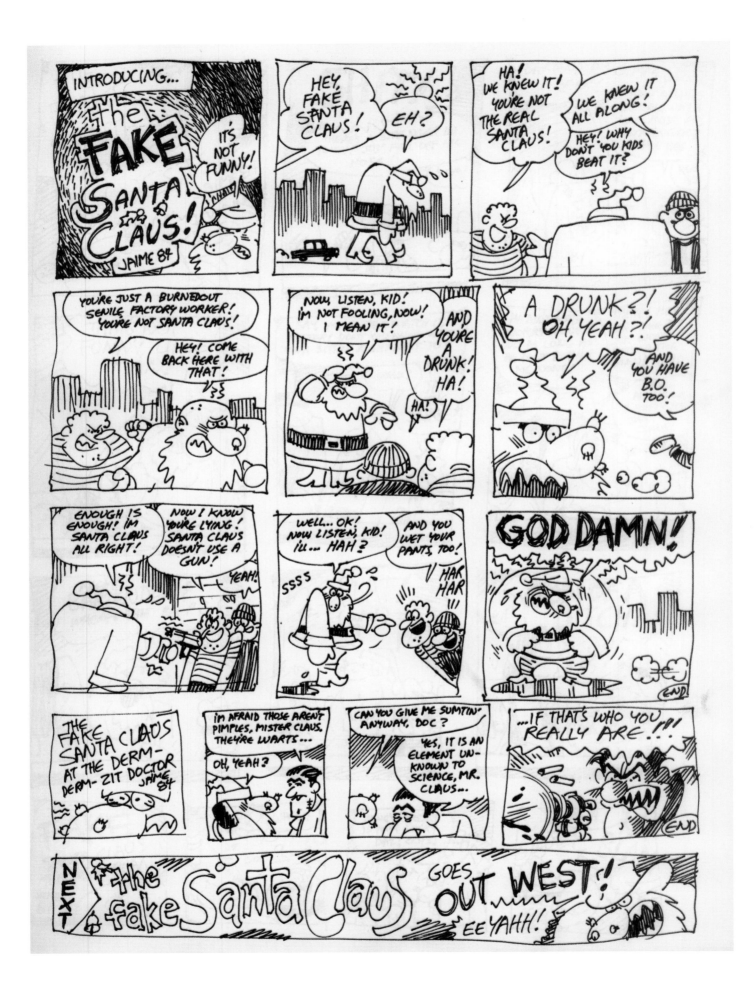

HECK, I AIN'T THAT OLD... IT'S GOTTA BE THE GODDAMN CIGARETTES... OR THE HOOCH...

TODAY, I DREAMT I WENT TO THE MOON. I GOT BORED FAST.

opposite
Maggie in costume: "I have a weakness for a fat Wonder Woman."

right
"A study for a series about Mrs. Costigan that was never realized."

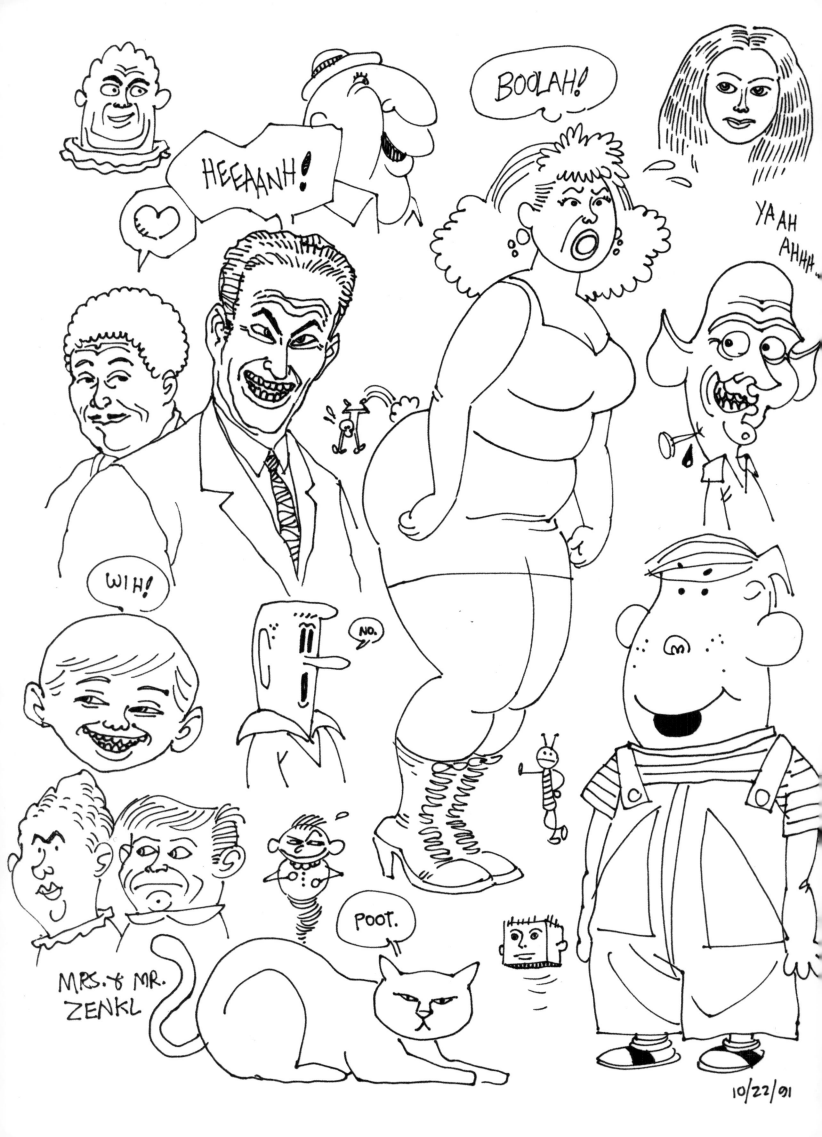

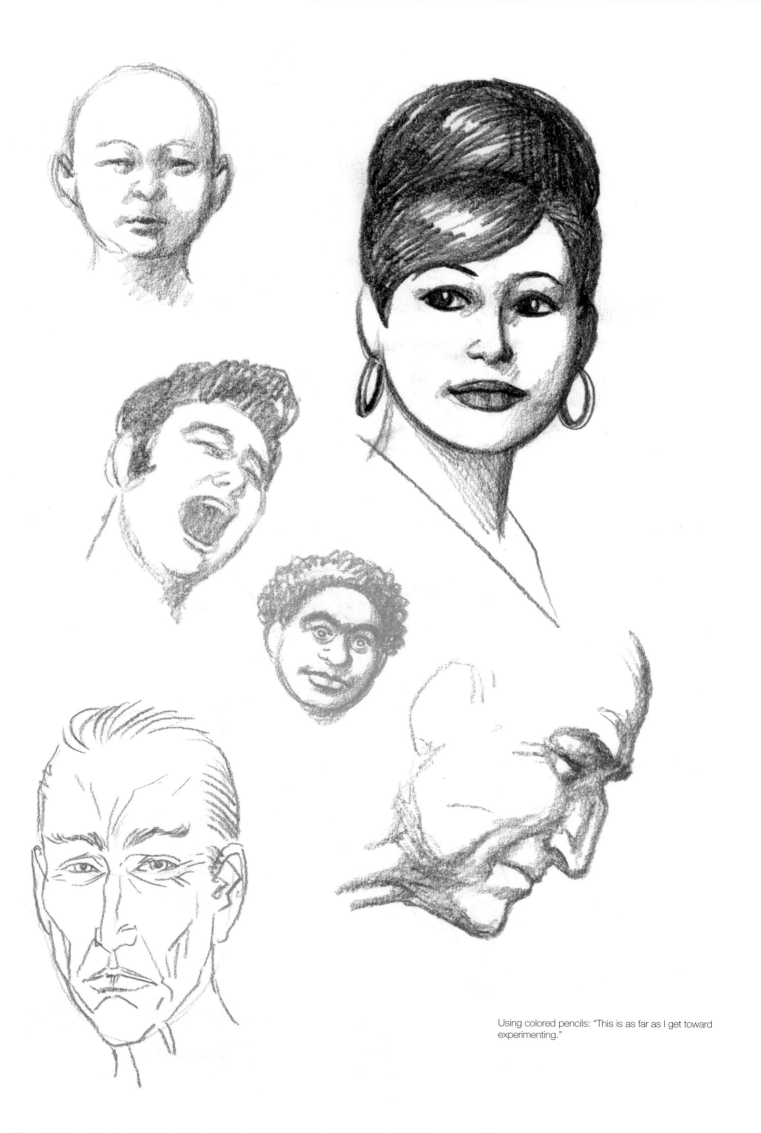

Using colored pencils: "This is as far as I get toward experimenting."

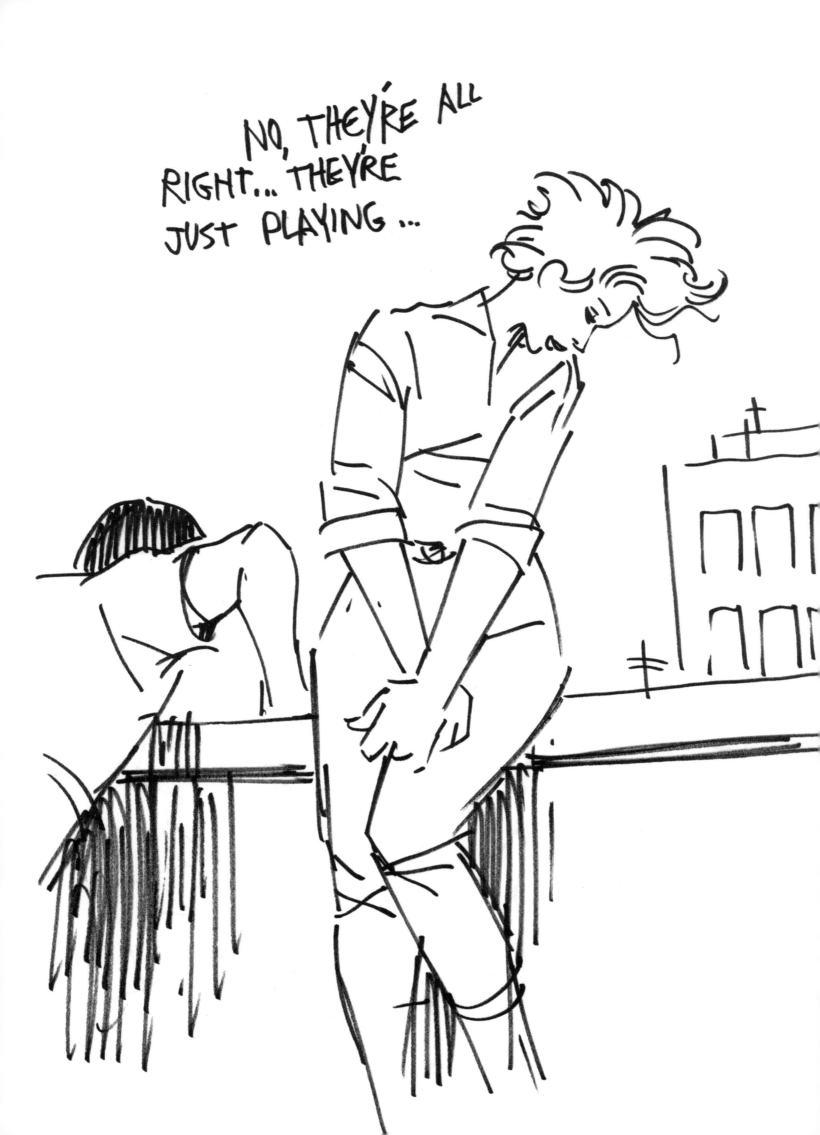

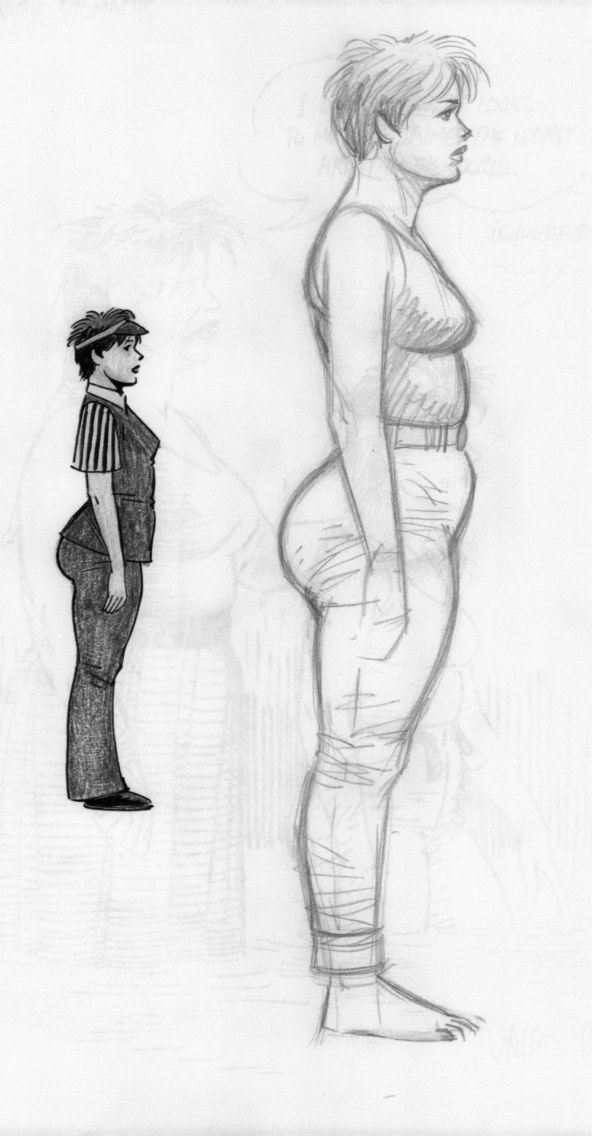

I REMEMBER A PHOTO LIKE THIS OF PICASSO ONCE UPON A TIME.

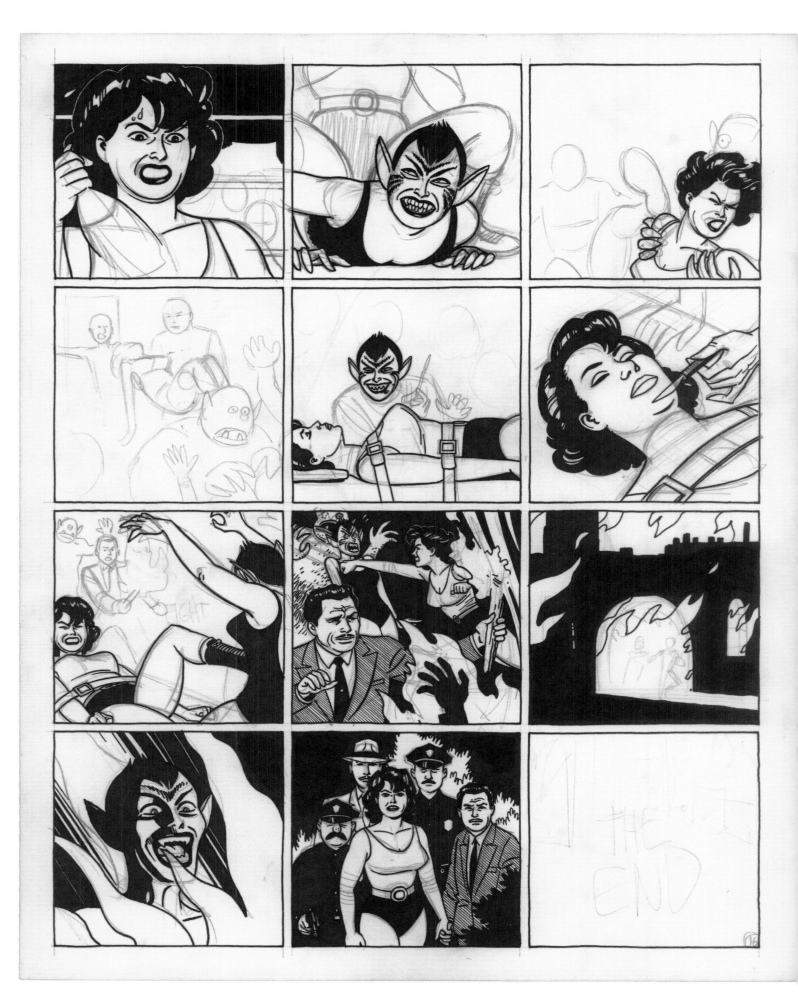

Original unfinished artwork for Rena Titañon story,
c. 1988.
"This was a story about a movie Rena made, but
I rejected it because I was merely lifting from old
Mexican wrestling monster movies."

Afterword: The Secrets of Life and Death

Owen Fitzgerald, Oxnard, Jack Kirby, *9th Street Bridge*, The Sex Pistols, Edward G. Robinson, wax museums, Harry Lucey, Fred Blassie, X, John Stanley, true ghost stories, R. Crumb, The Fabulous Moolah, Forrest J. Ackerman, El Santo, *Mr. Magoo's Christmas Carol*, Picasso, Benny Hill, The Easybeats, *Of Mice and Men*, Dr. Smith, Bob Bolling, Jean Peters in *Pickup on South Street*, Jesse Marsh, Anthony Quinn, Aalon, Shemp, *Mars Attacks* cards, Johnny Cash, Jerome Horwitz, Ice Cube, *MAD* Magazine, Black Flag, Toshiro Mifune, *Winchell-Mahoney Time*, Paul Klee, Beto, baseball, Rosalind Russell, The Replacements, women in swimsuits, Rembrandt, Mott the Hoople, Dr. King, *Peanuts*, Frankenstein, *Stay*, true crime, Roy Crane, dinosaurs, Jem & Scout Finch, J. Russell Finch, local commercials, Ray Harryhausen, *White Fang*, Frazetta, and Lili from *A la cama con Porcel*.

Jaime Hernandez
A list of some important art, 2007

JAIME HERNANDEZ'S COMICS ARE HONEST, even when framed in superficially unbelievable situations; this honesty lies in the constantly conflicting emotions and motivations that lead to all manner of heartbreak and self-destruction on the way toward spiritual fulfillment. The punk milieu and its aftermath is a true, oversaturated microcosm of such pitfalls. These themes are beautifully articulated, yet it is impossible to pigeonhole Hernandez's ineffable vision, as messy and sometimes contradictory as life itself, which is perfectly realized (if not contained) by his spare, virtuosic art. The much-lauded reality of *Love and Rockets* does not stem from documentary exactitude—although the accumulation of telling details evinces a subliminal piecing together of events into a perfectly integrated world in the mind of the reader—but rather from the combination and juxtaposition of what is depicted and left out, internal monologues, too often humble existence, and dreams. For all the discussion of realism and well-rounded characters, the potency truly lies in the in-between—in between perfectly paced "real life" and symbolic fantasy—that makes the emotional chord all the more heightened (his early super heroes and space princesses—and rockets—can at this point be read as almost purely internalized, wistful metaphors).

Original artwork for Los Lobos, *The Town and the City*, CD interior illustration, 2006.

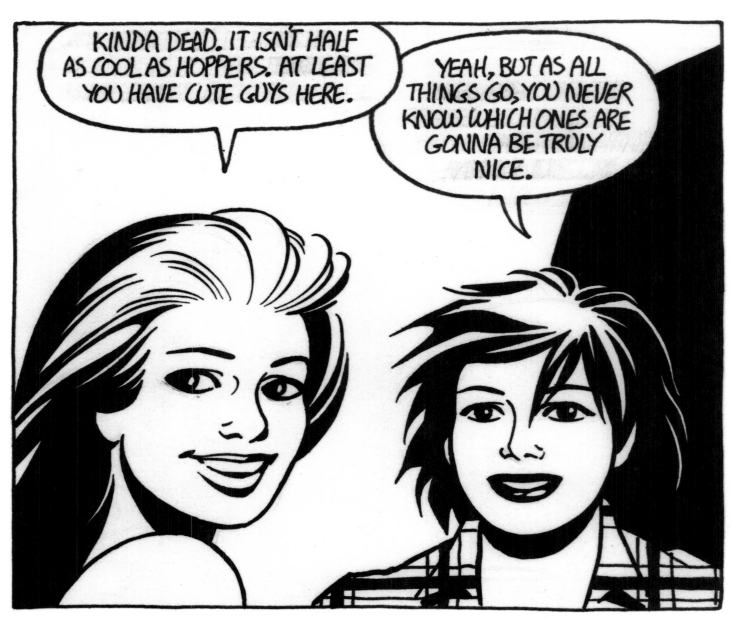

As skillfully as any cartoonist the medium has seen, Hernandez creates a total reality within comics' inherent magic realism, which is much more effective than one-note reportage. Real life is declared as the cumulative effect of his ongoing anticlimactic rhythm; this achievement is infinitely more realistic than "realism," as it accentuates the fantastic and ever-shifting internal impressionism of the human experience. The focus is always on lives writ; on the characters to whom he returns as they age. Hernandez's evolving dramas become deeply ingrained by nature of their serial form; characters are followed forward and backward in time, always there for the reader to return to, and thus remain life-affirmingly alive.

The bold single images that lead his process mirror how the reader recalls the stories. This is how memory functions, and why these characters reverberate so strongly, as snapshots from another life. If capturing modern life is about capturing essence, the best comics, in their sequences of still images, are nothing if not distillations of essence which hold the potential to achieve a visual poetry, a universal truth. In their stillness, these comics function the way memories function—in frozen flashes, as opposed to flowing action. They are still in their juxtapositions, in the same way memories are still: "memory drawings," a description wonderfully articulated by Seth, another distinguished

contemporary cartoonist, in an essay on artist Thoreau MacDonald. "It's a coded message . . . The cartoonist works with stylized forms that represent things. He develops visual shorthand that allows the reader to read the visuals in the same way that he reads the words in the word balloons. True—they are drawings. A cartoon drawing of a house is a drawing of a house—but it is simplified in a way that allows the reader to absorb it as a memory picture. You can't possibly convey the actual experience of walking barefoot through the grass in a pen-and-ink cartoon drawing—but you can convey the essence of this in a kind of memory drawing that the reader will understand and plug his own experiences into."

While Hernandez's drawing, pacing, and manner of storytelling are unmistakably rooted in comic books, his characterization is anything but. Life's importance is comprised of details, not a grand arc, and the weight of his world can be revealed in each clean mark that begs to be meditated on. Hernandez's subtle sophistication in all areas of cartooning is always in the service of low-key naturalism, which, as the artist himself has stated repeatedly, seems "old-fashioned" in the sense that all formal/conceptual concerns are housed underneath. The artist immediately presents the viewer with clearly defined lines and symbols, depicting forms and situations apparently so obvious upon

Original artwork for "The Return of Ray D," page 5, detail, *Love and Rockets* no. 20, 1987.

first glance that it might seem there is nothing further to see: such forthrightness, in both form and content, is perhaps embarrassing to some.

Punk was about thwarting expectations, a totalizing way of life that combined social awareness with an unapologetic love for beauty in unexpected forms. Hernandez's comics steadfastly refuse to become palatable to those who want their art in identifiable containers. His art is earnestly clear, not self-consciously murky, while characters never align themselves in one camp. Hernandez's stories stand in direct opposition to presupposed ideas about seriousness—they're the highest form of art that reads as, and gives the visual and narrative pleasure of, the best popular entertainment.

The subtitle of this book, "The Secrets of Life and Death," is the title of Izzy Ortiz's diary, which is in turn borrowed from Dr. Frankenstein's diary in the movie *Frankenstein Meets the Wolf Man*. Such a connection between the profound and supposedly slight popular culture is a key to Hernandez's world, and in repeatedly reconfiguring these sources, Hernandez demonstrates how such entertainment has the power to sustain; old comics and "forgotten" television shows are Maggie's lifeboat in times of difficulty. Preconceptions, based on culture, gender, sexual orientation, ethnicity, or anything else, exist only to be decimated; beauty knows no definitions, and art, wherever you find it, survives all.

The Secrets of Life and Death, then, are all there in Jaime Hernandez's comics over the last twenty-nine years. Hernandez's list of "important art" at the outset of this chapter, which he cautions would be different at any given time, provides the best entryway into his aesthetic. His stories offer forth with open arms everything there is to love about comics—the remembered pleasure of discovering them as a child, and the rewards of reading the best of them as an adult. For Hernandez, comic characters are vital, and ultimately all responses to his work lead emotionally back to his rich characters—specifically Maggie and Hopey—who are the true mythic figures in his world.

"Locas: 8:01 AM," page 10, detail, *Love and Rockets* no. 18 (Fantagraphics Books, 1986).
"I could be remembering it wrong, but I recall Lon Chaney, Jr., finding the book and reading the title out loud. I always thought that was the greatest title for any book ever."

BIBLIOGRAPHY

JAIME HERNANDEZ COLLECTED WORKS

FIFTY ISSUES OF THE ORIGINAL *Love and Rockets* series were released by the Hernandez brothers' publisher, Fantagraphics Books, between 1982 and 1996. Jaime subsequently created the solo comic books *Whoa, Nellie!* (three issues, 1996), *Maggie and Hopey's Color Fun* (1997), and *Penny Century* (seven issues, 1997–2000). Gilbert and Jaime then reteamed for *Love and Rockets, Volume II*, which ran a total of twenty issues (2001–07), and the current *Love and Rockets: New Stories*, two issues of which have been published so far, in the summers of 2008 and 2009, respectively.

Virtually all of the Hernandez brothers' material has been kept perpetually in print in variously formatted book collections by Fantagraphics. There is the ongoing *Love and Rockets Book* series that continues to collect the serialized stories of both Gilbert and Jaime up to their most recent comics, and which numbers twenty-four volumes as of this writing. Volumes 1–6, 9, and 15 combined the work of the two cartoonists, with the remaining books alternating between the two. Jaime's solo volumes are Book 7 (*The Death of Speedy*, 1989); 11 (*Wigwam Bam*, 1994); 13 (*Chester Square*, 1996); 16 (*Whoa, Nellie!*, 2000), 18 (*Locas in Love*, 2000); 20 (*Dicks and Deedees*, 2003); 22 (*Ghost of Hoppers*, 2005); and 24 (*The Education of Hopey Glass*, 2008).

A good portion of Jaime's *Love and Rockets* work was also collected in the massive hardcovers *Locas: The Maggie and Hopey Stories* (2004), and *Locas II: Maggie, Hopey & Ray* (2009).

In addition, there are recent reprint collections in a handy smaller format, which are the best source for the bulk of each artist's work. The Jaime solo titles are: *Maggie the Mechanic* (2007); *The Girl from H.O.P.P.E.R.S.* (2007); and *Perla La Loca* (2007).

There are also two collections of assorted sketchbook drawings, spot illustrations, and flyers by both Gilbert and Jaime: *Love and Rockets Sketchbook One* (1989), and *Love and Rockets Sketchbook Two* (1992).

JAIME HERNANDEZ: INTERVIEWS, CRITICAL ESSAYS, AND OTHER SOURCES

Arnold, Andrew. "Graphic Sketches of Latino Life." *Time*, February 19, 2001. p. 64.

Chang, Jeff. "Locas Rule." *ColorLines*, Spring 2002. pp. 39–41.

Fiore, Robert. "No Hopey for the Future: *Wigwam Bam*, *Love and Rockets* no. 33–39 (Funnybook Roulette)." *The Comics Journal* no. 156, February 1993. pp. 3–8.

Gaiman, Neil. "The Hernandez Brothers Interview." *The Comics Journal* no. 178, July 1995. pp. 91–123.

Gravett, Paul. "Locas." *Graphic Novels: Everything You Need to Know*. New York: HarperCollins, 2005. pp. 44–45.

Groth, Gary. "Comics Can Be Art and Here Are Some of the Reasons Why." *Love and Rockets* no. 2, Spring 1983: inside front and inside back covers.

———. "Love, Rockets and Thinking Artists." *The Comics Journal* no. 67, October 1981. pp. 52–54.

———. "O, What a Wonderful Book It Is." *Love and Rockets* no. 1, Fall 1982: inside front cover.

———. "Shootin' the Breeze with the Bros.: A Conversation with Jaime, Gilbert, and Mario Hernandez." *Lone Star Express* no. 123, April 1983. pp. 10–15.

Groth, Gary, with Robert Fiore and Thom Powers. "Pleased to Meet Them: The Hernandez Bros. Interview." *The Comics Journal* no. 126, January 1989. pp. 60–113.

Heintjes, Tom. "Rocket Engineer." *Hogan's Alley* no. 11, 2003. pp. 78–82.

Hignite, Todd. "Jaime Hernandez." *In the Studio: Visits with Contemporary Cartoonists*. New Haven and London: Yale University Press, 2006. pp. 132–63.

———. "Jaime Hernandez's 'Locas.'" *Strips, Toons, and Bluesies: Essays in Comics and Culture*. D. B. Dowd and Todd Hignite, eds. New York: Princeton Architectural Press, 2004. pp. 46–59.

Huestis, Peter. "*Love and Rockets* Is Dead—Long Live *Love and Rockets!*" *Your Flesh* no. #34, Fall 1996. pp. 66–71.

Humphreys, Quanah. "Jaime Hernandez." *Punk Planet* no.46, November/December 2001. pp. 38–45.

Knowles, Chris. "The Mechanic of Love: Jaime Hernandez Talks About Life with Maggie and Hopey." *Comic Book Artist* no. 15, November 2001. pp. 56–64.

Markee, Patrick. "American Passages." *The Nation*, May 18, 1998. pp. 25–27.

Mendoza, Ruben. "Fear of Chicano Comics: Los Bros Hernandez, Maestros of the Anti-Canon." Radio program, August 2006. www.sicklyseason.com/los-bros-hernandez/

Mitchell, Elvis. "¡Vaya Con Los Bros!" *Vibe*, March 2001. pp. 100–101.

Morales, Robert. "Los Bros. Body Slam the House." *Reflex*, August 1991. pp. 56–60.

Nichols, Natalie. "¡Viva Locas!" *Los Angeles City Beat*, vol. 2 no. 51, December 16–22, 2004. pp. 16–20.

Pekar, Harvey. "Comics and Genre Literature," *The Comics Journal* no. 130, July 1989. pp. 127–33.

Roberts, Andy. "Thirty-Five Dollars and a Six Pack to My Name." *Comics Forum* no. 13, Winter 1996–97. pp. 11–19.

Rosenfelder, Mark. "The Jaime Hernandez Chronology." www.zompist.com/loveroc1.html

———. "*Love and Rockets* Character Index." www.zompist.com/lovinchar.html

Rubin, Rachel. "Love and Rockets." *Aztlán: A Journal of Chicano Studies*, vol. 24 no. 2, Fall 1999. pp. 169–92.

Rubinstein, Anne. "Amour's Orbit." *OutWeek*, May 30, 1990. p. 50.

Sayenga, Kurt. "The Fire of Love (and Rockets)." *Greed* no. 5, Summer 1988. pp. 32–40.

Scholz, Carter. "A Habitable World: The Brothers Hernandez." *Love and Rockets Book One: Music For Mechanics*. Agoura Hills, CA: Fantagraphics Books, 1985. pp. i–iv.

Schutz, Diana. "Bring on the Hernandez Brothers!" *The Telegraph Wire* no. 16, August/September 1984. pp. 6–12.

Smith, Kenneth, "Shaggy Shapes, Modern Motions." *The Comics Journal* no. 86, November 1983. pp. 39–50.

Spurgeon, Tom. "The Education of Hopey Glass." February 12, 2008. www.comicsreporter.com/index.php/briefings/cr_reviews/12820/

Stevens, Robin. "Love and Rockets." *Out/Look*, Spring 1992. pp. 32–35.

Sullivan, Darcy, "Back to the Drawing Board: 'I'm Drawing What I Want to Draw ...' How Jaime Hernandez Creates His World Class Cartooning." *The Comics Journal* no. 150, May 1992. pp. 60–65.

Wolk, Douglas. "Jaime Hernandez: Mad Love." *Reading Comics: How Graphic Novels Work and What They Mean*. Cambridge, MA: Da Capo Press, 2007. pp. 193–202.

Young, Robert. "TCI Interview: Jaime Hernandez." *The Comics Interpreter* no. 6, Winter 2001. pp. 8–19.

GENERAL SOURCES

Acuña, Rodolfo. *Occupied America: A History of Chicanos*. Second edition. New York: Harper & Row, 1981.

Barrier, Michael and Martin Williams, eds. *A Smithsonian Book of Comic-Book Comics*. Washington, DC, and New York: Smithsonian Institution Press and Harry N. Abrams, Inc., 1981.

Barthes, Roland. "The World of Wrestling." *Mythologies*. Translated by Annette Lavers. New York: Hill and Wang, 1972.

Baudelaire, Charles. *The Painter of Modern Life and Other Essays.* Translated and edited by Jonathan Mayne, second edition. London: Phaidon Press Limited, 1995.

Carducci, Joe. *Enter Naomi: SST, L.A. and All That . . .* Centennial, WY: Redoubt Press, 2007.

Carlin, John, Paul Karasik, and Brian Walker, eds. *Masters of American Comics*, exhibition catalog. New Haven: Yale University Press, 2005.

Cervenka, Exene, et al., eds. *Forming: The Early Days of L.A. Punk.* Santa Monica: Smart Art Press, 1999.

Davis, Mike. *City of Quartz: Excavating the Future in Los Angeles.* London and New York: Verso, 1990.

———. *Magical Urbanism: Latinos Reinvent the U.S. City.* London and New York: Verso, 2000.

Dean, Mike, Anne Elizabeth Moore, and Matt Silvie, compilers. "Timeline." *The Comics Journal* no. 235, July 2001. pp. 82–133.

Estren, Mark James. *A History of Underground Comics* (1974). Berkeley: Ronin Publishing, Inc., 1993.

Feiffer, Jules. *The Great Comic Book Heroes.* New York: Dial Press, 1965.

Fox, Geoffrey. *Hispanic Nation: Culture, Politics, and the Constructing of Identity.* Secaucus, NJ: Carol Publishing Group, 1996.

Groth, Gary. "*The Comics Journal* and the New Comics." *The New Comics.* Gary Groth and Robert Fiore, eds. New York: Berkeley Books, 1988. pp. ix–xii.

———. ed. *Misfit Lit: Contemporary Comic Art*, exhibition catalog. Seattle: Fantagraphics Books, 1991.

———. "The Top 100 (English-Language) Comics of the Century." *The Comics Journal* no. 210, February 1999. pp. 34–108.

———, and Kim Thompson. "Introduction." *1980–1990: The Best Comics of the Decade*, Volume 1. Seattle: Fantagraphics Books, 1990.

Harvey, Robert C. *The Art of the Comic Book: An Aesthetic History.* Studies in Popular Culture, ed. M. Thomas Inge. Jackson, MS: University Press of Mississippi, 1996.

Hatfield, Charles. *Alternative Comics: An Emerging Literature.* Jackson, MS: University Press of Mississippi, 2005.

Hayes-Bautista, David E. *La Nueva California: Latinos in the Golden State.* Berkeley: University of California Press, 2004.

Hebdige, Dick. *Subculture: The Meaning of Style.* Oxford: Routledge, 2005.

Inge, M. Thomas and Dennis Hall, eds. *The Greenwood Guide to American Popular Culture.* 4 volumes. Westport, CT: Greenwood Press, 2002.

Jones, Gerard. *Men of Tomorrow: Geeks, Gangsters and the Birth of the Comic Book.* New York: Basic Books, 2004.

Kurtzman, Harvey, with Michael Barrier. *From Aargh! to Zap! Harvey Kurtzman's Visual History of the Comics.* New York: Byron Preiss/Prentice Hall, 1991.

Maulhardt, Jeffrey Wayne. *Oxnard: 1941–2004.* Images of America series. Charleston, SC: Arcadia Publishing, 2005.

Meier, Matt S., and Feliciano Ribera. *Mexican Americans/American Mexicans: From Conquistadors to Chicanos.* Revised edition. New York: Hill and Wang, 1993.

Merino, Ana. *Fantagraphics, creadores del Canon.* Gijon, Spain: Semana Negra, 2003.

Miller, Craig, and John Thorne. "The Many Origins of *Cerebus* I: The Comics World of 1977." *Following Cerebus* no. 6, November 2005. pp. 2–13.

Mullen, Brendan, with Don Bolles and Adam Parfrey. *Lexicon Devil: The Fast Times and Short Life of Darby Crash and The Germs.* Los Angeles: Feral House, 2002.

Robbins, Trina. *From Girls to Grrrlz: A History of Women's Comics from Teens to Zines.* San Francisco: Chronicle Books, 1999.

———. *A Century of Women Cartoonists.* Northampton, MA: Kitchen Sink Press, 1993.

Rosenkranz, Patrick. *Rebel Visions: The Underground Comix Revolution 1963–1975.* Seattle: Fantagraphics Books, 2002.

Sabin, Roger. *Comics, Comix & Graphic Novels.* London: Phaidon Press Limited, 1996.

———, and Teal Triggs, eds. *Below Critical Radar: Fanzines and Alternative Comics from 1976 to Now.* Hove, United Kingdom: Slab-O-Concrete, 2001.

Schelly, Bill. *The Golden Age of Comic Fandom.* Seattle: Hamster Press, 1999.

Seth. "TM." *DA, A Journal of the Printing Arts* no. 60, Spring/Summer 2007. pp. 3–25.

Spitz, Marc, and Brendan Mullen. *We Got the Neutron Bomb: The Untold Story of L.A. Punk.* New York: Three Rivers Press, 2001.

Watson, Elena M. *Television Horror Movie Hosts: 68 Vampires, Mad Scientists and Other Denizens of the Late-Night Airwaves Examined and Interviewed.* Jefferson, NC: McFarland & Company, Inc., 1991.

Wright, Bradford W. *Comic Book Nation: The Transformation of Youth Culture in America.* Baltimore and London: The Johns Hopkins University Press, 2001.

INDEX

ACKNOWLEDGMENTS

THANK YOU FIRST AND FOREMOST to Jaime Hernandez. Without his willingness and generous participation, a project such as this would, of course, not be possible. Jaime went well beyond the call of duty, agreeing to lengthy interviews, inquisitions, and intrusions in person (including a great day in Oxnard), on the phone, and via e-mail, as well as permitting me to peruse and scan tons of original art and material from his archives. I'm forever in his debt for all of his efforts as well as for his beautiful original artwork for the cover and endpapers, which is a far more perfect window into his world than anything I could have written.

Special thanks to Jordan Crane for the absolutely stellar design—it's greatly rewarding to me that this is as much his book as anyone's—and to Alison Bechdel for her wonderfully illuminating introduction. The most exciting part of working on a project so dear to one's heart is turning it over to others and witnessing their brilliance transform what existed nebulously in your head into something much greater.

For all manner of help, thanks very much to: Meg Bradbury, Carol Kovinick Hernandez, Gilbert Hernandez, Mario Hernandez, Coco Shinomiya, Darren Aronofsky, Alvin Buenaventura, Glenn Bray,

Daniel Clowes, Jeff Smith at Tornado Design, Louie Pérez, David Snow at Hollywood Records, Michael Schmitz, Casey Jones, Eric Kroll, Steven Weissman, David Miller, Paul Gravett, Jeet Heer, Trina Robbins, Brian Tucker, Dave Schmidt, and Gary Groth, Kim Thompson, and Eric Reynolds at Fantagraphics Books, Jaime's publisher since 1982.

My gratitude to Ken Parille, one of the smartest writers on comics around, for his perceptive comments on an early draft of my text, which improved markedly as a result.

Thank you as well to Denis Kitchen and John Lind, of Kitchen, Lind & Associates, for placing this book with Abrams and helping in too many ways to count throughout the process of its creation. I'm grateful to have them in my corner.

I owe a substantial debt to executive editor Charles Kochman at Abrams ComicArts, whose enthusiasm and expert input at every stage of this book made a huge difference. The entire staff at Abrams has been a pleasure, so thanks also to Sofia Gutiérrez, assistant editor; Neil Egan, studio manager/designer; and Andrea Colvin, managing editor. I can't imagine a better team.

And, as always, thanks more than I can express to my wife, Sara, for her sage advice and keen editorial eye, and to both her and our daughter, Ava, for their love and support.

Editor: Charles Kochman
Assistant Editor: Sofia Gutiérrez
Designer:)Crane
Production Manager: Alison Gervais

Library of Congress Cataloging-in-Publication Data

Hignite, Todd.
 The art of Jaime Hernandez : the secrets of life and death / by Todd Hignite.
 p. cm.
 ISBN 978-0-8109-9570-3
 1. Comic books, strips, etc. I. Hignite, M. Todd.
 II. Title.

PN6727.H478A6 2009
741.5'69—dc22

 2008016642

Text and compilation copyright © 2010 by Todd Hignite

Introduction copyright © 2010 by Alison Bechdel

Unless noted below, all images copyright © 2010 by Jaime Hernandez

American Comics Group: 49 (bottom left)
Archie Comic Publications, Inc.: 49 (top left; top right), 53 (bottom right), 125 (top left)
Jordan Crane: 134, 136
DC Comics: 51 (top left)
Disney Enterprises, Inc.: 49 (bottom right)
E.C. Publications, Inc: 53 (top right)
Carol Kovinick Hernandez: 71, 86, 96 (left), 104, 109
Gilbert and Jaime Hernandez: 77, 87, 113
Gilbert, Jaime, and Mario Hernandez: 70, 73 (top)
Ismael Hernandez: 75 (left)
Hank Ketcham Enterprises, Inc.: 47 (left)
Carol Kossack: 79
Eric Kroll: 188 (left)
M.F. Enterprises: 51 (right)
Mammoth Records, Inc.: 200 (top)
Marvel Characters, Inc.: 51 (bottom left)
Olympic Auditorium: 53 (left)
Raymond Pettibon/SST Records: 65 (left), 82
St. John Publishing Co.: 192 (top right)
United Features Syndicate: 192 (bottom right)
Warren Publishing Co.: 47 (right), 76
Wrestling Confidential: 170
X/Slash Records: 66 (upper left)

Unless otherwise noted in the text, all of Jaime's quotations come from interview sessions conducted by the author in person during October 2007, or via e-mail or telephone at various times over the last few years. All other quotations come from e-mail interviews with the author done specifically for this book, except where otherwise credited.

Printed and bound in China
10 9 8 7 6 5 4 3 2 1

Abrams ComicArts books are available at special discounts when purchased in quantity for premiums and promotions as well as fundraising or educational use. Special editions can also be created to specification. For details, contact specialmarkets@abramsbooks.com or the address below.

ABRAMS
THE ART OF BOOKS SINCE 1949
115 West 18th Street
New York, NY 10011
www.abramsbooks.com

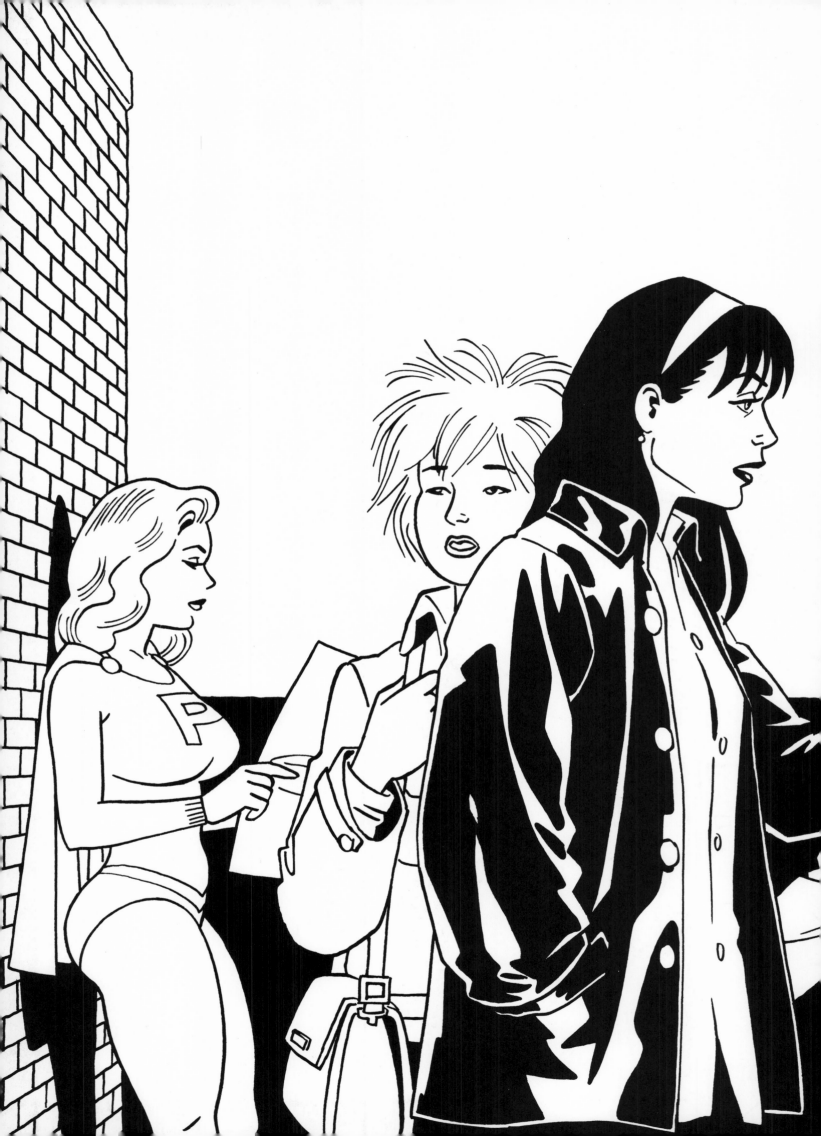